Beginner's Guide to Creating Characters in
Blender

Acknowledgments

Thanks very much to Pierrick Picaut for reviewing this book and for answering all our questions.

3dtotal Publishing

3dtotalPublishing

Correspondence: publishing@3dtotal.com
Website: www.3dtotal.com

First published in the United Kingdom, 2021,
by 3dtotal Publishing.

Reprinted in 2022 by 3dtotal Publishing.

Address: 3dtotal.com Ltd, 29 Foregate Street,
Worcester, WR1 1DS, United Kingdom.

Soft cover ISBN: 978-1-912843-13-8

Printing & binding: Dongguan Everbright
Printing Co.,Ltd. (China)
www.everbrightprint.com

Visit www.3dtotalpublishing.com for a
complete list of available book titles.

Managing Director: Tom Greenway
Studio Manager: Simon Morse
Lead Designer: Fiona Tarbet
Lead Editor: Samantha Rigby
Editor: Melanie Robinson
2nd Editor: Marisa Lewis
Designer: Joseph Cartwright

Cover images by individual artists
as credited or copyrighted throughout the book.

ONE TREE PLANTED FOR EVERY BOOK SOLD

We at 3dtotal Publishing donate 50% of our profits to charity. For every book sold, we give to reforesting charities to plant new trees. This is just one part of our annual donation to a large number of the most effective charities, covering causes such as humanitarian work, animal welfare, and the protection of existing rainforests. We also aim to be a carbon-neutral publisher with carbon-neutral products, which means that by buying from 3dtotal Publishing, you are helping to balance the environmental damage caused by the publishing, shipping, and retail industries, as well as supporting many other causes. See 3dtotal.com/charity for full details.

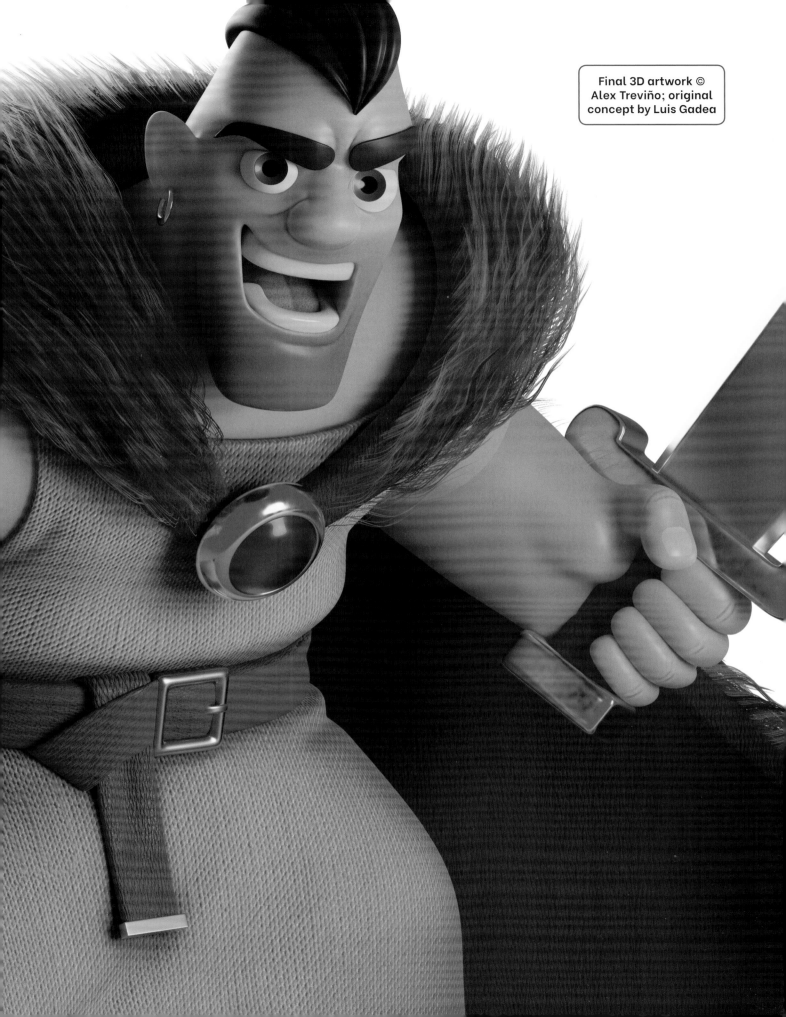

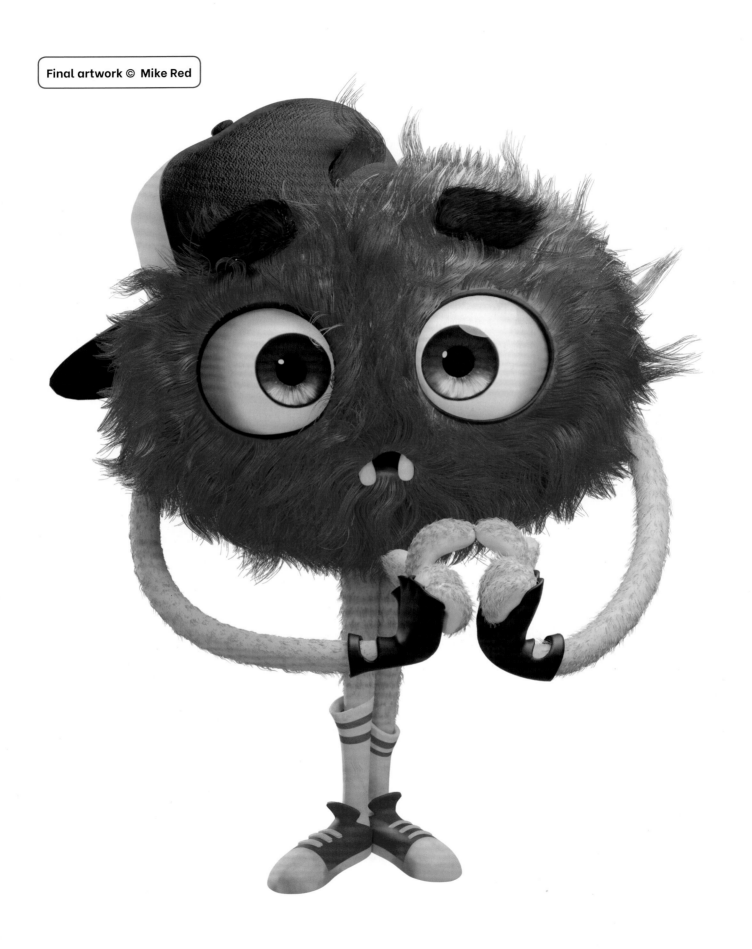

Contents

Artwork acknowledgments as in individual chapters

How to use this book

Blender is the world's premier open-source 3D software, created by some of the best digital artists in the world, and this beginner's guide offers a clear, straightforward route to getting started on your own journey into 3D character creation.

Blender is a versatile and expansive tool, but this book presents all the information you need in an easy-to-follow way. Beginning with an introduction to the fundamentals of working with 3D, we will help you build a skill set that will enable you to create incredible characters, even if you are completely new to 3D.

Focusing on stylized characters, the book will teach you how to create a still character model, covering key topics such as modeling, sculpting, lighting, textures and materials, and rendering. You can also find out how to create a turntable animation of your project on page 181. And you can rest assured you're in the hands of experts, including Blender foundation-certified trainer Pierrick Picaut.

Book structure

The book is split into two main parts – an extensive **introduction** to the software and how to use it, followed by in-depth **step-by-step projects**, which guide you through creating a 3D character from concept to rendering. We recommend that you read the introduction chapters before starting the projects, as these will provide you with important information. You will still be able to start modeling as early as page 42.

Techniques take practice – if you haven't worked in 3D before then be patient and give yourself a chance. Familiarize yourself with moving around your model and the scene, and where key tools are first, as it will make the creative side easier. There's a **chapter overview** at the start of each chapter that explains what the following pages will cover. Toward the back of the book, there's a useful **glossary** to refer to when needed.

Chapter title

Chapter overview

Plus 3 types of information boxes (see top of opposite page)

Image captions

CORE ADVICE	TIP	TROUBLESHOOTING
Key concepts	Handy hints from the experts	To help you if you get stuck

Downloadable resources

To help you as you learn, the generous artists in this book have shared a range of resources, including textures and the original Blender files for you to explore and learn from. Where downloadable resources are available, there will be an arrow icon at the start of the chapter.

Download from
3dtotalpublishing.com/resources

DOWNLOADABLE RESOURCES

Look out for the downloadable resources icon

If you share any of your progress please ensure you attribute the original concept artist and Blender artist.

DOWNLOADABLE CONTENTS

Modeling – Pierrick Picaut
▷ Blender modeling files

Materials & textures in action – Mike Red
▷ Blender modeling and final Blender files
▷ Brush textures
▷ Textures: clothes, fur, skin, and eye
▷ Bumps: bat and ball
▷ Videos: texturing and fur
▷ PDF tutorial for modeling and rendering the character

Warrior – Alejandro Treviño
▷ Final Blender file

Fish - Juan Hernández
▷ PDF tutorial for posing the character using an armature

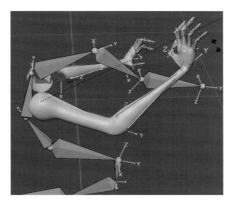

Getting started

By Pierrick Picaut

CHAPTER OVERVIEW

▶ Setting up

▶ Introduction to 3D

So why Blender? First, it's free! Second, it is becoming increasingly popular at a professional level, so learning it today can open you up to many job opportunities tomorrow.

Blender is fantastic because it can do absolutely everything: modeling, sculpting, texturing, rendering, video editing, FXs, simulations, animation, drawing, 2D animation, and motion design. While some other specialized software might be slightly more powerful in its field, such as ZBrush for sculpting, Blender is "hub software," meaning that every step of the production process can be achieved, gathered, or organized in this software. You can also plug in assets from ZBrush for sculpting, textures from Substance Painter, output video sequence for After Effects, or even output an animated model for a game engine like Unity. For example, **image 01** shows a character that was modeled in Blender, sculpted in ZBrush, prepared for painting in Blender, painted in Substance Painter, shaded, articulated, and animated in Blender, and can be used in a game engine like Unity or Unreal.

Blender's versatility is one of its best strengths, and it also makes it a fantastic tool through which to learn all of the 3D pipeline, whether you want to be a character creator, an animator, or a film maker.

Substance Painter

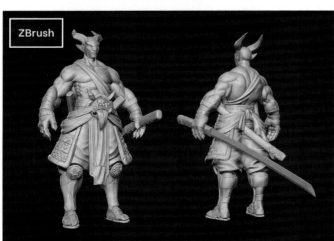

ZBrush

01 A character made using multiple software with Blender as a core. Artwork © Pierrick Picaut

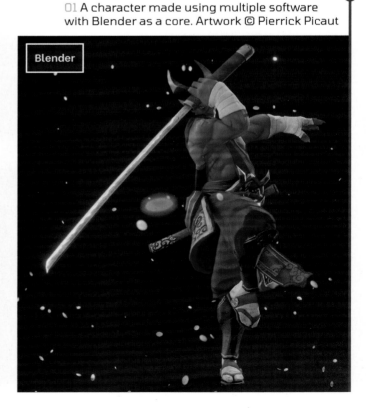

Blender

Setting up

Hardware

3D software packages are generally quite demanding when it comes to computation performance. But fortunately, computers nowadays are very powerful and you can buy a good workstation even with a tight budget. If you have a big budget, then go ahead with a high-end workstation, but if you have a limited amount of money, try to match the following specifications as a minimum:

▷ **Having an SSD hard drive** for your system and software means they will load lightning-fast, while a classic hard-drive disk is great for saving your files and resources.

▷ In terms of CPU, 6 cores/12 thread CPU is recommended.

▷ You will need **at least 8 GB of RAM** but if you can afford **16 GB or 32 GB**, that is better. Anything above would be overkill for a beginner, and even for a professional user in most cases.

▷ The **graphics card** (GPU) is one of the most important elements as it will make some stages of the production pipeline, such as rendering and material previews, up to twenty times faster. **Gamer graphics cards** can be good because the price/performance ratio is the best you will find, and most Blender users, even professionals, use them.

▷ While a **workstation PC** is highly recommended, if you want mobility and therefore a laptop, again gamer laptops will be the best choice for those with the funds.

▷ You should have a **mouse**, a **keyboard with a numeric keypad (numpad)** (as a lot of Blender shortcuts are bound to this), or a separate numpad device to add to your laptop.

▷ When it comes to character modeling or any organic modeling, a **graphics tablet** is a must-have. Sculpting with the mouse is difficult. However, you don't need a top-end screen tablet; you can get excellent results and comfort starting with a good-quality drawing tablet. If you can afford it, screen tablets are excellent; however, you should test one before you buy as they do not suit everyone and some seasoned artists prefer drawing with classic graphic tablets.

Download & installation

To get your copy of Blender, just go to **blender.org** and click the download button to get the latest version. This will bring you to the downloading page where you can choose to download the Windows version or any other version. Just click the download button and the installer will be downloaded automatically.

Once the installer file has downloaded, just double-click it and follow the instructions. The great thing is, if you have a previous version of Blender installed, the installer will update it without resetting your personal and custom settings.

Launching Blender

When you launch Blender for the first time, you will see a window in the middle of the interface called the splash screen (image 02). It features artwork by a selected artist for each new version of Blender – perhaps the next one could be you! This window will ask you if you want to use left or right-click to select, how you want the Spacebar to behave, and if you want to use previous version settings. Keep everything as it is and save the settings.

When you open Blender again, there will be a different splash screen, which is the welcome window that appears each time you open Blender. In the top right-hand corner of this window, you will see the current Blender version.

From the splash screen you can easily create a new file with a prebuilt template, open other files, recover your latest session if Blender has crashed, or open a selection of your most recent Blender files.

You will also find a shortcut to the release notes detailing all the new tools and features of the current version and a link to donate to the Blender development fund.

To start working in a new Blender file immediately, you can simply click outside the splash screen.

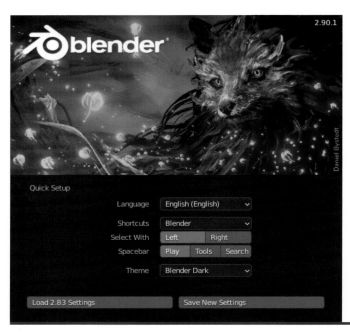

02 The splash screen you see when you first open Blender

Opening new & existing Blender files

When you launch Blender, it automatically creates a new file and a new scene, with the legendary default cube, a camera, and a point lamp. You can work here and save this file by going to **File > Save As** on the Topbar as you would in most software (image 03).

You can create a new file by pressing **Ctrl + N** or go going to **File > New**. You can open an existing file by pressing **Ctrl + O** or going to **File > Open**. **File> Open Recent** will show you a list of the latest Blender files you have used.

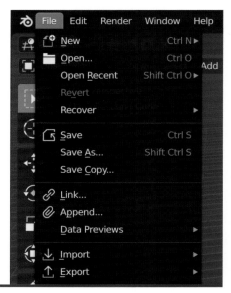

03 The File menu, where you can save or open Blender files, or create new ones

Introduction to 3D

Overview

One of the main differences between 2D and 3D is the fact that you are no longer working with layers on top of each other like in Adobe Photoshop or GIMP, but with objects in space. Your canvas is no longer comparable to a piece of paper; imagine it more as an open world and you as a creator. You are moving into this space and shooting photos or videos in this space (image 04).

In this regard, 3D creation is very different from 2D creation. While drawing and painting require you to figure out perspective, what is in front or behind, 3D software will allow you to rotate around your creation, and to work on it from any angle. This sometimes makes it longer to craft but way more intuitive. You are no longer adding or removing pixels to try to represent something; you are manipulating shapes and pushing points in space to model something. You don't have to paint light and shadows – you can use lamps as if the model is on stage or in a photography studio.

04 A 3D character shown from different angles in a few clicks. Artwork © Pierrick Picaut

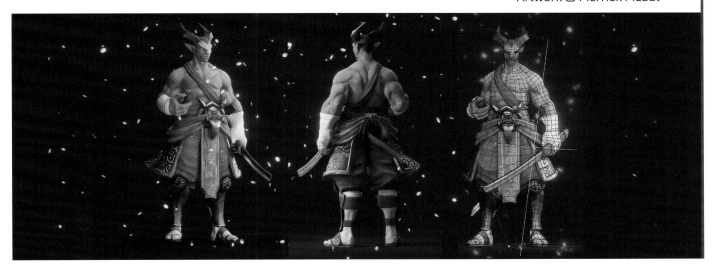

Objects, meshes & polygons

We will now look at some of the key terms you will come across when you initially start working in Blender. As you will learn, to create a character in Blender you will be working with "objects." Blender objects are containers of data and can be a wide range of items, including meshes, armatures, lights, and cameras.

Modeling is generally a mesh-focused workflow. A **mesh** is a collection of points (vertices) linked to each other that are bound to an object. If you imagine a character object, its body structure is the mesh of the character.

A mesh object is made of **vertices** (plural of vertex) that are connected to each other by edges. Connecting multiple **edges** together forms a closed shape and filling this shape with a **face** will generate a **polygon** (see image 05 on the next page).

Faces or polygons constitute a surface that can be lit and shaded, and will therefore be rendered. The simplest polygon shape is the **triangle** as it is made of the minimum number of vertices and edges needed to generate a face. Faces with four vertices are called **quads** and will be your best friend (or nightmare when you're struggling to create them!). Faces or polygons with five or more vertices are called **n-gons** and you should generally try to avoid them as they can generate bugs.

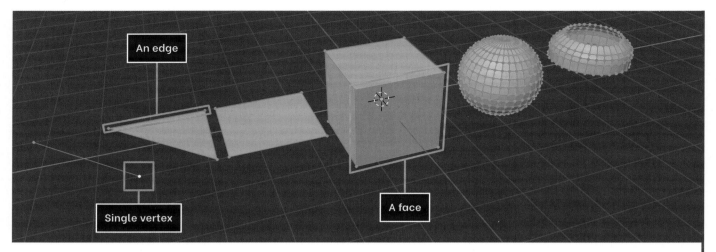

05 Different meshes made of vertices connected into edges and faces

It is important to understand these elements as they enable good manipulation of edge flow. **Edge flow** is the way vertices are connected to each other. A good edge flow will make a character deform (adapt into different positions) properly during animation, for example, and will make UV unwrapping easier and more intuitive.

EDGE LOOPS

Edges are generally connected into edge loops. Edge loops are connected paths of edges that generally go around part of the mesh in a continuous path and are a very important. Multiple edge loops generally form face loops.

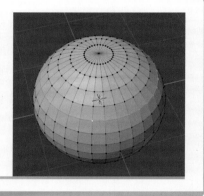

An edge loop in orange

Normals

Faces have an orientation with an outer and inner side. This orientation defines the "normal" orientation of a polygon or face. The **normal** of a surface is a line perpendicular to the surface. Normals are important as they influence surface shading. You can display the normal and surface orientation using one of the Overlay options in Blender (more about these on page 21) as shown in image 06. Selecting this option will make the normals appear as small cyan lines.

You can also ask Blender to identify the inside and outside of your mesh by selecting the Face Orientation option, which shows the outside as blue and the inside as red.

06 A mesh with face orientation and surface normals displayed

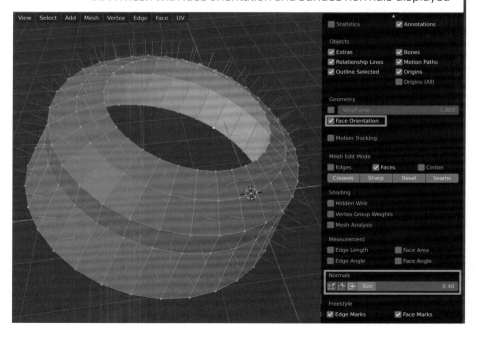

Basic Blender workflow

You will learn more about each of the below workflow stages throughout this book, but as a basic overview, character creation in Blender generally consists of the following.

01 Base mesh modeling
This initial stage is like thumbnailing or sketching in 2D drawing. You will create a basic 3D shape, or model, that roughly sets the base structure, masses, rhythm, and shape of your character.

02 Sculpting & detail sculpting
This is the part of the process in which you will start refining the shapes of your character as if you were sculpting a piece of clay. It is a very creative process where you can push the level of detail of your character without technical constraint.

03 Retopology
This is a stage where you turn the sculpted character, with a messy structure, into a model with a better structure, so that it will allow better deformation, making it animable and paintable. Upon this optimized model, finer details can be sculpted.

04 UV unwrapping
When you paint a character, you need to be able to transfer a 2D painted picture onto the surface of the 3D character. Unwrapping is the process of unfolding the surface of a 3D object and projecting it onto a 2D plane that can be painted.

05 Texture baking and painting
This is a specific technique that allows you to convert the detail you have sculpted into image information, like making pores of the skin darker and the edges of a tooth lighter. These images can then be combined, as you would do in Adobe Photoshop, to paint your character or any 3D object. This stage is not mandatory and not covered by this book, but is often part of the 3D workflow in the industry, which is why it is mentioned here. You will learn how to add textures using UVs.

06 Shading & lighting
Shading is the act of creating material for an object. While painting the skin color might be an easy concept to understand, how would you make an object more or less shiny to convey wetness? This is where shading starts, when you begin to set the properties of a surface, for example its shininess and transparency. Good shading needs good lighting to bounce around and display the object; this is where a lighting artist's work begins, creating digital lamps and lighting environments to make a 3D object shine in the scene and create atmosphere.

07 Rendering & compositing
The rendering process is the moment where your object, with its texture and shaders, and the light, is calculated by the digital camera to output a 2D image – a snapshot of what you want the audience to see. Rendering captures a lot of different information, such as the depth of the scene, light values, and special effects. You can then combine all of these elements into an enhanced picture during the compositing stage.

> **Now you are armed with a basic knowledge of 3D, let's take a look at the Blender interface.**

The Blender interface

By Pierrick Picaut

CHAPTER OVERVIEW

- 3D Viewport
- Outliner
- Properties Editor
- Customization

- Add-ons
- Modes
- Editors
- Workspaces

As a multitask software (covering 3D modeling, sculpting, animation, video editing, and more), Blender comes with a unique user interface (UI) that is highly customizable. By default, the UI contains the following features (image 01a):

- Topbar
- Areas
- Status bar

As you would find in most software, the Topbar at the very top of the interface allows you to access your files, save and manage them, and customize your preferences. It also provides premade UI templates, known as layouts or workspaces, optimized for specific tasks in the 3D production workflow. We will look at workspaces in more detail on pages 39–41.

Areas

3D Viewport | Outliner | Properties Editor

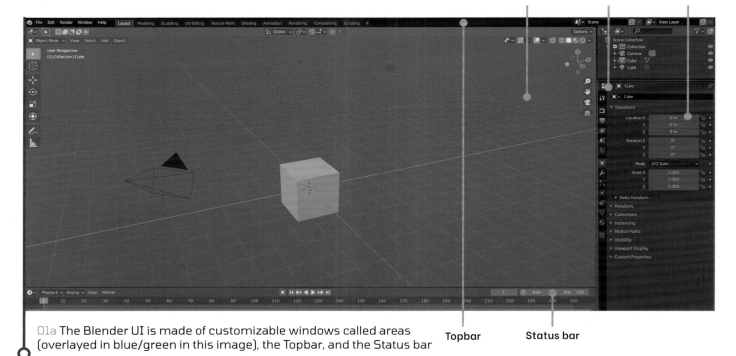

Topbar Status bar

01a The Blender UI is made of customizable windows called areas (overlayed in blue/green in this image), the Topbar, and the Status bar

The Blender UI is then divided into areas where different Editors are bound. Areas are active whenever your mouse pointer is hovering over them, allowing you to use specific functions and keyboard shortcuts. Area boundaries are indicated by a dark gray outline with rounded corners that can be handled to customize these areas (image 01b).

All areas have a Header, which houses menus that allow you to access more complex commands specific to that area. Areas are highly customizable, so we will look more closely at this on page 28.

EDITORS

Editors have specific functions such as editing 2D images, animation data, compositing, or even editing text, and you will find out more about key ones later in this chapter. There are three Editors that open by default in Blender: the 3D Viewport, Outliner, and Properties Editor.

01b An example of area boundaries and the Header display menu (green)

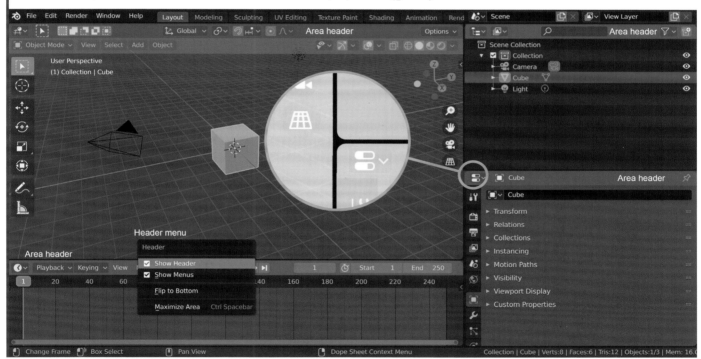

The Status bar at the bottom of the screen can be very handy, as it gives inputs and stats about the scene you are working on, such as number of objects, number of polygons, and hardware memory usage. It can also provide contextual information relating to the tool, mode, or object you are working with, shortcuts, and tools' behavior when activating them (image 01c). For example, if you are editing a scene in Object Mode, it will display the number of objects, vertices, and memory usage in the current scene.

01c The Status bar, showing the available shortcuts after pressing the Alt key

Alt [W] Tweak [B] Select Box [C] Select Circle [L] Select Lasso [⌴] Cursor [G] Move [R] Rotate [S] Scale [T] Transform [D] Annotate [M] Measure

3D Viewport

We will now look at three key Editors that open by default in Blender (the 3D Viewport, Outliner, and Properties Editor), starting with the 3D Viewport. The 3D Viewport (image 02) is where you will spend most of your time when creating a model in Blender. It allows you to navigate in your 3D scene, add new objects, and transform and edit existing objects. Within the 3D Viewport you have the:

▷ Header
▷ Toolbar
▷ Sidebar
▷ Navigation tools.

The Header contains a number of menus that allow you to carry out actions such as adding and editing an object, and also change the viewport **shading and display options** (for example you could choose for your object to be displayed as a wireframe or as rendered). You will come across these in more detail as we explore different options later in the chapter. The Header also provides options for **modes**, which are accessible in a dropdown menu.

Pressing the **N** key will hide/unhide the **Sidebar** (you can also click the small arrow icon on the right-hand side of the 3D Viewport), which includes **Transform** properties. This panel allows you to edit the transformation values of any item. If you select the **Tool** tab on the Sidebar, you will be able to edit the settings for the Active Tool, that is, the tool you are using. The **View** tab allows you to customize the perspective and depth value of your 3D Viewport.

Header

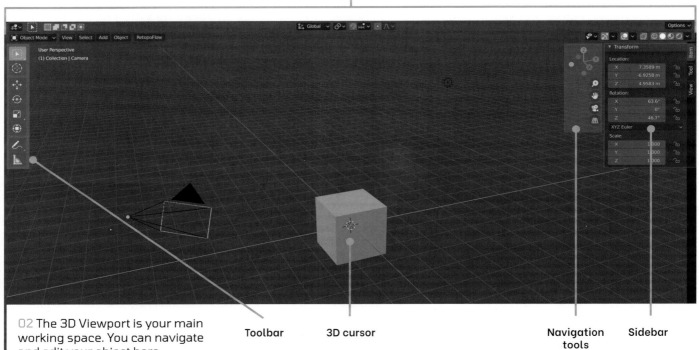

02 The 3D Viewport is your main working space. You can navigate and edit your object here

Toolbar 3D cursor

Navigation tools

Sidebar

Pressing the **T** key will hide/unhide the **Toolbar**, which gives you access to any editing and transformation tools available in the current mode, such as selection tools, a 3D cursor, and many more. Different modes have different tools available; for example, the Sculpt Mode Toolbar will offer a wide range of sculpting brushes and tools.

The Toolbar and Sidebar can be resized by hovering over a border until you see a double-headed white arrow and then left-clicking and dragging.

You will find the **navigation tools** on the left of the Sidebar in the 3D Viewport. These include the **Rotation Gizmo** and Zoom and Pan buttons, and are key to moving around the 3D space. There are also options to change the view. We will look at navigation tools in more detail on page 18.

MODES

Modes are specific editing statuses that allow you to work on different features of an object's data, such as mesh and textures. Modes can be accessed in the dropdown menu on the left side of the Header in any Editor or, if you are in the 3D Viewport, by pressing **Ctrl + Tab**. They are optimized to offer a better workflow for each critical step of the creative workflow. Switching mode will give you access to specific tools that are only available in this context. You will learn more about these on page 31.

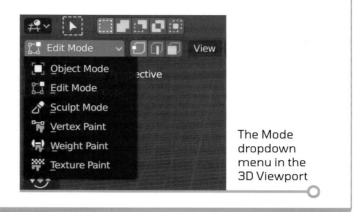

The Mode dropdown menu in the 3D Viewport

Viewport navigation

There are three main ways to navigate around the 3D space in Blender: rotate, pan, and zoom.

▷ **Rotating** rotates the view around the space.

▷ **Panning** moves the view up, down, left, and right.

▷ **Zooming** moves the view inward and outward from the space.

The default Blender navigation relies on using a three-button mouse with a mouse wheel. Hold the middle mouse button (**MMB**) and move the mouse in the 3D Viewport to rotate the view around the center of the viewport. Holding **Alt** at the same time will allow you to snap the view every 45° rotation.

Hold **Shift + MMB** while moving the mouse to pan around the 3D Viewport.

Hold **Ctrl + MMB** to zoom in and out. You can also use the mouse wheel to zoom in and out.

USING A TABLET

If you are using a tablet, go to **Edit > Preferences > Input** in the Topbar and activate **Emulate 3 Button Mouse**. Holding the **Alt** key and left-clicking will emulate the **MMB**.

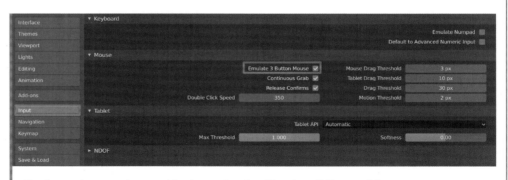

Easily navigate using a tablet by activating Emulate 3 Button Mouse

Navigation tools

It can be tough to remember every single navigation shortcut, especially when you are new to Blender; fortunately there are also navigation tools available in the 3D Viewport (image 03a).

Clicking and dragging on the **Navigation Gizmo** in the top right of the viewport that shows the X, Y, and Z axis will allow you to rotate the view. Clicking one of the colored circles will snap the viewport orientation to the corresponding view.

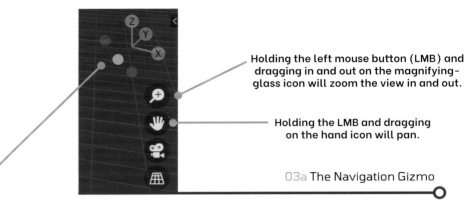

Holding the left mouse button (LMB) and dragging in and out on the magnifying-glass icon will zoom the view in and out.

Holding the LMB and dragging on the hand icon will pan.

03a The Navigation Gizmo

X, Y & Z AXES

While it is relatively easy to determine coordinates on a piece of paper or in any 2D space, it can become more complicated when it comes to 3D.

Left/right and up/down coordinates probably come fairly naturally to you when working in 2D, but 3D brings a third dimension that we can call depth.

In Blender, the:

• **X axis** (indicated by the red line in the viewport and in red on the Rotation Gizmo) is generally used as the left/right axis;

• **Y axis** (green) determines depth;

• **Z axis** (blue) defines the up/down axis.

With a given value for each of these axes, you can determine a point in the 3D space also known as the coordinates. These axes can be interpreted differently depending on the space you are working in but you will learn more about that later (page 55).

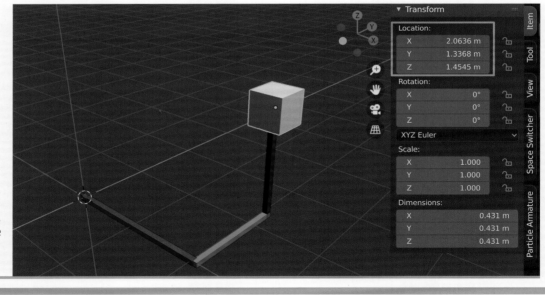

The 3D cube, moved in the 3D space on all the axes

There are also different views you can choose from. The default view is User view, which is the view you can see as the user. Click on the camera icon to jump into **Camera view**. This view shows you what will be rendered. Imagine you are a film director and you are directing everyone in your 3D Viewport, moving the characters and environment so that they have a specific position in what will be filmed or, in this case, rendered. Click the icon again to return to User view.

Click the grid icon to switch between Orthographic and Perspective views (image 03b). You will generally use **Orthographic view** when modeling as it is easier for identifying parallel edges and evaluating distances.

Perspective view is great for double-checking the composition of a scene, or getting a more cinematic overview of an object. When sculpting a character, for example, it is better to use Perspective view as it is closer to

a real-life point of view and so you will have a better understanding of proportion. If you are modeling a car, using Orthographic view is better because you can work as if you were working on layers of a blueprint.

03b Examples of a cube in Perspective and Orthographic views, respectively

It is very useful to disable the **Auto Perspective** option in the **Navigation** tab of the **Blender Preferences** menu (image 03c) as it prevents Blender from switching back to Perspective mode each time you rotate the viewport.

03c Disable the Auto Perspective option in the Navigation preferences

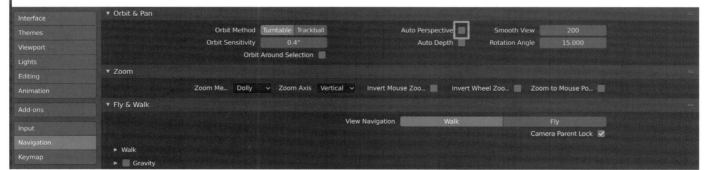

Toggling between different views

Using a numeric keypad (numpad) is highly recommended for Blender in order to access most of the navigation shortcuts. You can switch between different views as described below.

The view name can be seen in the top-left corner of the 3D Viewport (image 04). You can access all the views using the **Navigation Gizmo** as explained before, or by going to the View menu on the Header.

NUMPAD 1	Front view
NUMPAD 3	Right view
NUMPAD 7	Top view
CTRL + NUMPAD 1	Back view
CTRL + NUMPAD 3	Left view
CTRL + NUMPAD 7	Bottom view
NUMPAD 0	Camera view
NUMPAD 5	Switch between Perspective and Orthographic view
NUMPAD 2, 4, 6, AND 8	Rotate the view by a 15˚ increment
NUMPAD "."	Frame the 3D Viewport on the selected object
NUMPAD "/"	Isolate the selected object (i.e. work in Local view; hit again to return to the previous viewport orientation – this is a very handy feature when working on complex scenes)

LOCAL VIEW

When entering Local view, any unselected item will be uneditable. The current selection will also be framed or focused upon on your screen. This is ideal when you need to isolate a part of your 3D scene to work on, without having to hide other elements manually. When you exit Local view, the 3D Viewport will reset to the view you were in before you entered Local view.

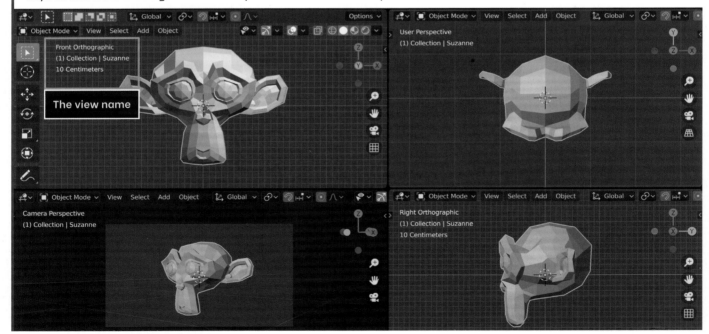

04 3D Viewports showing an object in different views. Note that it says which view is being used in the top-left corner of the viewport

Viewport overlays & shading

An overlay is additional information displayed on top of renderable objects. Overlays can be toggled on and off using the **Show Overlays** button in the top right of the viewport. When overlays are disabled, the 3D Viewport will only show objects that can be rendered (mesh objects).

In the **Viewport Overlays** menu, which is accessed by hitting the dropdown arrow next to the **Show Overlays** button (see image 05a), you can choose whether to display the grid, 3D axes, and several other options that can help you to navigate and manipulate your 3D scene. For example, the **Grid** and **Axes** overlays are useful because they help you understand the orientation of your scene. The horizontal grid also gives

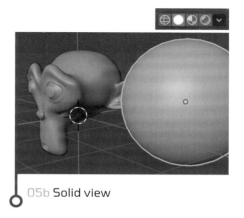

05b Solid view

you a sense of scale as the gridlines are graduated in meters.

In addition, the 3D Viewport features different **shading modes** that will allow you to change the way your objects are displayed, for example showing them as pieces of clay, with different colors to identify them easily. The different shading modes can be accessed on the right of the Header or by pressing the **Z** key in the 3D Viewport (if you have the **3D Viewport Pie Menus** add-on enabled – see pages 29–30).

▷ **Solid** mode displays the surface of the object, giving you a sense of shape and volume (image 05b).

▷ The **Wireframe** option allows you see the edges of your mesh (image 05c).

▷ **Toggle X-Ray** allows you to see through different objects in a scene and can be turned on and off with the **Alt + Z** shortcut (image 05c).

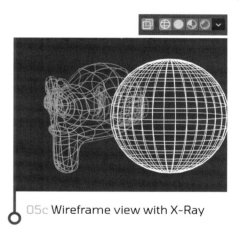

05c Wireframe view with X-Ray

05a The Viewport Overlays menu

▷ The **Material Preview** option (image 05d) displays objects with their materials in a given lighting condition. You can also use different "material captures" known as **Matcaps** to simulate specific surfaces such as a mirror ball, car paint, or skin. To do this, go to the **Viewport Shading** menu by clicking the arrow on the right side of the shading options. Under **Lighting**, select **Matcap** and click on the sphere to see the different Matcaps available.

▷ The **Rendered** option displays an object as it will be once rendered, using any materials, lights, and environment you have created.

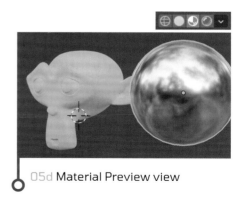

05d Material Preview view

Outliner

Scenes, objects & collections

Before looking at the Outliner itself, let's step back and familiarize ourselves with the key elements that make up a Blender file. An important thing to consider when using Blender is hierarchy.

Most Blender items are part of a hierarchy and can be considered as containers. Your Blender file is a container too, holding different **scenes**. You can create and work on multiple scenes within a Blender file. For example, a character animation in "Scene 1" and a 3D title screen in "Scene 2." Scenes can be totally independent or share data.

Each scene can contain **objects**, such as a mesh like a cube primitive, a

light, or a camera. These objects can be classified into **collections**.

By default, when opening Blender, you will find:

▷ a **cube** object, which is one of the primitive objects that can be added to your scene;

▷ a **point lamp**, which will enable you to light your scene and allow your object to be visible;

▷ a **camera** (image 06a), which will allow you to output rendered images of the current scene.

All these default objects are classified in the default Scene collection called

"Collection" as shown in the Outliner (image 06b).

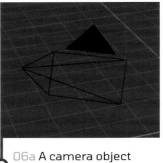

06a A camera object

06b The Scene collection and the default cube seen through the camera

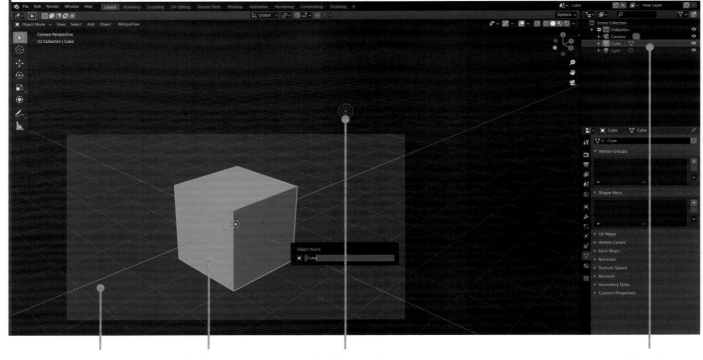

Camera view Cube (object) Light (object) Collection

Outliner functions

The **Outliner** is a powerful organization tool in Blender. It allows you to access any data in your Blender file. By default, it shows the different objects available in your scene when the default **View Layer** display mode is activated.

You can select any object in the Outliner by left-clicking it in a collection. Use **Ctrl + LMB** to select additional objects and **Shift + LMB** to select a range of objects in the collection from the active object. The selected objects will be highlighted in blue in the Outliner (image 07a).

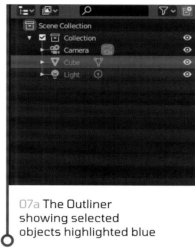

07a The Outliner showing selected objects highlighted blue

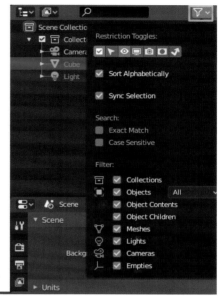

07b The Filter menu offers further options in the Outliner

You can browse through individual objects in the Outliner using the **up** and **down arrows** of your keyboard. Holding **Shift** will add the next/previous object to your selection. Any selected item can be renamed using the shortcut **F2** or by double-clicking the name.

To create a new collection, right-click in the Outliner and select **New Collection**. Left-click, drag, and drop any object into any collection. You can hide/unhide an object in your 3D Viewport by clicking the eye icon on the right-hand side of the object in the Outliner. This can be useful if you want to focus on working one element of your scene – for example if your model is comprised of different cubes and cylinders that represent different body parts, you may want to be able to just view and work on one of the arms or both of the legs.

You can display and toggle more filters by accessing the **Filter** menu (image 07b). Filters will allow you to reorganize your collection display, hide objects, and further manipulate the way they are displayed/used in your scene.

You can deactivate or exclude a whole collection clicking the check icon to the left of the collection name.

OUTLINER DISPLAY MODES

The multiple image icon with a dropdown arrow is where you can change the Outliner's display mode. You will mainly use the **View Layer** mode in the Outliner, as it is the most obvious way to classify and manage your scene. But other modes will give you access to absolutely all the data available in your Blender scene. This can be useful for more advanced manipulations.

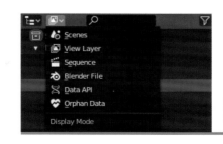

Different Outliner display modes and their options

Properties Editor

The Properties Editor (image 08) allows you to edit the data of a given scene, object, or whichever element is being used in your Blender file. It is divided into several tabs that can be accessed by clicking the different icons on the left-hand side of the Properties Editor. Note that, depending on the object selected, these tabs can be different.

These tabs are generally organized from the higher element in the hierarchy to the most specific data. The following section summarizes the function of each one for reference.

You don't need to memorize all their functions now, as you will come across some of them in more detail as you begin building a character. The ones most relevant to you initially will be the **Object Properties** and **Modifier Properties**.

08 The Properties Editor sits to the right of the 3D Viewport

Active Tool and Workspace Settings contains settings for the active tool in the 3D Viewport, but these can be accessed directly in the Sidebar of the current workspace so you will probably never use this tab.

Render Properties allows you to choose which render engine you want to use, and set up and adjust any rendering option to achieve the best quality and performance for your renders. Render options will be discussed in more detail on pages 178–179.

Output Properties allows you set the size of a rendered image, the number of frames, the frame rate of any animation, and the file format in which you want to save these images.

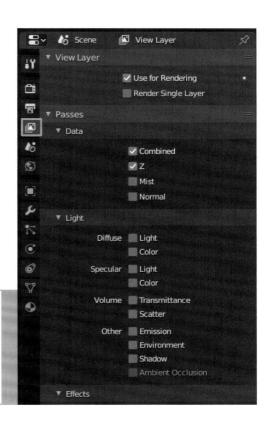

View Layer Properties allows you to choose what kind of information will be available for compositing once you render an image.

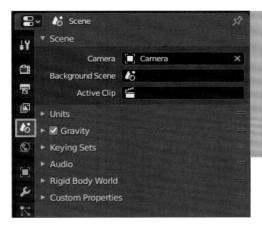

Scene Properties allows you to choose which camera, measurement unit, and scale will be used by default in your scene, as well as a lot of core information, such as the gravity intensity and audio setup.

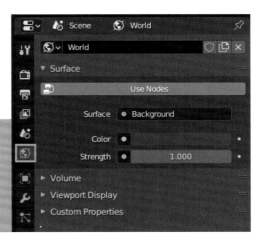

World Properties allows you to edit the world color and lighting of your scene. Consider the world as a sphere surrounding your 3D scene that can light it.

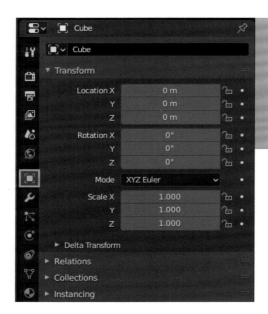

Object Properties gives you access to the object name, its transform channel (i.e. the location/rotation/scale axes positions), collection information, relationship with other objects, and the way it's displayed, and allows you to edit any of this information.

Modifier Properties allows you to add, remove, and set any modifier (you will find out more about modifiers on pages 102–129) to the active object. Note that some objects cannot have modifiers.

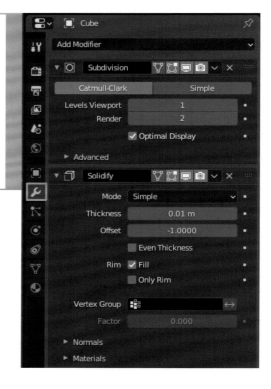

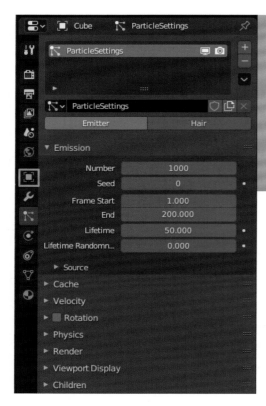

Particle Properties allows you to add and edit particle systems (such as for hair or FX) to the active object. Note that some objects cannot have particles. You will learn more about particles on pages 176–177.

Physics Properties allows you to give a physical behavior to an object, such as being affected by gravity or acting like cloth.

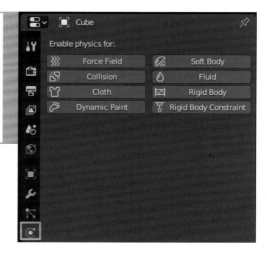

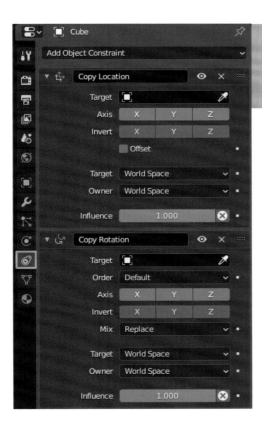

Object Constraint Properties allows you to add and edit the constraints of an object. These are useful for animation. Note that an armature object will have a specific **Bone Constraint Properties** tab.

Object Data Properties allows you to access the data of a specific type of object. For a mesh object such as a cube, it will show the vertices' positions and the way they are ordered, for example. For a camera, you can view properties such as its focal length information, and depth of field setting. The data option will be different depending on the selected object type.

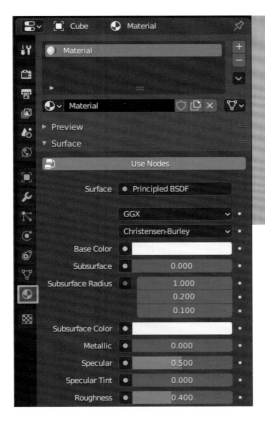

Material Properties allows you to edit your materials. Create wood, concrete, or glass through multiple settings. Note that there is a dedicated Editor for that, the Shader Editor, which will be discussed in more detail on pages 38 and 158.

Texture Properties allows you to create texture that can be used as a brush alpha, or used by a modifier to deform a mesh, for example.

Customization

As mentioned, the Blender UI is highly customizable and you can configure it by adding as many areas as you want. Left-click and drag an area border to **change its size**. Right-click an area border to open the **Area Options** menu that will allow you to **split the current area into two areas**, either vertically or horizontally (**image 09a**). Move the mouse to drag the line to where you would like the area to extend to, and left-click to accept the position. Splitting an area like this can be useful if, for example, you could set them as two separate views to work on your model from one angle while seeing the effects from another angle.

The **Area Options** menu also allows you to collapse one area over another (choose **Join** in the menu) or swap two areas. When collapsing/ joining areas, an overlaid arrow shows you which area is going to be collapsed, and you simply click on it to confirm. The rounded corner of an area also allows you to split the area using left-click and drag inward, or collapse using left-click and drag outward. Finally, you can also create a new floating window by **Shift + left-clicking** and dragging the rounded corner. This is ideal when using multiple monitors, for example.

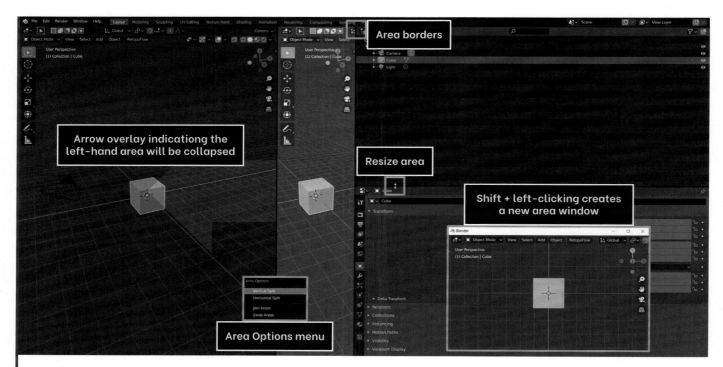

09a The Blender UI can be customized in multiple ways using the Area Options menu and mouse manipulations

Area Headers can be bound to the top or bottom of their respective area by right-clicking the area Header, and selecting **Flip to Bottom/Flip to Top**. You can also maximize by right-clicking on the Header and selecting **Maximize Area** or by hovering over it and using the **Ctrl + Spacebar** shortcut. This makes the chosen area fill the whole program window, which is useful for removing distractions or browsing complex projects. Press **Ctrl + Spacebar** again to reset the viewport or click the **Back to Previous** option in the Topbar (**image 09b**). You can even go fullscreen using the **Ctrl + Alt + Spacebar** shortcut. Repeat the shortcut to get back to previous view.

09b The Back to Previous button

Add-ons

As an open-source software, Blender's strength lies in part in involvement from the community. Many people work on additional functionalities or optimized tool sets that are called "add-ons" in Blender (but are often referred to as plugins in other software). Blender comes with many pre-installed add-ons that can simply be enabled in the **Blender Preferences** window. Go to the Topbar and select **Edit > Preferences > Add-ons** (image 10a). You can then scroll down the list to view all the add-ons, add a filter by clicking the arrow next to All, or search for a specific add-on in the search bar. To enable an add-on, check the box next to it. The add-on will then appear in the corresponding Editor.

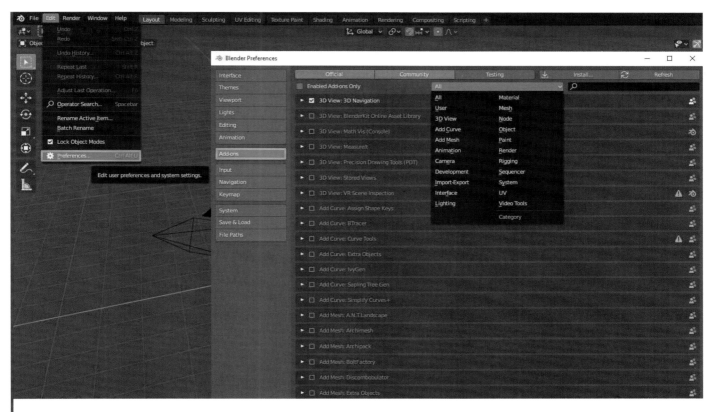

10a Accessing the Blender Preferences window

Other add-ons can be found on community forums such as **blenderartists.org** or sites such as **blendermarket.com.** Most add-ons are delivered as downloadable zipped files. Always make sure you download any additional add-ons from a trustworthy source.

To install a new add-on, click on **Install** in the **Add-ons** menu (image 10b) to browse for and select the file you are looking for (image 10c) and then click **Install Add-on**. The add-on will automatically appear in the available add-ons list (image 10d). To activate the add-on, just check the box next to its name.

10b Select Install

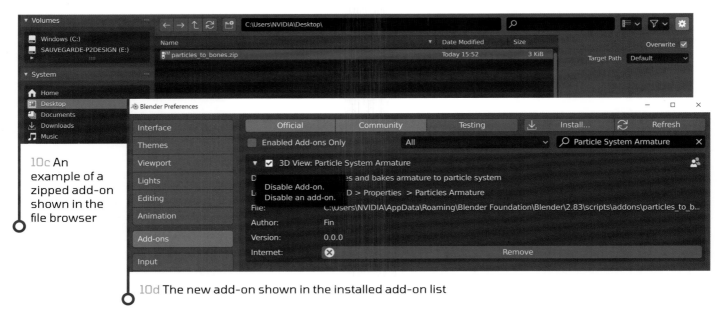

10c An example of a zipped add-on shown in the file browser

10d The new add-on shown in the installed add-on list

Useful add-ons

As mentioned, Blender is packed with lots of add-ons that are already installed. There are some add-ons that are so useful that they have become almost mandatory when learning Blender. Find each of the must-have add-ons described on the right and activate them by searching for each one in the search bar of the **Add-ons** menu and checking the box next to the add-on you want to enable.

When activating an add-on, you can click the dropdown arrow by its name to expand its details and find associated documentation or other useful information. This is useful if you want to find the version ID of the add-on, links to tutorials, who has made it, and sometimes where to contact the creator for further help.

Now you have a basic understanding of the Blender UI and 3D Viewport, and how to customize your experience, we will look more closely at the different modes you can work with.

RECOMMENDED ADD-ONS

F2	Will increase your modeling speed with a set of new shortcuts
NODE WRANGLER	Provides a lot of additional tools to facilitate any node-based Editor use
LOOPTOOLS	Offers additional modeling functions that allow you to proceed with complex manipulations in a click.

PIE MENUS

The **3D Viewport Pie Menus** add-on can be another useful add-on to enable as it allows quick, visual access to a range of menus. It comes preinstalled with Blender, you just have to enable it.

SHORTCUTS

All shortucuts can be customized by going to **Edit › Preferences › Keymap**.

Modes

As mentioned on page 17, modes are specific editing statuses that allow you to work on different features of an object's data, such as mesh or textures. Modes also depend on objects, so a cube will have an **Edit Mode** and **Sculpt Mode** for example,

but a camera won't; an armature designed for animation and posing will have a **Pose Mode**. The 3D Viewport has six modes as discussed in the following sections, but other Editors (find out more on pages 36–38) also have other specific modes.

As you learned, modes can be selected from the dropdown in the top left of an Editor, but you can also access them from a pie menu by pressing **Ctrl + Tab** if you have the **3D Viewport Pie Menus** add-on enabled (image 11).

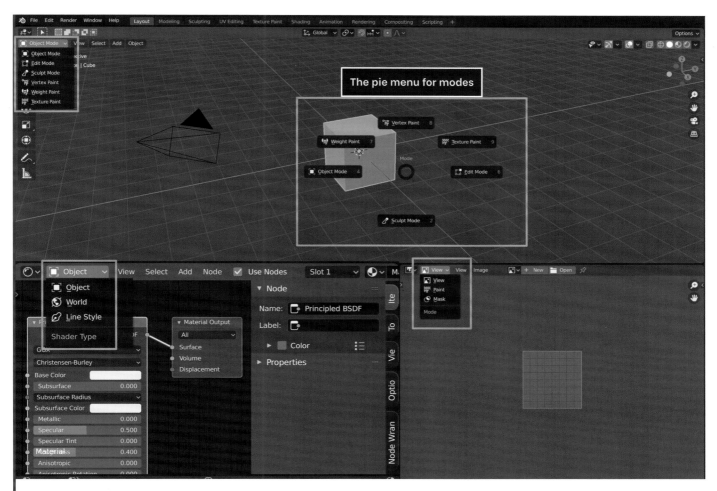

11 Different Editors (the 3D Viewport, Shader Editor, and Image Editor) and their available modes shown in pie and dropdown menus

Object Mode

Object Mode (image 12) is the default mode in Blender. It allows you to adjust the **object data**, such as location, rotation, and scale. It is available for all 3D objects (meshes, cameras, curves, empties, and so on – you will learn about the range of objects available in Blender on page 46) and is mainly used to organize a 3D scene, position objects, or even work on their animation. Object Mode will allow you to add new objects and position them at will. You can also duplicate objects. This is the mode in which you will first start building up a character on page 58.

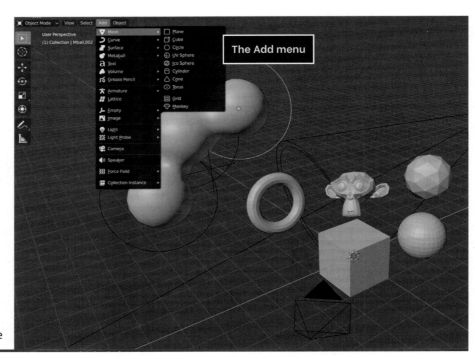

12 The 3D Viewport filled with objects created in Object Mode

Edit Mode

This is the mode that you will use the most for modeling. Edit Mode allows you to edit any **geometrical data** that can be rendered. This can be the polygons of a cube or a character, or even the vectors of a 3D curve. A camera or light object won't have Edit Mode as an option.

When entering Edit Mode you have access to a lot of specific tools (image 13a) that will allow you to add or remove vertices and move them at will to model whatever shape you want. The Header and Toolbar also provide a set of selection and editing tools, allowing you to select vertices, edges, and faces and carry out actions such as extruding (image 13b) and adding a bevel (see pages 58–86).

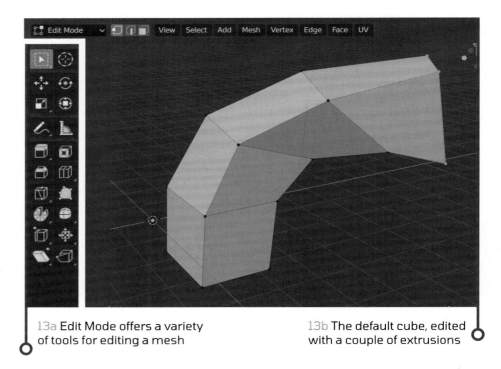

13a Edit Mode offers a variety of tools for editing a mesh

13b The default cube, edited with a couple of extrusions

Sculpt Mode

Sculpt Mode (image 14) is an alternative way of editing mesh objects. It allows you to edit the **mesh data** of a given object as you would in Edit Mode but in a more intuitive way, as if you were sculpting a piece of digital clay. Note how the mouse cursor has become a circle representing the sculpting brush and its size, as you would see with a painting brush in Photoshop, for example. Sculpt Mode gives you access to specific tools and brushes in the Toolbar to shape your mesh and generate geometry more organically. It is the perfect mode in which to work on characters or any type of organic shape. It can also be used to sketch hard-surface subjects, like robots or vehicles, but this requires a bit of experience. Each brush has a specific algorithm that modifies its behavior.

> Find out more about the tools and settings available in Sculpt Mode on pages 138–151.

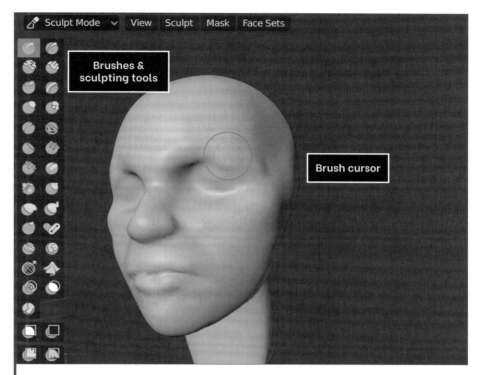

14 A head shape being sketched using the power of Sculpt Mode

Vertex Paint Mode

Vertex Paint Mode (image 15) allows you to "paint" your object by setting color per vertex. This means that the resolution of your painting is tied to the number of vertices of your object. This is particularly useful when making a rough color pass on a sculpt, for example. Vertex painting is generally used for prototyping or to create quick color patterns on a sculpt. The color will blend from one vertex to another. This mode only works on mesh objects.

> Find out more about the tools and settings available in Vertex Paint Mode on page 173.

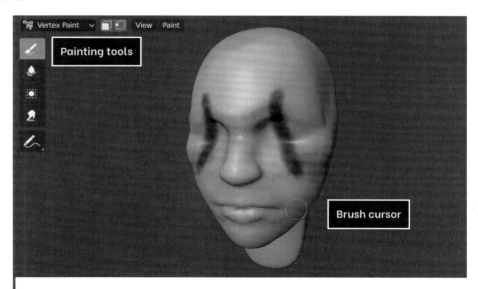

15 A head sculpt and a cube with some vertex colors applied

Weight Paint Mode

The notion of "weight" is very important in 3D. Consider the weight as an influence level that can be used to drive a lot of elements, such as the thickness of a plane, the amount of deformation of a mesh, or the number of hairs growing on a specific area. Weight is per-vertex information, so it only works with mesh objects.

Vertex weight can be edited in **Edit Mode**, but Weight Paint Mode (image 16) allows you to do it in a more intuitive way. You will find similar painting tools to **Vertex Paint Mode** and **Texture Paint Mode** (see next page), except this time they enable you to paint influence over an element such as number of hairs. Dark blue areas on the mesh have 0 influence and red areas have 1 or full influence. In the example of applying hair, this would mean dark blue areas would have no hair whereas red areas would have full hair; colors in between, such as orange, yellow, and green would have a gradually decreasing amount of hair, respectively.

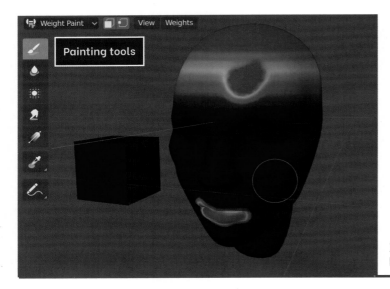

Painting tools

16 A head object with Weight Paint influence displayed

See Weight Paint in action
on page 332.

Texture Paint Mode

Texture Paint Mode (image 17) allows you to edit a 2D image texture directly on your 3D mesh object, making texture painting very intuitive.

The mouse cursor becomes a round shape displaying the size of your painting brush. You will find a set of brushes in the Toolbar and their properties in the Sidebar along with options for Texture.

IMAGE TEXTURES

If you go to **Texture Paint Mode** now, you will likely notice that it shows the default cube in a pink color. The pink color, in most 3D software and engines, means that the object is missing an image texture. To paint on a mesh you first need to create and associate an image with your object, also known as an image texture. You will find out how to do this on page 171.

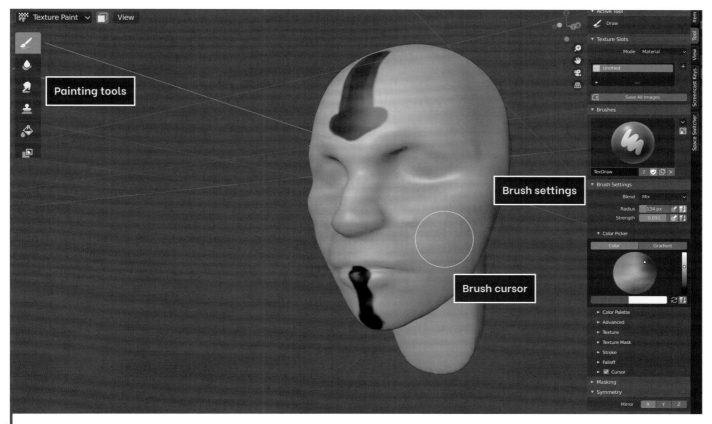

Painting tools

Brush settings

Brush cursor

17 A color texture being painted directly on the 3D model

VERTEX VERSUS TEXTURE PAINT

Vertex paint is mesh resolution dependent, so you would use it on very high-poly meshes like sculptures. But if you try to paint a cube, for example, you won't be able to paint the middle of the cube as you will set colors only on the vertices of each corner, and the color will blend along the surface of the cube.

Texture paint resolution is based on the image resolution, so you can paint very detailed color on a very low-poly character for example. This mode generally needs the model to be prepared with UV unwrapping (see page 165–169).

Vertex painting is generally used for prototyping or to create quick color patterns on a sculpt, while texture painting is the most-used method in production.

You will learn more about Texture Paint on pages 171–173.

Editors

Any project items, also known as data, can be edited inside Blender. The item/data can be a mesh object such as a cube, an image, a video, a sound, or a material, as examples. Editors are specific sets of tools that are optimized to edit a specific type of data. They can be accessed by opening up the **Editor Type** menu in the Header (image 18).

Aside from the Properties Editor and Outliner already mentioned, each Editor has its own Header with a specific menu that also changes depending on which mode is in use.

Similarly, the options in the Sidebar will vary depending on which Editor and mode you are using. The same goes for the Toolbar.

Editors can be opened in any Blender area or floating area by clicking the very first icon on the left of the area header. You can open as many Editors as you want and open the same Editor multiple times. This can be very useful with the 3D Viewport so that you can display different viewpoints to see an object from the side, top, and front and be able to edit it without changing your

viewpoint. For example, you could have one 3D Viewport in Camera view to see what will be rendered and another 3D Viewport where you edit the scene. Remember that to close an Editor/area again, you can use the **Join** customization option described on page 28.

You have already learned about the 3D Viewport, Outliner, and Properties Editor. We will now look in more detail at some of the key Editors you may come across when creating a character in Blender.

18 The Editor Type menu is found in the Header and lists all the different types of Editors available

Image Editor

The Image Editor (image 19) is the main 2D painting tool in Blender. As with the 3D Viewport, there are different modes available. By default, it's set to **View Mode**, which only allows you to see and navigate through an image with a limited set of tools. If you switch to **Paint Mode** in the Header, you will be able to paint on the image as if you were in Photoshop or GIMP, with a specific set of tools in the Toolbar. You can access detail properties of the different painting tools in the Sidebar. Next to this, the Navigation tool allows you to pan and zoom in to the image.

> You will learn more about the Image Editor on page 170.

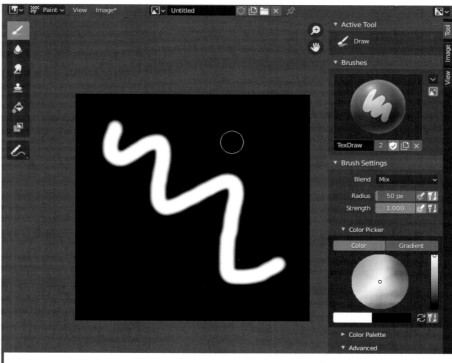

19 An image being painted in the Image Editor in Paint Mode

UV Editor

The UV Editor (image 20) allows you to work on the unfolded, 2D version of your mesh, also known as a UV map. UV maps are a 2D projection of a 3D model, allowing you to paint the object much like the flat, unfolded shape you would use to make a cube out of paper.

From the Header, you can load and display an image in the UV Editor, but you won't be able to edit the image here; you would edit the image in the Image Editor.

> You will learn more about creating UVs and the different tools available in the UV Editor on pages 165–169.

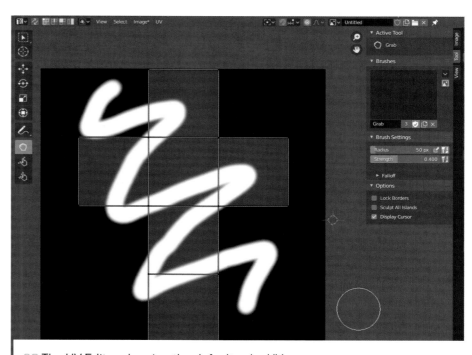

20 The UV Editor showing the default cube UV map

Shader Editor

The Shader Editor allows you to create and manipulate the materials of a given object, whether it's wood, concrete, fog, or even environment lighting. As with the 3D Viewport, it has different modes available: one for editing the object material, one for the environment (or "World") background, and one for editing line style. While the set of tools is fairly limited, the Shader Editor gives you access to a whole range of nodes, which allow you to create and edit materials for an object. Image 21 shows an example of an edited material in the Shader Editor.

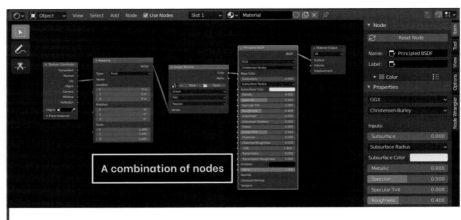

A combination of nodes

21 An edited material in the Shader Editor

> You will learn more about different nodes and the Shader Editor on pages 158–164.

NODES

Nodes are a combination of properties and functions that allow you to create very complex material surfaces and effects for an object once they are plugged into a **Material Output** node. Each node has a very specific task, whether it's editing a color property or mimicking an existing material feature such as specularity, surface roughness, or transparency.

Compositor

Post-processing or compositing is a key step in computer graphics. The Compositor allows you to manipulate and combine rendered images or animations to enhance the output or even completely change the mood and style of a render. In the example of a rendered 3D scene in image 22, you can see the effect of slight contrast being added to the original render.

> You will learn more about the Compositor on pages 182–185.

Set of nodes and their different outputs

Backdrop options

22 A rendered image being composited

Workspaces

Workspaces are a custom set of Editor windows optimized for specific workflows. Access them by clicking their tab in the Topbar (image 23), or cycle between workspaces using **Ctrl + PageUp** or **Ctrl + PageDown**. Double-click a tab to rename it and click the **+** icon on the right to create a new custom workspace based on the current one. There are different organizations for each layout, which are discussed over the following pages.

23 Workspaces can be selected from the Topbar

Layout workspace

The Layout workspace (image 24) is Blender's default workspace and one you will have already seen in this book. It is designed to allow you to edit the major features of the scene. The 3D Viewport allows you to organize objects, cameras, and lights. The Outliner organizes the scene assets and the Properties Editor, open on the **Object Properties** tab by default, gives access to specific data from a given asset. Its default mode is **Object Mode**. Layout is generally the workspace you will spend the most time in because it gives you a great overview of your scene.

24 The Layout workspace

Modeling workspace

The Modeling workspace is optimized for object editing, also known as modeling. When selecting this workspace, you instantly enter **Edit Mode** for the active object (in image 25, the cube) in the 3D Viewport, which means you have all the editing tools available in the Toolbar. The **Modifier Properties** tab is selected by default in the Properties Editor.

25 The Modeling workspace

Sculpting workspace

When you select the Sculpting workspace, the 3D Viewport will switch to **Sculpt Mode** on the selected object, optimizing your options for using brushes to sculpt your model intuitively like clay. The Properties Editor is on the **Active Tool and Workspace Settings** tab by default, showing all the selected brush options (image 26).

26 The Sculpting workspace

UV Editing workspace

The UV Editing workspace (image 27) is optimized to generate and edit UV maps, with the UV Editor on the left and the 3D Viewport on the right. Since UV maps are part of the mesh data, you need to be in **Edit Mode** on the object to access them. When you select the UV Editing workspace, the 3D Viewport will therefore switch to **Edit Mode** on the selected object. The UV Editor will open in a new window. The UV map will be generated in the 3D Viewport and polished in the UV Editor. The Properties Editor is open on the **Object Data Properties** tab.

27 The UV Editing workspace

Texture Paint workspace

The Texture Paint workspace (image 28) allows you to paint directly on a 3D object or in the 2D space of the Image Editor. In terms of areas, it is similar to the UV Editing workspace: the left area is the Image Editor that allows you to paint images as you would in Photoshop; on the right the 3D Viewport, in **Texture Paint Mode**, shows the default cube in a pink color and the mouse cursor is now a round shape displaying the size of your painting brush. The Properties Editor has the **Active Tools and Workspace Settings** tab open by default.

28 The Texture Paint workspace

Shading workspace

The Shading workspace (image 29) is built to allow you to create materials for your objects and characters. Since this is a stage that involves a lot of external resources, the workspace includes a file browser, alongside the Image Editor, to help you see the texture you may apply to your material. The 3D Viewport has the display mode set to **Material Preview**, allowing you to see your object in a realistically lit context. The Shader Editor allows you to manipulate the material property and add new shading components to it, such as transparency, its capability of emitting light, and the bumpiness of the surface.

29 The Shading workspace

Rendering workspace

The Rendering workspace features the Image Editor with an empty render result and the Properties Editor with the **Render Properties** option selected, allowing you to set up the rendering quality. You can render an image by hitting the **F12** key or going to the Header and selecting **Render > Render Image**. A new floating Image Editor window will pop up with the rendered image, in this case the default cube (image 30).

30 The Image Editor showing the rendered cube

Compositing workspace

The Compositing workspace (image 31) is optimized to rework and enhance rendered images. It features the Compositor. It also features the Dope Sheet, which is a more advanced timeline where you can access more detailed animation data, and the Outliner, Properties Editor, and Timeline.

31 The Compositing workspace

Modeling

By Pierrick Picaut

CHAPTER OVERVIEW

▶ Adding an object

▶ Transforming an object

▶ Editing an object

▶ Working with multiple objects

▶ Modifiers

▶ Topology

Now that you are familiar with the Blender interface, it's time to take your first step in 3D character creation and get modeling! This chapter will guide you through modeling basics such as adding and manipulating objects in addition to more complex (but highly useful!) topics such as modifiers and topology. By the end, you will have created a cute character model based on a concept by Aveline Stokart.

Original concept by Aveline Stokart

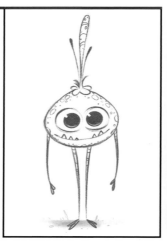

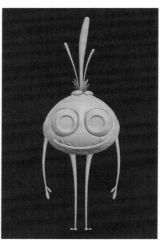

Adding an object

How to add an object

To begin, open up a new Blender file and delete the default cube so you have an empty scene. You can do this by selecting the object in **Object Mode** and pressing **Delete** on the keyboard.

To add an object in the 3D Viewport, go to the **Add** menu on the Header or press **Shift + A** and select the type of object you want to add. As explained before, objects can be meshes, curves, cameras, and so

on. Try adding a cone, which is under the **Mesh** section of the **Add** menu (**image 01a**).

Whenever you execute an action or function in Blender, a contextual menu will pop up in the lower left corner of the 3D Viewport, where you will be able to further set up the object you have added. In the case of a mesh object, you will be able to change its number of vertices (that is, its resolution), its size, default

alignment, position, and rotation. You can also tell Blender to automatically generate a UV map or not.

Note that when you add an object, it will be automatically added at the position of the 3D cursor and will be aligned with the scene axis or "world space" by default (**image 01b**; find out more about world space on page 55). You will also see that the new object appears in the Outliner.

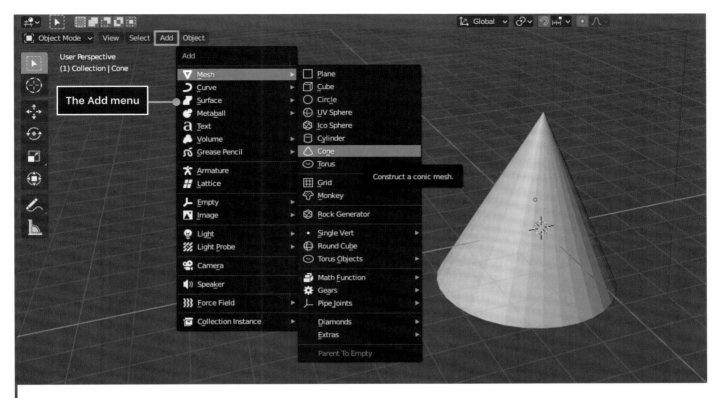

01a The Add menu that pops when you press Shift + A

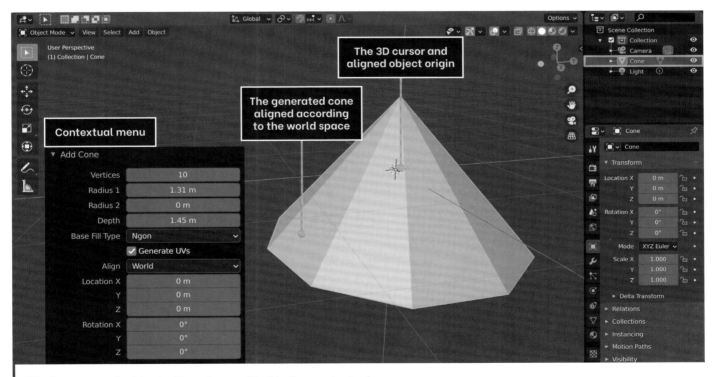

01b A cone mesh object with options edited in the contextual menu

Origin of an object

The origin of the scene (world origin) is the center of the world you will be building in. It is where the representations of the X, Y, and Z axes cross and it corresponds to the coordinate zero on all of these axes. The origin of an object is by default its center, but it can be moved. As mentioned on page 11, an object is a container that can be empty or filled with a lot of different types of data. Thus we need a point to determine the position of this object in the scene, using its distance from the world origin, a point around which translation (that is, the movement of an object) information will be measured.

The origin of an object is the large orange dot that appears inside the 3D cursor in both **Object** and **Edit Mode** (image 02a). As mentioned, when you add a new object, its origin point will be aligned with the 3D cursor. You can place the 3D cursor where you want with **Shift + RMB** or set its position coordinates based on the world origin in the **View** tab of the Sidebar (image 02a). You can reset the 3D cursor to the world origin with the shortcut **Shift + C** or by entering 0 in the 3D cursor's X, Y, and Z location in the **View** tab of the Sidebar.

CANCELING A TRANSLATION

You can reset the position of an object by "canceling" any translation using the **Alt + G** shortcut with the object selected, or set its position value to 0 in the **Item** tab of the Sidebar.

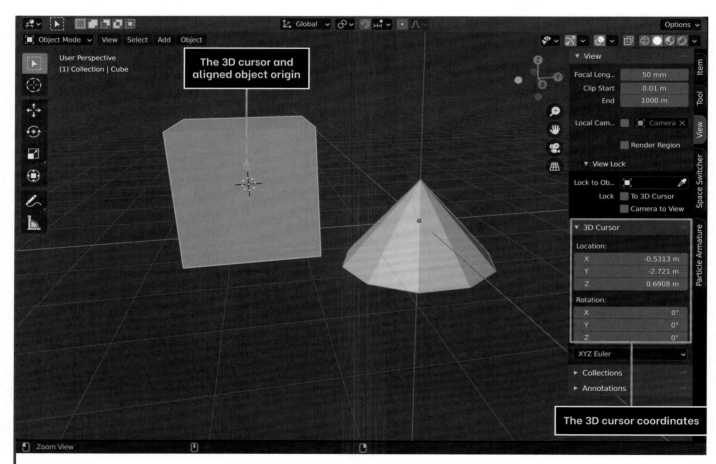

02a A cube object and its origin point

You can change the origin of an object by going to the Header and selecting **Object > Set Origin** (image 02b). For example, you could set it to be aligned with the 3D cursor or move it to the center of an object's bounding box. This can be useful when adding and editing objects.

Note you can also edit the location, rotation, and scale axes value of the object in the **Object Properties** section of the Properties Editor.

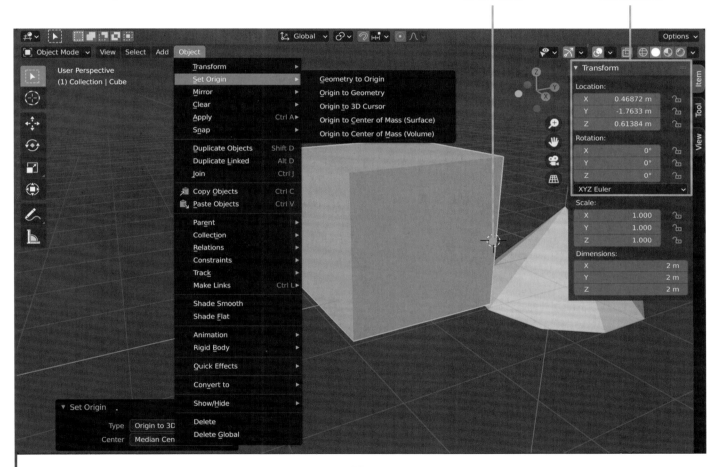

02b The new origin of the cube set to be aligned with the 3D cursor

Different types of object

When accessing the **Add** menu in **Object Mode**, you will notice that there are a lot of different objects that can be added. The most common are **primitives**. These are **mesh objects** with basic shapes most often used as a base to start building a more complex object. For example, to model a house, you could start with a cube and make a couple of holes for the windows. There are many meshes available, including a monkey head (nicknamed Suzanne), which you will see more of in the coming chapter!

Curve objects are also very useful as a curve can be used to bend other objects along it, make objects follow them as a path, or simply model wires, hairs, or even spaghetti with ease.

Empty objects are, as their name suggests, empty objects. They are very useful, though, as you can use them as pivot points (see pages 56–57) to rotate other objects around or to constrain other objects. The behavior of some tools can also be edited using empty coordinates, like using an empty as the imaginary mirror object to symmetrize an object.

Light objects are very important, as they are the main features that allow anything to be rendered, giving off light as in real life. They have different properties that are generally self-explanatory, such as lighting power and color. Lights will be covered more on pages 153–157.

Camera objects are also very important, as you can't render out an image or an animation without one. They allow you to frame the scene you want to render with physical-based properties, such as focal length and sensor size.

Metaball objects are a bit particular in the way they are edited, but they can be very useful for quickly building a base mesh. These objects, when close to each other, will join as water drops would. This behavior means they are often used in motion design, too.

Armature objects enable you to build a digital skeleton with bones that will allow you to transform your character object into a posable and animable puppet. Basic skeleton armatures are very useful for quickly and naturally posing a character.

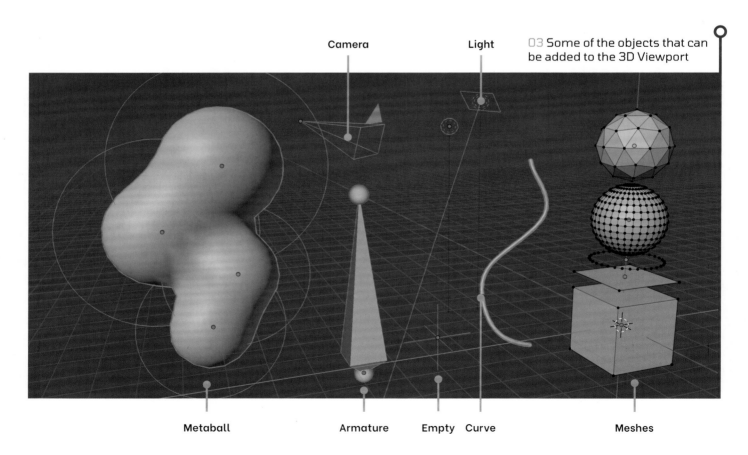

Camera Light

03 Some of the objects that can be added to the 3D Viewport

Metaball Armature Empty Curve Meshes

SETTING UP A CAMERA

When editing your 3D scene, you can navigate freely without worrying about a camera, but when it comes to rendering, Blender will warn you to add a camera. The camera defines which part of your Blender scene is being "seen" or "rendered." Cameras are objects, so you can add a camera in the 3D Viewport with **Shift + A** or by going to the **Add** menu.

You can move and rotate a camera at will to frame your scene with the same tools used to move other objects (see pages 52–54). You can also match the camera to the current viewport point of view using the **Ctrl + Alt**

+ Numpad 0 shortcut. In the **Object Data Properties** section of the Properties Editor you can edit a range of camera settings, such as the focal length and depth of field, as if it was a real-life camera.

If you have multiple cameras in your scene, you can choose which one to use in the **Scene Properties** section of the Properties Editor. Note that the image size framed by the camera depends on the resolution of your file output, as Blender will use the output resolution as the camera format. You can edit this in the **Output Properties** section of the Properties Editor.

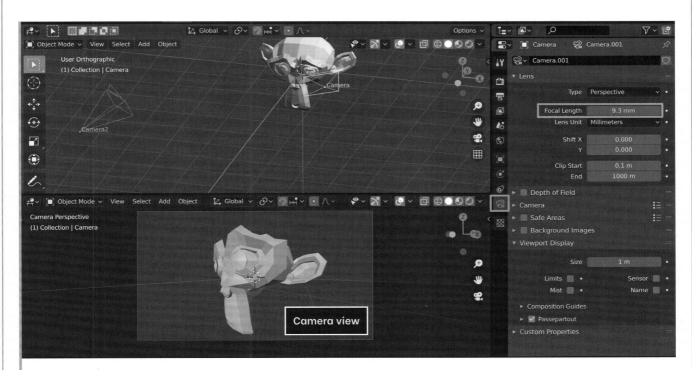

The camera options and the camera view with a very short focal length (broad angle)

Object properties

As you will learn, there are many ways an object can be manipulated, including through its properties. Object properties can be accessed in the **Object Properties** tab of the Properties Editor, and in some other Editors, such as the 3D Viewport.

Transform properties (in the Properties Editor and the 3D Viewport Sidebar; image 04a) show the object location, rotation, and scale based on the origin of the scene (world origin). While objects can be manipulated in the 3D Viewport, which you will learn how to do on pages 52–54, you can also modify these values in the **Transform** panel to move, rotate, or scale the object. The **Delta Transform** panel is generally used in animation to offset a movement.

The **Relations** section (image 04b) in the Properties Editor shows if the selected object has a parent. **Parenting** is often used in 3D and 2D animation software to make an object follow any transformation of its parent. You will learn more about Parenting on pages 100–101.

The **Collections** panel allows you to assign an object to a new collection or see in which collection it belongs.

Instancing is a very powerful tool. It allows you to duplicate a model onto an object's faces or vertices. This is very useful when you want to build a regular pattern of objects on a complex surface, for example metal rings on chainmail. In the Outliner, select the object you want to be

duplicated and make it the child of the object you want it to be instanced on by selecting it in the **Relations > Parent** list in the Properties Editor. Select the parent object, and enable instancing by choosing whether you want to duplicate the child object on the vertices or on the faces of the object in the Instancing panel (image 04c).

The **Visibility** options allow you to select whether or not an object is selectable in the 3D Viewport (like locking a layer in Photoshop), visible in the 3D Viewport, or rendered (image 04d).

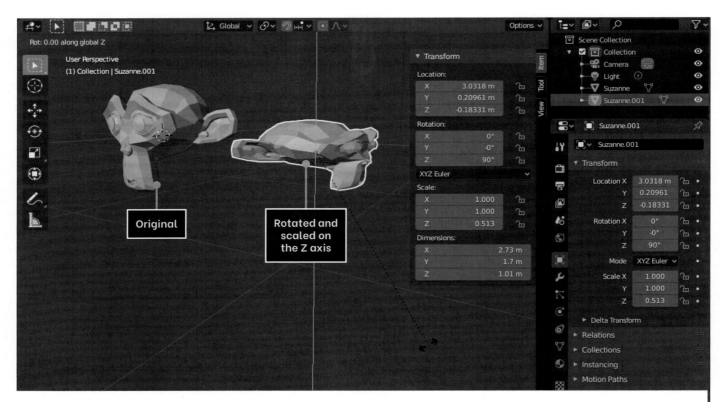

04a Transform properties for a monkey object, showing its location, rotation, and scale

04b Relations properties, showing the object's parent and in which collection it belongs

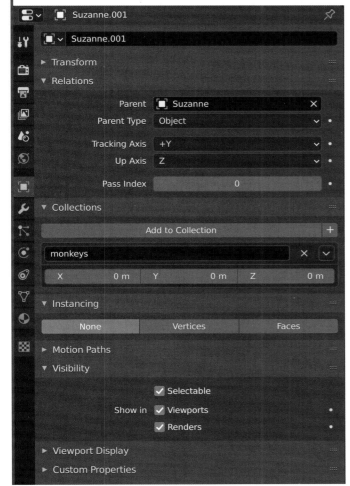

04c The monkey head instanced on surface vertices

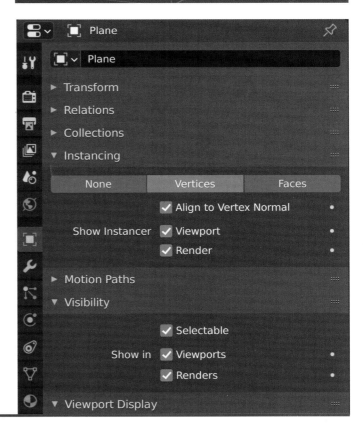

04d The Visibility options in the Object Properties panel

Different ways to view an object

You can toggle different features to be displayed on an object by going into the **Viewport Display** tab of the **Object Properties** section of the Properties Editor. You can display its name and axis in the 3D Viewport, which is useful for seeing the object's orientation in the space (image 05a).

The **Wireframe** option is great for checking an object's complexity and edge flow in **Object Mode**.

The **Texture Space** option shows a bounding box around the object from where a texture could be projected in specific cases.

The **Shadow** option determines whether the object projects shadow or not in the 3D Viewport, but it does not affect the render.

The **In Front** option is very useful, as when toggled it shows the object on top of any other object whatever its position in the space (image 05b). This is very useful for retopology or when working on tight areas or hidden objects.

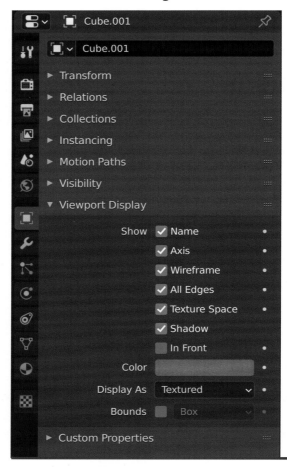

05a The Object Properties > Viewport Display options

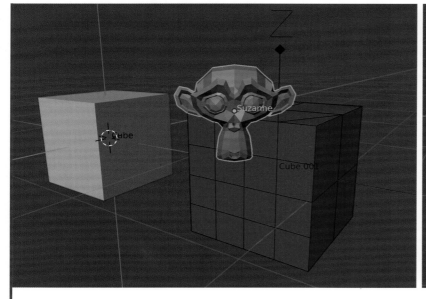

05b As you can see in the right-hand side of this image, the monkey is behind the red cube in the 3D space, but with the In Front option selected it appears in front of the cube in the left-hand part of the image

You can also set a **color** to be used when activating the **Object** color option in the **Viewport Shading** menu (image 05c). Go to the **Object Properties** section of the Properties Editor and change the color in the **Color** field. This means you can use different colors for different objects or groups of objects.

Toggling the **Bounds** box displays an aligned box shape in which the object geometry will fit (image 05d). This can help you see if the object has enough room in a given situation.

The object can also be displayed only as a bounding box by going to **Object Properties > Viewport Display > Display As** and selecting **Bounds** from the dropdown. This can be useful when you have a lot of very detailed objects and the 3D Viewport lags, as it will limit the number of polygons to be drawn in the 3D Viewport. This won't affect what is rendered.

These options can be combined with the **Shading** and **Overlay** options discussed on page 21.

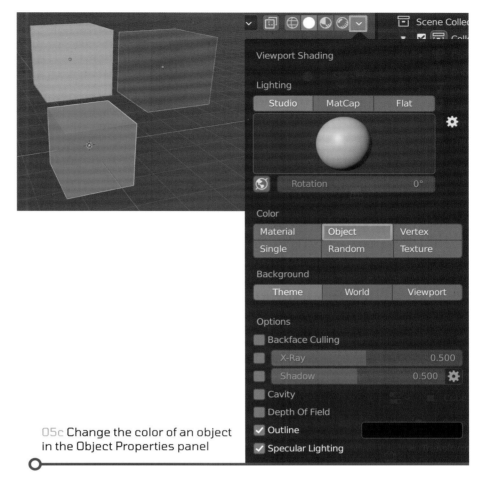

05c Change the color of an object in the Object Properties panel

05d Monkey heads shown in Solid mode, Wireframe, and with a bounding box

Transforming an object

Move, scale, and rotate

You can manipulate any object in **Object Mode**, by default, around its origin. To **move** an object press the **G** key once, move the mouse to the desired position, and left-click to confirm. Right-clicking will cancel the movement.

You can constrain the object to move along a single **axis** by pressing the relevant letter on the keyboard once. For example, press **G** followed by **X** to constrain movement to the X axis (**image 06a**). Left-click to confirm. You will notice that the object moves along its origin, with another X axis line appearing through the object origin while you carry out the transformation. You can see how far you have moved the object away from its previous origin in the top left of the 3D Viewport.

The same shortcut combination can be used with **R** to rotate and **S** to scale.

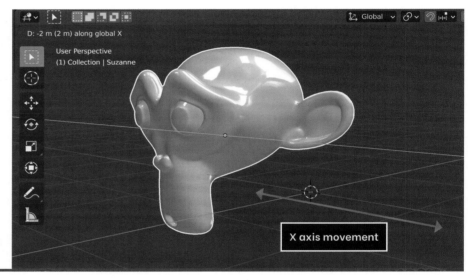

06a The object moving on the global X axis

You can also press **G** followed by **Shift + X** to move the object along the global Z and Y axes, but not the global X axis (**image 06b**). Left-click to confirm, right-click to cancel. This shortcut also works with other axes, for example use **Shift + Y** to move along the Z and X axes only. This also works for scale and rotation.

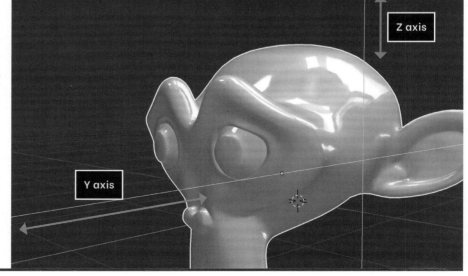

06b The object moving with the global X axis locked

Transformation Gizmos

You can also use the **Transformation Gizmos** to move an object in the 3D space. With each of the tools described here, you release the mouse button to confirm the transformation or right-click before releasing to cancel. The red part of the Gizmo relates to the X axis, the green the Y axis, and the blue the Z axis. As with most Blender manipulations, a contextual menu will pop up allowing you to manually enter the value you want to move on each axis (image 07a).

Move

With the object selected in **Object Mode**, go to the Toolbar and select the **Move tool** (image 07a). The Move Gizmo will appear around the origin of the object. Click and drag the white circle to freely move the object. Click and drag one of the colored arrows to move only along the specific axis. You can also click and drag on the colored planes to move with the corresponding axis locked (so that your object will move along all unlocked axes and not locked axes). For example, the red plane will lock the X axis, green the Y axis, and blue the Z axis.

Rotate

To rotate the object using the **Rotate tool**, select it in the Toolbar (image 07b). Click and drag the white circle on the outside to rotate the object along an axis from its origin and your current point of view (imagine you are pointing at what you are looking at with your finger; the rotation axis would be your finger). Click and drag one of the colored circles to rotate on a specific axis.

A slight transparent sphere appears when hovering in the middle of the Gizmo. Click and drag it to use trackball rotation; the object will rotate around its origin according to your mouse cursor. This can be a bit harder to master but is a very useful function.

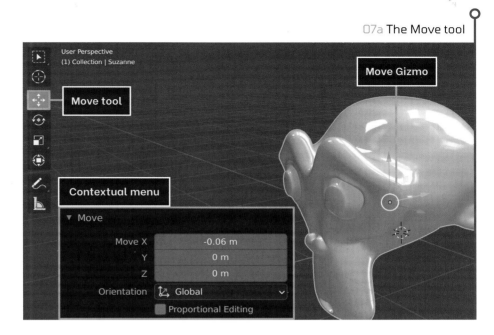

07a The Move tool

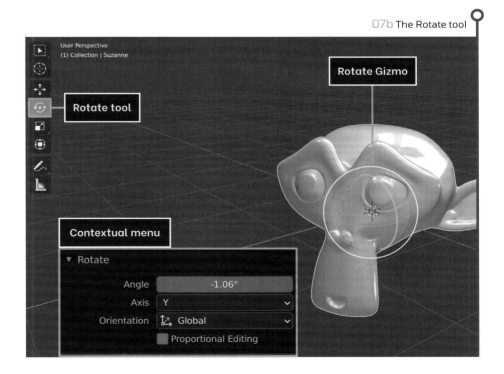

07b The Rotate tool

Scale

To scale the object using the **Scale** tool, select it in the Toolbar (image 07c). Click and drag the white circle on the outside to scale the object on all axes homogeneously from its origin. Click and drag one of the colored handles to scale along an axis. Click and drag one of the colored planes to lock an axis while you scale.

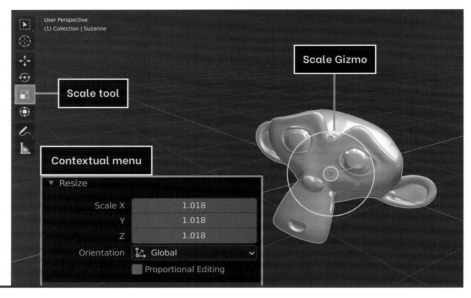

07c The Scale tool

Transform

You can also use the **Transform** tool (image 07d) in the Toolbar, which is a Gizmo combining all of the above with a few limitations, such as not being able to use global scaling (scaling on all axes at once).

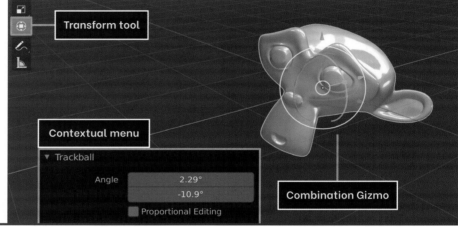

07d The Transform tool

TRANSFORMATION TIP

When transforming an object, you can enter a value manually. For example, press **G** to move, **X** to constrain on the X axis, and type 3.5 on your keyboard then hit **Enter**. The object will move by 3.5 meters on the global X axis. It works with degrees for rotation and factor value for scaling.

You can also use this technique by holding down the **LMB** on the manipulator you are using

and then entering the axis and value. Holding the **Shift** key will enable you to manipulate in very low increments, which is useful for fine-tuning your transformations

These transformations can be canceled or reset to 0 by using **Alt + G** for move, **Alt + R** for rotation, and **Alt + S** for scaling.

World space versus local space

It is very important to understand the difference between local space and world space in Blender and 3D in general.

When an object is added in Blender, it is aligned with world space by default, meaning its X, Y, and Z axes are aligned with the scene's X, Y, and Z axes. In images 08a and 08b, you can see the arrows of the Move Gizmo pointing along their relevant scene axes. Larger arrows have then been added for the purposes of illustration to demonstrate the object's axes. Image 08a shows the object aligned with world space – the illustrative arrows point in the same direction as the scene axes arrows.

However, as soon as you rotate the object (image 08b), you will notice that the illustrative arrows (the object's axes) are no longer aligned with the arrows of the Gizmo (the scene axes). However, if you were asked to locate the front and sides of the monkey's head, you would still point out that the nose and eyes are on the front and the ears are on the sides. This is because however you rotate a body in a world space, the head is always on top of the body in its local space.

If you are manipulating an object whose axes no longer align with the global axes, it can be useful to change the Transformation Gizmo's settings so that its axes match the object's rather than the scene's. You can switch from using world space axes to local space axes through the **Transformation Orientation** menu in the Header (image 08c – notice how the object axes and Gizmo axes are now aligned in the rotated object).

If you are using shortcuts, pressing **G** and then **X** twice will switch to an axis translation constrained to the local X axis. If you press **Shift + X** twice, it will lock the local X axis while moving the object. It works the same for the other axes and for rotation and scale too.

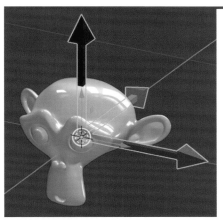

08a The Move tool aligned with world space

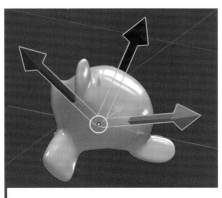

08b The Move tool aligned with world space but with the object rotated

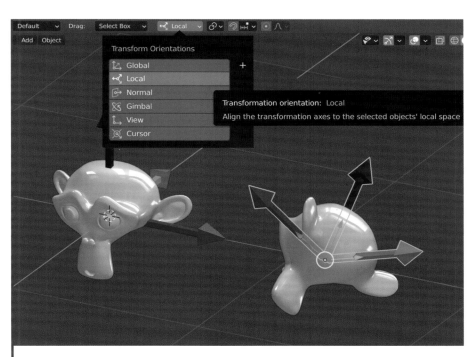

08c The Move tool aligned with object local space

Pivot points

Any transformation executed in **Object Mode** is, by default, executed from the origin of the object. The origin is considered the **pivot point** of the object.

You can switch to using different pivot points by going to the **Transform Pivot Point** menu in the middle of the Header (image 09a).

BOUNDING BOX	Uses a bounding box as a pivot point. It will find the average position based on the outer limits of the selected object(s).
3D CURSOR	Uses the 3D cursor as the pivot (image 09b). Any rotation will occur around the 3D cursor. Scaling will be executed toward the 3D cursor, involving both scaling and location modification (that is, moving toward or away from the 3D cursor; this is because you are also scaling the distance between the 3D cursor and the origin of the object).
INDIVIDUAL ORIGINS	Is very useful as you can manipulate multiple objects at once and they will be transformed around their own origins. Rotating or scaling multiple objects this way will keep them in their relative position to each other (image 09c).
MEDIAN POINT	Uses the average position of multiple object origins as a pivot point.
ACTIVE ELEMENT	Uses the active object origin as a pivot. Selected objects are outlined in orange; the active object is outlined in a yellow.

09a Rotation tool using the 3D cursor as a pivot point

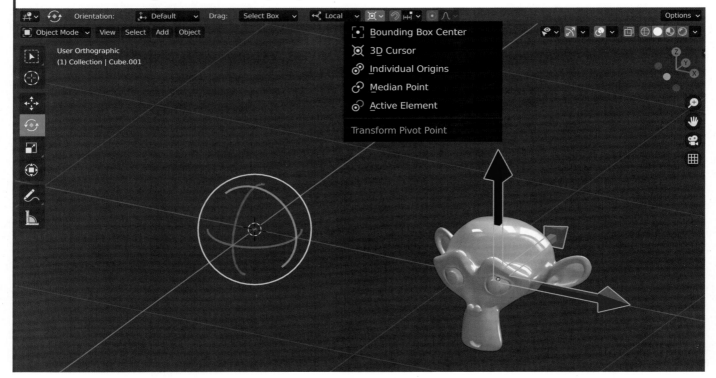

3D CURSOR PIVOT POINT

Scaling two objects from a point in space to 0 will align these objects with that point, as the distance to this pivot point will be 0. For example, create two different objects and move them arbitrarily. Then select the 3D cursor as a pivot point in the Header. Select the two objects and scale them to 0 on the Z axis (press S for scale, Z to constrain on the Z axis, and **Numpad 0** to set the scale value to 0). Both objects will be flattened on the global Z axis but also aligned on the Z axis.

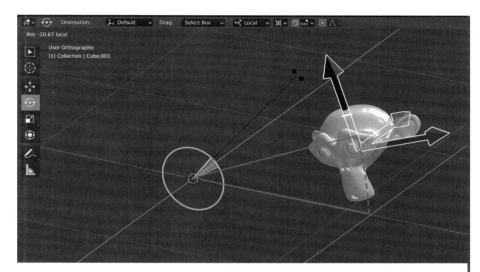

09b Rotating an object around the 3D cursor. The green circle is the Rotation widget around the Y axis. The red triangle has been drawn to show the angle of rotation from the 3D cursor

09c Rotating multiple objects using the Individual Origins pivot point setting. Holding the Ctrl key on the selected axis of the Rotation widget will show increments in white

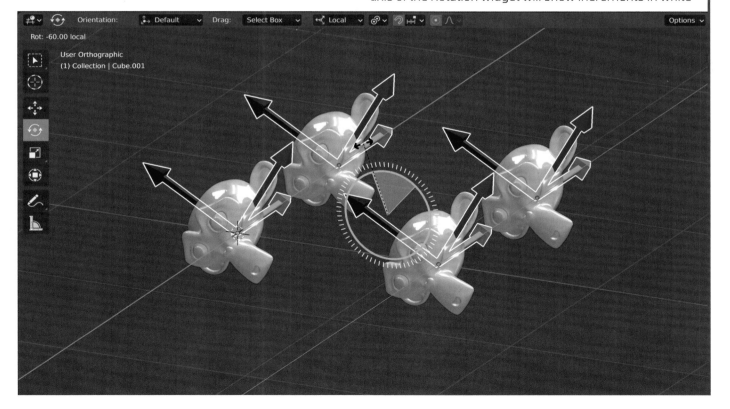

Editing an object

Basics

To explore modeling in the rest of this chapter, you can start to create a basic character such as the creature shown in image 10a. First, create a UV sphere with 24 segments, 12 rings, and a 0.5m radius:

▷ in **Object Mode**, press **Shift + S** and set the cursor to world origin;

▷ go to the **Add** menu or press **Shift + A** in the 3D Viewport;

▷ then select **Mesh > UV Sphere**;

▷ set the radius, number of segments, and number of rings in the **Add UV Sphere** contextual menu that appears in the bottom left of the 3D Viewport (image 10b).

You may also want to add a new area (refer back to page 28 for how to do this), choose the Image Editor from the **Editor Type** menu, and load a reference picture to refer to as you work (image 10b). Simply click the folder-shaped Open icon and select the file you want to upload.

Back in the 3D Viewport, enter **Edit Mode** with the sphere selected by pressing the **Tab** key or switching modes in the Header. Using manipulators (move, scale, rotate), you can modify the shape of the object. You can cancel using the **Ctrl + Z** shortcut or by going to **Edit > Undo** on the Topbar.

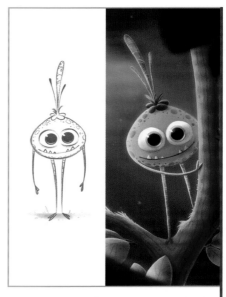

10a Original final artwork
© Aveline Stokart

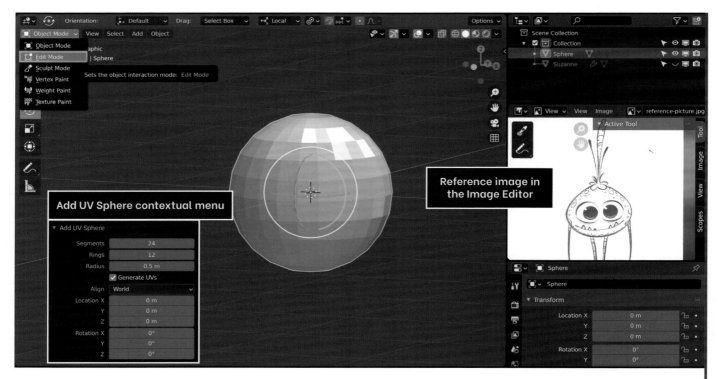

10b Add a UV sphere and switch to **Edit Mode**

Edit Mode allows you to manipulate the mesh of the object, so you can also choose to select vertices, edges, or faces using the 1, 2, and 3 keys on the keyboard top row or by selecting the relevant icon in the Header (image 10c). You can **Shift + click** multiple selection modes to combine them.

To deselect the sphere so you can select specific vertices, edges, or faces, left-click and drag anywhere outside the object. You can then left-click on a vertex, edge, or face to select it depending on the selection mode you are in. To select more than one vertex, edge, or face, hold down **Ctrl** as you left-click. Selected items will appear orange, with the active selection outlined in white (in **Object Mode**, the active object will be outlined in yellow rather than white).

Try moving, rotating, and scaling some of your selections (image 10d). Moving vertices, edges, and faces occurs in the same way as moving objects. You can use world or local space. You can also use different pivot points. Remember to use **Ctrl + Z** to return to the basic sphere.

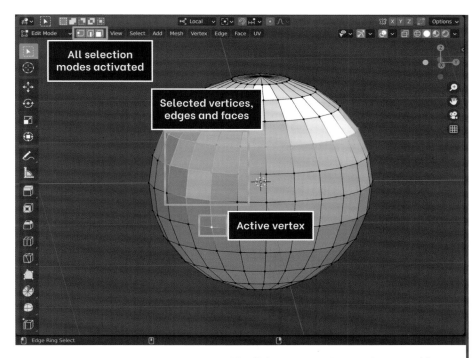

10c Selecting vertices, edges, and faces

10d The sphere mesh after a couple of manipulations

Selection tools

Selecting is one of the most important inputs in any 3D software. You've already seen that you can choose whether to select vertices, edges, or faces, and there are a lot of different ways to select or modify a selection.

In the Toolbar, click and hold on the first icon to access different selection tools as described in the table on the right.

TWEAK	Will allow you to select one item at a time.
SELECT BOX	Click and drag in the 3D Viewport to frame the item you want to select. When this tool is selected, options in the Header appear so that you can change the behavior of the tool to make selection additive, subtractive, inverted, or intersected (image 11a).
SELECT CIRCLE	Works like a brush. Click and drag over the items you want to select. You can change its radius in the Header.
SELECT LASSO	Allows you to draw a non-uniform frame around what you want to select. This is very useful for accurate selection of multiple items.

You can also see the different options for each tool in the **Active Tool** section of the Sidebar (image 11b). Press the **W** key to swap selection tools in the 3D Viewport.

11a Performing a box selection

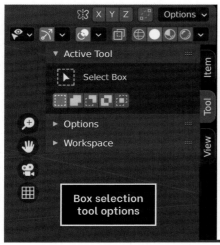

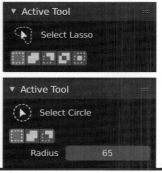

Other selection tools option

11b The different selection tool options in the Sidebar

11c Some edge loops and face loops selected

You can also hold the **Alt** key and left-click on an edge to select the edge loop linked to the clicked edge. This works the same with face loops if you are in Face Select mode. Hold **Alt + Shift** and left-click to add or remove a selection (image 11c).

With a vertex, edge, or face selected, hold **Ctrl** and left-click to select the shortest path of vertices, edges, or faces between the two items (image 11d). A contextual menu will appear, allowing you to change the selection behavior.

You can select all by pressing the **A** key (note that if you have the **3D Viewport Pie Menus** add-on enabled you will have to press **A + 8** or **A + Select All Toggle**). You can deselect all by pressing **Alt + A** or by pressing the **A** key twice rapidly. You can also access these in the **Select** menu of the Header.

Hover over a vertex, edge, or face and press the **L** key to select all linked vertices, edges, or faces. With one or more vertex, edge, or face selected, press **Ctrl + L** to select all linked vertices, edges, or faces. You access this function by going to **Select > Select Linked** in the Header.

11d Using the "select shortest path" method

With one or more vertices, edges, or faces selected, press **Ctrl + +** on the numpad to grow the selection, or press **Ctrl + -** on the numpad to reduce the selection (images 11e and 11f). Again, you can access this function via **Select > Select More/Less** in the Header or via the **3D Viewport Pie Menus** if you have that add-on activated.

11e The selected vertex

11f The grown selection of vertices

Proportional Editing

You have already seen that you can move, rotate, and scale vertices, edges, and faces. This is a very basic technique to use whenever you want to shape a model, but it can be cumbersome to move vertices one by one to achieve the desired shape. The **Proportional Editing** option is perfect for manipulating multiple vertices, edges, or faces without having to select them one by one.

You can activate it by clicking its icon on the Header or pressing the letter **O** key on the keyboard. Press **O** again to deactivate. Pressing **Alt + O** will enable or disable the **Connected Only** option. When this is activated, transforming a vertex, edge, or face will also transform the nearby vertices depending on the falloff you have selected. The influence area size will be displayed as a white circle around the selected vertices and can be increased or decreased using the mouse wheel or the **PgUp/PgDn** keys (image 12a).

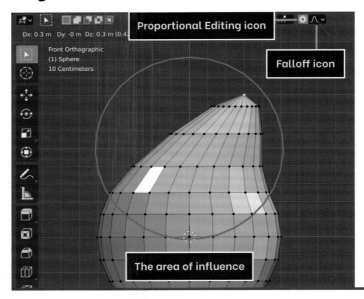

12a The Proportional Editing icon and area of influence

FALLOFF

The further from your selection the vertices are, the less influence they will receive when being transformed; they will be moved, rotated, or scaled less than the vertices closer to your selection. The falloff influence depends on the profile you have selected; for example you can choose **Smooth**, **Linear**, or **Random**. Each of these options is available in the menu that appears when you click the Falloff icon in the Header.

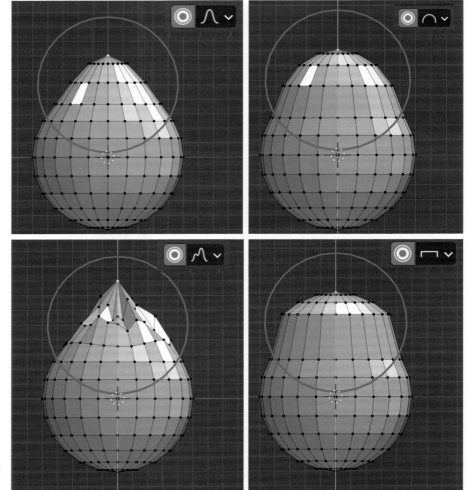

12b Meshes edited with different proportional editing falloffs

The **Proportional Editing** option comes with many different falloff curves that will modify its influence behavior (image 12b); these can be accessed in the dropdown menu that appears when you click on the downward arrow to the right of the Falloff icon.

By enabling and disabling the **Connected Only** option, you can choose whether to modify connected vertices only or all; in the second case, imagine the falloff as a sphere around your selection – anything in this sphere will be transformed (images 12c and 12d).

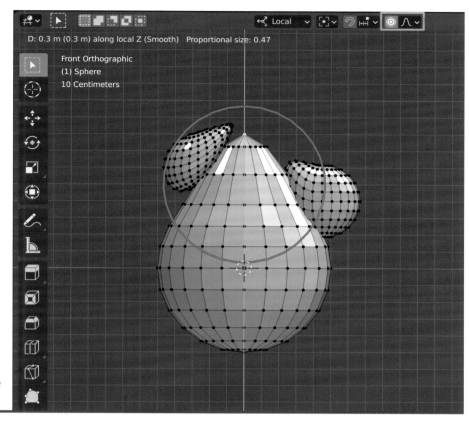

12c Without the Connected Only option enabled, any objects inside the falloff area are influenced

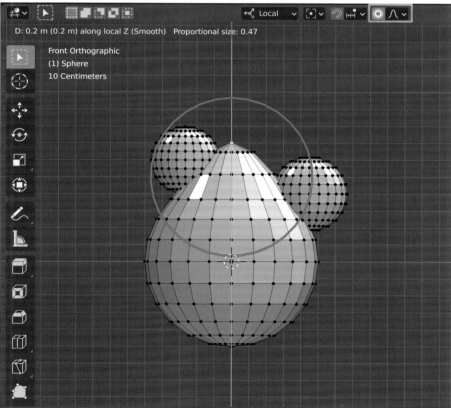

12d With Connected Only enabled, the proportional editing only applies to connected mesh

The **Project from View** option in the **Falloff** dropdown will project the influence toward your point of view, influencing any geometry it comes across (**image 12e**).

Using the **Smooth Falloff** setting of the Proportional Editing tool, try shaping the UV sphere into the squashed egg-like shape shown in image 12f, so that it matches the reference image. Simply select the edge loop as shown (using **Edge Select** and **Alt + left-clicking** an edge) and scale on the Z axis (**S + Z**).

OBJECTS

The Proportional Editing option also works in **Object Mode** and will influence multiple objects' position, rotation, and/or scale based on their distance.

12e Proportional editing with the Project from View option enabled. The red shading indicates the approximate area of influence determined by the user's point of view.

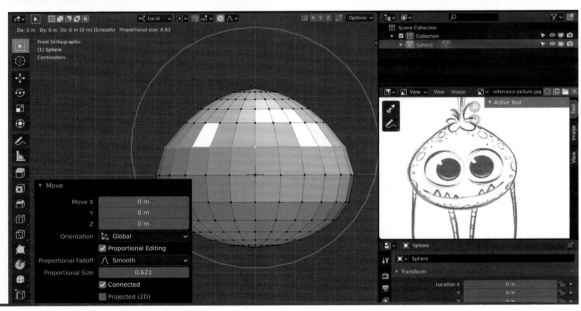

12f The character taking shape with the Proportional Editing option

Extrude tool

Now that you know a couple of tricks to move geometry, you need to learn how to generate more of it. The most common process is to extrude new geometry.

The Extrude tool can be found in the Toolbar of the 3D Viewport when in **Edit Mode**. You can only extrude geometry in this mode. When selected, a manipulator will appear on top of your selected vertices, edges, or faces (image 13a). If you click and drag the **+** icon, it will extrude the selected vertex, edge, or face along its normals. If you right-click it will cancel any transformation, but the extruded item won't be deleted. You need to press **Ctrl + Z** to cancel any extrusion.

When left-clicking and dragging in the circle, you will perform a free extrusion, allowing you to extrude in the direction you want. You can constrain the extrusion along any axis as if you were performing a transformation by using the **X**, **Y**, and **Z** shortcuts.

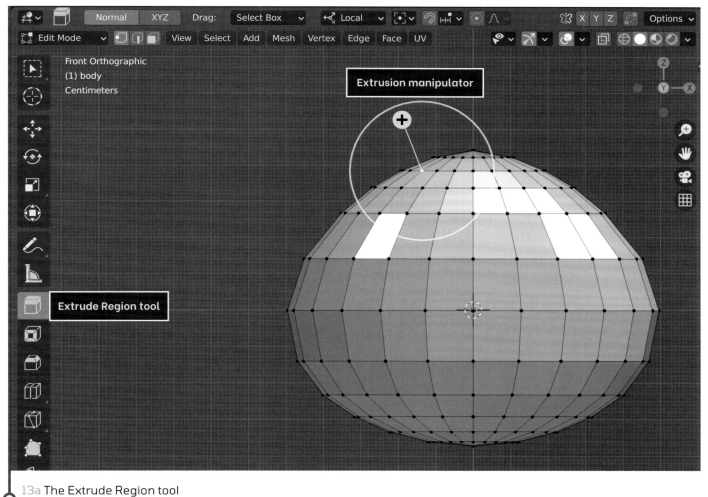

13a The Extrude Region tool

You can use the **E** key to perform an extrusion. It will be performed along the normal for any selected face; it will be performed freely for any selected vertex or edge (image 13b). The **Alt + E** menu gives you access to more advanced extrusion tools (if you have a face selected), like **Extrude Individual Faces**. This option will extrude each face individually rather than as a whole: if you have multiple, connected faces selected, the regular behavior is that all these faces will be extruded together, in a big connected patch along a single axis; in the case of **Extrude Individual Faces**, each face will be extruded along its normal and will be disconnected from the previous consecutive face, generating a "wall" between each of the extruded faces (image 13c). You can also access these tools via **Mesh > Extrude** in the Header.

PIVOT POINTS

The pivot point is quite important when extruding. You will generally work using the **Bounding Box Center** option, but using an individual origin can be very handy as it will extrude along each selected item's normals.

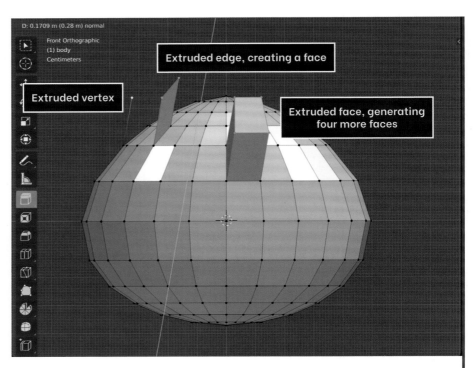

13b Different ways to perform an extrusion

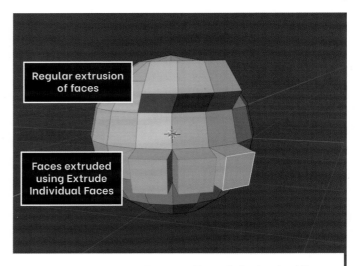

13c An extrusion example using Extrude Individual Faces

Let's create a basic shape for the creature's arm. From Front view (**Numpad 1**), select the vertex as shown in image 13d and press **Shift + S** to open the **Snap** menu. Choose **Cursor to Selected** to snap the cursor to this vertex. Add a new circle, whether with **Shift + A** or through the **Add** menu, and in the contextual menu set **Vertices** to 8 and **Radius** to 0.05m (image 13e). Extrude, rotate, and scale it downward a couple of times to generate the basic arm shape (image 13f).

Repeat the process for the leg. There is no need to do it on both sides, as you will mirror the geometry later on.

13d Snap the cursor to the selected vertex

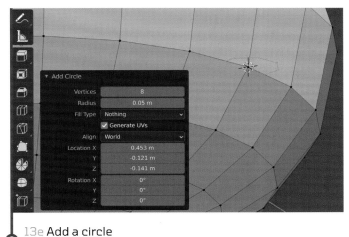

13e Add a circle

13f Extrude, rotate, and scale the basic shapes of the character limbs

67

Loop Cut tool

So far, you have kept the limbs of the character as low poly (fewer polygons) or low resolution as possible to make editing easier. Now you need to increase this resolution to make them more curved, as on the reference. This is a very common task that can be processed rapidly using the Loop Cut tool.

Stepping away from the model temporarily (you will use the tool in context on page 70), the Loop Cut tool can be found in the Toolbar in **Edit Mode**. When selected and hovering over any quad of the mesh, you will see a yellow line appearing that will run along any face loop until it reaches any non-quad face or empty area. You would left-click and drag to create a new edge loop along this yellow line; the edge loop will slide between the two parallel edge loops that bind it (image 14a).

The tool has to be used with care as the edge loop will continue its path all around the geometry if it doesn't meet a triangle, n-gon, or empty space, and it can therefore lead to undesirable complex geometry (images 14b and 14c).

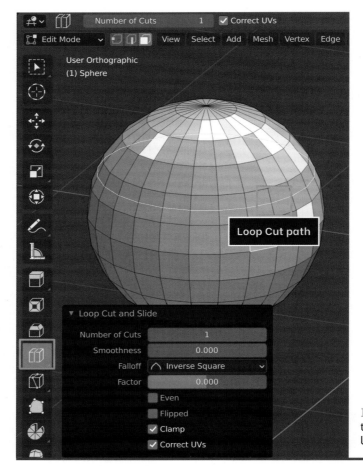

14a The Loop Cut tool on a primitive UV sphere

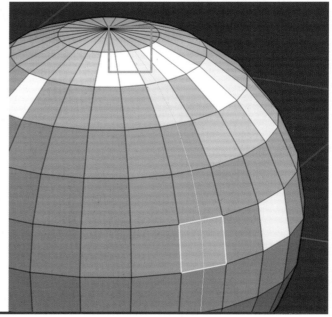

14b The path stopped by a triangle

LOOP CUT AND SLIDE MENU

When performing the loop cut, a contextual menu allows you to increase the number of cuts and control their behavior when sliding toward one or the other binding edge loop. You can make them morph into the same shape as the nearby edge loop with different smoothness and falloff settings, or you can choose to make them perfectly parallel to the chosen side. You can also automatically update your UV maps so that you won't have to re-unwrap your model.

The Loop Cut and Slide menu

14c Examples of bad Loop Cut behavior due to bad topology

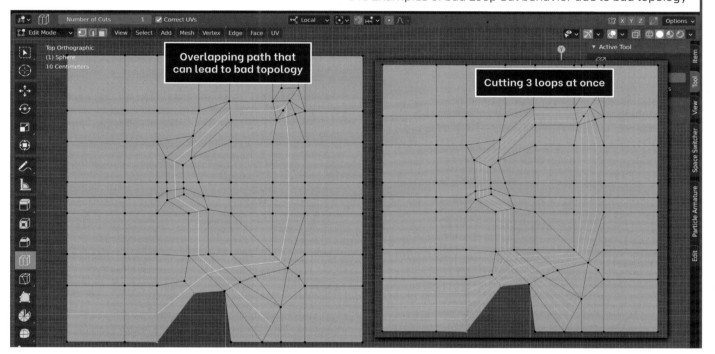

Before we go further, let's add the reference picture of the forest creature in the background. Press **Shift + C** in the 3D Viewport to center the 3D cursor. In **Object Mode**, press **Shift + A**, select **Image > Background Image**, and browse for the reference-picture.jpg provided. An empty object is created, with a plane shape including the reference picture. In the **Object Data Properties** panel of the Properties Editor, adjust the **Size** slider and the **Offset X** to fit the image's size and height to the object you have made so far (image 14d). Move the object as needed to line it up with your model.

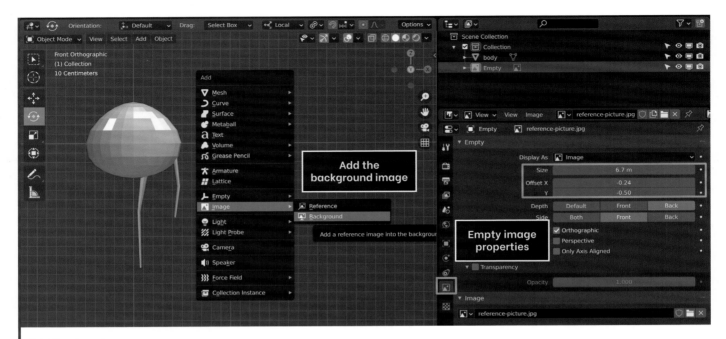

14d Setting the background image

Back to modeling, try adding a leg originating from the bottom of the body, using the same **Add > Circle** method as you used for the arm.

Once done, return to **Edit Mode** and edit the arm and leg by adding a couple of edge loops on the upper part and lower part of each limb using the Loop Cut tool. You should have five edge loops going through each limb (**image 14e**).

Use **Alt + left click** to select one of the new edge loops of the arm and move it into position to match the reference. Continue this for the rest of the arm. Try pressing the **Toggle X-Ray** icon (near the top right of the Header) to make the mesh semi-transparent as in **image 14e**; this will make it easier to line the model up with the reference.

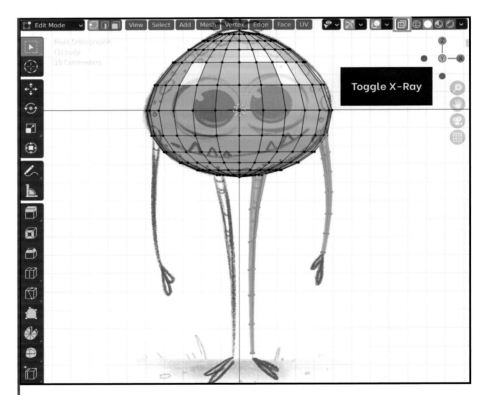

14e Our character with smoother limbs

Inset tool

The Inset tool is very basic but so powerful. It creates an inset of any selected face, generating extra face loops around an area of selected faces. You can use it to make the glass of a window in a couple of clicks, or to generate edge loops from simple or complex geometry like n-gons.

You can activate the tool by selecting the Inset Faces tool on the Toolbar (image 15a) or by pressing the letter I key with at least one face selected and then drag to change the inset's depth (image 15b).

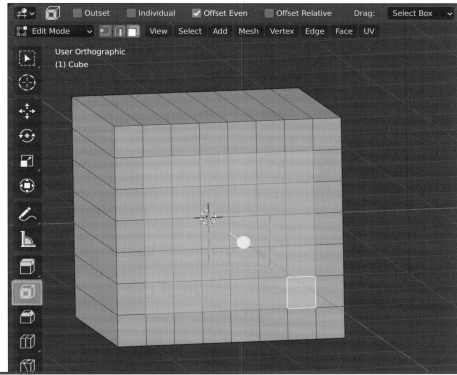

15a The Inset Faces tool and its manipulator

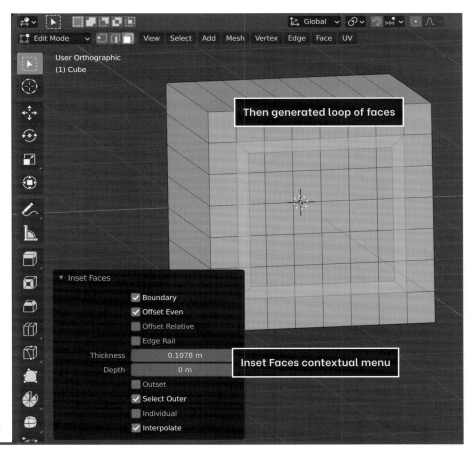

Then generated loop of faces

Inset Faces contextual menu

15b The generated loop of faces

As with any other tool, when activated, a contextual menu will pop up, giving you new options. Some of these options are also available in the Header. The most useful options are:

Boundary
Will toggle whether open edges (with no geometry attached) will be inset or not.

Outset
Will generate the inset on the outside of the selected faces, pushing the outer geometry (image 15c).

Individual
Will create an inset for each selected face. This is very useful for creating something like a window frame, for example (image 15d).

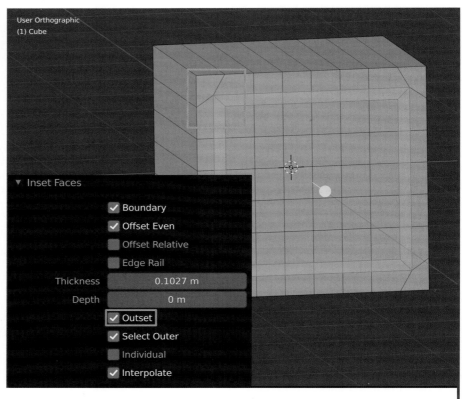

15c Outset option

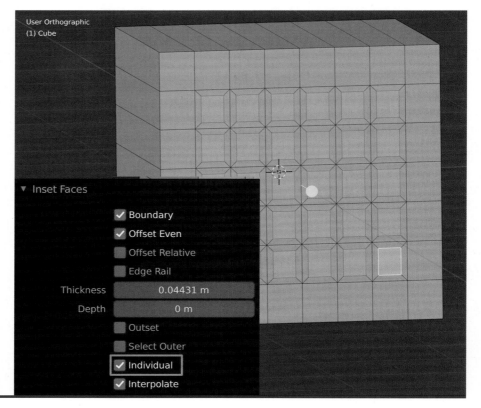

15d Individual option

On the character, select the 12 faces that will make the eye area as shown in image 15e and create an inset (image 15f). Then select the faces on the other side and press **Shift + R** to repeat the inset. You can access this **Repeat Last** function in the **Edit** menu of the Topbar.

Select the inner faces and extrude them inward slightly (image 15g). These will be the eye sockets.

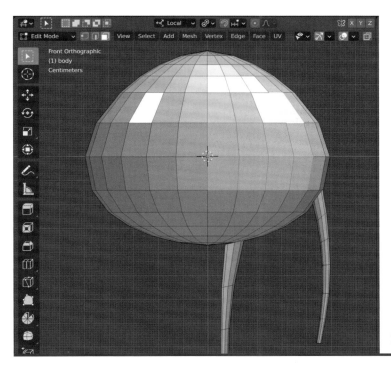

HIDING THE BACKGROUND IMAGE

You can hide the background image at any time if you find it easier to work without it for certain steps. Simply toggle the eye icon in the Outliner to hide/unhide the image or select it in the 3D Viewport and press **H** – see page 89 for more information on hiding/unhiding objects.

15e Left eye socket

15f Create an inset

15g You can use Shift + R again for the second extrude, so both eye sockets are the same depth

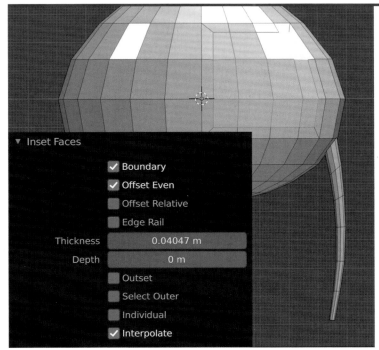

Knife tool

The Knife tool allows you to generate new edges on a surface as if you were cutting it. It is a very useful alternative to the Loop Cut tool in cases where you're not working on all-quad geometry.

It is often used in hard-surface modeling to quickly sketch panels on the side of a spaceships, for example.

It can also be used to fix the geometry of a character by cutting polygons to achieve a smoother flow of topology (the way the faces are connected and flowing one with the other – you will find out more about this on page 130).

You can use the **K** key to activate the tool in **Edit Mode** or select it from the Toolbar. As soon as you click on your mesh surface, edge, or even vertex, a red temporary vertex will appear showing you where the surface will be cut. You can then draw a path of edges to be cut each time you left-click (image 16a). Press **Enter** to confirm or **Escape** to cancel.

16a New geometry generated with the Knife tool

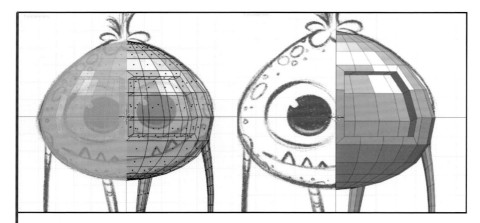

16b Remove half of the character

When using the Knife tool, note the shortcuts available in the footer. **Ctrl** will allow you to cut along constrained angles and the **Z** key will allow you to cut through the mesh to slice it.

You will use it to add a loop on the lower part of the character. However, first, delete half of the character: press **Alt + Z** to enable the X-Ray view, select the left half of the character, and delete all the faces by pressing **Delete** and selecting **Delete Faces** (image 16b; make sure you don't select **Delete Vertices** as this

will delete the central row of vertices, which are important). You will only work on one half and then mirror it later on.

Toggle X-Ray view back off. On the bottom of the character, use the Knife tool to draw a new loop of edges as shown in image 16c. Press **Enter** to confirm. This will allow you the freedom to create a hole to connect the leg to the body.

Continuing with the general development of the model, select the eight faces that are near the legs, as shown in image 16d. Press the letter **I** to inset the faces and then press **X** to get rid of the remaining faces inside the inset (image 16e). This will form the leg socket.

Do the same with the four faces near the root of the right arm (image 16f).

16c Create a new loop of triangles with the Knife tool

16d Select faces to form the leg socket

16e Delete the faces

16f Create the arm socket in the same way

Fill tools

Before we discuss the different fill tools, let's improve the shape of the character's eye socket. You can use X-Ray display to see the background image through your mesh.

As it is important not to move the vertices in the center of the character (as this will affect the mirror function later on), select them and press **H** to hide them (image 17a). Use proportional editing and transform tools to better match the eye socket to the reference image. Move the different vertices by hand to get used to mesh manipulation (image 17a).

Once you are done, you can select the different edge loops shaping the eye socket, right-click, and use the **LoopTools** add-on, Relax. This will average the vertices' position in a smoother manner (image 17b).

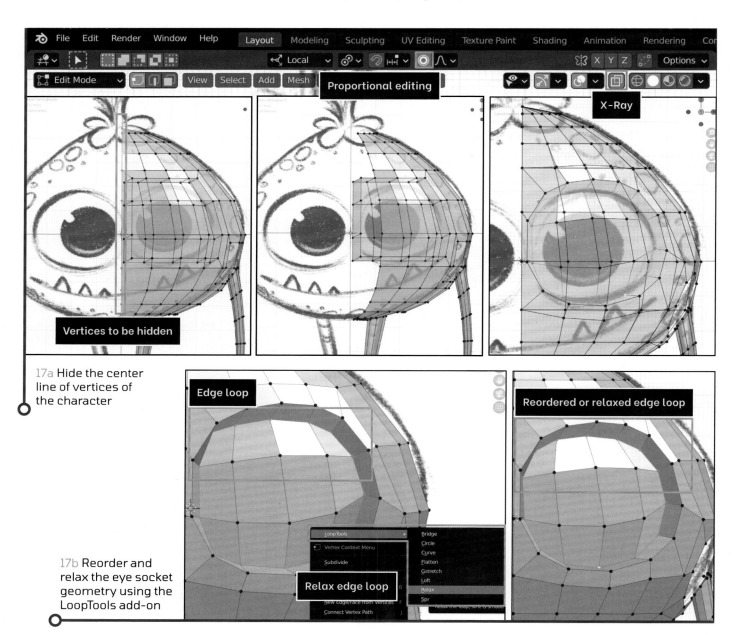

17a Hide the center line of vertices of the character

17b Reorder and relax the eye socket geometry using the LoopTools add-on

Filling big holes in a mesh, or creating patches of faces, can be quite complicated, especially when beginning in 3D. Fortunately, there are many options to fill these holes with ease, including those discussed in this section, and the Bridge Edge Loops function in the next. For demonstration purposes and to understand the fill tools, delete the inner faces of the eye socket. **Image 17c** shows different ways you can fill this hole with the Fill tool:

A You can use the Fill tool on two vertices by selecting them and pressing the **F** key.

B This will create an edge connecting the selected vertices. You can also find this option in the Header via **Vertex > New Edge/Face from Vertices.**

C Selecting three vertices and pressing **F** will generate a triangle.

D Selecting four vertices or two disconnected edges will create a quad.

E Selecting more than four vertices will create an n-gon.

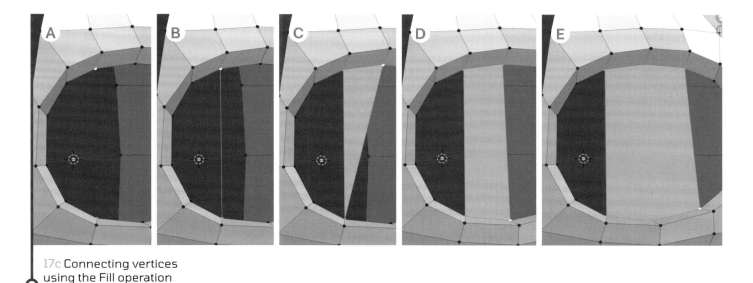

17c Connecting vertices using the Fill operation

Having to select multiple vertices to fill multiple faces can be tedious. This is where the **F2** add-on is very useful. Select two vertices or an edge, and place your cursor in the area you want to fill. Press **F** once and it will generate a face; press **F** again and it will create a face as soon as it can fill along a generated face loop (**image 17d**). It's a very powerful add-on, and you should always have it enabled.

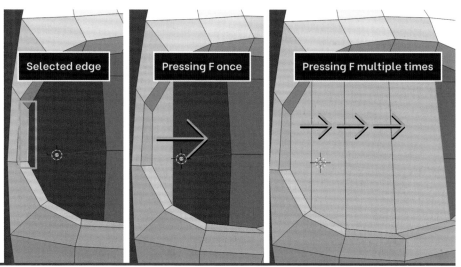

17d Connect multiple faces into a loop with the F2 add-on

You can also use the **Grid Fill** option. Press **Ctrl + Z** to undo the faces you have just created so you can try a different way of filling the hole. Select the edge loop that defines the eye socket and press **Ctrl + F** or go to **Face > Grid Fill** in the Header (image 17e). As with every tool, a contextual menu will appear in the bottom left corner where you can decide the number of horizontal versus vertical cuts (**Span**) and rotate the generated patch using the **Offset** value. The **Simple Blending** option will generate a simple grid of faces instead of an interpolated one (that is, **Simple Blending** will generate an orthographic grid with perpendicular faces rather than trying to create a smooth grid that blends with the surrounding loop; image 17f). Note that you need an even number of vertices on your closed loop to perform the grid fill.

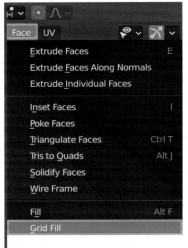

17e **Create a patch of faces with the Grid Fill operation**

17f The Grid Fill menu with the Simple Blending option enabled (left) and disabled (right)

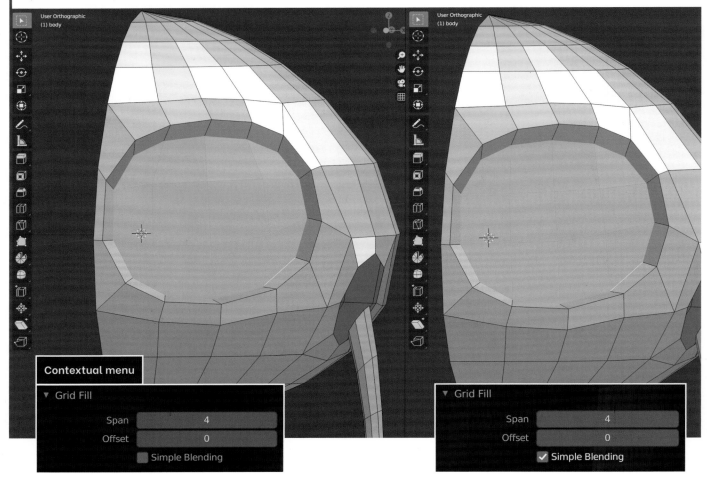

Bridge Edge Loops

First, make the arm socket appear more octagonal by selecting its vertices, right-clicking, and selecting **LoopTools > Circle** (image 18a). To connect the arm to the body, you can use another tool. Select the body loop and then the arm loop as shown in image 18b (**Alt + left-click** on one of the body loop edges and then **Shift + Alt + left-click** to select the arm loop as well). Go to the Header and select **Edge > Bridge Edge Loops**. The edge loops will be bridged as shown in image 18c.

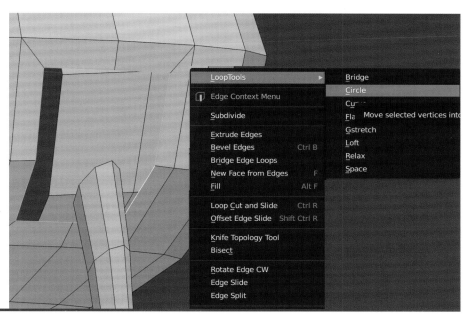

18a Use the LoopTools add-on to edit the arm socket loop

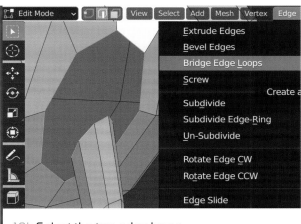

18b Select the two edge loops

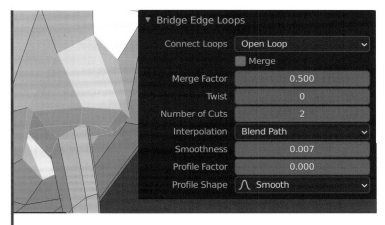

18c The effect after Bridge Edge Loops has been used

In the contextual menu in the bottom left of the 3D Viewport you can create additional loops to support the arm (important for animation) by increasing the **Number of Cuts**. You can also achieve better blending by switching to **Blend Surface** in the **Interpolation** option and increasing the number in the **Smoothness** field (image 18d).

18d Edit options in the Bridge Edge Loops contextual menu

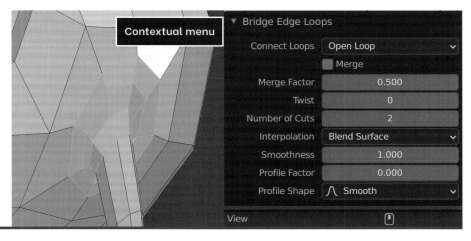

Repeat the process with the leg. Note that you will likely have 12 vertices on your leg socket loop, so you will need to reduce this to 8 to match the leg edge loop. To do this, you can use the Merge function and LoopTools; follow the steps shown in image 18e:

A Select two of the vertices as shown and press **M > At Last** to merge them.

B Select the two vertices on the other side as shown and again press **M > At Last** to merge them.

C On the wider part of the leg socket, merge the bottom three vertices with **M > At Center**.

D Select all the vertices on the socket loop and right-click to select **LoopTools > Circle**.

E The socket should now appear as shown.

F Move, scale, and rotate the generated circle to better fit the leg loop shape. Slightly move the surrounding vertices to get a smoother topology.

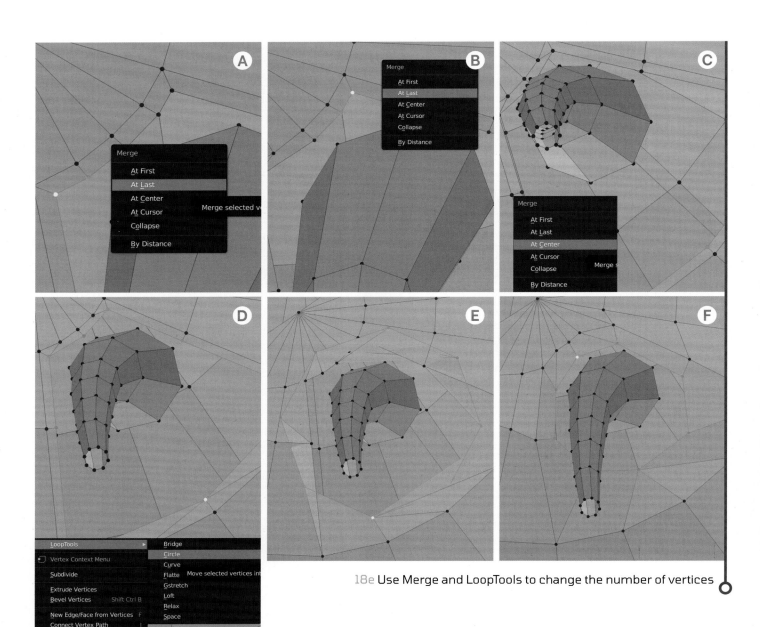

18e Use Merge and LoopTools to change the number of vertices

Edge Slide

You can adjust the position of edge loops without modifying the overall profile of the mesh by making them slide along their perpendicular edges using the Edge Slide tool. You can find the Edge Slide tool in the Toolbar (image 19a) or you can select a loop and press **G** twice.

A yellow path will appear showing you in which direction the edge loop is sliding (image 19b). If you have selected the tool from the Toolbar, hold the **LMB** and drag the yellow circle to slide the loop; if you have pressed **G** twice you can simply move the mouse. The loop will slide between the two edge loops it is bound to.

Holding **Alt** will allow you to slide beyond the binding loops (image 19c). As usual, left-click or press enter to confirm; right-click to cancel.

Using this technique, you can adjust the loops connecting the legs and body and achieve a smoother transition (image 19d).

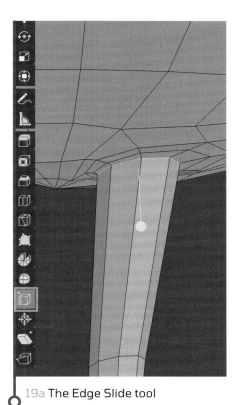

19a The Edge Slide tool

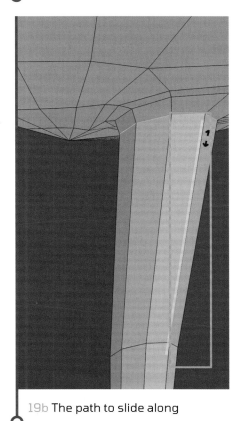

19b The path to slide along

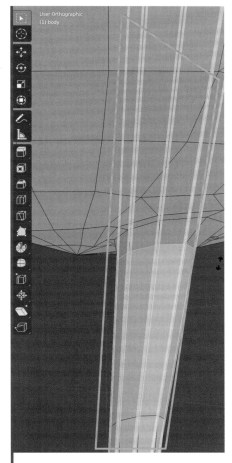

19c Holding Alt reveals an extended path to slide along

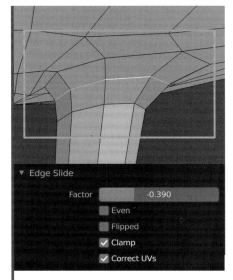

19d The relaxed connection between the body and the leg

Bevel tool

The Bevel tool allows you to create supporting, sloping edges around selected edges. Using it on a single edge is not necessarily the most useful operation, but using it on multiple edges at once or on an edge loop can be a big time saver. It is very useful in hard-surface modeling for creating clean bevels on a model, keeping its overall shape, and improving its edges.

To make the effect of the tool more obvious, try it on a default cube. In **Object Mode**, right-click on the cube and switch to **Shade Smooth** (image 20a). The cube doesn't looks very good at all now, as Blender is trying to blend the shadows and light effects from one face to another, and the cube is way too low-poly and hard-edged to display proper shading this way (image 20b).

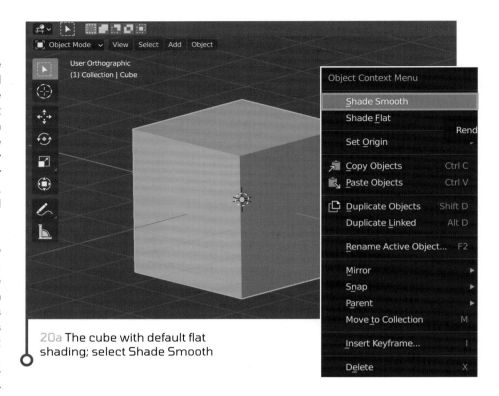

20a The cube with default flat shading; select Shade Smooth

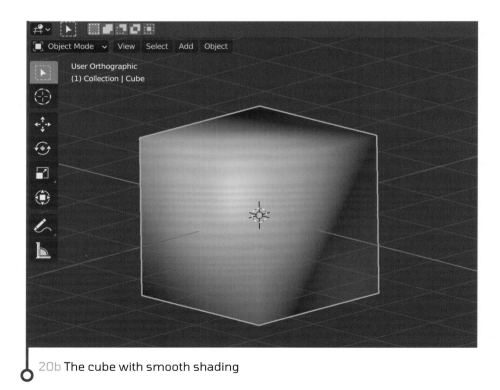

20b The cube with smooth shading

In **Edit Mode**, select all the edges of the cube, then select the Bevel tool in the Toolbar or use the **Ctrl + B** shortcut. Drag and you will see the edges getting separated into two sets of edges (image 20c). As usual a contextual menu allows you to change the tool behavior (image 20d). You can increase the number of cuts to increase the cube's geometry and change the **Shape** option to 1 to achieve a harder profile for the edges. A 0.5 value will make rounded edges, or a rounded bevel profile (image 20e). A 0 value will push the outer edges inward, creating concave edges.

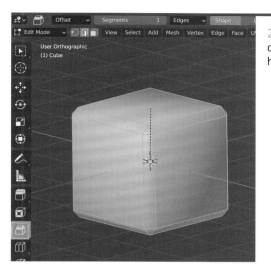

20c Perform a bevel operation to improve hard-edge shading

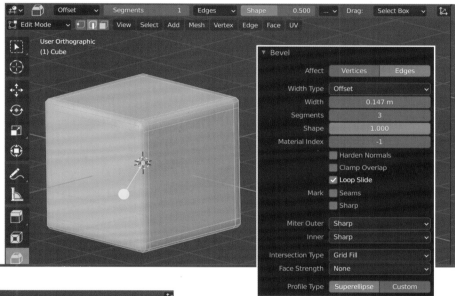

20d Adjust some of the settings in the Bevel contextual menu

20e The cube with better geometry and improved shading

You can use the Bevel tool on the character, as it can be very useful on organic models too. In **Object Mode**, select the character and switch to **Shade Smooth** (image 20f). Back in **Edit Mode**, select the eye socket edge loop and proceed with a bevel with only one cut, as shown in **image 20g**.

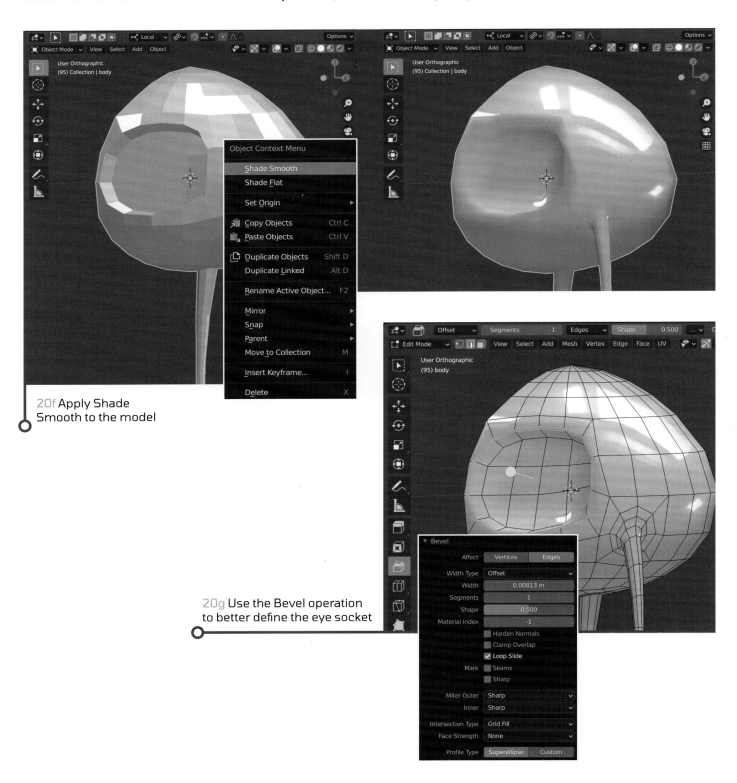

20f **Apply Shade Smooth** to the model

20g **Use the Bevel operation** to better define the eye socket

Let's create the teeth. In **Object Mode**, press **Shift + S** to set the cursor to the world origin, and add a new plane using **Shift + A**. In **Edit Mode**, select two consecutive vertices as shown in image 20h and press **M** to **Merge At Center**. You can also find this operation in the Header by going to **Mesh > Merge**.

20h Add a new plane object to create a tooth for the character

The two selected corners of the plane will be merged together, creating a triangle. Use the Move tool to shift the triangle away from the rest of the character, so you can work on it more easily.

Select all the vertices of the remaining triangle and extrude them by pressing the **E** key or selecting the Extrude tool from the Toolbar (image 20i).

20i Extrude to create a 3D tooth

Select all the vertices and proceed with a Bevel operation as shown in image 20j. Select all vertices and scale down until you get something closer to the teeth in the reference image (image 20k). Finally, in **Object Mode**, go to the Header and select **Object > Set Origin > Origin to Geometry** to center the origin around the rounded triangle shape (image 20l). This will make further manipulation more intuitive. You can leave the tooth where it is for now, as we will revisit this on page 118.

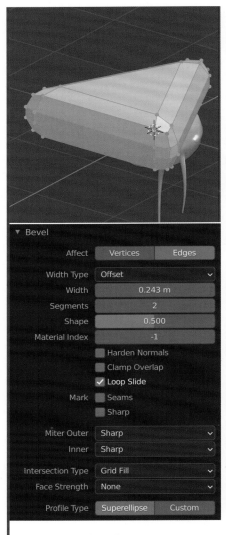

20j Use the Bevel operation to shape the tooth

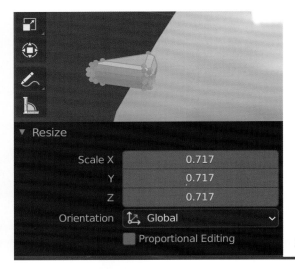

20k Scale the object down

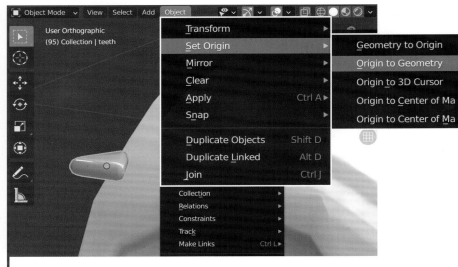

20l Reset the origin

Working with multiple objects

Selecting & hiding

Before we start manipulating different objects, let's create a couple more. Display the background image again if you had previously hidden it. In **Object Mode**, press **Shift + A** and add a circle with 8 vertices at the world origin. A size of 0.03m should be enough.

Using the Move tool, move the circle on the Z axis so that it is aligned with the top of the character's head (make sure Proportional Editing is deactivated). Then, in **Edit Mode**, using Extrude, Scale, Rotation, and Move, extrude three new edge loops following the most distinctive parts

of the character's main antenna: the thinner part, the bigger part, and the tip (**image 21a**).

21a **Create the main antenna from a circle**

ADDING IN OBJECT MODE

Make sure you double check the context in which you add a new object. If you add a circle, for example, in **Edit Mode**, it will just add a circle mesh to the current edited object. If you add a circle in **Object Mode**, you create a new object containing a circle mesh. This will ensure that objects you add are created as separate objects

From there, select one of the inner loops, and proceed with a bevel, using the Bevel tool or **Ctrl + B** shortcut. With 4 segments, a smooth 0.5m shape, and large 0.2m width you can create additional edge loops that will fit the curvature of the model in just a few clicks (image 21b). If your bevel becomes buggy or behaves unexpectedly, select all the vertices of your mesh and press **Shift + N** to recalculate the normal. Use **Shift + R** to repeat the bevel on the second inner loop.

Proceed with a grid fill on the tip of the antenna (**Ctrl + F > Grid Fill**) with a span of 2 and move the middle vertex to fit the background image (image 21c). Repeat the process for the thin antennas. You can set them to **Shade Smooth**.

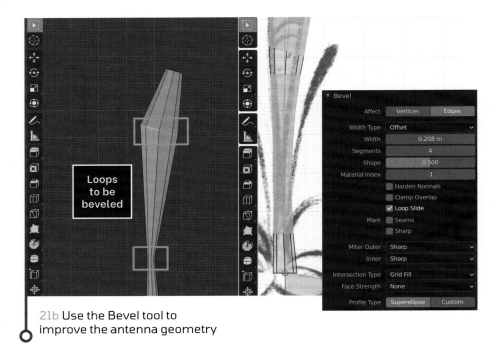

21b Use the Bevel tool to improve the antenna geometry

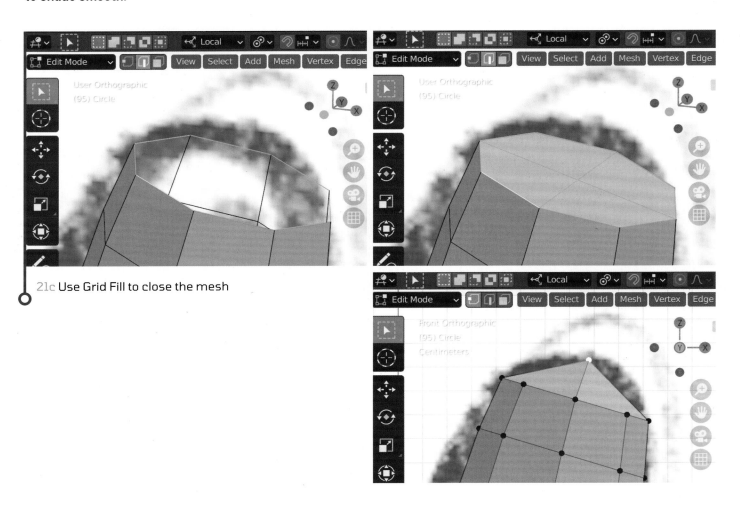

21c Use Grid Fill to close the mesh

"Working with multiple objects"

Press **Numpad 1** so you are in Front view, set the cursor to world origin, and, in **Object Mode**, add a new circle with 8 vertices and a 0.05m radius. Set the **Align** option to **View** in the contextual menu so that the circle faces the Front view (image 21d). This circle will be used for the skin dots on the creature's surface.

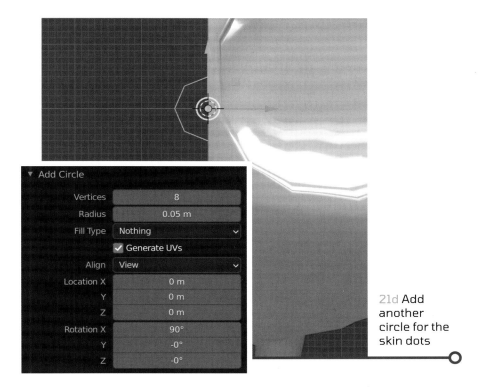

21d Add another circle for the skin dots

HIDING OBJECTS

You can hide a selected object by pressing the **H** key or going to **Object > Show/Hide > Hide Selected** in the Header in Object mode. Press **Alt + H** to unhide every hidden object at once. You can press **Shift + H** to hide everything but the selected objects. You can also check/uncheck the eye icon in the Outliner to hide/unhide any object. Note that if you unhide a selected object, it will no longer be selected so you will need to unhide it by toggling the eye icon in the Outliner.

With the latest circle selected press **Shift + H** to hide everything except the circle. In **Edit Mode**, select all vertices, press **Ctrl + F**, and use the **Grid Fill** option. With all faces selected, press the letter **I** to inset the faces and create an outer face loop (image 21e).

Return to **Object Mode**, then press **Alt + H** to unhide everything. It is a good time to rename every object properly using the **F2** shortcut or using the Outliner.

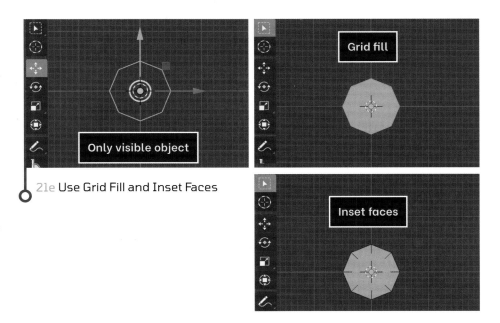

21e Use Grid Fill and Inset Faces

Object selection works in a similar way to mesh selection:

▷ Pressing the **A** key will select all objects.

▷ Pressing **A** twice or **Alt + A** will unselect everything.

▷ **Left-click and drag** to select an object.

▷ **Left-click and drag** on the background to unselect.

▷ **Shift + left-click** to add or remove more objects to or from the selection.

The selection tools (such as Select Box and Select Lasso) work exactly as in **Edit Mode** (image 21f).

ACTIVE VERSUS SELECTED OBJECTS

Since one object can be used to influence another (for example by transferring its properties, modifiers, or material to the other, or becoming a pivot point or a parent), Blender needs to identify this "active" object from other selected objects. Note that it's the same for vertices, edges, and faces. If you select only one object, it will be the active object; if you select more than one, only one of them can be the active object.

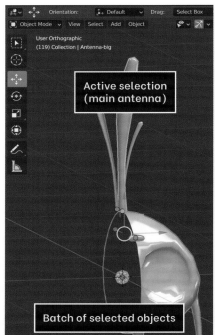

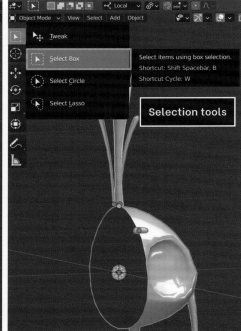

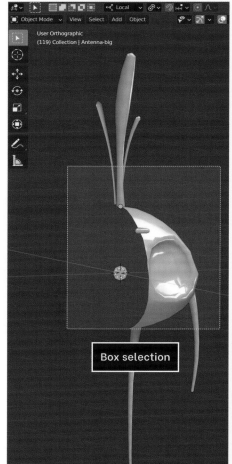

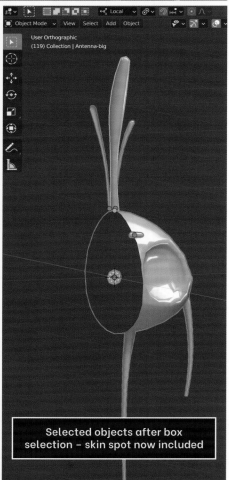

21f Selecting objects in the 3D Viewport

In **Object Mode**, you can also use the Outliner to select objects (image 21g):

You can also box select in the Outliner by left-clicking and dragging, or pressing the **B** key and left-clicking and dragging. If no object was active, all the objects selected will be tagged as selected. This would mean you wouldn't be able to use a specific object as a pivot point or to source data; you would need to **Shift + left-click** one of them to make it active.

21g **Selecting objects in the Outliner**

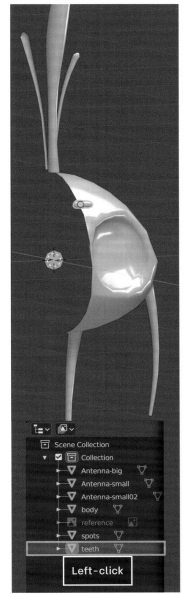

Left-click

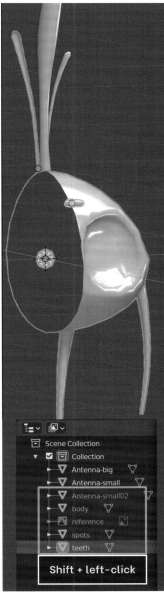

Shift + left-click

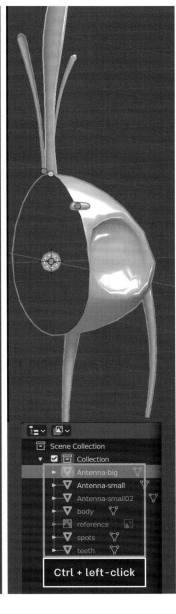

Ctrl + left-click

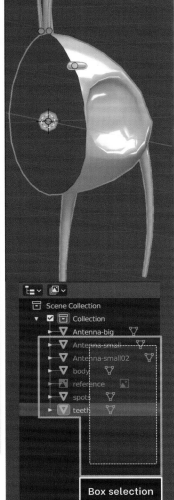

Box selection

▷ **Left-click** to select one object.

▷ **Shift + left-click** another object to select it and all the intermediate objects in the list (note that the first selected object is still the active object).

▷ **Ctrl + left-click** to add any other object from the Outliner to your selection. Note that the latest object added will be the active object.

▷ **Ctrl + left-click** again to unselect

Duplicating

Duplicating objects is a fundamental operation, as it will save you a lot of time. As with most software, you can copy and paste an object using **Ctrl + C** and **Ctrl + V** or by going into the **Object** menu in the Header. Any selected object will be duplicated on top of the existing object. Note that Blender will automatically add an incremental .001 to its name as the software can't manage different data with the same name (image 22a).

You can also duplicate an object using **Shift + D** or by going to **Object > Duplicate** in the menu. Note that as you execute the operation, you will be able to move the object straight away without any additional operation required; the duplicate operation acts as a duplicate and move (image 22b). Left-click to confirm position or right-click to keep the object in place.

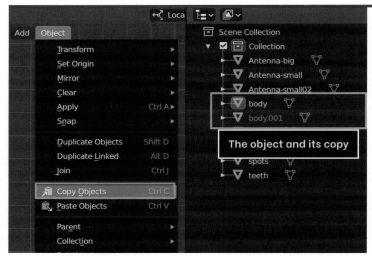

22a You can use copy and paste as with most other software

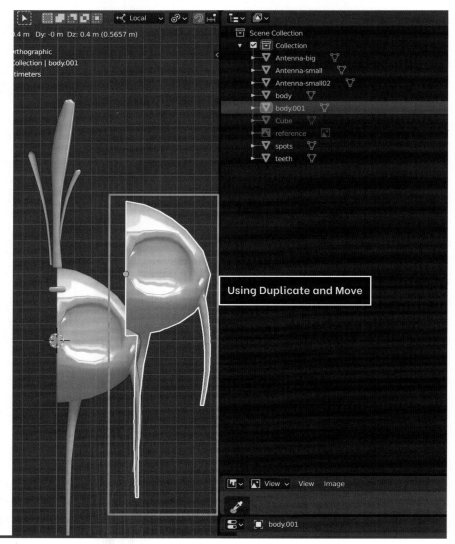

22b You can also duplicate and move an object with Ctrl + D

Another useful operation is to use **Alt + D** or go to **Object > Duplicate Linked**. Blender will create a new object that has linked data with the other object (image 22c). This means that as soon as you edit one of the objects it will edit the other object at the same time, as they share the same mesh data. This is very useful if you have multiple instances of the same object and you need to modify them.

Before you move onto the next step, delete your duplicate body as this was just for demonstration purposes.

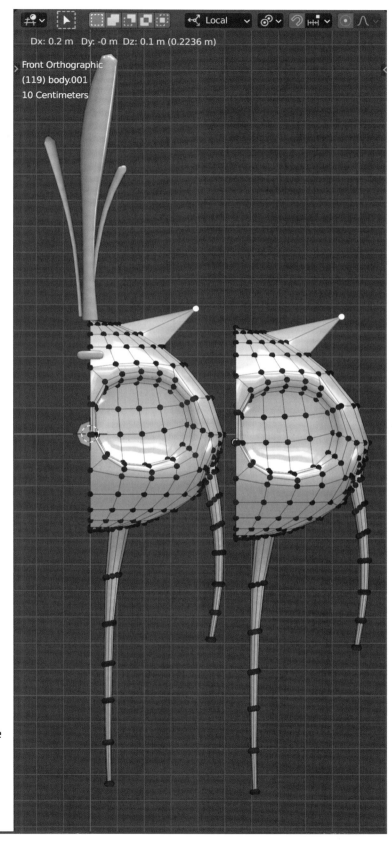

22c A mesh and its linked duplicate on the right. When you enter Edit Mode on one of these two objects, you can see that the other object is also displayed as if we were in Edit Mode. As soon as you edit one, the other updates in real time

Create a couple of additional objects for the character by following the instructions as shown in image 22d:

A In **Object Mode**, add a cube.

B Then go into **Edit Mode**, select all vertices, and use the **Bevel** operation with 2 segments, a width of 0.75m, and a 0.5m shape.

C Scale on the Z axis to flatten the shape into the ellipsoid shown, and reduce its scale to roughly the size of the fluffy hair roots shown in the reference image.

D Then, using the Proportional Editing tool if it helps, move the back face on the Y axis.

E Move the top face on the Z axis to give it a drop shape.

This object can then be duplicated and used as hair roots.

22d Modeling the hair root

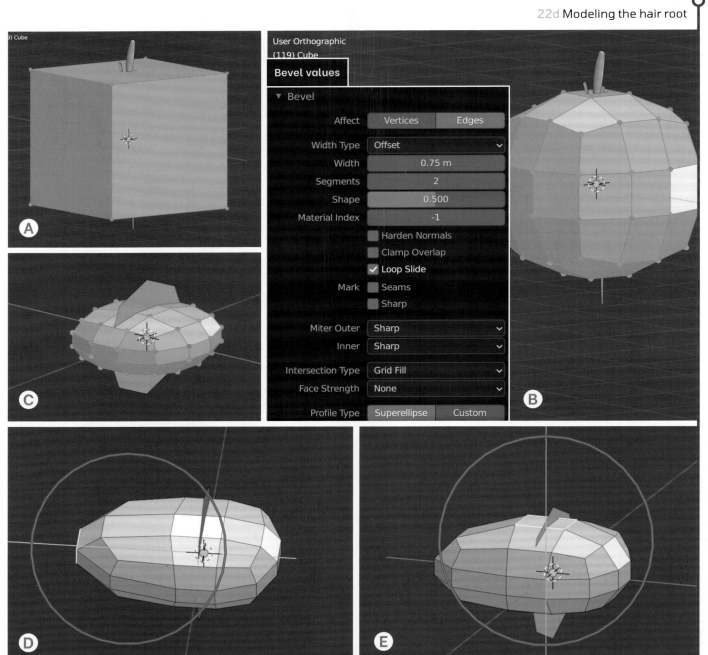

Snapping

You can use the Snap tool to help you manipulate the object. It will snap the object origin or part of its mesh to the selected target following the selected behavior in the **Snap** menu. You can activate the Snap tool in the Header by clicking the magnet icon. Holding the **Ctrl** key while moving an object will enable the Snap tool if it is deactivated and will disable it if it is activated.

If you open the **Snap** menu by clicking on the button to the right of the magnet icon you will see the different snap behaviors available. By default the Snap tool will affect the object only when using a move operation, but you can enable it to be activated during rotation and/ or scale operation by selecting the relevant option in the **Snap** menu.

The **Increment** option will snap the object origin to the background grid based on its size. It can be useful if you are working on a technical design.

To try the Snap tool, select the body object of the character in **Object Mode**, turn on the Snap tool by clicking the magnet icon in the Header, and select **Increment** from the **Snap** dropdown menu. If you now press **G** to move the object, you will notice it moves in steps along the background grid (**image 23a**).

23a **The Snap menu and the Incremental Snap tool**

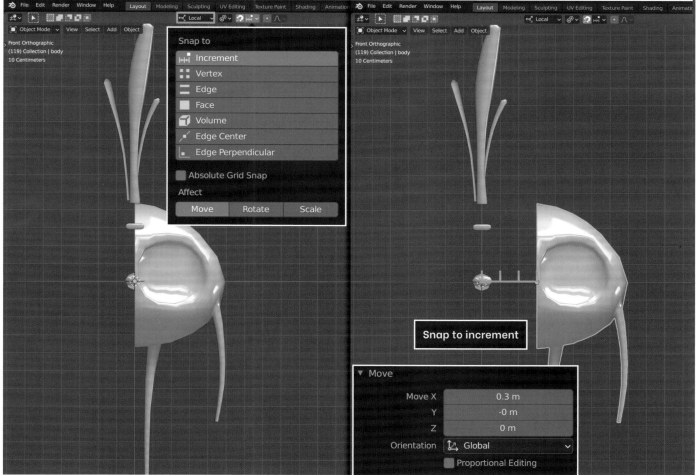

You can also choose whether to snap to the face, vertex, edge, volume, or even the middle of the targeted edge of other objects. When using the Snap tool, a yellowish circle will appear around the target your object is currently snapping to (**image 23b**). You can choose whether you snap to the **Closest**, **Center**, **Median**, or **Active** snapping target.

Another useful option is the **Align Rotation to Target** option. It will align the manipulated object orientation with the normal of the targeted surface (**image 23c**). This will be very useful for placing the dots on the creature's skin (page 110) or if you were placing bolts on a curved metal pipe or airplane model, for example.

Explore the Snap tool in action more on page 110.

23b Snapping to the center vertex

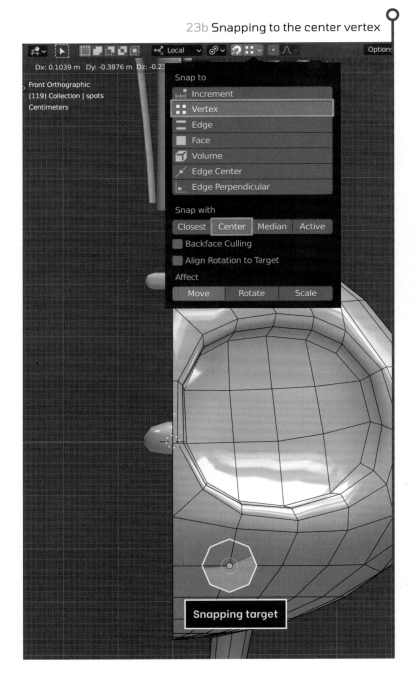

23c Aligning to the target surface

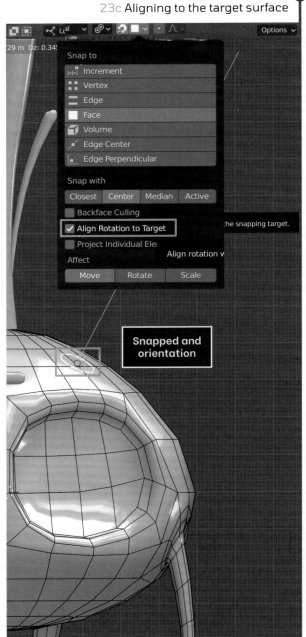

Now let's add the creature's eyeball. In Front view (press **Numpad 1**), add a UV sphere to the scene in **Object Mode** with 24 segments, 12 rings, a radius of 0.2m, and choose the **Align > View** option (image 23d). Press **Shift + H** to hide everything except the sphere, and in the Outliner, unhide the reference image. Press **Alt + Z** to activate X-Ray and roughly align the center of the sphere with the iris of the character (image 23e).

Follow the instructions as shown in image 23f to shape the iris of the eye:

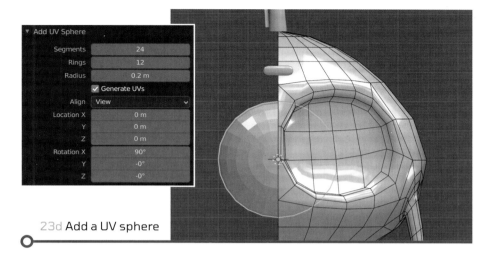

23d **Add a UV sphere**

A Go into **Edit Mode** by pressing the **Tab** key, select the middle vertex, and push it backward on the Y axis.

B Press **Ctrl + Numpad +** to select the next ring of vertices and move backward on the Y axis again.

C Deselect those two loops and then select the next edge loop and use the Bevel tool (**Ctrl + B**) as shown.

In **Object Mode**, right-click on the eye and set it to **Shade Smooth**, then manually position it in the eye socket. You will adjust the geometry later on so that it matches.

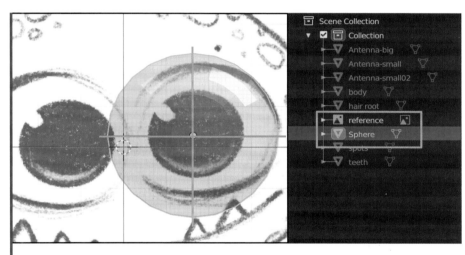

23e **Positioning the eye**

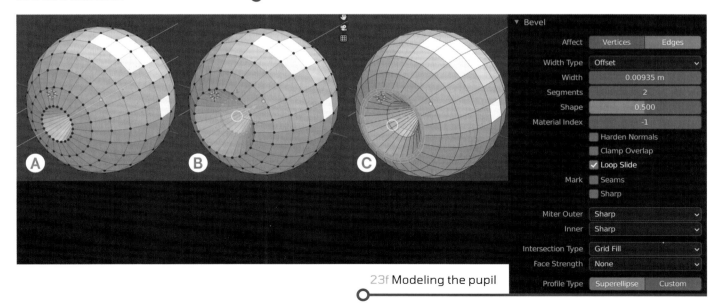

23f **Modeling the pupil**

Joining

It can be easier to model different parts of a model separately and join them later on. You can for example model the hands of a character separately and then join them to the body.

Quickly model a couple of fingers for the character by following the instructions demonstrated in image 24a:

A First add a circle with 8 vertices at the world origin.

B In Front view, move and align the object with the reference image.

C In a side view, move it so that it is under the arm of the character.

D Go back to Front view and, as you did for the antenna, extrude the circle three times following the most distinctive parts of the finger of the character.

E Then use the Bevel tool to soften the shape and use **Grid Fill** to close the tip of the finger. You can use the Edge Slide tool (press **G** twice) to evenly adjust the edge loops' position.

F Repeat the process to create the thumb.

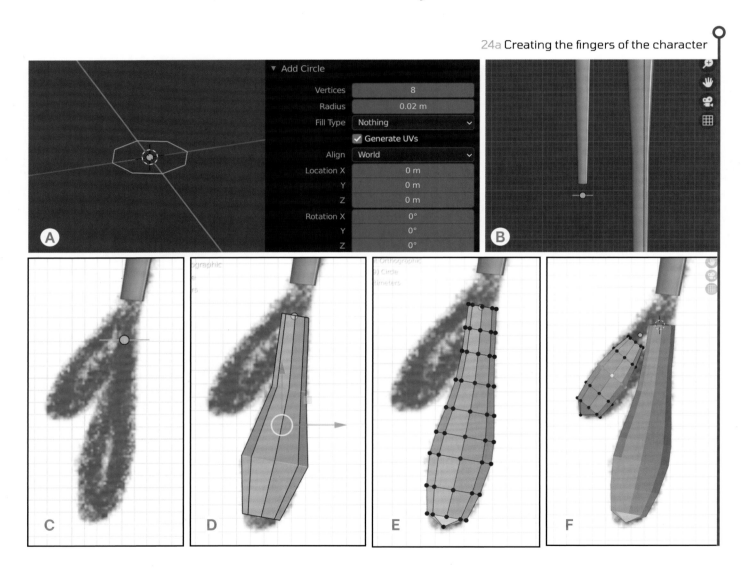

24a **Creating the fingers of the character**

To join one or multiple objects to another, first select the objects to be joined in the 3D Viewport in **Object Mode** (in this case, you will be joining the fingers to the body) and make sure that the object you want to join *to* is **active** (the body). You can do this by selecting it last or **Shift + left clicking** until it turns active; note that the active object should be outlined in yellow not orange (image 24b). Press **Ctrl + J** to join the objects together or go to the Header and select **Object > Join**.

You can also do this by selecting the objects in the Outliner rather than the 3D Viewport – the only difference is that you may need to use **Ctrl + left-click** to select multiple objects that aren't next to each other in the Outliner, and manually click **Object > Join**.

Now both finger objects will have disappeared from the Outliner and have been added to the body mesh object (image 24c). If you go into **Edit Mode** on the body, you can now see that the fingers are part of it (image 24d).

Repeat the process for the foot, moving the circle into an appropriate position (image 24e). Make the inner toe a little bigger and the outer toe a little smaller. You should also flatten their lower surface as if they are squashed on the ground.

24b Select the objects to be joined, ensuring that the body is the active selection

24c Note how only the body, and not the two finger objects, is now visible in the Outliner

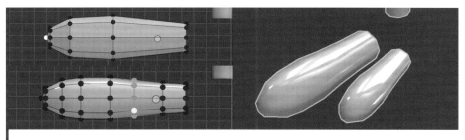

24e Make the toes in the same way as the fingers and then join them to the body

24d The body and fingers as one object in Edit Mode

Organizing

Organization is a key component of 3D production, as it is for any kind of production. The fact that you are working on a three-dimensional project can bring a lot of complexity, so properly naming each object and organizing them is crucial. And here we're not even talking about the fact that time can also be a fourth dimension to deal with when it comes to animation.

You saw how to create collections and move objects in these collections on pages 22–23. If you are working on a complex scene or even just a complex character, it absolutely makes sense to create a separate collection for the clothes or props. Similarly, if you were working on an anatomical model of a head, separating the bones, teeth, and fleshy components into different collections can help.

From a character point of view, just use the collections as subparts of the character to help you hide, select, or isolate them (image 25).

If you are working on a larger-scale scene, it can be good to organize according to depth (such as foreground and background) and object type, for example characters, lights, and assets.

25 An example of different collections that could be used for the character you are creating

Parenting

The parent–child relationship is very common in computer graphics and in software development. Basically, when an object is the child of another, it will follow any of the parent object's transformation. For example if you want to animate a car with a driver, you can parent the driver to the car and make it move, and the driver will follow the car movement as expected.

An object can have only one parent but can have as many children as needed. You can parent a parent to a parent and so on to create parenting hierarchy.

In character production, it can be useful to parent parts of the body or equipment to the main body, so that when you transform the body, the different children items will follow the body.

26a The selected antennas, eye, and active body

To parent an object to another, select the object(s) you want to become the children and make the parent object active. In the case of the forest creature, select the antennae and eye, and make the body the active selection (**image 26a**). In the Header in **Object Mode**, go to **Object > Parent > Object**, or press **Ctrl + P** and choose **Object** or **Object (Keep Transform)** so that children objects will stay where they are in the scene.

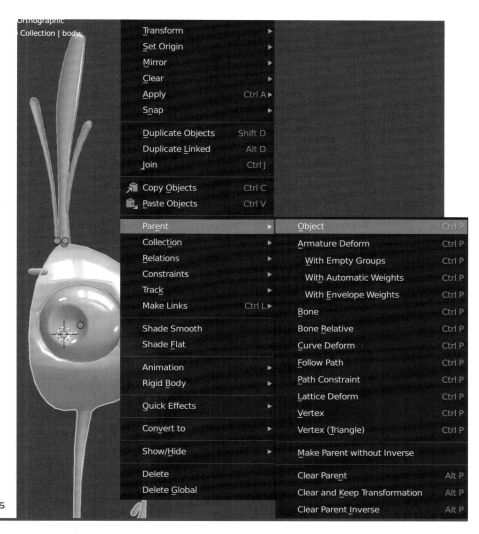

26a Parent the body to the selected objects

You will notice that in the Outliner, the antenna objects are stacked under the body object.

In the 3D Viewport you can see dotted lines from the origins of the antennas to the origin of the body, showing the relationship (**image 26b**). If you now rotate, move, or scale the body, the antennas will follow.

26b Note that the parenting is shown in the Outliner and the dotted lines in the 3D Viewport

Modifiers

Modifiers are among the tools that really distinguish Blender from other 3D software. They allow you to deform your object, generate more geometry, duplicate, distort, mirror, soften, and much more, without editing the data of the object, meaning that you are not altering the mesh (**image 27a**). This is what is called a non-destructive workflow. While the 3D result in **Object Mode** will change, whenever you enter **Edit Mode** you will see that your original object's mesh has not changed. It is a bit like combing hair: you change your hair design but the hairs' original length and position are not modified.

Modifiers can be found in the Properties Editor under the **Modifier Properties** tab. To add a modifier to an object, simply select the object and then click **Add Modifier** in the **Modifier Properties** tab. You will then be shown a menu from which you can select which modifier to add (**image 27b**). You can add multiple modifiers to a single object, combining their different functions to create a complex model without even using modeling tools.

Modifiers are classified into four families:

▶ **Modify:** Edit mesh data such as vertex groups and UVs.

▶ **Generate:** Generate more geometry (vertices, edges, faces) from a given object.

▶ **Deform:** Bend, twist, and displace existing geometry.

▶ **Physics:** Make a mesh behave as if it is a piece of cloth, generate smoke, generate fluids, or even explode!

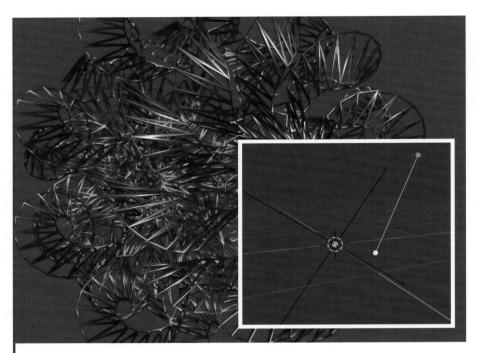

27a An abstract model generated from a single edge and a combination of modifiers

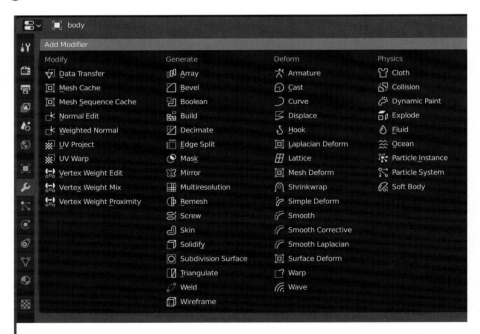

27b The list of modifiers available in the Modifier Properties section of the Properties Editor. Note that the Properties Editor has been widened in this example for display purposes

You can choose whether to show the modifier effect in the 3D Viewport or not, make it affect the render, or show in **Edit Mode** by toggling the different display icons next to the modifier's name once you have added it (image 27c).

You can apply a modifier to transform the procedural into mesh geometry as if you have modeled it by hand.

PROCEDURAL

When we discuss something being "procedural," we mean that it has been processed on top of the original object mesh without editing its data. The output is modified and the number of polygons generated has increased, but the mesh data is the same. If you enter **Edit Mode** you will see that the original mesh has not changed.

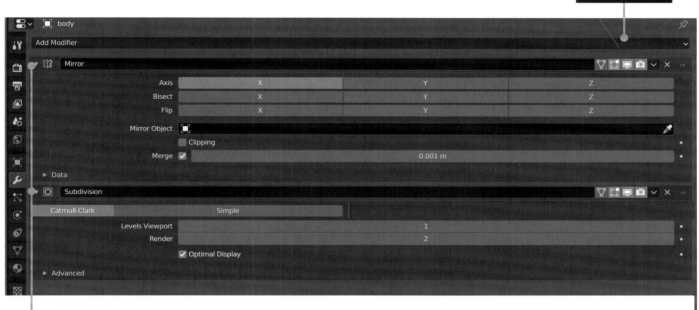

Display options

Added modifiers in the modifier stack

27c Added modifiers shown in the Modifier Properties panel

AVOID UNEVEN SCALING & ROTATION

A very important thing to remember is that most modifiers use the origin of the object and are influenced by the object's transformation (rotation and scale). Unexpected modifier behavior is generally due to uneven scale or rotation.

If you manipulate objects in **Object Mode** to position them and, for example, rotate them (like the fingers) or change their size in **Object Mode**, and decide you need to make them a bit shorter and resize them on their Y axis, you may get a scale value of x0.5 y0.2 z0.5. In this case, you would have uneven scaling, as the three axes do not have the same scale value.

Whenever you scale a 3D object and want to make the new scale its default scale, use the **Apply All** function. Press **CTRL + A** in **Object Mode** and choose what you want to set as default: location, rotation, and/or scale.

Mirror

The Mirror modifier allows you to symmetrize an object around its origin (by default) on a given axis. Select the character's body mesh and add a Mirror modifier (found in the **Generate** family in the **Add Modifier** menu). This will generate the second half of the character, mirroring it along its origin on the X axis (image 28a).

MIRROR ALIGNMENT

If you find that your mirrored half isn't aligned correctly, you may have an unapplied transformation – similar to what was described on the previous page. Simply hitting **Ctrl + A** and **Apply All** should help.

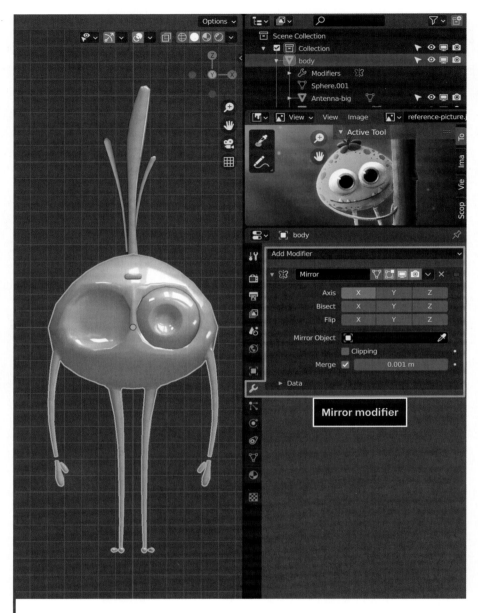

28a The Mirror modifier and the mirrored mesh

You can mirror the object on the Z or Y axis too, or even on multiple axes at once, by selecting the X, Y, and Z buttons in the Axis section (image 28b).

If you edit the character, you will see the other side of the mesh updating in real time (image 28c). Enable the **Clipping** option in the modifier so that the vertices aligned with the origin will stick to an imaginary plane aligned with the origin (image 28d): imagine that you are enabling a wall between the original and the mirrored part of your mesh; whenever you try to cross this mirror border with any vertex, the vertex will become stuck on this wall. If you release your selection, you won't be able to move this vertex from this imaginary wall; it will stay stuck to it. This is useful because if the vertices go beyond this line, they won't be merged or welded together in the middle and you will have a non-closed mesh. The **Merge** distance is a threshold used to snap the vertices on the mirror axis.

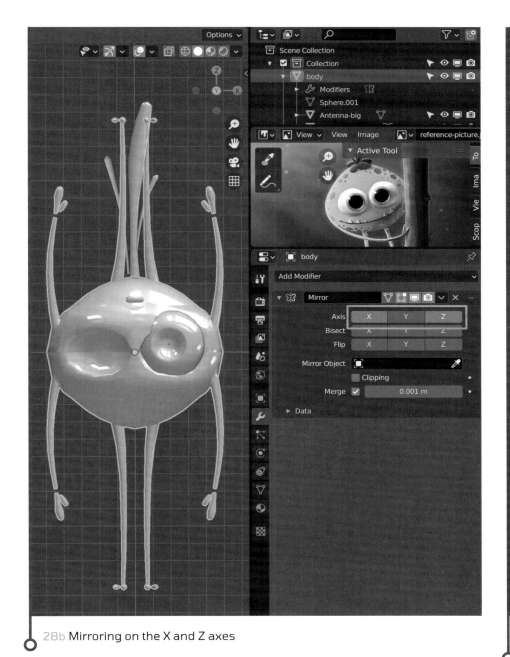

28b Mirroring on the X and Z axes

28c The edited mesh and its mirrored geometry

Select the character's eye and add the **Mirror** modifier to this as well. You will notice that nothing seems to happen, and this is because you are mirroring a sphere based on its center (its origin point), so the geometry has been generated but it is currently on top of the existing geometry. You therefore need to move the origin of the eye to the middle of the character to mirror the eye on the other side.

CLIPPING

Clipping means intersecting. In 3D we talk about clipping for any intersecting information. Regarding two mesh objects, we say they are "contacting" when both their surfaces are tangent, and "intersecting" or "clipping" when they get too close and interpenetrate.

However, that would mean that you will not be able to rotate the eye around its orbit, since an object rotates around its origin. What you can do instead is set the body object as the **Mirror Object**. This way, Blender will use the origin of the body to perform the mirror of the eye, but the eye's origin will still be its own center. To do this, click on the **Mirror Object** field to select the body from the list, or use the dropper tool on the right of this to select the body in the 3D Viewport (**image 28e**).

The **Bisect** option erases the original geometry along the mirror axis to avoid clipping geometry, essentially generating a mesh object that is the fusion of the original object and the mirrored object. By default, it erases the parts of the mesh that are intersecting. Using the **Flip** option will allow you to switch the side of the symmetry to be erased – it will

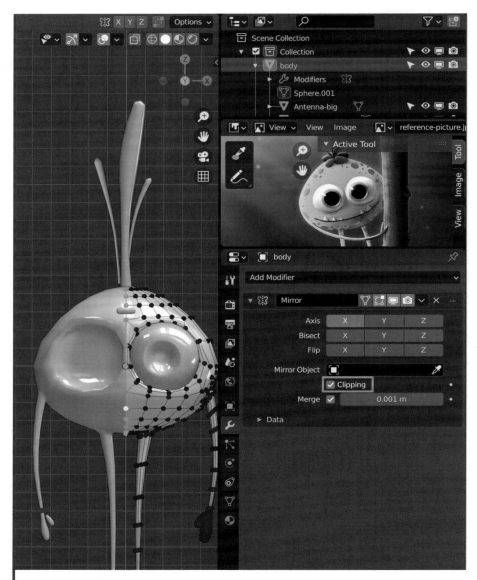

28d **Enable Clipping**

28e **The eye mirrored using the body as the Mirror Object**

merge the parts of the mesh that are intersecting rather than erasing them. This is great for creating new geometry from primitives, for example.

You can test this out by adding a UV sphere in **Object Mode** and adding a **Mirror** modifier to it. Go into **Edit Mode** and move the sphere slightly so it overlaps with the mirrored object (image 28f). To observe the effects of **Bisect** and **Flip**, turn on **Wireframe** mode in the **Viewport Shading** options. If you toggle the **X** axis option for **Bisect** in the **Mirror** modifier, you will see that the intersecting parts of the mesh are erased. If you toggle the **X** axis option for **Flip** in the **Mirror** modifier, you will see that the intersecting areas of mesh are retained and the areas outside this removed.

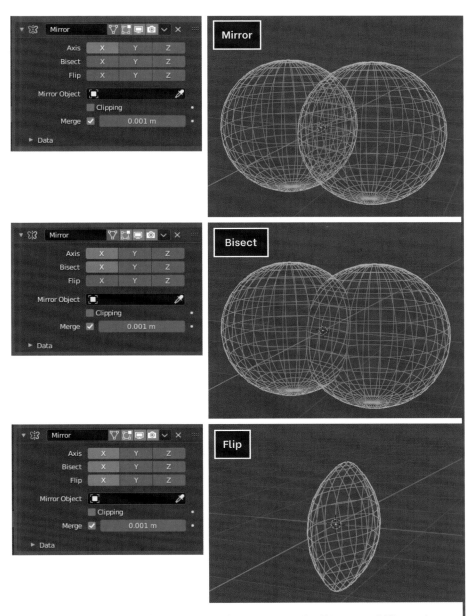

28f A UV sphere used to demonstrate the Bisect and Flip options

Subdivision Surface

The Subdivision Surface modifier is probably the most used modifier in Blender. It allows you to increase the resolution of the mesh procedurally, increasing its polycount by dividing each face into four faces. It is used intensively in feature films as it allows you to achieve a high-resolution model to be rendered,

from a lower resolution one that can be animated with more ease, for example. This technique is slowly making its way in the games industry too, with hardware acquiring more computation power.

In the modifier settings, the **Simple** option just divides the mesh as you

would expect; the **Catmull-Clark** option subdivides the face and then interpolates the subdivided geometry to achieve a smoother transition (image 29a). This is the most frequently used method as it allows you to achieve soft surfaces, ideal for vehicles or character modeling.

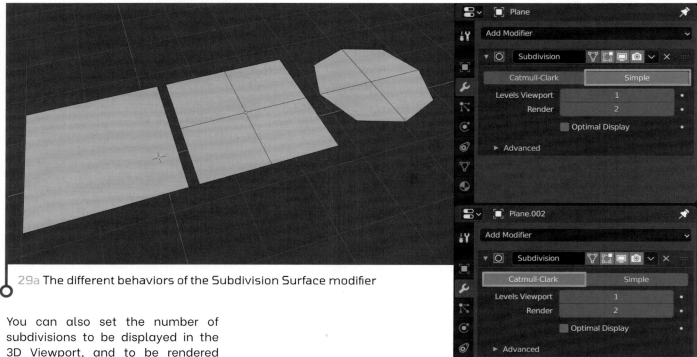

29a The different behaviors of the Subdivision Surface modifier

You can also set the number of subdivisions to be displayed in the 3D Viewport, and to be rendered (image 29b). This way you can keep your 3D Viewport smooth, using fewer subdivisions, and still get very high-poly render using a higher level in the **Render** field.

29b You can change the number of subdivisions to be displayed in the 3D Viewport, and the number to be rendered

SUBDIVISIONS

A subdivison is the operation of dividing a mesh component without separating it. You can't divide a vertex, but a subdivded edge will become a 3-point edge, and a subdivided face will become 4 faces. It allows you to increase the resolution of the mesh.

The **Advanced** tab allows you to fine-tune the modifier behavior on UVs, but you can keep this as it is in this case.

29c The character before and after the Subdivision Surface modifier has been applied to give smoother geometry

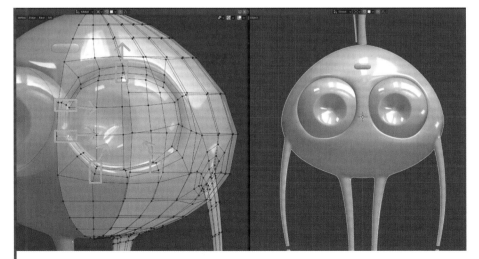

Add a Subdivision Surface modifier to the body of the character with **Catmull-Cark** selected and both **Levels Viewport** and **Render** set to 2. Do the same for the eyes, antennae, and skin dot (image 29c).

Edit the eye socket of the character to better wrap the eye ball as shown in image 29d. Make sure that you move the groups of three vertices together (those highlighted in image 29d) to keep the overall shape consistent.

29d Adjust the eye socket of the character

Shrinkwrap

The Shrinkwrap modifier is not the easiest modifier to use but, like all of them, it is very powerful. It allows you to project a given object's geometry onto another object. It is very useful when retopologizing a character, which you will learn more about on pages 148–151 and 228–249.

Imagine that you want to create a superhero costume and you want it to stick to the skin of a character.

It will be easier to use this modifier than trying to manually match the clothing's geometry to the body.

In **Object Mode**, select the dot object and snap it onto the head of the character using the Snap tool: activate the Snap tool by clicking the magnet icon in the Header; in the **Snap** menu, select **Face** and **Align Rotation to Target** (image 30a) and then use **G** to move the dot into place.

30a Position the dot object on the character's head using the Snap tool

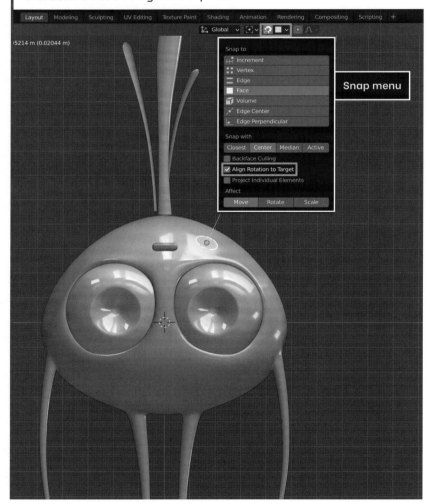

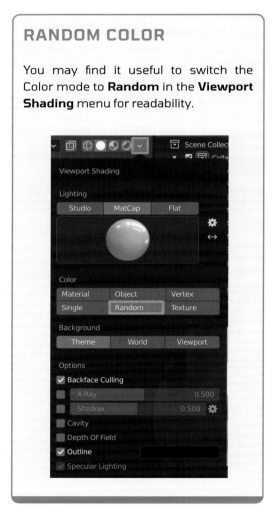

RANDOM COLOR

You may find it useful to switch the Color mode to **Random** in the **Viewport Shading** menu for readability.

Add the **Shrinkwrap** modifier. Nothing will happen and the modifier will be highlighted in red until you define a target on which it will be projected. Use the body as the target (image 30b). Once the target is defined, the vertices of the modified mesh will be projected onto the surface of the target: the flat, circular dot shape will be projected and will likely acquire a concave shape in order to stick onto the surface of the character. Imagine the dots as stickers – they are flat, but if you stick them onto your forehead, they will inherit the shape of your skull.

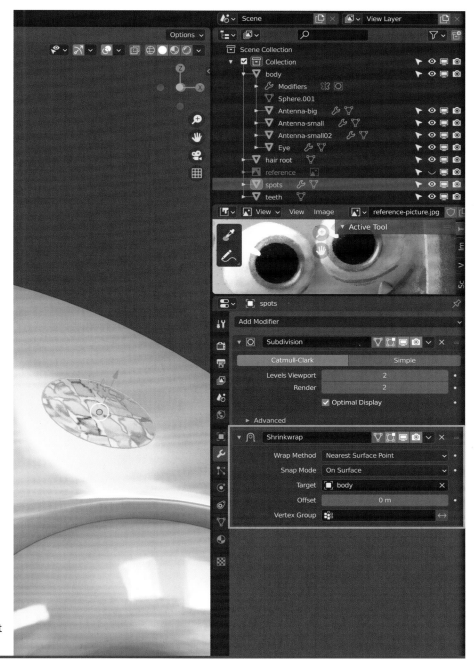

30b Use the Shrinkwrap modifier to project the dot object onto the head of the character

Within the Shrinkwrap modifier you can choose the projection or wrap method (see the **Wrap Method** field). **Nearest Surface Point** will make any vertices from the modified object search for the nearest point on the target surface. This is good in most situations but can be buggy on complex surfaces. **Nearest Vertex** behaves the same but snaps onto the target's nearest vertex. It can drastically modify the object's shape. The **Project** method is the one that is most frequently used, as it uses the modified object's local axis and projects it straight onto the target object, making its behavior more obvious.

The **Negative** and **Positive** options allow you to project toward the selected axis or backward. You can select both. Use the settings as shown in image 30c.

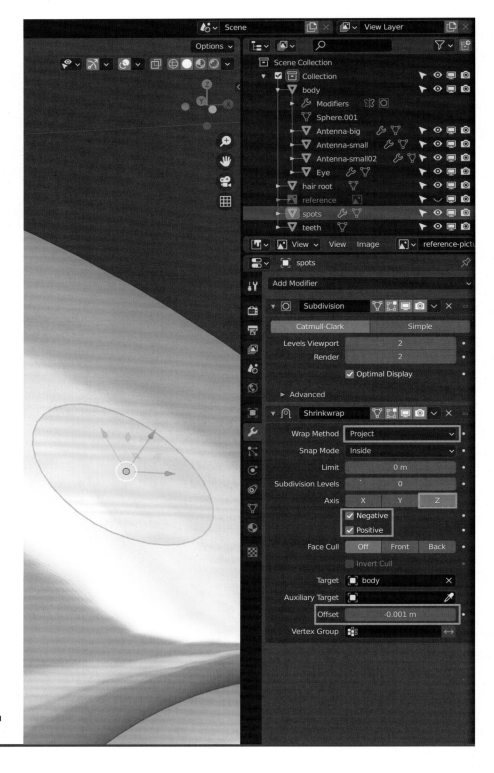

30c Use the settings as shown to the Shrinkwrap modifier

Target Normal Project is another **Wrap Method**, close to the **Project** behavior but based on the target closest normal. This makes it ideal for large-scale projection.

In the **Snap Mode** field you can choose to project from the inside, outside, on the surface, outside the surface, or even inside the surface (based on surface orientation).

The **Offset** option allows you to move the projected mesh from the target after the projection. Use a very small value to make the dot object float upon the body instead of clipping.

Finally, drag and drop to move the **Shrinkwrap** modifier above the **Subdivision Surface** modifier. This way the shrinkwrap will occur before the mesh is subdivided and interpolated, making the surface smoother (image 30d).

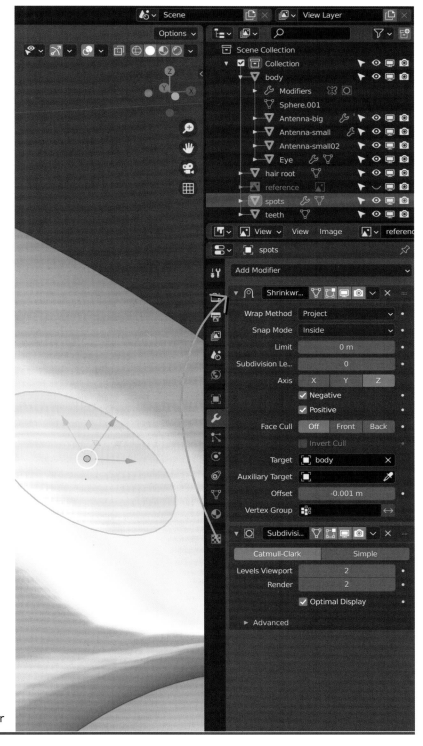

30d Move the Shrinkwrap modifier above the Subdivision Surface modifier

Solidify

The Solidify modifier allows you to give depth to any surface as if you were extruding its faces. It is often used on car models, for example, to give depth to the car body.

Select the dot object and press **Shift + H** to hide everything but the dot. Add a Solidify modifier to it and place it just after the **Shrinkwrap** modifier. The dot instantly gets some thickness. You can adjust it by playing with the **Thickness** value. The **Offset** option will make the surface thicker inward, outward, or on both sides.

The **Rim > Fill** option will generate a surface along the edge of the generated surface, making it a closed mesh (image 31a).

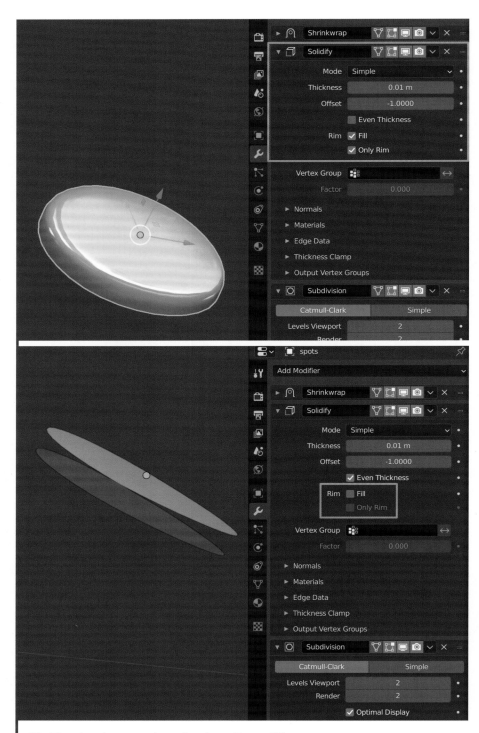

31a The dot shown with and without Rim > Fill

The **Even Thickness** option (image 31b) forces the modifier to keep the thickness even on every part of the solidified surface, even on pinched geometry. It generally looks better but can become buggy on tight areas.

The other options allow you to change the material used for the generated rim of the object and fine-tune the behavior of the modifier.

You can use a vertex group to adjust the influence of the solidify modifier. If you have a thickness of 1.0m and you assign a vertex group with a 0.5 value, the thickness will be 0.5m. This allows you to control the thickness for each vertex on your whole model.

From there, set the **Offset** value of the Solidify modifier of the dot to 0 (image 31c). Using the Snap tool,

duplicate the dot object multiple times and distribute it on the head of the character. If you need to scale the different duplicated dots, do it in **Edit Mode** to avoid uneven scaling issues. This is because when you work in **Edit Mode**, you work on an object's data, inside the "container." Scaling is relative to the object (the container), not what is inside it, which means

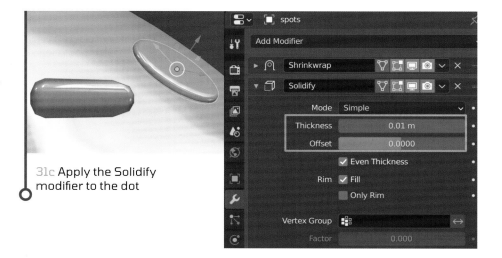

31b An example of Even Thickness enabled and disabled

only an object can output a scale. Its mesh data can only output location coordinates as vertices or points, and you can't rotate a point. When connecting all these points together you create a shape that you can visually rotate, but in the end, the data of the mesh are just these connecting vertices. All these data are bound to the object that can be rotated, scaled, and moved.

31c Apply the Solidify modifier to the dot

You can select all the dot objects, press the **M** key, and move them into a new collection to make any further selection easier (image 31d).

VERTEX GROUPS

Vertex groups allow you to tag a vertex with a value or different values. This is generally used to influence other behavior: for example, you can use a vertex group to influence the number of hairs growing on a surface, or the hairs' length. You can also use vertex groups to tell a surface how much it has to bend using a **Deform** modifier.

You can use a vertex group to tell a surface how high it has to be displaced using a displacement modifier in order to generate a terrain: to do this you would paint random values on the surface and the highest values would generate mountains while the smallest values will generate valleys.

31d The character with his dot pattern created using multiple modified objects

Bevel

You have used the Bevel tool several times while modeling your character but let's look at the Bevel modifier too. The Bevel modifier generates procedural bevels the same way you would by hand, with some additional options. You can choose the number of segments generated, the width, and the shape or profile of the bevel.

You can choose whether to bevel the edges, as you did manually, or the vertices. In the second case it will mainly affect hard corners of the geometry. The **Width Type** won't change the modifier behavior, but it will allow you to use a different reference point.

By default, the Bevel modifier will affect all the edges of your model as on the second cube in image 32a, but you can use different **Limit Method** options to affect specific edges. A common one is to use the angle-based method, which will only affect the edges defining an angle above a given value. On the cube, a value below 90° will bevel the outer edges (as on the third cube in image 32a).

The **Profile** option allows you to create anything from a hard-edged (convex) to concave bevel profile depending on the Shape value. But it also allows you to build a custom profile using a curve (image 32b).

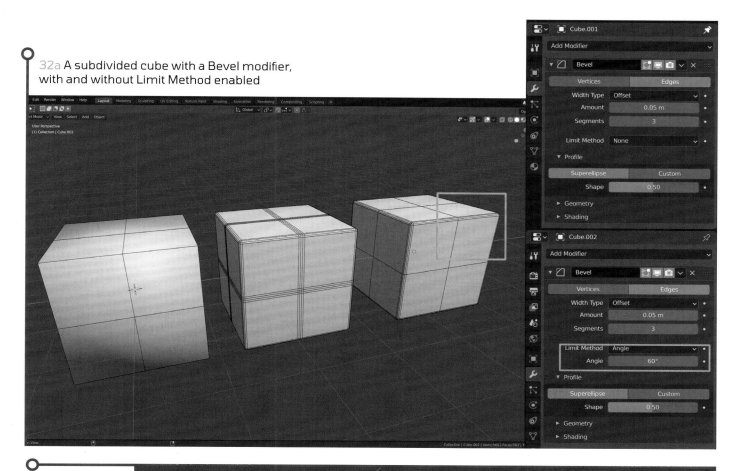

32a A subdivided cube with a Bevel modifier, with and without Limit Method enabled

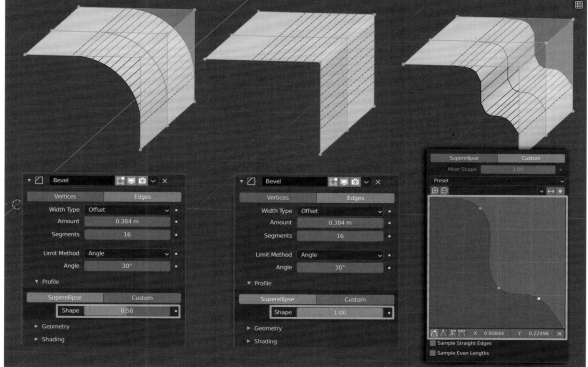

32b The Bevel modifier with different Profile setup

The **Geometry** options allow you to change the modifier behavior on more complex geometry while the **Shading** options affect the surface normal behavior or the material to be used on the bevel. These are more advanced options.

You have used the Bevel tool previously to build the character's tooth model. Let's make another tooth using the Bevel modifier instead so you can familiarize yourself with this method (image 32c). Add a new plane and, in **Edit Mode**, scale it way down based on the tooth size. Select two consecutive vertices as you did on page 85 and press **M** to **Merge At Center**. Select an edge of the triangle, right-click, and select Subdivide. This will create a new vertex in the middle of this edge. Select this vertex and the opposite triangle corner and press **J** to create an edge in the middle.

Select the left and right edges and subdivide them. Then select the two generated vertices and press **J** to create another edge across the middle of the triangle, creating a cross. You will have a subdivided triangle that will be easier to shape. Move it onto the face of the character.

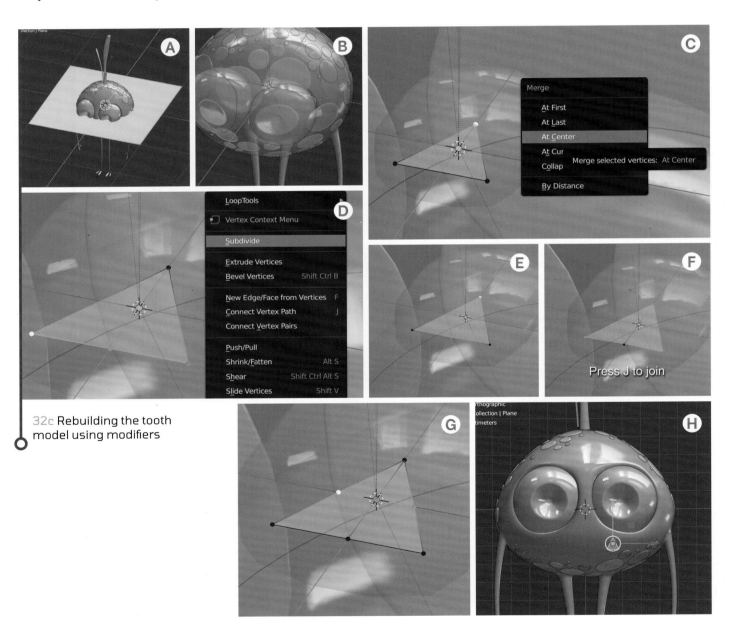

32c Rebuilding the tooth model using modifiers

Add a **Solidify** modifier and tweak the **Thickness** value to something that fits the picture, such as a 0.02m value (image 32d). Next, add a **Bevel** modifier with **Segments** set to 3, **Amount** set to 0.004 (this may vary depending on your scene), and **Limit Method** set to **Angle** with a value of 30 so that only the outer edges will get beveled (image 32e).

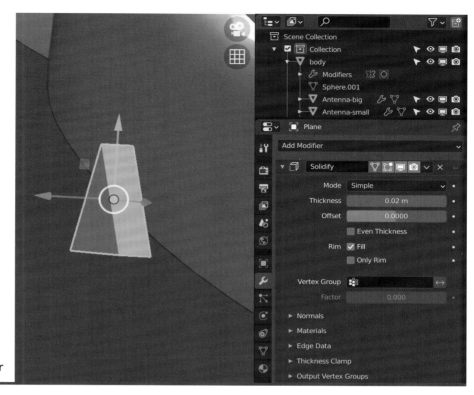

32d **Add a Solidify modifier**

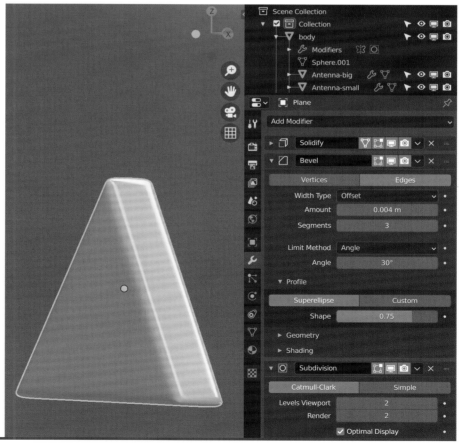

32e **Add a Bevel modifier**

Add a **Subdivision Surface** modifier. Now, in **Edit Mode** you can slightly bend the tooth and give it a rounder shape as shown in image 32f.

In **Object Mode**, duplicate the tooth model and place it on the face of the character as on the reference. You can use the Snap tool as you did for the dots (image 32g). You can then move all the teeth into a new collection named **Mouth**.

SUBDIVISION SHORTCUT

If you are in **Object Mode** and have the object selected, you can use **Ctrl + 1** to add a Subdivision Surface modifier. **Ctrl + 2** would create two subdivisions, **Ctrl + 3** three subdivisions, and so on.

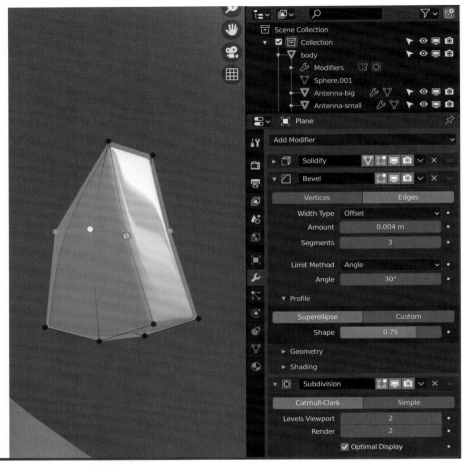

32f Add a Subdivision Surface modifier and slightly bend the tooth

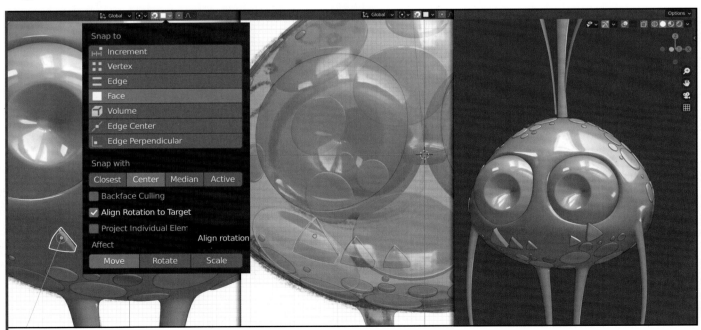

32g Duplicate and position the teeth

Add a new plane with a size of 0.05m and snap it on the face of the character. Add a **Mirror** modifier to it and use the body as the **Mirror Object** and enable **Clipping**. Add a **Shrinkwrap** modifier and use the body as a target. Use a small **Offset** value of 0.002m so that the object stays in front of the body. You can set the **Snap** mode to **Outside** (image 32h).

In **Edit Mode**, move the left vertices toward the middle of the character until they merge together. Then extrude the right edge several times into a mouth shape (image 32i).

32h **Use a plane to start building the mouth**

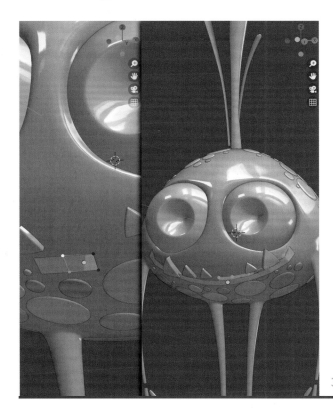

32i **Move vertices and extrude**

Apply the **Mirror** modifier by selecting Apply as shown in image 32j. Add a **Solidify** modifier with **Thickness** set to 0.05m and **Offset** set to 0. Adjust the **Offset** setting of the **Shrinkwrap** modifier if needed. Since you have applied the **Mirror** modifier, you can now edit both sides of the mouth separately to break the symmetry as on the reference. Adjust the teeth position too if needed (image 32k).

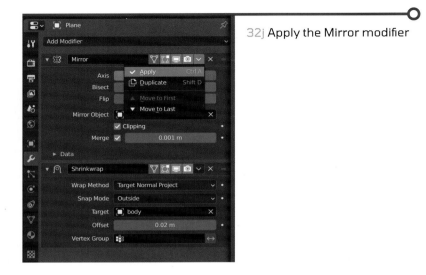

32j Apply the Mirror modifier

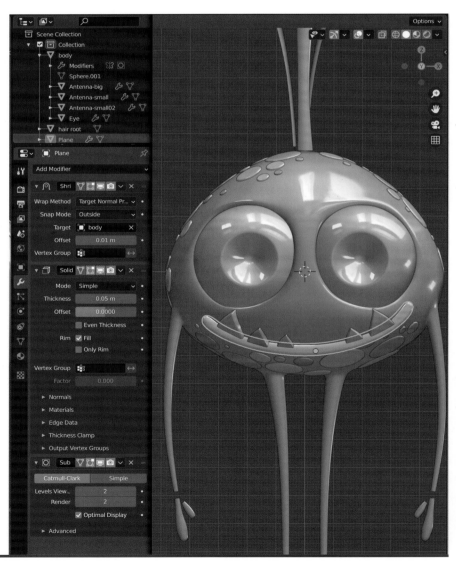

32k Add a Solidify modifier and adjust the mouth and teeth

You can build hair strands in almost the same way as you built the teeth, following the instructions as shown in image 32l:

A Start with a small plane and subdivide it once.

B Scale it on the X axis to give it a rectangular shape and move the vertices into a leaf shape.

C Add a loop cut and scale it on the Y axis to make it longer.

D Move the edge loops and vertices to give it a slight curvature and concave shape in the middle.

E Add a **Solidify** and a **Subdivision** modifier as shown.

F Then duplicate and position the hair strand object as on the reference image. You can also place the hair root object you created on page 94.

Move everything into a new collection called **Hairs**.

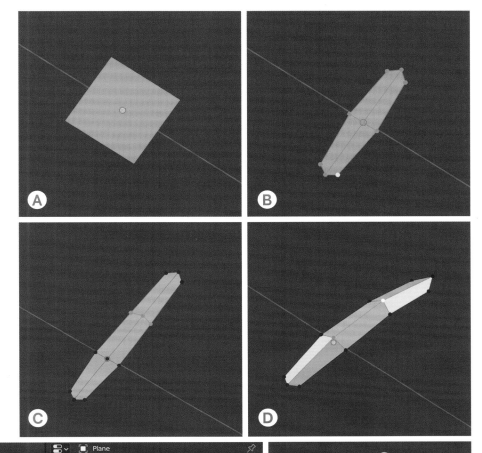

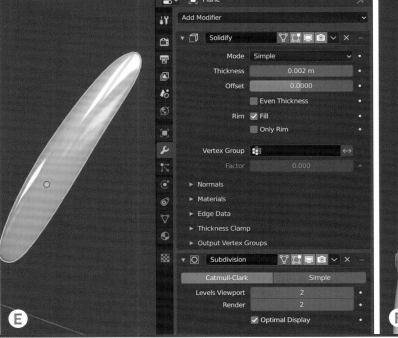

32l Create and place the hairs

Array

The Array modifier allows you to duplicate the mesh along an axis or a pattern (image 33a). By default, the **Fit Type** option is set to **Fixed Count**, allowing you to create as many iterations of your object as you want. Start with a basic cube, apply the modifier, and then increase the Count to see the number of objects increase.

You can switch the **Fit Type** option to **Fit Length**, which will duplicate the object until the original and the duplicated objects' bounding box is as large as the set length on the chosen axis.

When using **Fit Length**, the **Array** modifier uses the size of the object in meters, not its scale value. This means that if you don't go over two times the size of the cube, it won't create any new cube instance. For a cube of 2m, for example, setting the **Fit Length** value above 4m will generate a second cube, above 6m a third, and so on.

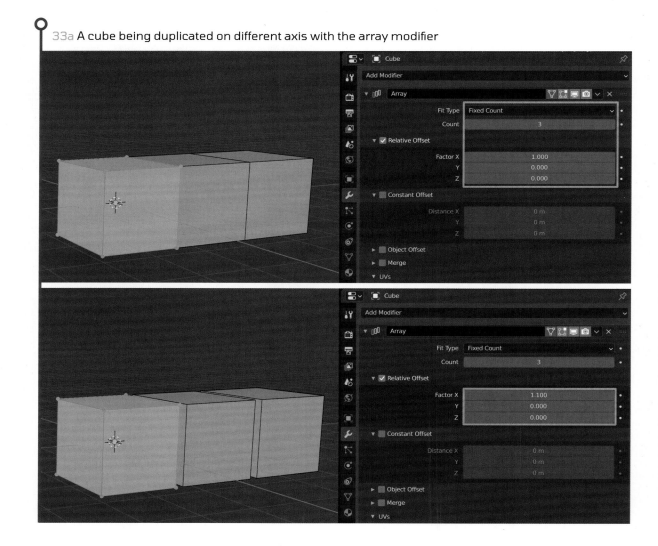

33a A cube being duplicated on different axis with the array modifier

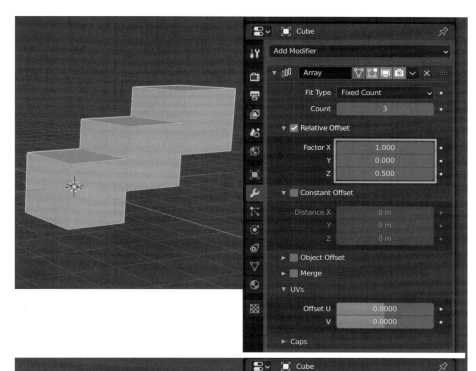

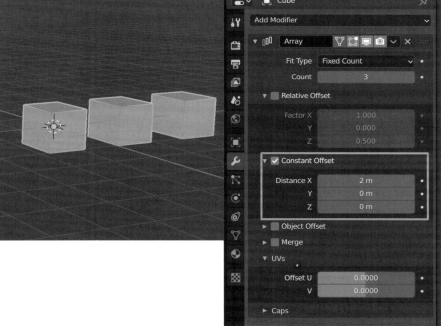

33a Continued

The **Fit Curve** option is to be used with a **Curve** modifier. The **Curve** modifier allows you to bend and twist a mesh along a curve. Imagine a chain; you can model one ring and then use the **Array** modifier and the **Curve** modifier to bend the chain and generate as many chain rings as needed. Start with a basic cube again and then also add a Bezier Curve to the scene; scale the curve so it is longer than the cube so you will be able to see the effects of the **Array** modifier. Select the cube and add an **Array** modifier, setting it to **Fit Curve**. In the **Curve** field, select the Bezier Curve object. Now add a **Curve** modifier, and select the Bezier Curve in the **Curve Object** field. You will see that the duplicated mesh now follows the curve. If you edit the bend of the curve in **Edit Mode**, this will also edit the curve of the cube mesh.

You can choose whether to use the **Relative Offset** option, which will be based on the bounding box of the object. A value of 1 will make the next iteration bounding box "touch" the previous one, whatever the size of the object. You can set different offsets on multiple axes at the same time (image 33a). Editing your mesh size will influence the array.

The **Constant Offset** option will use a distance value that is independent of the size of the modified object. It allows you to keep the distance constant while editing your mesh.

The **Object Offset** is super powerful as it will take the transformations applied to the target object (an Empty object in image 33b) and use it to offset the iteration of the modified object. Let's say you rotate the target object by 45° and move it by 0.5 units on X and Z and 0.2 units on Y. Each iteration of the object will be offset by all these different values, creating a spiraling shape.

The **Merge** option allows you to merge any vertices from the object to its next iteration within a threshold value set in the **Distance** field. This is handy for creating wires for example, modeling a small segment and then duplicating and merging it using the **Array** modifier (image 33c). The **First to Last Copies** option will merge the original object with the last iteration, if they are within the threshold distance. This is useful when using an array to generate a closed shape, like a necklace or a ring.

The **UVs** option allows you to offset the position of the UV island of each iteration to avoid repetition in the texture of all copies.

The **Caps** option allows you to use any other object to be added before the original object and after the last iteration (image 33d). This is ideal for cables. You can use the array to generate a wire and use a 16mm jack model at the beginning and the end to plug in your 3D guitar and rock!

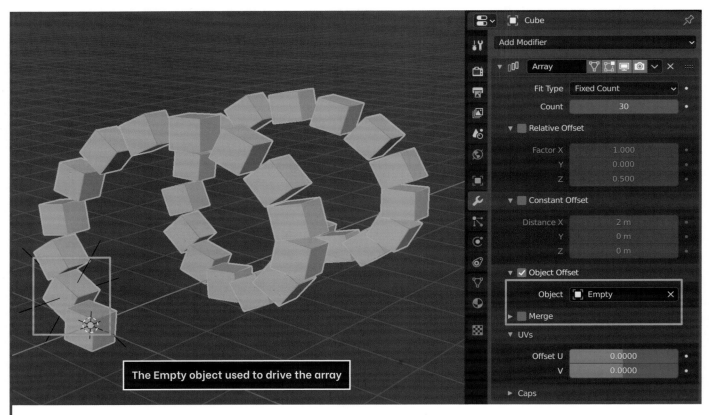

The Empty object used to drive the array

33b A more complex and interesting pattern created with the Object Offset option enabled

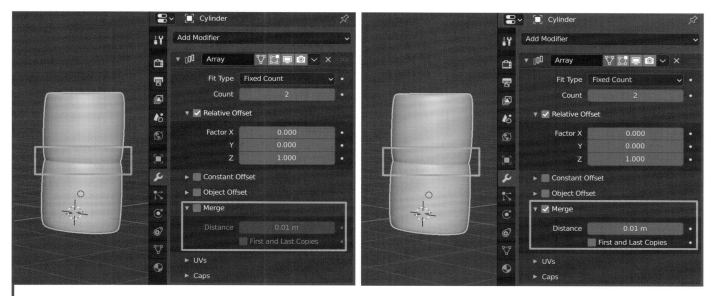

33c The effect of the Merge function in the Array modifier

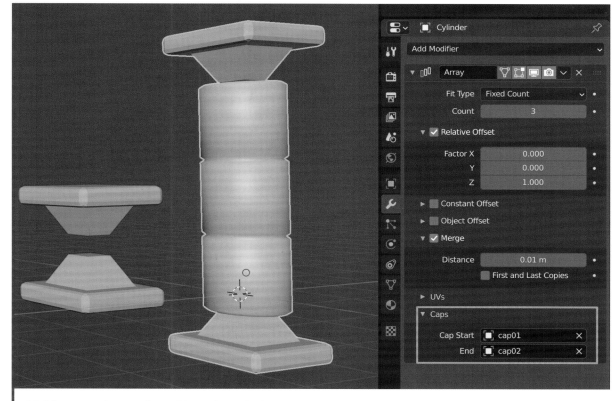

33d Caps can be used to add an object before the first and after the last iteration

Boolean

The Boolean modifier allows you to meld multiple objects together, or carve one with the other. It is perfect for concepting and experimenting as it allows you to create complex geometry without any real modeling skills. It is ideal for creating a base mesh for sculpting or trying new ideas. However, it does have some downsides.

You need at least two different objects to be able to perform a Boolean operation: one binding the modifier and the other, a target object, to affect the modified object. For example, in images 34a–34d, the cube is the modified object and the sphere is the target object. The Boolean modifier is added to the cube, and the sphere is selected in the **Object** field of the modifier. Click the arrow next to the modifier name and click **Apply** to apply the Boolean operation. You may need to move the target object to reveal the effect on the modified object.

Within the modifier, you have three options:

INTERSECT	This will remove any geometry that is not bound to both objects' mesh (image 34a).
UNION	This will fuse both meshes, like joining two meshes, connecting their surfaces, and getting rid of any intersecting geometry (image 34b).
DIFFERENCE	This will subtract the intersecting part of the target mesh from the modified mesh (image 34c).

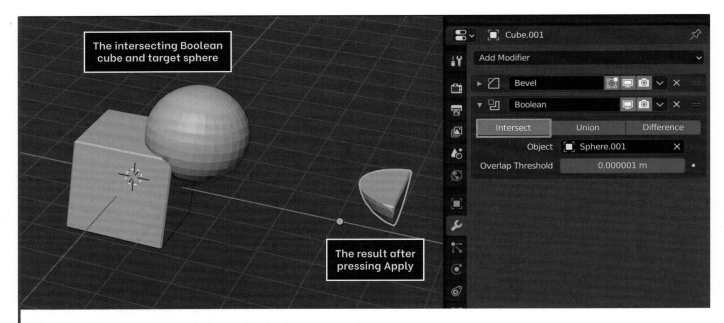

34a A Boolean operation carried out with the Intersect option

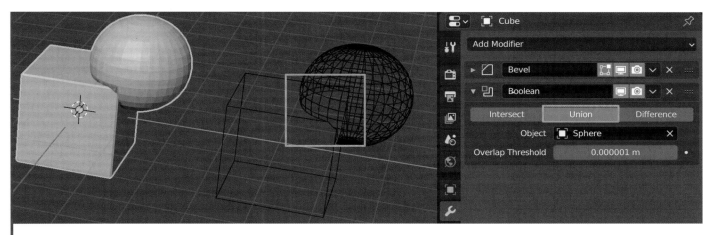

34b A Boolean operation carried out with the Union option

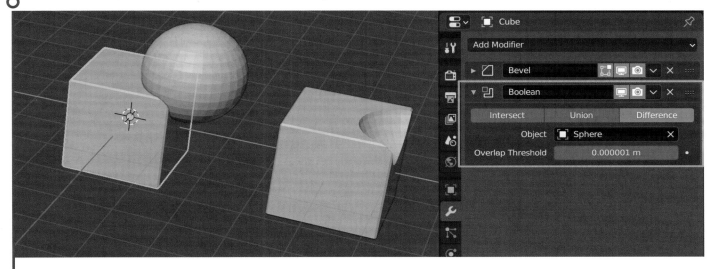

34c A sphere subtracted from a cube using the Difference option

The **Overlap Threshold** value is used to evaluate the distance between the two objects before performing the Boolean operation. You can leave this setting as it is.

The main issue with Booleans is that they generate a lot of n-gons and bad face distribution, creating unexpected shading behavior and making meshes hard to work with (image 34d); they can generate bad topology, which is what we will look at next.

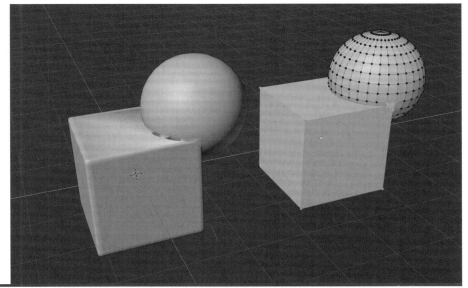

34d United meshes showing shading glitches due to bad topology

Topology

Overview

As you are embracing 3D modeling, you will hear or read this word a lot. Topology is basically the way vertices are connected to one another, or the way the faces flow when they are connected. You saw some topology behavior while using the Loop Cut tool and Edge Slide. Face and edge loops are the most important aspects of topology, as they create and orient an object's topological flow.

Good topology will enhance modifier behavior, make your UVs easier to generate, make your character easier to animate, and make any of your 3D models better by making the edge flow behavior more predictable – whether it offers better deformation of a limb on a character, or better reflection on a car hood. For character modeling you will generally use a topology that follows the muscular flow of the character. This way, when animating, the body will have a more natural behavior.

Topology in itself is a significant topic and you should always search for topology references when working on specific tasks like modeling a character's face or hand, for example. See image 35.

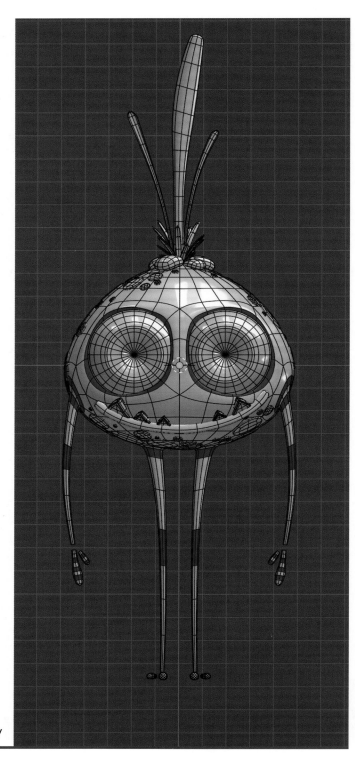

35 Showing the important face loops of the character's topology

Fixing topology

To illustrate the importance of topology, you can try to bend the arm of your character as if he has an elbow. Snap the 3D cursor to the elbow region, by selecting the elbow loop and using **Shift + S** to set **Cursor to Selected**. Then select all the vertices of the forearm and switch from **Bounding Box Center** to **3D Cursor** as a pivot point in the **Transform Pivot Point** menu in the middle of the Header. If you try rotating the arm now, you will see how the geometry becomes pinched and it doesn't bend properly (image 36a).

A way to fix this topology issue is to add supporting edge loops. Add an edge loop on each side of the elbow edge loop and use them to distribute the bending; you can do this in a few clicks using a Bevel operation with 2 segments. Now if you rotate the forearm and use some proportional editing and tweak the loops, you can achieve a much better deformation (image 36b). You need to create these kinds of supporting loops on all the joints of the character, such as the knees, wrists, and shoulders.

PRODUCTION PIPELINE

If you were working as a character artist or modeler in general who was part of a 3D pipeline, for an animation for example, it would be important to speak with riggers, animators, and all the people involved in the 3D production because any choice you make can affect the other steps of production.

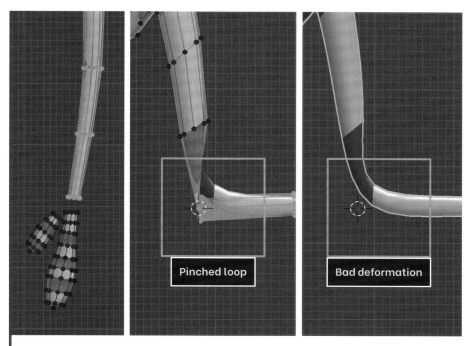

Pinched loop

Bad deformation

36a Pinched geometry and bad deformation once the arm is rotated – that is, the elbow is not preserving its volume; it becomes thinner while bending, which doesn't look good

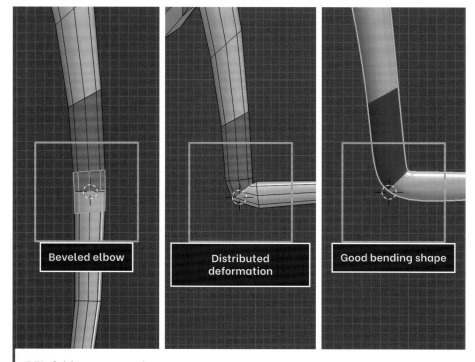

Beveled elbow

Distributed deformation

Good bending shape

36b Add supporting loops to the elbow joint

131

At this point, you still need to connect the character's fingers to its arms and legs. Start with the fingers and arms, as demonstrated in image 36c:

A Connect the inner vertex of the main finger to the outer vertex of the thumb by selecting them both in **Edit Mode** and pressing the **F** key.

B Press the **F** key again to create a face between the next and the previous vertex. Add a further face consecutively.

C Add two further faces as shown.

36c Connect the finger to the thumb

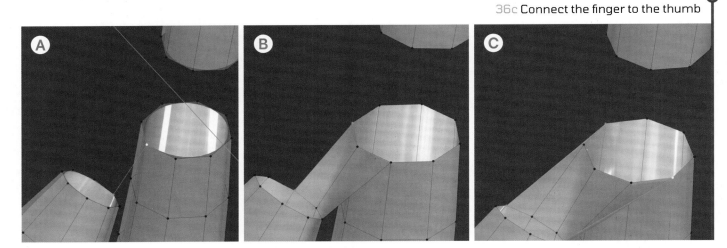

As shown in image 36d:

A Add an edge loop with the Loop Cut tool.

B Then move the generated edge loop up a bit to even the connection between the thumb and the finger.

C Connect the thumb to the wrist as shown, creating two faces.

D Then connect the main finger to the wrist, creating four faces.

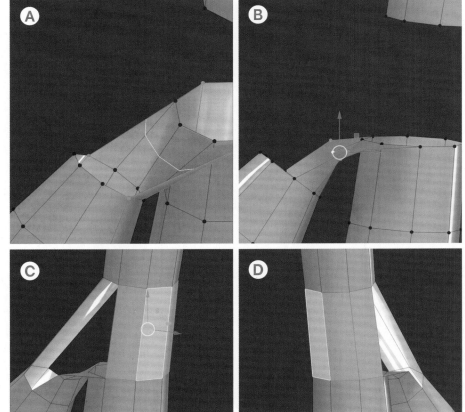

36d Connect the finger and thumb to the wrist

To improve and finish the hand shape, follow image 36e:

A Create two loop cuts between the thumb and the wrist and one between the main finger and the wrist.

B Fill between the two faces (as shown) on each side of the hand using the **F** key.

C D With the Edge Slide tool, move both loops in the inner part of the finger down, which will relax the connecting arc between the finger and thumb.

E Add a new loop cut between the two fingers.

F Fill the two remaining holes with a couple of faces. Tweak the position of the vertices to get a smooth flow between the finger and the thumb (that is, note that when you add the cut you can see that the connection between the thumb and the finger is straight (**E**), while once the vertices' position is tweaked (**F**), there is more of a U-shape that blends with the orientation of the thumb and the finger).

G Don't forget to add a couple of supporting loops on the wrist.

36e Improving hand shape

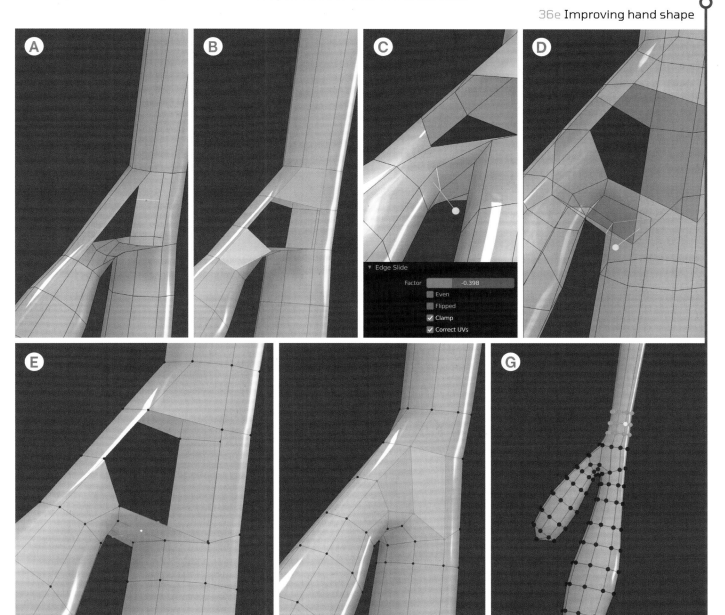

Moving onto the eyes and looking at **image 36f**:

A You may notice some shading issues on the eyes due to bad topology – the accumulation of triangles in the center does not look very good.

B Select the center vertex and remove it.

C This will leave a hole in the middle of the eye, which you can now enlarge and edit to create better topology.

D Select the inner loop and press **S** to make it larger. This will define the pupil of the eye. Left-click to confirm.

E Press **Ctrl + F** or go to the **Face** menu and use the Grid Fill tool.

F Then add a couple of loop cuts between the generated grid and the outer edge of the eye iris using the Loop Cut tool.

G The eyes should now look similar to those shown.

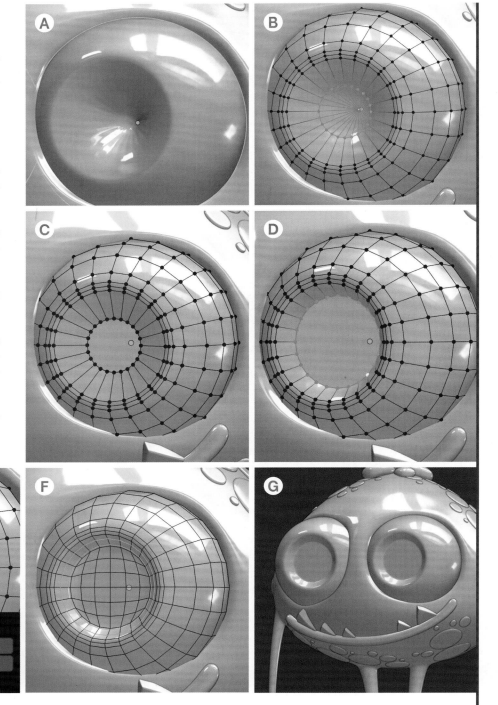

36f Fixing the eye topology for better shading

You now need to finish the foot, which will be similar to the process for the hand. Follow **image 36g**:

A Connect the toes together as shown.

B Select the vertices of the generated loop.

C Extrude the loop on the Y axis.

D Scale down a bit and move the generated loop to get a more organic foot shape.

E Add a loop cut on the generated face loop.

F You now need to reduce the number of vertices of the open loop (16 vertices) to be able to properly connect it to the ankle (8 vertices). You can do this by merging the three vertices on the top center part of the foot by pressing the **M** key and selecting **At Center.**

G The result should look like that shown in the image.

H I Do the same with the bottom vertices.

J Merge the next vertices in pairs as shown.

K The result should look like that shown in the image.

L Select the generated loop of the foot and the open loop of the leg.

36g Connecting the toes, preparing the foot shape, and connecting the foot to the ankle

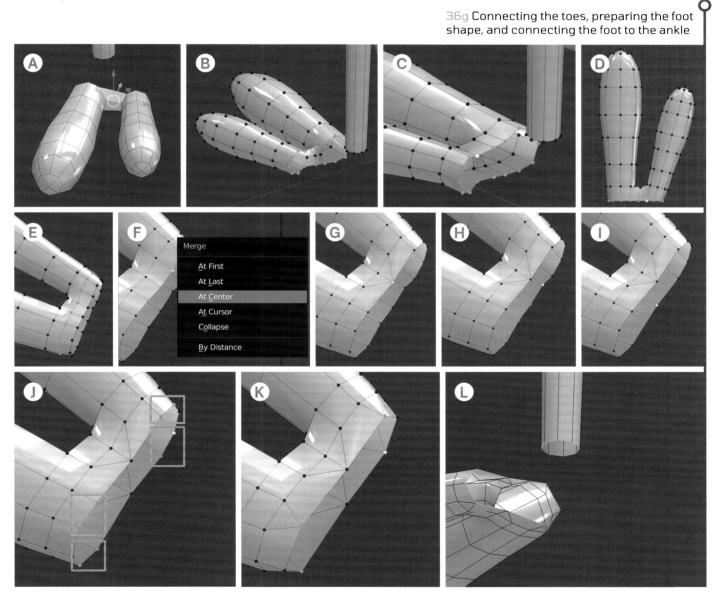

M Press **Ctrl + E** and use the **Bridge Edge Loops** option. In the **Bridge Edge Loops** contextual menu, use 2 cuts and choose **Blend Surface**.

N Use Edge Slide to slightly relax the foot shape.

O Select the vertex connected to the two triangles on top of the foot and slide it toward the toe.

P Select the center edge between the two triangles, press **X**, and select **Dissolve Edges**.

Q Do the same on the bottom part of the foot.

R Finally, add a couple of supporting loops on the ankle.

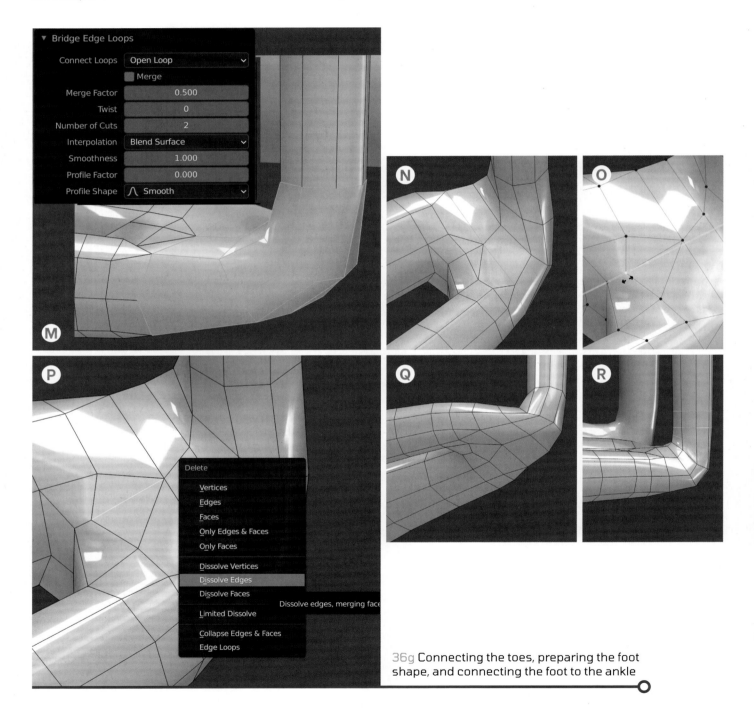

36g Connecting the toes, preparing the foot shape, and connecting the foot to the ankle

With that, the basic model of the character is complete! Turn to the next chapter to discover ways you can sculpt, texture, and render characters.

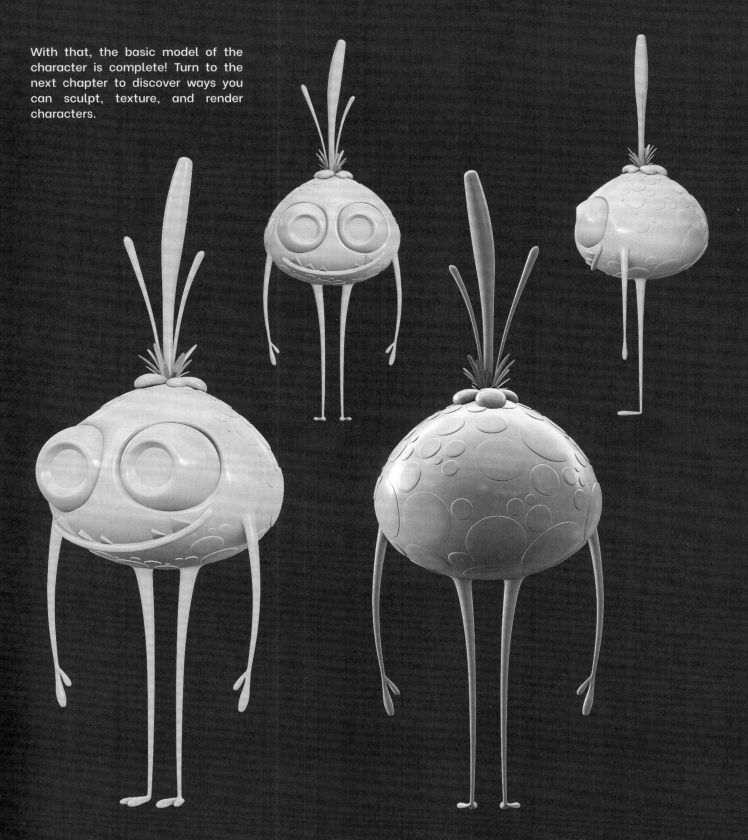

36h The finished character. Original concept by Aveline Stokart

Sculpting

By Alejandro Treviño

After you have modeled a basic mesh for a character, you may find that sculpting is a more convenient way to create organic shapes and details. Sculpting allows you to focus only on the shape, making the process more intuitive and artistic, just like with real-world clay. Keep in mind that you need good topology to be able to create UVs and texture the mesh, so after sculpting you will often need to carry out some level of retopology (a streamlining and clean-up of the surfaces).

There are generally two workflows – one uses the **Multiresolution** modifier and the other uses **Dyntopo**, both of which you will find out more about on pages 146 and 147. The **Multiresolution** modifier and **Dyntopo** options have different benefits, so you will need to decide which workflow works best for you and the model you are working on: the **Multiresolution** modifier allows you to increase the resolution of the current mesh and sculpt detail for each level of resolution without modifying the original topology, keeping its number and order of polygons the same; **Dyntopo**, or dynamic topology, will generate new topology on the fly while sculpting, whether by adding or removing polygons on your mesh.

If you use the **Multiresolution** modifier and then add small details with the sculpting brushes, it may not be necessary to retopologize. If you use **Dyntopo** to sculpt, then use brushes to generate the sculpture, the topology will not be clean, so you will need to retopologize. You can sculpt without the **Multiresolution** modifier or **Dyntopo**, but you will lack resolution; you can't use both.

To be able to sculpt in Blender, you must be in **Sculpt Mode**. When in this mode in the 3D Viewport, you will find all types of brushes in the Toolbar. You can move, smooth, fill, scrape, pinch, pose, relax the model, and much more (image 01). There are also multiple settings for each brush, varying the effects even further. You will learn all about these, along with other important sculpting and retopology tools, in this chapter.

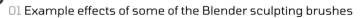
01 Example effects of some of the Blender sculpting brushes

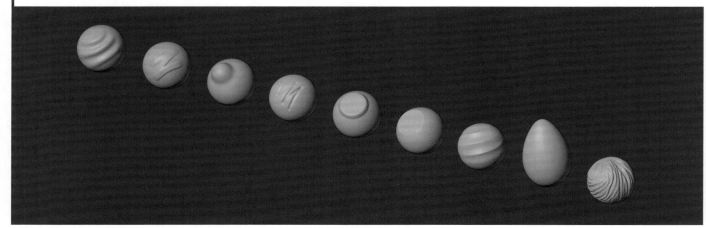

Brushes

Brush basics

To select a sculpting brush you must be in **Sculpt Mode.** The Toolbar in this mode holds all the brushes. Remember that if you can't see the Toolbar, you can use the shortcut **T** inside the 3D Viewport to make the Toolbar appear. You can use this Toolbar in three different ways. The default option shows the brushes in a reduced form in a single column (**image 02a**). With this option you may not be able to see all the brushes at once, and you will have to scroll to view the other brushes.

Pulling the Toolbar out by hovering over the edge until you see a double-headed white arrow, and clicking and dragging it, will present the brushes in two columns, allowing you to see all the brushes at the same time (**image 02b**). Finally, if you pull the Toolbar again, the names of each brush will appear to the right (**image 02c**), but again it will be necessary to scroll to see all brushes. This last option is useful for learning the names and icons of each brush, but once you memorize what each brush is, the two-column option is the most efficient.

> ### TOOLBAR SIZE
>
> You can use these different sizes of Toolbars in other modes in Blender.

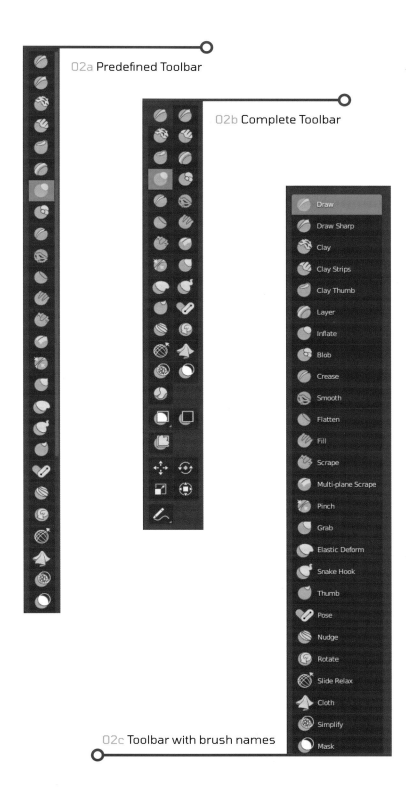

02a Predefined Toolbar

02b Complete Toolbar

02c Toolbar with brush names

Brush settings

Each brush has different settings. With the brush selected, these settings can be found in the **Tool** tab of the Sidebar or the **Active Tool &**

Workspace section of the Properties Editor (**image 03**). Key settings also appear in the Header.

○ 03 Brush settings available throughout the Blender interface

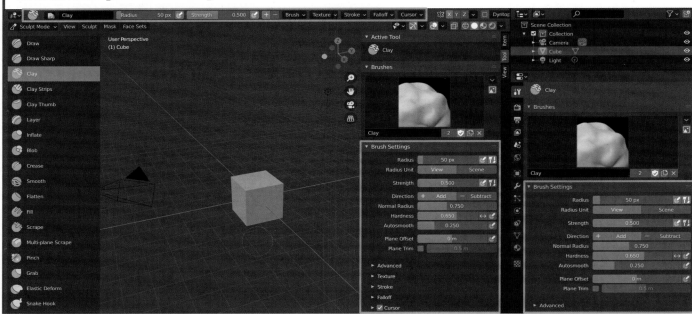

All brushes have six basic settings:

▷ **Radius** affects how wide the brush will be;

▷ **Radius Unit** defines how the brush radius is measured;

▷ **Strength** affects the power of the brush;

▷ **Normal Radius** controls how the brush tilts according to the mesh normals;

▷ **Hardness** affects the falloff in relation to the edge of the brush;

▷ **Autosmooth** defines the level of smoothing applied to each stroke.

There are also some other settings that are repeated across several brushes. For example, you can find **Plane Offset** and **Plane Trim** in the Clay, Clay Strips, Clay Thumb, Flatten, Fill, and Scrape brushes. **Direction** is repeated in the Draw, Clay, Clay Strips, Layer, Inflate, Blob, Crease, Flatten, Fill, Scrape, and Pinch brushes. Some brushes have unique settings, such as **Height** in Layer, **Magnify** in Blob, and **Pinch** in Crease.

Direction options **Add** or **Subtract** either add the brush effect to a model or subtract the brush effect from a model. For example, when using the standard brush, **Add** will create a bump on the surface while **Subtract** will create a valley or dig the surface.

These options appear as plus (**+**) and minus (**–**) signs on the Header, and you can also toggle between them with **Ctrl**.

You can also choose the **Spacing** of the **Stroke** of a brush. This impacts the spacing of the effect within a brushstroke. For example, if you use a smaller percentage in the **Spacing** option, the brush will make a smoother shape.

The **Symmetry** option can also be useful, allowing you to *mirror the brush effect* in one or more of the axes. Play around with the different settings as you trial the brushes throughout this chapter to familiarize yourself with their effects.

Key brushes

To test the brushes, first create a sphere as shown in image 04a:

A Add a cube with **Shift + A** and select **Mesh > Cube**.

B Add a **Subdivision Surface** modifier with **Ctrl + 4** and click **Apply** in the dropdown to the right of the modifier name in the **Modifier Properties** panel.

C Go to Edit Mode, select all the faces, and use **Face > Shade Smooth**.

D Finally, switch to **Object Mode** and add a **Multiresolution** modifier (more about this on page 146) by going to the **Modifier Properties** panel and selecting the modifier from the **Generate** section of the **Add Modifier** dropdown. Subdivide it two times by pressing the **Subdivide** button twice.

E With this, you are ready to move to **Sculpt Mode** and test each of the brushes described in the rest of this section. Note that Symmetry is turned on by default in **Sculpt Mode** but can be turned off by clicking the respective axis next to the butterfly-shaped Symmetry icon at the top of the 3D Viewport.

Draw is the primary brush and is used to give a basic shape (image 04b). This brush adds volume by default, but when **Ctrl** is pressed it does the opposite, removing volume. You can also switch to the **Smooth** brush by holding down **Shift**, which removes irregularities by smoothing the position of the vertices.

The **Clay Strips** brush is very similar to the Draw brush, but this brush uses a square shape whereas the Draw brush uses a sphere (image 04c). You can smooth out the corners with the **Tip Roundness** option, which is located in **Properties > Active Tool > Brush Settings** (image 04d).

04a Clay ball setup

04b The effect of the Draw brush

04c The effect of the Clay Strips brush

04d Tip Roundness in Brush Settings

The **Inflate** brush allows you to displace the mesh in the direction of the normals (image 04e).

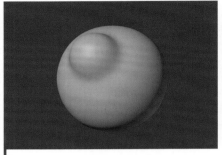

04e The effect of the Inflate brush

The **Crease** brush creates sharp indentations by pushing or pulling the mesh (image 04f).

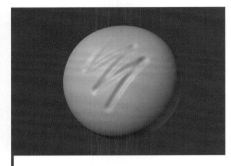

04f The effect of the Crease brush

With the **Flatten** brush, you choose an area to straighten the mesh (image 04g). If you hold down **Ctrl** while using it, it becomes the **Contrast** brush, which pushes the vertices away from the plane.

04g The effect of the Flatten brush

The **Scrape** brush resembles the Flatten brush, but it pushes the plane downwards (image 04h). If you hold down **Ctrl** while the Scrape brush is selected, it becomes the **Fill** brush, which brings vertices below the brush plane upwards.

04h The effect of the Scrape brush

The **Pinch** brush contracts vertices toward the center of the brush, almost as if you were pinching the clay (image 04i). If you hold down **Ctrl**, the brush becomes the **Magnify** brush, which has the opposite effect – it stretches the vertices away from the center of the brush.

04i The effect of the Pinch brush

With the **Elastic Deform** brush, you can make realistic deformations that emulate organic forms, allowing you to pull and stretch out whole areas of clay (image 04j). When using **Ctrl**, this brush deforms oriented to the normals. You can choose different deformations such as Bi-scale Grab, Scale, and Twist. These options are located in the **Deformation** section of the **Brush Settings** in the Properties Editor (image 04k).

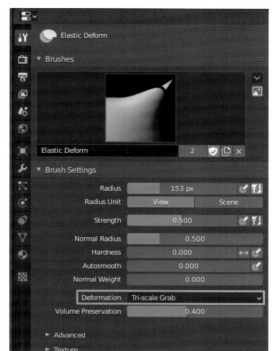

04j The effect of the Elastic Deform brush

04k Deformation properties for the Elastic Deform brush

See sculpting in action on pages 220–227.

Finally, the **Cloth** brush simulates the physics of fabric compellingly (04l). For this brush, you can choose different deformations like Drag, Push, Pinch Point, Pinch Perpendicular, Inflate, Grab, and Expand, which you can again find in the **Deformation** section of the **Brush Settings** in the Properties Editor. You can also decide the mass of the cloth for the simulation of particles (more about particles on pages 176–177) with the **Cloth Mass** option in the Tool section of the Sidebar. The **Cloth Damping** option here determines the amount of force applied and the propagation of the effect.

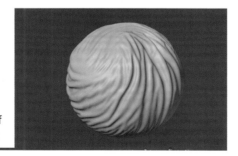

04l The effect of the Cloth brush

BRUSH SHORTCUTS

Not all brushes have a shortcut, but these are the ones that do. For the brushes that don't have a shortcut, go to the Toolbar to choose them by their icon.

Draw	X
Clay	C
Layer	L
Inflate	I
Crease	Shift + C
Smooth	S
Flatten	Shift + T
Pinch	P
Grab	G
Snake	K
Mask	M

Masking

The **Mask** brush is available in the Toolbar in **Sculpt Mode**. This brush allows you to "paint" areas of the mesh to prevent them from being affected by other brushes. With this, you can control which areas of the mesh will be affected by sculpting.

 05a Mask brush

To create a mask, select the **Mask** brush from the Toolbar or with the shortcut **M** and paint areas of the mesh with the **LMB**. Paint the parts you want to be unaffected by brushes and you will see the masked area in black (**image 05b**). Having the mask ready, you can then select a brush to sculpt outside the masked region.

If you click on **Mask** in the Header (**image 05c**), you will see that there are different tools you can then use to edit your mask. For example, you can invert the selection with **Invert Mask** (**image 05d**); remove the selection with **Clear Mask** (**image 05e**); and create a rectangular selection with **Box Mask** (**image 05f**) or a freeform mask with **Lasso Mask** (**image 05g**).

 05b Mask

05c The expanded Mask menu in the Header

 05d Invert Mask

 05e Clear Mask

 05f Box Mask

 05g Lasso Mask

MASKING SHORTCUTS

Invert Mask	Ctrl + I
Clear Mask	Alt + M
Box Mask	B
Lasso Mask	Shift + Ctrl + LMB
Mask Edit Pie Menu	A

If you have the **3D Viewport Pie Menus** add-on enabled, press the **A** key to display multiple filter operations for masks (image 05h), such as:

▷ **Smooth** and **Sharpen** to change the crispness of the mask;

▷ **Grow** and **Shrink** to expand or reduce the size of the mask;

▷ **Increase Contrast** and **Decrease Contrast** to change the contrast of the mask.

These options are also available if you click **Mask** in the Header.

You can also create a mesh from a mask with **Mask Extract**. Although this tool does not work if you are using the **Multiresolution** modifier, you can remove the modifier or apply it to make it work. With the mask created, go to **Mask > Mask Extract** (image 05i) and a menu will appear. You can modify the options, or you can use the default and click **OK** (image 05j). This will create a new mesh with the shape of the mask (image 05k).

You can also cut a mesh with **Mask Slice**, which will remove the masked area.

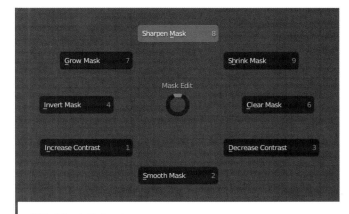

05h Mask Edit pie menu

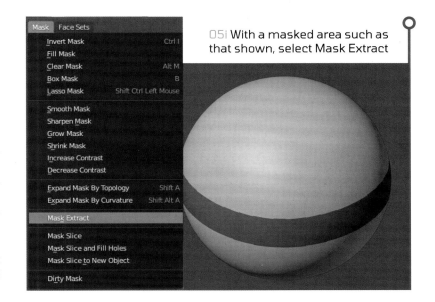

05i With a masked area such as that shown, select Mask Extract

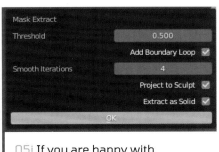

05j If you are happy with the options, click OK

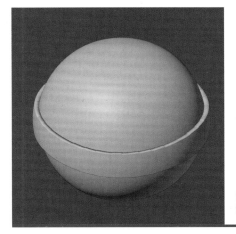

05k The new mesh with the shape of the mask

Resolution

Multiresolution modifier

To sculpt in detail, you need a mesh with many subdivisions. The **Multiresolution** modifier gives you the option to subdivide a mesh, splitting the faces of a mesh into smaller faces, giving it a smooth appearance, as with a **Subdivision Surface** modifier.

Unlike the **Subdivision Surface** modifier, the **Multiresolution** modifier allows you to add detail in **Sculpt Mode**. To use this modifier, select the mesh, then go to the **Modifier Properties** panel in the Properties Editor and select **Multiresolution** from the options (image 06).

Within the **Advanced** options of the **Multiresolution** modifier you can choose the type of subdivision: Catmull-Clark or Simple. **Catmull-Clark** gives a smooth surface like the **Subdivision Surface** modifier; **Simple** keeps the current shape.

Use **Subdivide** to add more levels of subdivision. You can set the number of subdivisions in different contexts in the **Level Viewport**, **Sculpt**, and **Render** fields. Use **Subdivide** to add another level of subdivision. Finally, you can tick the **Optimal Display** option to see the edges of the original geometry. Hit **Apply,** ensuring you are in **Object Mode,** to apply the modifier to the object.

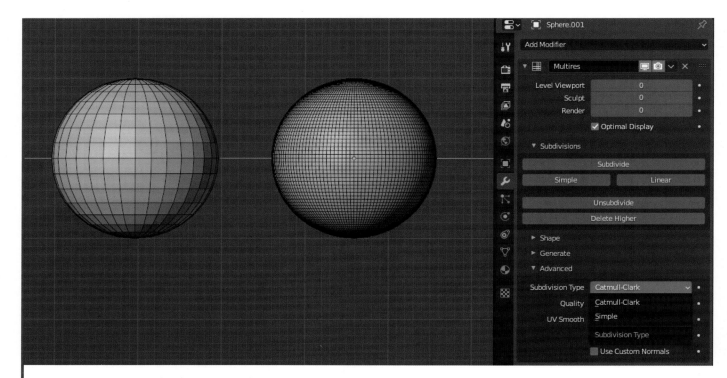

○ 06 A basic UV sphere (left) with the Multiresolution modifier applied (right)

Dyntopo

With Dyntopo you can use **Sculpt Mode** without topology restrictions.* Dyntopo is a method that removes and adds detail on the go, so you can focus on the artistic side without the need to think about the topology in the moment. With this, you can sculpt complex objects even if you start with a simple shape at the beginning, because the topology changes as you sculpt. With this method, you can add detail in specific areas without increasing the number of polygons in the whole mesh, as it will add more polygons only where you are currently using the brush.

To use it, select an object and go to **Sculpt Mode** (image 07a). Then check the **Dyntopo** option in the 3D Viewport Header, or use the shortcut **Ctrl + D** and click **OK**. Click the dropdown arrow to see the Dyntopo options, go to **Detailing** and select **Constant Detail** (image 07b). This will allow you to set a level of detail to sculpt with or to generate on the surface. Use the eyedropper in the **Resolution** option and select the actual mesh, go to the Dyntopo menu to see the current resolution of your mesh, and click on **Detail Flood Fill**. With this, you are ready to sculpt without any limitations (image 07c).

It is necessary apply the **Subsurface Subdivision** and **Multiresolution** modifiers before using Dyntopo, or it will not work.

07a Go to Sculpt Mode

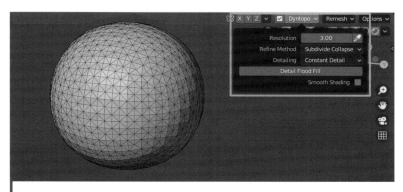

07b Apply Dyntopo

DETAILING OPTIONS

Relative Detail is relative to your distance from the surface you are sculpting with. It is screen-space based. If you are sculpting from afar, it will generate low-resolution geometry, while if you zoom in a lot on your model, it will create high-frequency detail. The behavior of **Constant Detail** is more predictable and easier to understand.

07c An example of the sphere being sculpted with Dyntopo. The left-hand image shows the mesh with Relative Detail (see Detailing Options box on the left); the right-hand image shows the mesh with Constant Detail

*Topology restrictions include, for example, the case where your mesh has uneven topology and you try to sculpt small details on a surface with a low resolution – you will have to subdivide many times until you have enough geometry in this area to achieve the details you want; however, this will create a very dense file to handle. Similarly, as topology dictates the behavior of a mesh deformation, poor topology can make sculpting complicated.

Retopology

Overview

As you learned on pages 130–131, it is good practice to maintain clean topology while you are modeling, ensuring an even spacing of faces where possible and smooth edge flow. When you sculpt, however, the focus is on the aesthetic, which means you can end up with a dense mesh and uneven topology that is difficult to work with going forward.

Retopology is the process of creating simpler topology based on a high-resolution model, and you essentially create a new topology on top of your original model. In the example in **image 08**, you can see that a new, more simple mesh has been created using planes on top of the original, more complex mesh.

Benefits of a simpler topology include facilitating the process of making UVs as well as reducing file size. Also, in an industry context, there is often a limit on the number of polygons allowed for a project.

The retopology process involves using modeling tools to extrude and develop the plane to cover the surface of the original mesh, starting with key edge loops.

Once you have used these tools to manually create a simplified replica of the original sculpt, you can then delete the mesh underneath (you can save it but this will increase the file size and may cause lag). While this manual version of retopology will take more time and requires some skill, it generally gives a very good result.

08 Retopology process

See the manual retopology of a character in more detail in the Fish tutorial on pages 228–255.

Poly Build

With the **Poly Build** tool, you can add, delete, and move faces, edges, and vertices. This tool is very handy for the retopology process. The key objective of this process is to create a lower poly mesh, preferably only with quads. This means that each face should have only four sides, trying to avoid triangular polygons and not using n-gons at all costs to avoid glitches and bad mesh behavior.

This tool is available in the Toolbar in **Edit Mode** (image 09a). You can find out more about how to use the tool in context on page 305.

Other methods

You can also use basic transform and editing tools such as Move and Extrude to manually retopologize, starting with a single vertex. With these, and with Poly Build, **Snap** settings and modifiers such as **Shrinkwrap** and **Mirror** can be invaluable. Refer to pages 228 and 229 to see them in action.

The principles remain the same – you are aiming for quads and a good edge flow around the model. It can be useful to plan your retopology in advance, considering where edges and loops connect areas such as the body and face.

09a The Poly Build tool

09b Add, delete, and move faces, edges, and vertices with the Poly Build tool

Remesh

Remeshing is a technique used to reconstruct geometry with a uniform topology. Lowering the number of polygons while preserving the overall shape is the main objective of this tool. Afterwards, the mesh should only have quads. At the time of writing, Remesh will not allow you to achieve as good topology as you would if you retopologized by hand, but it can be useful for joining several meshes together and generating a single mesh.

To use Remesh, go to **Sculpt Mode** and select the **Voxel Size** in the 3D Viewport using **Shift + R**. When you use this shortcut you will see a grid in real time and can choose the desired result more efficiently by moving the mouse (**image 10a**). Holding **Shift** while you adjust the size helps you change it with more precision, lowering the increment of the adjustment. When you have the desired grid size, click the **LMB**.

Now apply the **Voxel Remesh** with the selected resolution using the shortcut **Ctrl + R** (**image 10b**). You will find options such as **Fix Poles** and **Preserve Volume** in the **Remesh** menu located in the top right of the Header.

10a Use **Shift + R** to select the Voxel Size

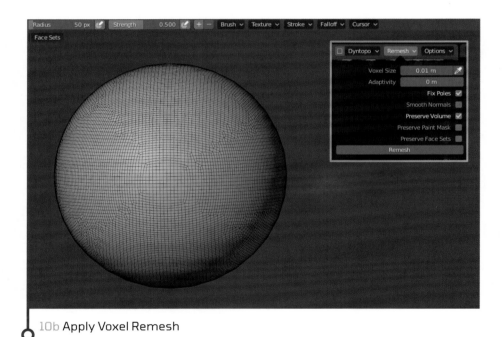

10b Apply Voxel Remesh

You can also use Remesh using the Object Data Properties panel - see this in action on page 221.

FIX POLES & PRESERVE VOLUME

For the **Fix Poles** setting, you should have as few poles as possible as they make the flow more complex, which can be messy.

When working in 3D, preserving the volume of an object is important as it means you are altering its outer shape less. Lowering polycount on a very distorted mesh can lead to loss or addition of overall volume. Imagine you have made a character with a slightly bent arm, and you lower its resolution so much that you lose the elbow joint and get a straight arm instead without a joint; in this case, it is very likely that the global volume of the arm will change this way. The **Preserve Volume** option tells the algorithm to make the Remesh fit the original shape as much as possible.

There is another way to make a Remesh; this uses another algorithm called **Quadriflow** and gives different results. Use the shortcut **Ctrl + Alt + R** in **Sculpt Mode**. A pop-up menu will appear where you can view multiple options (**image 10c**). Enter a value in the **Number of Faces** field for the new mesh and click **OK** (**image 10d**).

The results vary on every project so it can be useful to try both Voxel Remesh and Quadriflow Remesh to see which one works best for your current model.

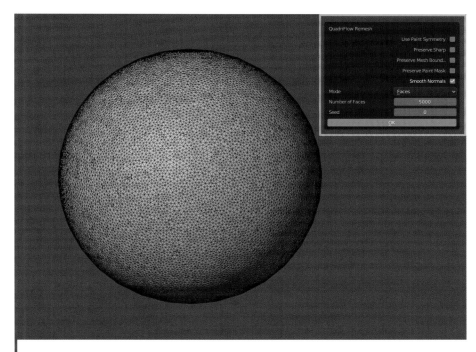

10c **Quadriflow Remesh options**

Note that there are some limitations for Remeshing: you must only use original geometry because the tool will ignore geometry generated from modifiers. Therefore, it is necessary to avoid the **Multiresolution** modifier, or it will not work. The tutorials in this book generally use the manual retopology approach, will give you plenty of practice in achieving smooth topology!

REMESH SHORTCUTS

Voxel Size	Shift + R
Voxel Remesh	Ctrl + R
Quadriflow Remesh	Ctrl + Alt + R

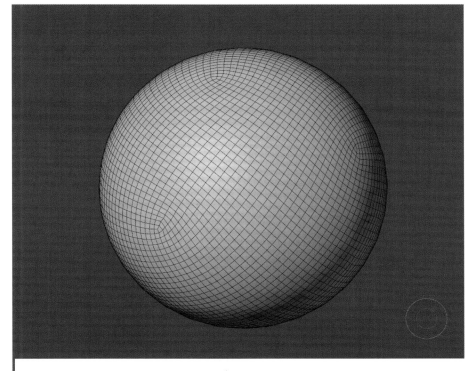

10d **Quadriflow result**

Rendering

By Alejandro Treviño

Rendering is the process of converting a 3D scene into a 2D image. To render, you need:

- at least one camera;

- some lights;

- polygons (your model); and

- materials.

In 3D, **materials** define how an object's surface reacts to light, for example its specularity, reflectiveness, and transparency. The more you understand about the behavior of light, the better the materials you can create. In Blender, you create materials through the Shader Editor, which you will look at in more detail on page 158.

Textures allow you to apply more detail to an object's material properties, meaning you can create

subtle differences on an object's surface such as wood grain and skin blemishes. Textures also allow you to apply different colors to different areas of the surface.

To generate textures, you need a **UV map**, which you will learn how to create on page 166. You can then use painting tools to generate 2D images that can be used as textures.

Blender also offers **procedural textures**, which allow you to add textures without the need for a UV map.

We will look at each of these, along with the use of **particle systems**, which can be used to create hair and fur, throughout this chapter.

Once you have completed rendering, there are a number of actions you can carry out in **post-production** to enhance your 2D image.

Lighting

Overview

Lighting is a fundamental part of creating an atmosphere in a scene, and although there are many setups, the most used is three-point lighting. This setup includes the following lights with specific positions in the scene to achieve their objectives.

Key light

The key light is the most important light, providing the main source of illumination for an object, giving dimensionality with shadows. This light usually casts hard-edged shadows. Image 01a shows an example of an object being lit by a key light.

Fill light

This adds light to the shadows and reduces contrast, illuminating a large part of the scene and casting soft shadows. Image 01b shows an example of an object being lit by a fill light.

Rim light

This light separates the object from the background, with a fine line on the silhouette edge. Achieve this by positioning the light behind the object. Image 01c shows an example of an object being lit by a rim light.

Image 01d shows an example of an object being hit by all three lights.

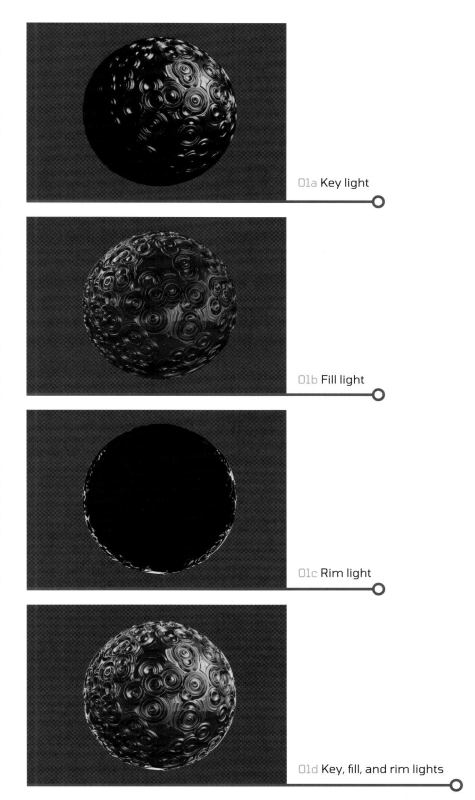

01a Key light

01b Fill light

01c Rim light

01d Key, fill, and rim lights

Creating a background

To set up lighting in your scene you will need a background. A simple way to create a background is to use a plane object to create an "infinity wall," imitating a photography studio by hiding the corners and blurring the floor with the wall. With this method, the background "disappears" so that the viewer will focus only on the subject. To achieve this, follow the steps in image 02:

A Add a plane in **Object Mode** and, in **Edit Mode**, extrude one edge on the Z axis to make an L-shaped object.

B Then add an extra edge loop on each side of the "fold" using the Loop Cut tool and **Ctrl + R**.

C Add further edge loops to avoid deformation, as shown.

D Finally, with the object selected in **Object Mode**, add a **Subdivision Surface** modifier with **Ctrl + 3**.

Still in **Object Mode**, select your object, right-click, and select **Shade Smooth.** You now have a studio background ready for lighting.

02 Infinity wall process

Different types of light objects

In Blender there are four types of light objects (image 03a):

▷ **Point light** – radiates from a point in space, in every direction, with a loss of intensity the farther it gets away from the point;

▷ **Sun light** – evenly illuminates the whole scene, no matter its position in space;

▷ **Spot light** – emits a cone-shaped directional beam with a loss of intensity the farther away it gets;

▷ **Area light** – simulates a light-emitting surface with a loss of intensity the farther away it gets; this can be in the form of a square, rectangle, circle, or ellipse.

To add one of these types of lights, use the shortcut **Shift + A** in **Object Mode** and in the **Light** section of the **Add** menu you will find the four types of lights.

To edit any light, select the object and go to the **Object Data Properties** tab of the Properties Editor where you can choose the color, power, shape, and size (image 03b).

Point light

Sun light

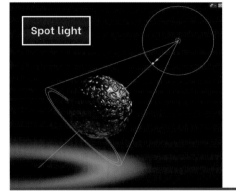

Spot light

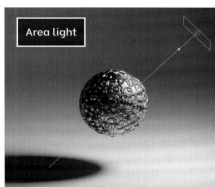

Area light

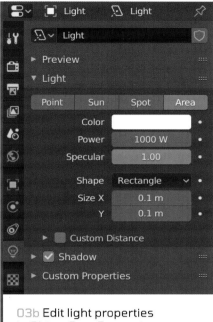

03b **Edit light properties in Object Data Properties**

03a **The four types of light in Blender**

Light size & shadows

It is essential to understand how to achieve hard and soft shadows. For that, you have to play with the size of the light emitter. The larger the size of the light, the blurrier the shadows are; the smaller the size of the light, the harder the shadow.

For the key light and rim light in the scenario shown in image 04, hard shadows are cast by small lights. For the fill light and bounce light, soft shadows are cast by medium or large lights.

04 **The size of the light affects the hardness/softness of the shadow**

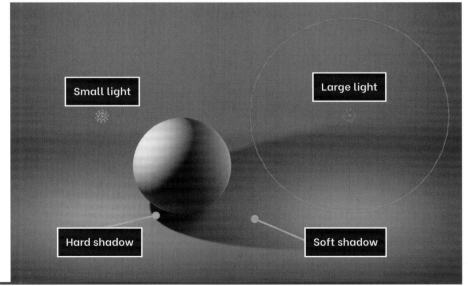

Small light

Large light

Hard shadow

Soft shadow

Light temperature

To talk about light is to talk about temperature. With a Kelvin-based color temperature chart, you can choose the temperature for each light. A low number gives a warm color and a high number gives a cold one.

To experiment with light temperature in Blender, add a UV Sphere in **Object Mode** and set the Viewport Shading to **Rendered**. Ensure you have the light object selected in **Object Mode**. Select the **Cycles** render engine in the **Render Properties** tab of the Properties Editor, go to the **Nodes** section of the **Object Data Properties** tab and click **Use Nodes**. Click on the round button next to the in the **Color** field, which will bring up a range of options; select **Blackbody**, which is found in the **Convertor** list (image 05a). You can then increase or decrease the number in the **Temperature** field. Images 05b–05e show a range of different temperatures.

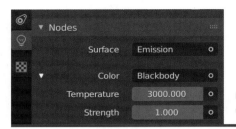

05a You can select the Blackbody option from Nodes > Color field

05b Blackbody Color 2000 Kelvin

05c Blackbody Color 4000 Kelvin

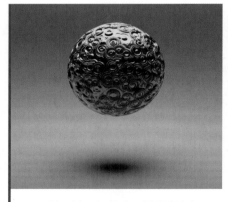

05d Blackbody Color 5000 Kelvin

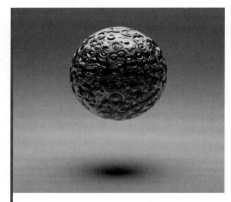

05e Blackbody Color 7000 Kelvin

HDRIs

A **high-dynamic-range image (HDRI)** is a 360° image map file that emulates the illumination of an environment. By using an HDRI (many of which are downloadable for free online), you can achieve much more realistic lighting and fine reflections; this is an effortless way to illuminate a scene and is an easy way for a beginner to achieve outstanding lighting results.

To use an HDRI, go to **World Properties** in the Properties Editor and click the small circle on the left-hand side of the **Color** field in the **Surface** section. Select **Environment Texture** from the options, then Open to choose an HDRI (**image 06a**).

To see the HDRI in real time, toggle the **Material Preview Viewport Shading** option in the Header and ensure

Scene World is selected from the **Viewport Shading** dropdown menu (**image 06b**). To be able to rotate it you need to open the Shading workspace; in the **Shader Editor**, select **World** from the dropdown in the Header (**image 06b**).

Select the **Environment Texture** node (this will be brown and have the name of the HDRI in) (**image 06b**) and if you have the **Node Wrangler** add-on activated, use the shortcut **Ctrl + T**; this will automatically add the **Texture Coordinate** and **Mapping** nodes.

In the **Mapping** node, you have X, Y, and Z values. If you want to rotate the HDRI, horizontally edit the **Z** value. You will learn more about the Shader Editor in the next section.

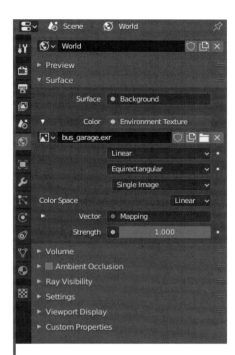

06a You can add an HDRI in the World Properties panel

06b The HDRI render and the Shader Editor. HDRI used from HDRI Haven (hdrihaven.com)

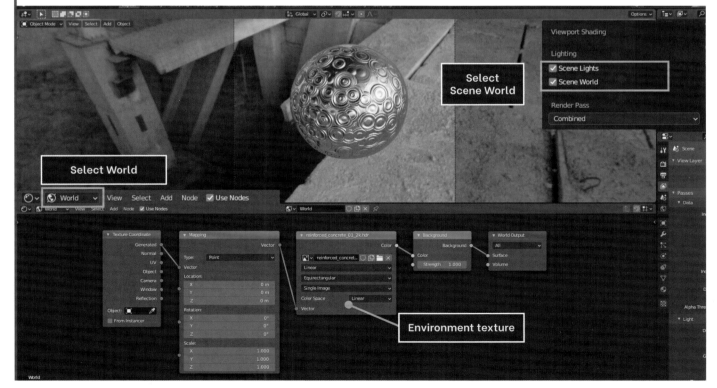

157

Materials

Shading workspace

The Shading workspace (image 07) offers tools for defining material properties. As you learned on page 41, this workspace has two main areas: the **Shader Editor** at the bottom, where you can edit your materials, and the **3D Viewport** at the top, where you see the results of what you do in the Shader Editor. To move around inside the Shader Editor, hold the **MMB** to pan and scroll the mouse wheel to zoom.

07 Shading workspace

Shader Editor

The Shader Editor relies on a **node system**, which offers a visual representation for texturing. Each node – that is, the rounded boxes housing different properties – has inputs and outputs called **sockets**. These can be four different colors:

▶ **Gray** to designate a numerical value.

▶ **Blue** to indicate a vector or coordinate.

▶ **Yellow** for color information.

▶ **Green** to indicate that is a shader (see next page).

To connect two nodes, you would left-click on one node's socket and drag to the node's socket that you want to connect to.

To test how these nodes work, first, create a basic mesh to work with as follows. In **Object Mode** in the 3D Viewport, use **Shift + A** to add a cylinder with 32 vertices. Make sure you have the cylinder selected in the

3D Viewport and then click on the **Shading** tab on the Topbar to open up the Shading workspace. You will see your cylinder in the 3D Viewport at the top and an empy Shader Editor below.

To add a material, select the cylinder, go to the **Material Properties** panel of the Properties Editor and press the **+ New** icon (image 08a). You will notice that a **Principled BSDF** node and a **Material Output** node appear in the Shader Editor.

08a Click the + New button to add a new material

To get the most out of the Shader Editor, ensure that you have activated the **Node Wrangler** add-on that is pre-installed in Blender (see page 30). This add-on includes shortcuts that speed up the process of adding nodes. For example, to add an **Image Texture**, select the **Principled BSDF Shader** node and use the shortcut **Ctrl + T**. Three nodes are added

automatically: **Texture Coordinate, Mapping**, and **Image Editor** (image 08b). These nodes give you more properties to control the image. We will edit some of these properties over the coming pages so you can see their effect on the cylinder. To move a node, simply click and drag.

SHADER EDITOR SHORTCUTS

Cut Link	Ctrl + RMB Drag
Connect Nodes	F
Duplicate Connected	Ctrl + Shift + D
Mute Node	M

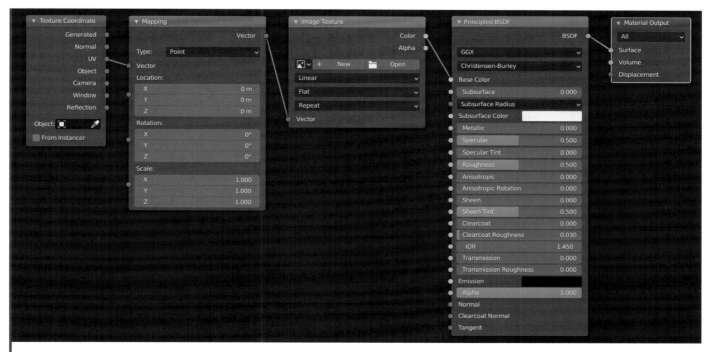

08b Connected nodes added with Ctrl + T

Principled BSDF

Let's take a look at some of the different types of node in more detail. The most important node is the **Principled BSDF** node (image 09). This is a **shader** used to texture physically correct materials. It uses the **Metal/Roughness workflow,** in which you have to specify the color, whether it is metallic or not, and the roughness of a basic material. This node is based on the shader created by Disney.

As you will notice in the Shader Editor, objects with a material in Blender utilize the **Principled BSDF** shader by default, which has multiple layers and helps in the creation of materials, keeping it simple. With this shader, you can create all of your materials.

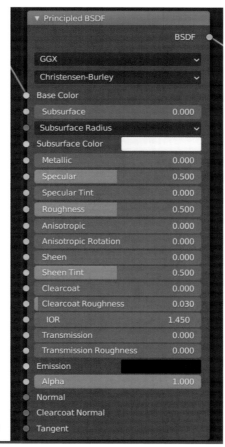

09 The Principled BSDF node

MATERIAL OUTPUT

Note that a **Material Output** node is always needed to affect the material.

SHADERS

A shader is a mathematical function, packaged in a node, that defines how a material will interact with light. Keep in mind that different shaders use different mathematical models.

Commonly used inputs in the **Principled BSDF** shader are described in the table on the right. Each of these inputs uses values, whether they are simple 0 to 1 values or groups of values like color (made of red, green, and blue values). To explore the effects of these, change some of their values in the shader. If you are still in the Shading workspace, you will be able to see the impact on the material preview of your cylinder in the 3D Viewport.

It is very common to use textures or "maps" as these inputs. The texture (picture) value is read by these inputs and converted into material information. You will find out more about this technique in the Maps section on page 162.

BASE COLOR	Defines the base color of the material; composed of diffuse reflected color (albedo) and metallic reflectance values.
SUBSURFACE	Where white is translucent, and black is opaque. Light goes through a subsurface material at multiple irregular angles and "scatters" before leaving it. This is useful for shading translucent subjects such as skin, leaves, and wax.
METALLIC	A value that drives whether a material is metallic or not using a 0 to 1 value. It can be driven by a black and white mask, where black is 0 and white is 1.
ROUGHNESS	Represents micro-surfaces, where 0 values are mirror-like and smooth, and values close to 1 are rough.
TRANSMISSION	Allows you to decide whether you want a material to be translucent like glass, or opaque.

MAPS/TEXTURES

Any output in Blender except the shader output (green) can be used to drive any other input. Everything is just value information. If you take an image, for example, it is a combination of red, green, and blue values that generally range from 0 to 1 (it can be beyond these values). This means you can use a color to drive a numeric value – this is why you can use black and white maps, or even colored maps, to drive numeric inputs such as **Metallic**, **Specular**, **Roughness**, and so on. This is something used in all 3D software and pipelines.

Other nodes

You can also add specific nodes using the shortcut **Shift + A**, for example nodes focused on textures, colors, or effects. There is an extensive list of nodes, but the essential ones are:

▷ **Texture Coordinate**
Used to decide what type of coordinates to use, in conjunction with a **Mapping** node, which transforms the input by applying location, rotation and scale.

▷ **Principled Volume**
Can be used to create smoke and fire.

▷ **Image Texture**
Allows you to use an image as a texture.

▷ **Environment Texture**
Allows you to use an HDRI to illuminate the scene.

▷ **Color Ramp**
Allows you to generate gradients. It also acts as a level filter, converting a value from 0 to 1 into whatever color you want.

▷ **Material Output**
Allows you to output surface material information to a surface object. This one is a must-have; if you don't have this node or anything connected to it, your object will be rendered black without any light interaction.

With these, you can begin to create materials, but you should experiment with the other nodes as well.

NODE WRANGLER SHORTCUTS

Image Texture Setup	Ctrl + T
Swap Links	Alt + S
Switch Node Type	Shift + S
Mix Nodes	Ctrl + 0
Add Nodes	Ctrl + (+)
Subtract Nodes	Ctrl + (-)
Multiply Nodes	Ctrl + (*)

VIEWING THE RENDER

You can view materials anytime in the 3D Viewport even if you aren't in the Shading workspace. Being able to see the textures in real time speeds up the creation of materials. For this, go to the top right of the 3D Viewport, and choose **Material Preview** from the **Viewport Shading** options, so you can see the material without needing to build a lighting setup, since it provides a default HDRI. You can switch between the eight provided HDRIs through the **Viewport Shading** options.

Alternatively, select **Rendered** to see the textures and lighting at the same time and understand how the final render would look.

This works with the Eevee render engine as well as Cycles, but keep in mind that it can be taxing on the computer, so use it carefully (you will find out more about Eevee and Cycles on page 178).

See the creation of materials and textures in action using the Shader Editor on pages 315–332.

Maps

Maps are image textures (such as PNG or JPG), and with several maps, you can generate a material (Base Color, Metallic, Roughness). Suitable images can be downloaded from texture sites, made in Blender, or made in other programs such as Substance Painter and imported into Blender.

All maps are added as an **Image Texture**, but you will need to specify which **Color Space** each one uses to make them work properly.

▷ The **Base Color** map is where you decide the material's color. This is the only map that uses **Color Space: sRGB**.

▷ The **Metallic** map is a value that drives whether the material is metallic or not using a 0 to 1 value. It can be driven by a black and white mask, as with all value, where black is 0 (non-metallic) and white is 1 (metallic). This map uses **Color Space: Non-Color.**

▷ The **Roughness** map is value driven like the Metallic map. This time a value of 0 is softer (black) and a value of 1 is rougher (white) It uses **Color Space: Non-Color.**

▷ With the **Normal** map, you can create fake "relief" effects on the object's surface, such as bumps and dents that aren't sculpted but are part of the texture. Even though it is a map that uses RGB to represent the XYZ axis, it still uses **Color Space: Non-Color**. It needs to be connected to a **Normal** map node before going into the **Principled BSDF**.

For example, to change the **Base Color**, you can edit the **Image Texture** node that you added with **Ctrl + T** previously. Click on the **+New** icon

in that node, click in the **Color** field an change the color, using the color wheel, and then click **OK**. Your cylinder should now be the selected color in the material preview.

To use a texture created in other software with , click the **Open** tab in the **Image Texture** node and select an image file.

You would then need to connect the socket of each **Image Texture** to the relevant socket on the **Principled BSDF** (for example, the Image Texture you are using as a **Metallic** map would need to be connected to the **Metallic** socket on the **Principled BSDF**). Ensure all textures are connected to the **Mapping** and **Texture Coordinate** nodes (see image 10 as an example).

10 Principled BSDF maps

Alpha maps

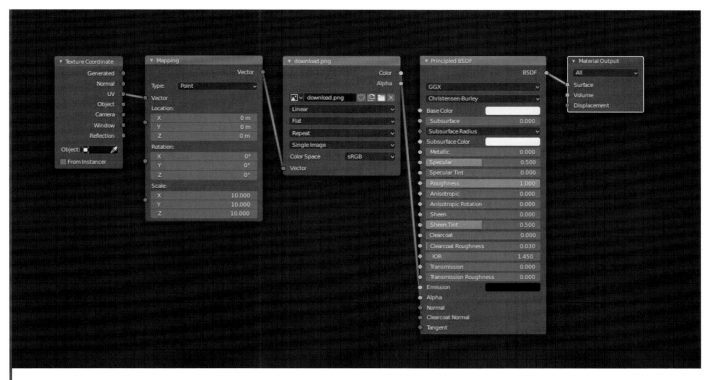

11a The Image Texture node connected to the Alpha layer

With an alpha map, you can decide which areas of the object will be transparent and which will not. You can also determine the amount of transparency using grayscale: the map is black and white, in which areas painted in black will be transparent and white areas will be opaque. Keep in mind that this map affects the light, which means that you will see how the shadows are affected by the alpha map.

The simplest way to use this map is to utilize the **Principled BSDF** shader and add an alpha map that you already have as an **Image Texture** node (**Texture > Image Texture** from the list of nodes), and connect it to the **Alpha** layer (image 11a). Alternatively, you can paint an alpha map in Blender by creating a texture in the **Image Editor** with a white background to make it opaque, using **Texture Paint Mode** to paint the parts you want transparent black (image 11b; learn more about texture painting on pages 170–173).

You can also add a **Color Ramp** between the **Image Texture** node and the Alpha socket of the **Principled BSDF** shader to sharpen the edges of the map.

11b The effect of the alpha map using Cycles Rendered view

163

Grouping nodes

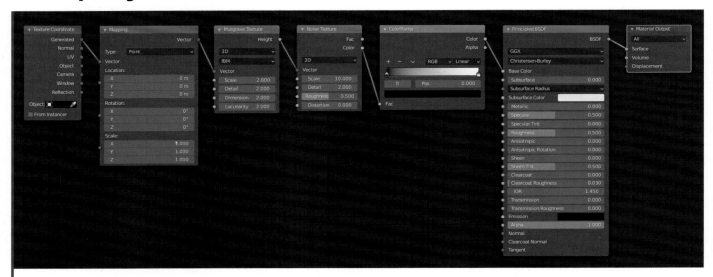

12a Before the node group is created

When you have a lot of nodes (image 12a), it becomes very tedious to make small changes. To simplify things, you can group different nodes into one.

To use node groups, select the nodes you want to group (hold **Shift** while left-clicking to select multiple nodes) and use the shortcut **Ctrl + G**. This changes the background of the Shader Editor to green and adds two more nodes: **Group Input** on the left and **Group Output** on the right (image 12b). You can drag sockets to the **Group Input** node to be able to view them outside the group, and by using the shortcut **N**, you can change the names of each socket in **Node > Interface**. To exit or enter the node group, click on **Tab** (image 12c).

Out of the node group but with it selected, use the shortcut **N** again to access the option of changing the **Node Label** and **Color**.

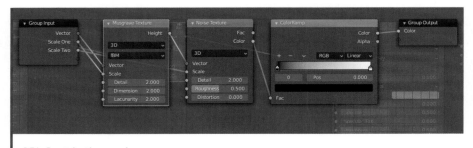

12b Inside the node group

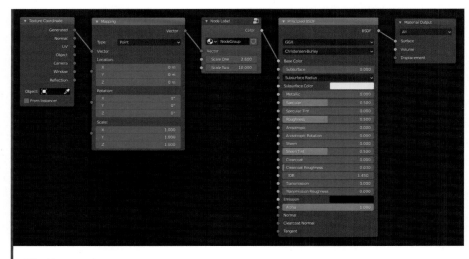

12c New node group

UVs

Overview

UV mapping is the process of projecting a 2D image onto a surface of a 3D model. UVs are an essential step in creating a 3D project because if they are poorly made, it will ruin a great model. The process of creating a UV map is called **unwrapping**, because you are basically unwrapping the outer surface of a model – see image 13 as an example of a cylinder and its UV map.

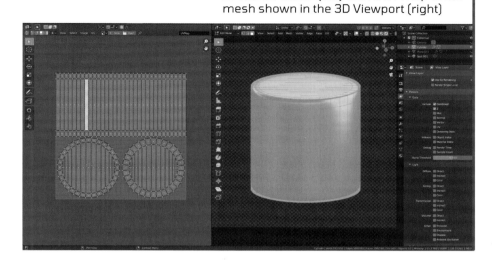

13 The UV Editor (left) with a UV map of the mesh shown in the 3D Viewport (right)

UV Editor

For the UV unwrapping process, it is necessary to use the **UV Editor**, where you can map the faces, edges, and vertices of the mesh on a flat image. It is better to use the UV Editor when you have the final model ready, to avoid doing the same process multiple times.

The UV Editor is empty by default, so you will need to have an unwrapped mesh, which you will learn how to create on the next page. The UV Editor's Toolbar has a number of tools to allow you to transform the UVs, as well as tools such as **Pinch**, **Grab**, and **Relax**. These all help to fit the UV map better to the object (as if you were smoothing out a piece of cloth and allowing it to fold in certain areas).

The UV Editor also has four types of selection modes: in the top left of the Header. From left to right, you have selection by **Vertex, Edge, Face,** and **Island**.

Use the **N** shortcut to see the Sidebar region. Here you will find the UV add-ons and essential tools such as **View > Overlays > Display As**, where you can select the overlay through which to see the model (image 14). Select **Modified** to preview the UVs with the active modifiers. You can also check **Stretching** to detect UV distortion (see page 167).

14 Display options

UV EDITOR SHORTCUTS	
Vertex selection	1
Edge selection	2
Face selection	3
Island selection	4
Move	G
Rotate	R
Stitch	Alt + V
Unstitch	V
Select All	A
Select UV Island	L
Zoom	Mouse wheel
Pan Viewport	MMB

How do you unwrap a mesh?

This process requires a few steps. Go into the UV Editing workspace so that you can view the 3D Viewport and UV Editor at the same time.

Using the cylinder you created on page 158, go to **Edit Mode** and use **Ctrl + R** to add edge loops close to the top and bottom of the cylinder, similar to those shown in image 15a. Select all the faces, and apply **Shade Smooth**.

Now you will need to mark seams on your mesh so that Blender knows how to unwrap the model. Think of it as if you want to cover the object with a piece of cloth – how would you need to cut that cloth so that it could be stitched together to create the correct shape? In the case of the cylinder, you would need one seam to attach the top face to the main body, one to attach the bottom face, and another cutting the main body in two.

In **Edit Mode**, mark the seam of the top face of the cylinder by selecting its edge loop (remember you can **Alt + left-click** on one edge) and then using the shortcut **U > Mark Seam**. If you make an error you can use **U > Clear Seam**. Do the same for the seam for the bottom face and for one vertical seam down the side of main body (image 15a).

Then select all the faces of the mesh and use the shortcut **U > Unwrap** to unwrap the mesh (image 15b). The selected parts of the mesh will then be displayed in the UV Editor (image 15c).

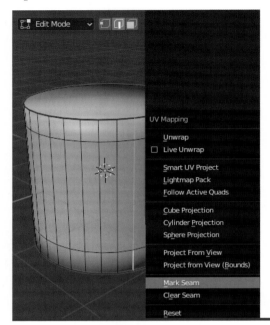

15a Mark seams using U > Mark Seam

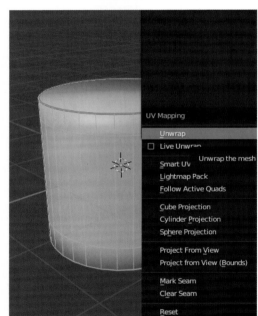

15b Select all of the object and use U > Unwrap

TILE SETS & ISLANDS

The tile set is the 2D area in which there are the UV islands. Each separate area in the tile set is called a UV island. For example, in image 14 of the cylinder, there are three islands.

It is possible to change the settings of the unwrap, and there are two methods: **Angle Based** or **Conformal**. Always try both to see which has the best result.

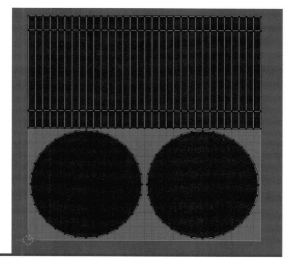

15c The cylinder's unwrapped UV in the UV Editor

Tips for UVs

A good UV is one that isn't distorted and which follows the structure of the object in a coherent, efficient way. To achieve good UVs, keep in mind the following key points.

All Transforms

Always apply **All Transforms** before working with UVs by pressing **Ctrl + A** in **Object Mode** and selecting **All Transforms** (image 16a), or by going to **Object > Apply > All Transforms** in the 3D Viewport Header. This will help you to avoid incorrect scale.

Seams

Seams can result in "texture offset", where the seams between textures are too obvious, so you should **hide the seams** as well as possible by selecting places that are less visible. For example, on a character you would try to add seams between the jaw and neck, behind the ears, or under the hair so that they don't show too much when viewing the character.

Stretching

Prevent or at least **minimize UV stretching,** otherwise any texture applied to the character or object will become deformed and look uneven or unnatural.

To see if UVs are stretched, go to the **View** section of the Sidebar in the UV Editor and activate **Display > Overlays > Stretching** (image 16b). Select **Area** in the **Type** option. You will now be able to see the areas that are not stretched (in blue) and the areas that are stretched (in warmer colors; image 16c). To fix a stretched UV, you will need to relocate the seams and redo the unwrapping.

16a Apply All Transforms

16b Display Stretching

Texel density

Aim to have the same **Texel Density** in all objects so that all their textures have the same resolution. You can find out more about this on pages 311 and 314.

Spacing

Prevent UV islands from being too close together and have at least small spaces between them (see image 16d versus image 16e). This is important because if you have overlapping UVs, painting on one area of your model will also paint on another. The texture will bleed from one island to the other, creating a texture artefact. To move an island, simply select it in the UV Editor using the **UV Selection Mode: Island** option in the Header, and use the **G** key to move it.

Organization

Try to have an **organized layout** to make it easier to understand the tile set. Although there is no exact way to organize the UV islands, the goal is to make it easy to know which area of the 3D model each island relates to.

16c A UV map with stretching – indicated in green

16d The UV islands are too close here

16e The UV islands with more space between them

UV grids

A **UV grid map** is essential to see the quality of your UVs. In Blender, it is possible to create two types of grid map: a checkered pattern in black and white, and another in color which includes characters that help to show the orientation of the UVs.

To generate one of these images, go to the UV Editor and click on **New** in the Header. This will open the **New Image** options (image 17a). You can choose the name, size, and **Generated Type** for the image – either **Blank**, **UV Grid**, or **Color Grid**. Select **UV Grid** and click **OK** – a checkered grid will appear in the UV Editor (image 17b).

To see the map on the model, select the mesh and go to the Shader Editor. Select **New** in the Header to add a **Principled BSDF** node and a **Material Output** node. Now, if you have the **Node Wrangler** add-on installed, you can use the shortcut **Ctrl + T** (with the **Principled BSDF** node selected) to add the nodes shown in image 17c. In the **Image Texture** node, choose the name of your created UV grid map from the dropdown next to the image icon. Ensure you select the **Material Preview** button from the **Viewport Shading** options in the Header of the 3D Viewport. You should now see the grid map on the object in the 3D Viewport (image 17d).

If you have some distortion, you can fix it by changing the placement of the seam (using **U > Clear Seam**, marking a new seam, and then unwrapping again).

17a New Image dialog box

17b UV grid map

17d The grid map on the cylinder

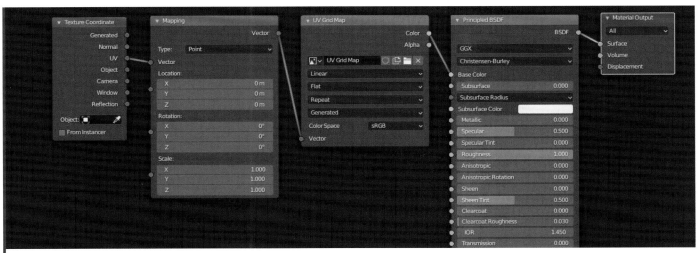

17c UV grid map as the Base Color

Texture painting

Editing an image

Once you have UVs, you can start texture painting a model. In the Image Editor you can edit 2D images that you might use on your UV map. If you select **Paint** from the **Mode** options in the Image Editor, you will have the same tools available in the Toolbar as in **Texture Paint Mode**.

If the Image Editor is empty, you will see two options in the Header:

▶ **New**, where you can create UV grids (selecting size and background color); and

▶ **Open**, to select a pre-existing image to use. You can also drag and drop an image into the **Image Editor** and achieve the same result.

To try out the functions of the Image Editor on your cylinder, go to the Texture Paint workspace and set the **Viewport Shading** to **Material Preview** in the 3D Viewport.

First, in the Image Editor, remove the UV Grid you added previously. Then click **New**, choose a color in the **Color** field, set the **Generated Type** option as **Blank**, and give the image a name. Click **OK**. Then, go to the Shader Editor and change the source in the **Image Texture** node to use the image just created.

Now return to the Image Editor and change from **View Mode** to **Paint Mode** in the top left of the Header. You will now be able to paint on the UV area and see the changes on your model in the 3D Viewport.

Instead of creating a new image, you could also use **Open** to add a texture. Select the image from the image browser in the Image Editor and change the source in the **Image Texture** node in the Shader Editor as you did before. Images 18a and 18b show a photo texture added to the cylinder.

USE SQUARE IMAGES

UV maps use a square space so it is recommended that you use square images as textures. While it is not mandatory, this is common practice in the industry.

18a An image texture added in the Image Editor

18b The texture on the cylinder in the 3D Viewport

Texture Paint Mode

Once a texture has been added to an object as described on the previous page, you can also use **Texture Paint Mode** in the 3D Viewport to paint directly onto the 3D surface. Once in **Texture Paint Mode**, you will see that in the **Brush Settings** section of the Sidebar's Tool tab (image 19a) you can choose the size and strength of the brush with **Radius** and **Strength**. These two settings have the option of using tablet **Pen Pressure**, which means if you are using a tablet and stylus, you can determine the radius and strength of your brushstrokes through the pressure you use.

19a **Brush Settings** in the Tool section of the Sidebar. These settings are also available in the Active Tool and Workspace Settings panel in the Properties Editor

PINK OBJECTS?

If you go straight to **Texture Paint Mode** without having added a material, you will notice that the object is pink because it has no texture. To fix this, go to the **Tool › Texture Slots** section of the Sidebar and click the **+** button. Choose the texture type you want to work on from the dropdown (such as **Base Color**) and Blender will automatically create a new material if you don't have one and connect the texture in the correct material socket in the Shader Editor.

Use Texture Slots to quickly create a material if you don't have one

TEXTURE PAINT SHORTCUTS

Radius	F
Strength	Shift + F
Copy Color	S

You can also choose colors in the **Color Picker** section and the behavior of the brush in the **Stroke** section.

If you go to the **Stroke Method** dropdown options you can choose one of the following options described in the table on the right:

SPACE	The stroke is a series of points. You can decide the distance between them by adjusting the **Spacing** value. You can also use **Stabilize Stroke**, which gives a slight delay to the stroke, making it easier to handle.
DOTS	The stroke is very similar to the Space setting, but without the Spacing option. You can use **Jitter** to generate a series of points with an unsteady line.
DRAG DOT	Creates a point which you can drag and position wherever you want.
AIRBRUSH	Adds points while the mouse button is pressed, even if the cursor remains in the same place. The **Rate** field with this method lets you decide how fast to add each point; with **Jitter** you can determine if you want the position to change every time a new point is added.
ANCHORED	Allows you to create a point, but the more you pull, the bigger it becomes.
LINE	Allows you to make a straight line, with the options of **Spacing** and **Jitter**.

The Header also provides easy access to many tool settings.

Finally, you will see the different painting tools in the Toolbar (**image 19b**):

▶ The essential brush is **Draw**, which allows you to paint.

▶ With **Soften**, you can create a blur effect.

▶ With **Smear**, you can blend the colors under the cursor.

▶ **Clone** allows you to copy the area where the cursor is; first, position the cursor with **Ctrl + LMB**, and then start to clone with the **LMB**.

▶ **Fill** allows you to fill the object with solid color.

19b The Toolbar in Texture Paint Mode

With these tools, you can paint directly on the model in the 3D Viewport. To see only the map you are modifying you have to be in the **Viewport Shading** mode **Solid**; after finishing painting, you can see all the maps at the same time if you go to **Material Preview** in the **Viewport Shading** options.

TEXTURE SLOTS

In **Texture Paint Mode**, **Texture Slots** allow you to choose on which texture you are currently painting and to switch between these maps directly in the Properties Editor instead of going into the Shader Editor and selecting the right texture node. See Texture Slots in action on page 197.

SAVING IMAGES

You need to manually save each image created with Texture Paint, otherwise when you close the program it will ask you if you want to save the modified images, which are the ones you textured. If you do not save them, when you reopen the scene, the textures will be deleted. Keep this in mind and don't lose the work completed and time invested in making your textures. To save a Texture Paint image, go to the Image Editor and choose the texture you made in the image browser. You can save the image you see in the Image Editor by going to **Image › Save As**.

Vertex Paint Mode

With **Vertex Paint**, you can paint colors directly onto an object using vertices. The resolution depends on the number of vertices the object has – the more vertices, the more detail you will be able to paint. The color will automaticaly blend from one vertex to another. Usually, to paint an object, you must have a UV map, but with this method it is not necessary. There are four tools in the Toolbar (image 20a):

20a The Toolbar in Vertex Paint Mode

▶ **Draw**, being the most crucial, allows you to paint the areas with the color you want.

▶ **Blur** to blend different colors.

▶ **Average** makes a blend with the average color.

▶ **Smear** drags color from one area to another.

Simply paint along the object's vertices, as shown in image 20b.

20b An object painted using Vertex Paint

You can edit brush settings in the Header and **Active Tool and Workspace** panel of the **Properties Editor**, again with settings such **Radius**, **Color Picker**, and **Stroke** (image 20c).

You can apply a single color to the whole object by going to **Paint** in the Header and selecting **Set Vertex Colors** or using the shortcut **Shift + K**. To invert the colors of the object use **Paint > Invert**.

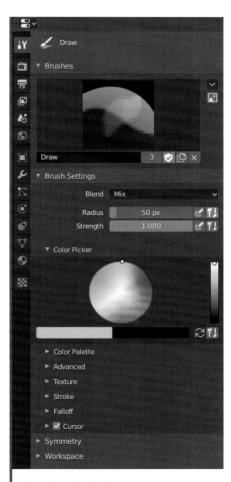

20c Brush Settings

Procedural textures

Overview

Procedural textures are textures defined by mathematical formulas rather than hand-painting. These procedurally generated textures range from simple to very complex. Using this type of texture has some advantages, such as lower memory usage, unlimited resolution, seamlessness, and the ease of not needing to have UV mapping to work correctly. The only downside of using this method is that it can be difficult to achieve appealing results. You need to invest more time to get the best out of procedural textures.

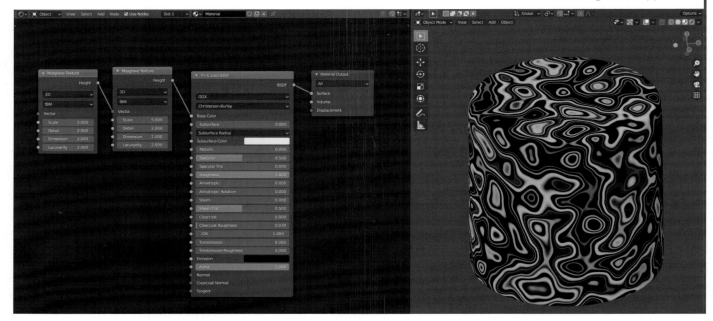

21 A procedural texture – Musgrave – applied

Examples

Blender has several procedural textures. To see the complete list, go to the **Shader Editor** and use the shortcut **Shift + A > Texture**. Procedural textures can be attached to any socket. The socket you put one into will impact the effect it generates.

Each of these textures uses a different mathematical pattern to achieve specific effects. However, not all the options are procedural textures.

22a Procedural Textures menu

Below is a list of the essential procedural textures and how they behave.

If you have the **Node Wrangler** add-on activated, you can use the shortcut **Ctrl + Shift + LMB** on a node to see a specific texture node in the 3D Viewport.

Brick Texture
Creates brick patterns. You can also use it as a base to create wooden floors and much more (image 22b).

Checker Texture
Creates a pattern of black and white squares (image 22c).

Magic Texture
Creates a texture with psychedelic colors (image 22d).

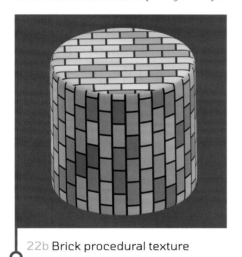

22b Brick procedural texture

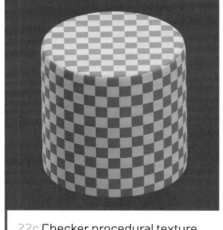

22c Checker procedural texture

22d Magic procedural texture

Musgrave Texture
Generates noise using the fractal Perlin pattern (image 22e).

Voronoi Texture
Generates noise, but using the Worley pattern (image 22f).

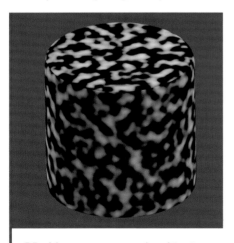

22e Musgrave procedural texture

22f Voronoi procedural texture

NOISE ALGORITHMS

Perlin noise is a mathematical algorithm for generating noise invented by Ken Perlin in 1983. Worley noise is another mathematical algorithm created by Steven Worley in 1996. Both are used in computer graphics to create procedural textures.

Particles

Overview

A particle system serves to represent elements such as hair, grass, fire, and smoke. The system emits a large number of objects from a mesh (**image 23**), and these can be influenced by movement, gravity, air, collisions with other objects, and many other variables. A mesh can have multiple particle systems, but the maximum number depends on the size of the computer's memory.

23 An example of a particle system

Creating a particle system

To create a particle system, you must first choose a mesh that will be the **Emitter**. For this example, use **Shift + A > Mesh** in **Object Mode** to add an IcoSphere (**image 24a**). Then go to the **Particle Properties** tab of the Properties Editor and click on the plus (+) sign (**images 24b** and **24c**). The particles are emitted at a specific time, so to see the particles it is necessary to move the frame on the timeline – simply slide the blue frame marker along the timeline at the bottom of the screen.

24a The basic IcoSphere, which will be the emitter

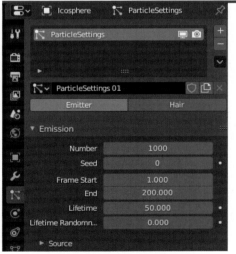

24b Particle system settings

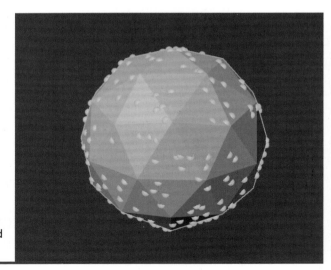

24c A particle system added to the emitter

There are two types of particle system in Blender:

▷ **Emitter**, which generates animated particles over time; and

▷ **Hair**, which generates static particles that can be use to make elements such as hair, fur, and grass. The strands can be then deformed or animated.

Each system has different settings. If you choose **Emitter**, you can decide:

▷ the maximum number of particles with **Number**;

▷ in which frame it starts to emit with **Frame Start**;

▷ when it stops emitting with **End**; and

▷ the lifespan with **Lifetime**.

As mentioned, particles can also collide with other objects: to enable this, go to **Physics > Deflection** and check the **Size Deflect** option.

Keep in mind that the objects you want them to collide with will need to have the **Collision** option activated in the **Physics Properties** tab. If you want to use an object as a particle, go to **Render > Render As > Object** in the **Particle Properties** tab. Then select the object in **Render > Object > Instance Object** (image 24d).

If you choose **Hair**, you can see that it has similar options, such as **Number**, but also **Hair Length**. To edit these particles, go to **Particle Edit** mode in the 3D Viewport and you will see that the Toolbar has different options for styling the hair particles.

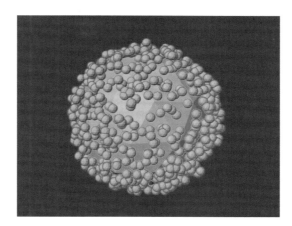

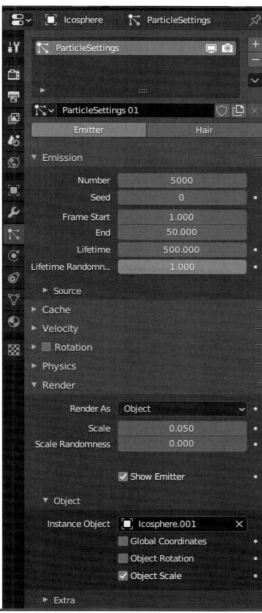

24d You can use an object as a particle in the Render section

See particles in action on pages 198–206 and 332–336.

Renders

Overview

As you learned on page 41, you can create a render of your 3D scene by pressing the **F12** key. This will generate an image that appears in a new window by default. You can preview the rendering in the **Rendered Viewport Shading** mode in the 3D Viewport.

There are many elements to take into account before you render an image, so this section will look at the different considerations required.

Blender has three render engines:

▷ **Eevee** is a real-time render engine.

▷ **Cycles** is a ray/path tracer – a render engine that follows all light paths in a scene to achieve a more realistic global illumination.

▷ **Workbench** is used for layouts and previews.

Each engine has different features, although some features are found in all.

The Cycles and Eevee render engines use the **physically based rendering (PBR)** workflow, through which it is simpler to produce photorealistic-looking images. This workflow also uses less texture memory. Within the PBR workflow. The shaders you make will work on both engines, meaning you can use Eevee to preview in real time and use Cycles for the final render.

Eevee

Eevee is a real-time, physically correct rendering engine, and uses a technique called **rasterization** to turn electronic data into images. Although it still does not deliver the realism of a ray-tracing engine like Cycles, it is very compelling.

The most significant benefit of this engine is the rendering speed, but the downside is that it requires multiple methods to emulate realistic lighting.

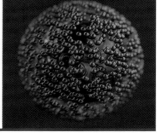

25 An example of an Eevee render

Cycles

Cycles is a **physically correct** or **unbiased** production render engine. It can render using the **CPU**, **GPU**, or **both** at the same time. It uses the **ray- or path-tracing** method to achieve a more realistic global illumination by calculating all the light bounces in a scene; the more rays of light, the more convincing the render, which

you measure in **Samples**. This render engine is an excellent option for a beginner due to its simplicity. Being unbiased makes it simpler to control settings and achieve better results, compared to biased render engines.

26 An example of a Cycles render

Render Properties

Let's now take a look at how to prepare a render. You can edit the properties of your render in the **Render Properties** section of the Properties Editor. (The 3D Viewport **Rendered** mode uses the same choice you have selected in **Render Properties**.)

Cycles has simpler settings, so it's easier for beginners. However, **Eevee** is faster, so it's better to use this one in the 3D Viewport.

If you select **Cycles** as the render engine:

▷ in the **Device** field you can choose whether to use the CPU or GPU to render;

▷ in the **Sampling** section, you can set the quality of the render for both the **Render** and the **Viewport**.

▷ in the **Performance** section, you can determine whether the rendering process uses all the threads of the CPU by leaving **Thread Mode** as **Auto-detect**, or choose how many threads to be used with **Fixed**;

▷ in the **Tiles** section, you can also change the size of the tile; generally, it is better to stick to powers of 2 to achieve fast renders (it is recommended that you use tiles from 8 to 32 when using the CPU and from 128 to 512 when using the GPU for better performance).

▷ in the **Color Management** section, choose the **Look** from different contrast options, and change the **Exposure** setting as desired. You may need to play around with these settings to achieve the type of render you want.

If you choose **Eevee** as the render engine, you again have the **Sampling** section where you can select the quality of the **Render** and the **Viewport**. You can also:

▷ activate **Ambient Occlusion** and change the **Distance** value to achieve a result you are pleased with – you may want to carry out tests with different distances to see what works best for each project;

▷ use the **Bloom** section to create a blur effect on the brightest pixels;

▷ enable **Screen Space Reflections** to achieve real-time reflections between objects, improving your scene's realism;

▷ select the precision of the shadows in the **Shadows** section – the bigger the number, the more precise the shadows will be;

▷ apply an indirect light by clicking on **Bake Indirect Lighting** in the **Indirect Lighting** section.

Finally, in the **Color Management** section you can again decide the **Look**.

GPU OR CPU?

There are several ways to render, using only the central processing unit (CPU), using the graphics processing unit (GPU, your computer's graphics card), or both at the same time. Rendering using only the GPU is much faster, but if you exceed the memory of your GPU, it will not be possible to render the image. If you only use the CPU, it is much slower but the memory limit may be higher, meaning you can render a larger scene.

Note that you need to have the CPU/GPU activated in **Edit > Preferences > System** in order to use it in the **Render Properties** panel.

27 Render Properties

Saving out an image

With the Render Properties now set, you can decide the resolution and size you want your image to be in the **Output Properties** panel. If it is a video, select the frames to render with **Frame Start** and **End**.

To save an image out either go to **Render > Render Image** on the Topbar (shortcut **F12**) or go to the **Image Editor** and select the **Render Result** in the image browser (image 28a). Then go to **Image > Save As** (image 28b) or use the shortcut **Shift + Alt + S**. This will give you options for the format of the file and the directory to which you want to save it (image 28c).

Note that the Header of the rendered image window shows the frame that has been rendered, the amount of time the rendering took, and the RAM used during the render (image 28d). This is incredibly useful if you need to assess the time required to render an animation or a higher quality image. Memory usage can be crucial if it reaches your hardware limitation and you know you have more objects to add and be rendered. In this case, you would have to find a way to simplify the scene or upgrade your hardware.

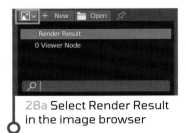

28a Select Render Result in the image browser

28b Image > Save As

28c Saving an image

28d Important information in the Image Editor Header

Turntable animation

If you want to make a **Turntable animation**, activate the **Animation: Turnaround Camera** add-on, which is pre-installed in Blender. This adds a new tab in the 3D Viewport Sidebar called **Animate** (image 29a). Choose the object that the camera will use as a center to rotate around, as well as the frames. Finally, click on the **Turnaround** button, and the animation will be ready to render.

To render a video go to **Output Properties > Output**, choose the folder to save the video out to, and change the **File Format** to one of the **Movie** options. Then go to **Render > Render Animation** (image 29b) or use the shortcut **Ctrl + F12**. Blender will then save out a turntable animation for you (image 29c).

29a The Animate section of the Sidebar". Please could you also add an orange box around the part that says "Turnaround" and "Cube

29b Select Render > Render Animation

29c It's very easy to create your own turntable animation

Post-production

Compositor

After the render is complete, you can apply different effects in the post-production phase. You may be seeking to produce an atmosphere and accent the central part of the image using effects such as color management, vignetting, chromatic aberration, brightness, contrast, and blur. This can be achieved within the Compositor.

The Compositor helps to enhance an image using nodes. The Sidebar provides access to tool properties and also the backdrop that displays the composited image in the background of the Editor

By default, the Compositor will be empty, as it is a node-based Editor as with the Shader Editor. To use it, go to the Viewport Header and select **Compositor** from the **Editor Type** menu and activate **Use Nodes** in the Header. Two nodes will appear (**image 30a**):

▶ **Render Layers**, which is the image you have rendered, and

▶ **Composite**, which is the output that will be saved.

With this, you are ready to add effects between these two nodes.

The **Render Layers** node has some layers by default, but you can add more in the **Passes** section of **View Layer Properties**. Keep in mind that **Cycles** and **Eevee** have different passes options. Use these passes in Cycles as a foundation to post-produce an image. The table on the right summarizes what the different passes do.

30a Use Nodes activated in the Compositor

MIST	Fades objects the farther away they are (image 30b).
DENOISING	Adds a noiseless version of the original image (image 30c).
DATA DIFFUSE	Has different channels for direct, indirect, and pure color light.
GLOSSY	Offers direct, indirect, and pure color reflection.
AMBIENT OCCLUSION (AO)	Generates a version with global illumination (image 30d).

30b **The Mist Render Layer**

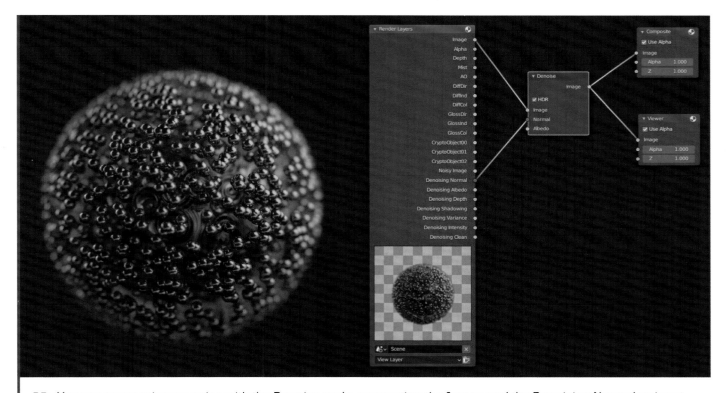

30c You can remove image noise with the Denoise node, connecting the Image and the Denoising Normal as input

30d **The Ambient Occlusion (AO) Render Layer**

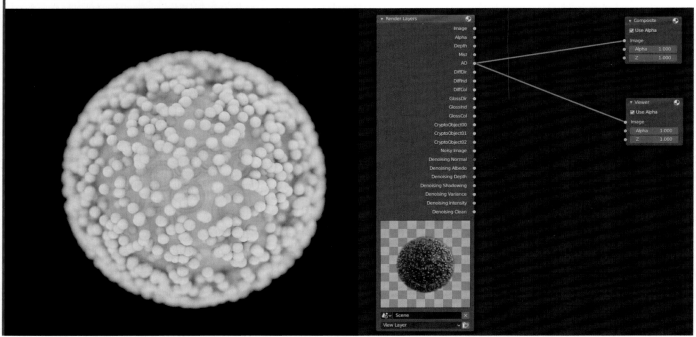

To add nodes in the Compositor, use the shortcut **Shift + A.** The essential ones are **Color > Bright/Contrast** and **Color > Hue Saturation Value**. With **Distort > Lens Distortion** you can add chromatic aberration (image 30e).

30e Chromatic aberration achieved with the Lens Distortion node

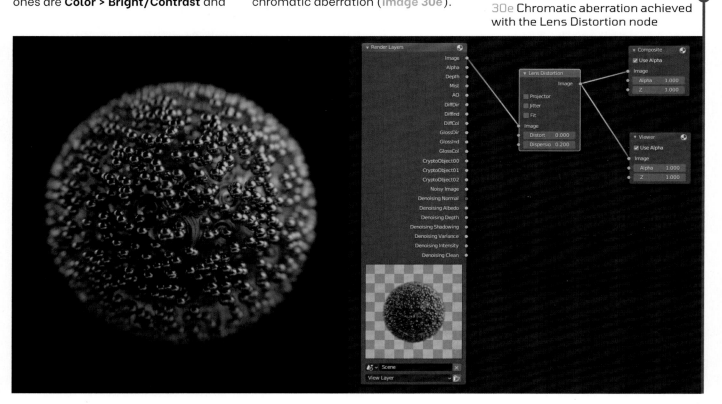

To make combinations between two nodes, use the **Color > Mix** node, which has several types of blend modes, the most used being **Add** and **Multiply**. With this node, join the original **Image** socket and the **Ambient Occlusion** socket, using the blend mode **Multiply** to intensify the global illumination shadows (image 30f).

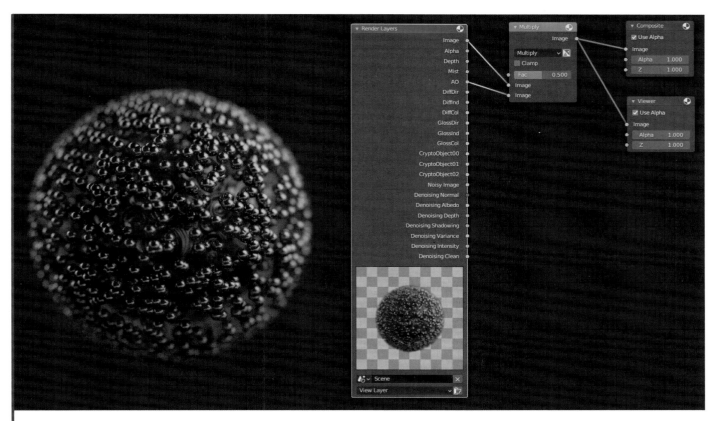

30f Mix node with Multiply blending mode

BLEND MODES

Selecting a blend mode changes the appearance of the image, based on the image it is mixed with. If there is only one image, the blending mode does not have an effect. There must therefore be at least two images to be able to use blend modes. With **Multiply**, the result is the sum of the dark parts of the two images. With **Add**, the high and low values of the image are added, giving a more illuminated image.

Materials & textures in action

By Mike Red

To explore materials and textures in more detail, download the basic model file from the downloadable resources for this chapter. You can then practice unwrapping UVs and add materials, texture, and fur to a base model created by Mike Red in the steps that follow.

You may notice that the Shader Editor is not used in this process. This is because when working on a material, the latest node connected to the surface output will be accessible through the **Material Properties** panel in the Properties Editor, allowing direct access for base editing. This can be a useful way to work when you are working on simple materials without too many nodes.

DOWNLOADABLE RESOURCES

Alternatively, create the model yourself using the full tutorial available in the downloadable resources.

CHAPTER OVERVIEW

▶ Preparation

▶ Materials & textures

▶ Fur

Preparation

01 Planning the UVs

As you learned on pages 165–169, UV mapping involves unfolding the character so that you can paint textures on a plane that is projected in 3D. For this project, create three UV maps: one for the body of the character, one for the clothes and props, and one more for the eyes. Open a new area and select the UV Editor from the **Editor** menu, which will allow you to create and import images within Blender. It is in this panel where the unfolded mesh will be created. **Image 01** shows the character already mapped for reference.

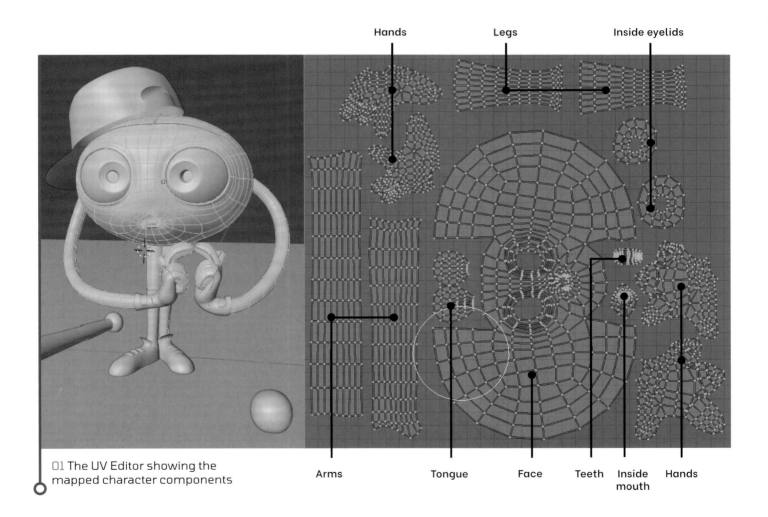

Hands Legs Inside eyelids

Arms Tongue Face Teeth Inside mouth Hands

01 The UV Editor showing the mapped character components

02 Setting up a grid texture

It is a good idea to test how the textures will look on the model as you create the UVs. For that you will need to add a grid image that will allow you to see the flow of the textures on the characters and props. In the UV Editor, click **New** in the Header and select **UV Grid** from the **Generated Type** selector (**image 02a**). A grid will appear over your UV map.

To add the texture to each of the objects, go to the **Material Properties** panel for each one and click the **New** button. Then click the small circle icon next to the **Base Color** option (**image 02b**). Choose the **Image Texture** option from the menu, then select your grid texture from the dropdown image browser on the left-hand side of the **New** button (**image 02c**). The grid texture will now be visible on your model if you are in **Material Preview** mode (**image 02d**). Follow the process with each of the objects.

Ideally, you want a uniform flow of squares without undue stretching. **Images 02d** and **02e** show good and bad examples of the UVs.

02a Create a new grid texture

02b Add the grid texture to the material

02c Select your grid texture from the image browser

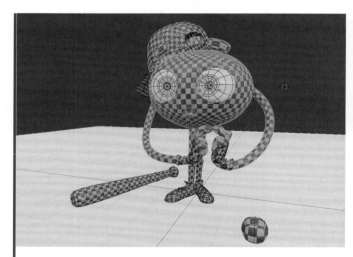
02d Good example of the flow of the textures in the character and props

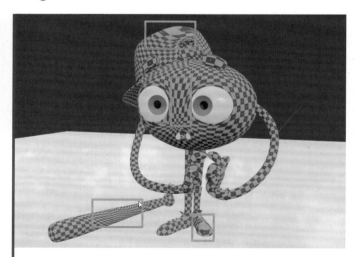
02e Note the stretching and distorted flow of the grid texture in the highlighted areas

03 Marking seams: body & eyes

Now it is time to make the UVs. You need to create seams by using Edge selection in **Edit Mode**, selecting an edge that will function as a seam, pressing **Ctrl + E**, and selecting the **Mark Seam** option. When all the cutting is done, select the entire object you are unwrapping, press **U** (ensuring you are still in **Edit Mode**), and choose the **Unwrap** option. You will then see the UV map in the UV Editor.

Take a look at the image to see how to make the cuts of each object, remembering that all parts of the body must be united. Create seam marks around the eyes, on the arms, hands, legs, and head. Note that you don't have to create seams on the edges of a non-closed mesh; for example, it is not necessary to mark a seam on the open ends of the arms. Remember to add seams to the teeth and uvula as well.

Make sure that the marks are well connected because otherwise you will experience problems when unfolding (**image 03a**). Once all the seams are marked, unwrap by selecting everything in **Edit Mode** and pressing **U > Unwrap**.

As the eye will be mapped separately, you only need two cuts to do the unwrap: one in the middle, and another just where the pupil ends (**image 03b**).

03a Watch out for disconnected lines, because they will cause problems when unwrapping

03b The seams and UV for the eye

04 Marking the seams: clothes & props

To do the UV mapping on clothes and objects, follow the same procedure as on the character. Try to imagine how the clothes and the elements will be stretched so that the seams are in the best possible place (**image 04a**). Take your time; it's a slow process, but the end result of good mapping is a good texture.

You can also make use of the UV Editor tools. At the bottom of the Toolbar are three hands with which you can move, relax, and inflate areas of the mesh. These are very useful for correcting the mesh, for example, smoothing the mesh or changing the direction of the topology so the texture looks more uniform. Any transformations made to the mesh on the UV map do not affect the character's topology, but will affect the way the texture will look (**image 04b**).

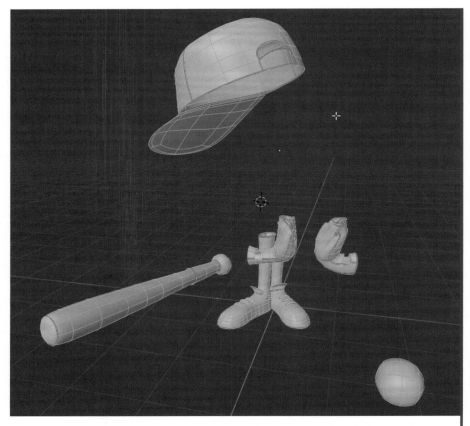

04a Unwrap the clothes and props

04b Use the UV mapping tools to correct the mesh

Materials & textures

05 Adding materials

Adding materials is quite simple: just go to the **Material Properties** panel of the Properties Editor and press the **+ New** button to add a materials slot (**image 05a**). A material called **Principled BSDF** is automatically created, which is a smart material that contains all the properties in a single node. If you go into the **Surface** tab, you can change the type of material that will be specific to the surface. For example, you can control the material's color, roughness, how metallic it is, how specular it is, transparency, and many other very useful options. You can change the name by clicking where shown in **image 05b**.

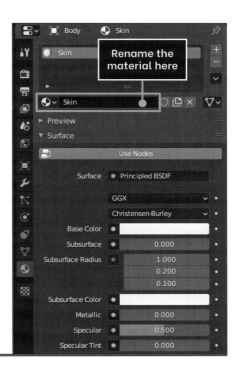

05a Add a new material

05b The Principled BSDF in the Material Properties panel

Create a new material for the creature's skin, clothes, and props. Name each material so it will be easy for you to refer back to it in the next step, for example "Body," "Cap," "Skin" (**image 05c**). Choose a different **Base Color** for each material so that you end up with a similar look to that shown in **image 05d**.

Ensure you are in **Material Preview** mode in the 3D Viewport so you can see the effects of the material (**image 05d**).

You can separate the character's pieces and clothes and add materials separately, or you can also add materials if objects are joined, selecting the entire object and assigning the desired material.

05c Add a material to each item

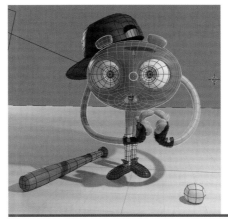

05d The materials with a Base Color set added to the model

06 Creating a texture

Now go to the Texture Paint workspace, which will split the workspace into two, with the Image Editor on the left and the 3D Viewport on the right in **Texture Paint Mode**. Select the body and create a new image by clicking on the **New Image** icon in the Header (**image 06a**), and name it "Skin." The proportions should be approximately 4K x 4K pixels for a better resolution, and the **Generated Type** should be **Blank**. Click **OK** (**image 06a**).

06a Create a new texture in the Image Editor for the skin

In the **Material Properties** panel, select the **Skin** material; you need to change the grid texture (remember that it was only for visualization) to the new texture you have created by selecting it in the **Base Color** image browser (**image 06b**). You should see the change in the 3D Viewport.

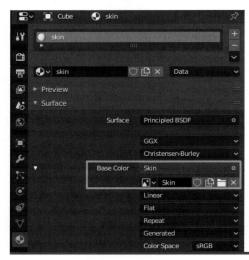

06b In the Material Properties panel, change the grid texture to the Skin texture

In the next step you will begin painting this new texture. The interesting thing is that you can paint in either editor – in the 2D view of the Image Editor or in the 3D Viewport in **Texture Paint Mode**.

07 Painting a texture

Make sure you have selected the objects that the texture is applied to in **Edit Mode** in the 3D Viewport, so that you can see the UV in the Image Editor. To start painting, ensure you are in **Paint Mode** in the Image Editor and **Texture Paint Mode** in the 3D Viewport. You should also have the Sidebar open on the right side of both editors, which will allow you to edit the painting tool properties. Just press **N** on the keyboard to open up the Sidebar. In it you will find the brush with which you are going

to paint, and the color. You can create palettes of colors specific to your character, and you can also create masks.

Begin by painting the whole texture red by selecting the Fill tool in the Toolbar, selecting the color in the Sidebar, and clicking on the image in the Image Editor to fill it (**image 07a**).

You can then paint other colors on top with the Draw tool, using the reference image as a guide (**image**

07b). You can do this either on the 2D image or the 3D model. Adjust the tool's settings to achieve different thicknesses and effects (refer back to page 172 for a summary of the different **Brush Settings**). Remember that most of the character's body is covered in fur, and according to the reference it is not a uniform red color; it has some variations. To achieve this, paint small dots with variations of light and dark red so that the fur looks more realistic and not so flat.

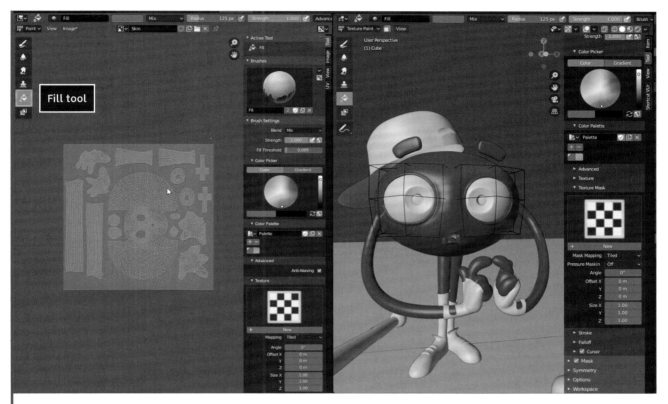

07a Since the character is red, fill the canvas with that color and paint the other colors on top

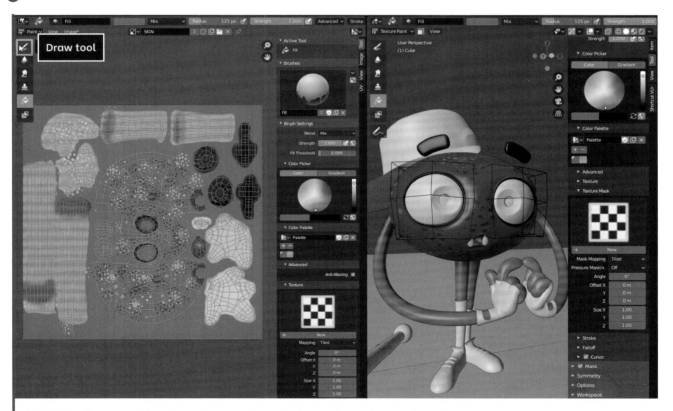

07b Paint the rest of the character, use the painting tools to change the color

08 Clothing & prop textures

To texture the objects, follow exactly the same process that you used to paint the body. Remember that you have already done the UV mapping in step 04 so you can just select the relevant object or objects in the 3D Viewport to work on them. Don't forget to create a texture image for each element and set it as the **Base Color** (**image 08a**).

One of the advantages of using the 3D Viewport to paint is that you can paint small details directly on the objects, such as the wood detail on the bat (**image 08b**).

Note that you will need to save each of your texture images. You can save an image by clicking **Image > Save as** and saving where you want, or by using the **Shift + Alt + S** shortcut.

COLOR PALETTES

If you go to **Tool > Brush Settings** in the Sidebar, there is a subsection called **Color Palette.** To create a palette, click the **New** button. Select the color you want on the chromatic wheel in the **Color Picker** section and use the + and icon to add a color to the palette. Use the - icon to remove a color from the palette. You can also click in the left box below the wheel, which will allow you to use an eyedropper to select a color you want in the 3D Viewport. You can use the color palette to quickly select your chosen colors for your texture.

Brush Settings > Color Palette

08a Follow the same steps as for painting the body to paint the props and clothes

08b You may find it useful to paint some details directly on the 3D surface

09 Texturing the eye

Texturing the eye is very easy because you can use the free texture available with the downloadable resources for this book (**image 09a**). You just have to select the eye in **Edit Mode** in the 3D Viewport and then go to the **Material Properties** panel and set the pupil texture file as the **Base Color** texture. In the UV Editor, select the part that is the pupil and move the mesh in the UV Editor so that it fits (**image 09b**). Make sure the 3D Viewport is set to **Material Preview** mode to see the texture move over the eye.

It is not necessary to render the back of the eye, so place your map in the bottom corner (see the bottom of **image 09b** - you can simply select that part and scale it to the area where the red color is).

Moving on to the cornea object, add a new material in the **Material Properties** panel and call it "Glass." Set **IOR** to 1.050 and **Roughness** to 0, leaving all other settings as they are. When you add materials without textures it is not necessary to create a UV map. The material of the cornea will help to give you light reflections (**image 09c**).

09a The eye texture

09b Apply the texture to the eye using the Material Properties settings shown

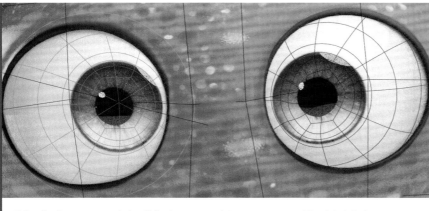

09c A glass material will help you achieve cartoon-like highlights

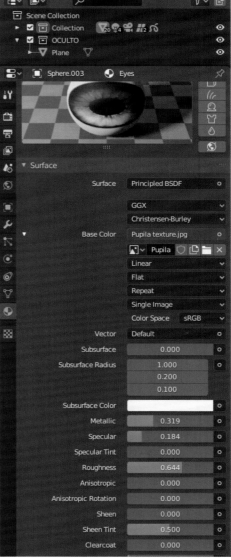

10 Material properties

Once you have finished the textures, you can edit the material properties of each component according to the type of material each object is made from. Each object, as in real life, has its own properties. For example, a glass is transparent and shiny, but a sheet of paper can be matte and unreflective. To create realistic material properties

you will need to separate the character again according to the type of material each component will have (**image 10a**). For example, the eyes, gloves, and bat are shiny, reflective materials. Identify them and then duplicate the material. Make sure you change the name so that it does not affect the other materials.

In the **Material Properties** panel you can modify a range of options according to each object. Looking at the gloves as an example, you can adjust the specularity and the roughness to make them look like leather (**image 10b**).

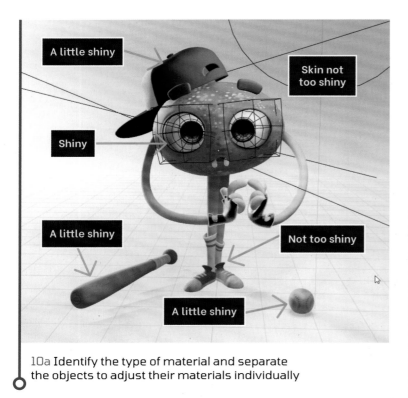

10a Identify the type of material and separate the objects to adjust their materials individually

DUPLICATING A MATERIAL

To duplicate a material, to go to the **Material Properties** panel and press on the icon that looks like two sheets of paper. This will create a copy of the material with the same values. In this way, the texture that you already have is maintained and you can adjust the values just for the new material, for example to increase brightness or specularity. To change the name, simply click on the bar where the name is and change it to find it quickly in the materials library..

Duplicate a material

10b The material properties for the gloves: a slightly reflective, textured material

TEXTURE SLOTS

There are elements that can make textures look a little more detailed and realistic. These are **Normal** maps, bumps, displacement, and roughness. For example, you could add some cracks to the bat or reliefs to the ball or cap. To do this, go to the **Tool** section of the Sidebar in **Texture Paint Mode** and look for the **Texture Slots** option. Press the **+** icon and you will see that you can add different maps to the object.

Choose the **Bump** map. The good thing is that Blender automatically connects the **Bump** map to the **Normal** map of the material. Now paint details, and you will see how when painting you will generate cracks or texture. This happens because the program recognizes white to generate relief and black to generate depth or cracks. For tasks like this it is very useful to use a graphics tablet, but if you don't have one you can also do it using the mouse.

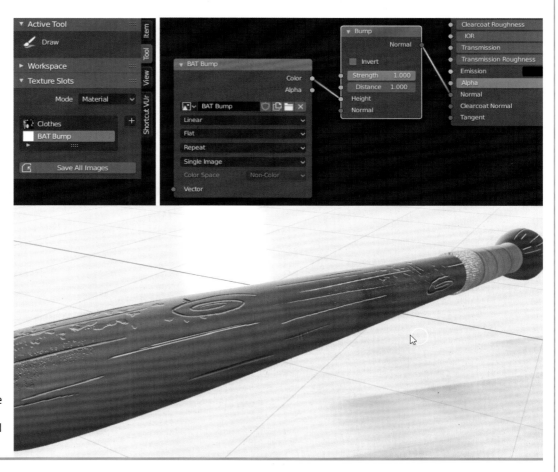

You can use the Bump map to add more detail to an object

197

Fur

11 Vertex groups

To add fur to the character, the first thing you must do is select the area where you want the fur to appear; otherwise it will appear in places where you do not want it, such as the eye area or the inside of the mouth (**image 11a**).

To set where the fur appears you need to create vertex groups. Vertex groups will tell Blender that the fur should only grow from the polygons you have selected. Go to the **Object Data Properties** section of the Properties Editor and, in the **Vertex Groups** section, create two groups by clicking the **+ icon** on the right: one for the head and the other for the face area. Double click on the group to rename (**image 11b**).

With one of the groups selected, go to **Edit Mode** and use **Face Select** to select the areas you want to grow fur for the head. You can also press the **C** key and click to select circular areas (press **Esc** to leave this tool). Once selected, press Assign underneath the **Vertex Groups** section in the **Object Data Properties** panel. Do the same for the face group.

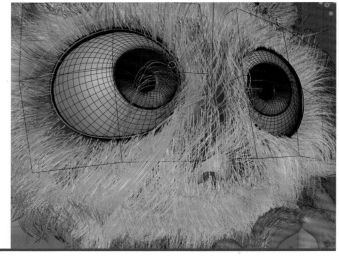

11a Fur appearing on the eyes and inside the mouth

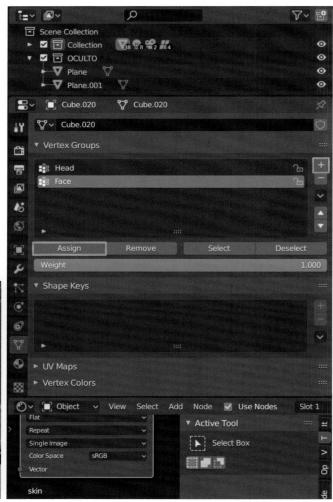

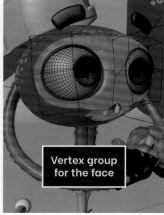

11b Create two vertex groups, one for the body and one for the face

Vertex group for the head

Vertex group for the face

12 Adding fur to the body

The character is very furry, so there will be four layers of hair in total (see **image 12a** for reference). In this step you will create the first fur layer for the character. Go to the **Particle Properties** section of the Properties Editor. Click on the **+** symbol and a Particle Setting will be created. You can change its name in the bar below, and then you must click where it says **Hair**. In the **Emission** tab you can control the number of strands, length, and segments.

So that the fur is only seen on the body area, go to the **Vertex Groups** section (still in **Particle Properties**), where you can select from the groups you made previously; select the body one, setting **Hair Length** to 0.6m (**image 12b**). In the following steps we will look at the other particle options in more detail. You should then be able to see the hair in **Object Mode** (**image 12c**).

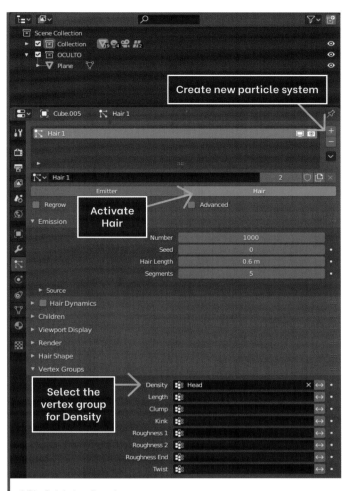

12b Add the first layer of fur to the character

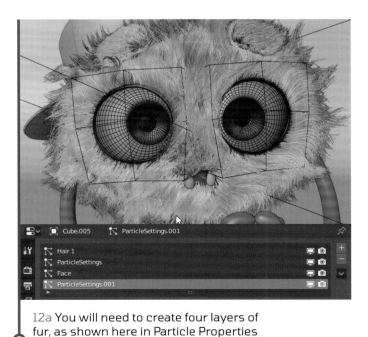

12a You will need to create four layers of fur, as shown here in Particle Properties

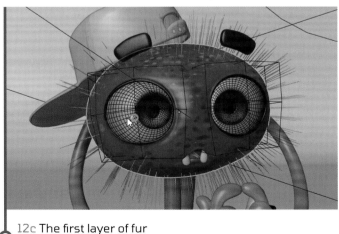

12c The first layer of fur

13 Editing fur

Now you are going to edit the fur using the tools found in the **Particle Properties** tab. The first thing you should do is go to the **Children** section and select **Interpolated**. This multiplies the controlled strands by the **Display Amount** and **Render Amount** numbers (**image 13a**). For example, if the number is 50, it means that 50 copies of each particle (or strand) will be created. This fur layer has 1,000 strands (shown in the **Number** field in the **Emission** section), so you will be simulating 50,000 strands .

If you go to the **Clumping** section, you can increase the numbers as shown in **image 13a**, which will make the fur look more pointed (**image 13b**).

In the **Viewport Display** section, raise the **Strand Steps** number to 5 (**image 13c**). This will make the strands look smoother. In the **Render > Path** section, turn on the **B-Spline** option and set it to 5. This will render it more smoothly.

Finally, in the **Children > Kink** section, choose Curl as the **Kink Type** and set the **Amplitude** to 0.05m. This will give a wavy shape to the fur (**images 13d** and **13e**).

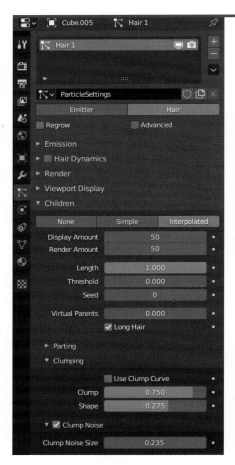

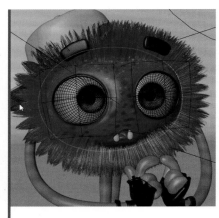

13a Adjust the options for the fur as shown

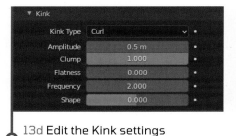

13b The effects of this first set of adjustments

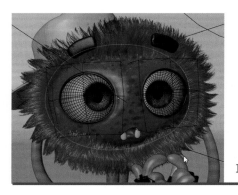

13d Edit the Kink settings

13c Edit further settings as shown

13e Now the fur has a few small ripples

14 Further hair edits

Other important options are the material of the strands, the thickness, and the number of strands that are displayed in the 3D Viewport and in the render:

▷ Make sure that the correct material (that is, the material you previosuly created for that object) is selected in the **Render** tab,

because the particles will copy the map to use the color.

▷ Adjust the diameter and thickness of the strand in the **Hair Shape** tab.

▷ Also, as you can see in the **Children** tab in **image 14a**, you can adjust the amount you want to see in the 3D Viewport and in the render. In

image 14a the **Display Amount** is set as 1, which means that the simulation is duplicating. Be careful not to place very high numbers in this field, because it can cause slowness when using the machine and when rendering.

Image 14b shows the effects of these settings.

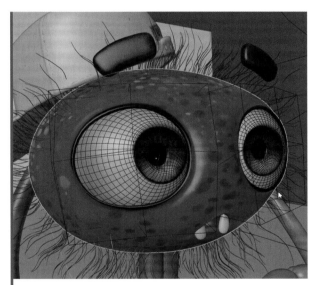

14a Other important settings when creating fur

14b The effect of the settings

15 Creating the face fur

Now repeat the same procedure to create the fur of the face. This time, however, lower the **Emission > Number** setting to 300, because it is a smaller selected area (**image 15a**). Also lower the **Display Amount** in the **Children** section from 50 to 10 so that it does not look as heavy and so the program is not slowed down, meaning you will have a better visualization of the final render.

And of course the vertex group you select this time should be the face group. The rest is exactly the same as step 14, including the settings.

At this point it seems that the fur comes out from all sides and is very messy (**image 15b**), but this is because it needs combing, which you can do in the next step.

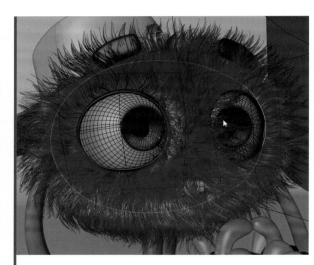

15a Add a layer of fur to the face

15b The fur of the face at this stage

16 Combing the character

To start combing the character, you must change to **Particle Edit Mode** in the 3D Viewport. Like other modes this has a Toolbar on the left. This includes tools that allow you to comb, soften, add more hairs, resize, puff, cut, and adjust the weight of the hair. In the **Tool** tab of the Sidebar you can change the radius and strength of the brush; in the **Options** section, you will find the active fur layers, so that it is easier to edit one or the other (**image 16a**).

It can be useful to turn the display on and off in the **Particle Properties** tab of the Properties Editor (for example, in **image 16b** the screen icon for the Face particles is disabled in the 3D Viewport, which will allow you to work more comfortable with other areas of particles). This way you can comb one part and then the other. Select the **Comb** tool and start combing the top of the hair that goes through the cap.

Once the head part has been combed, activate the face fur in the **Particle Properties** panel, and start combing the face hair (**image 16c**).

16a Start combing the character using the tools in Particle Edit Mode

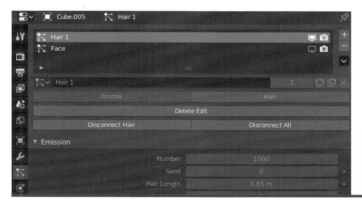

16b Enable and disable particles in the 3D Viewport

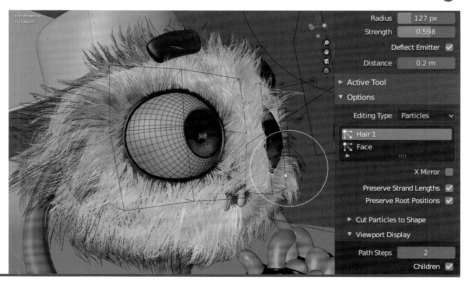

16c Comb the fur on the face

17 Adding more layers of fur

Back in **Object Mode**, you can create as many layers of fur as you want, but remember that the more you add the more particles the program will have to render, and it can therefore be slowed down. Create one more layer of fur by adding another particle setting, with **Number** set to about 15 or 20 and **Hair Length** set to 0.8m (**image 17a**) so that the fur protrudes from the body layer. Keep everything else the same as in the previous steps. Choose the head vertex group.

Then go into **Particle Edit Mode** and start combing the character. In the left part of the Header there are some options for selecting the particles, by path, point, or tip. These are very useful for styling (**image 17b**).

You can also add hair to the eyebrows by creating a vertex group for them and then creating a particle system for them (**image 17c**).

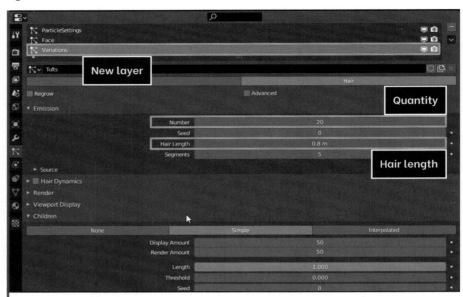

17a Add an additional layer with variations

17b Combing options can make the coat look more messy

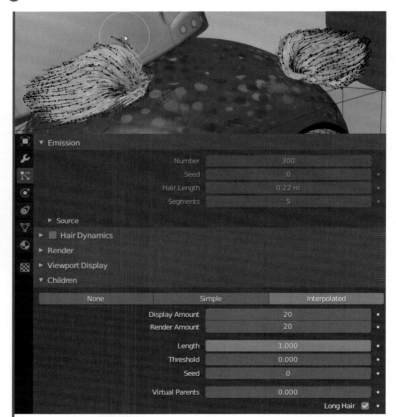

17c Don't forget to add hair to and comb the eyebrows

18 Fur on the limbs

Create a vertex group for the legs that reaches the area of the stockings. For the arms, create two vertex groups: one for the arms and one for the hands (image 18a). To create the coat of fur for the arms and legs, you can follow the same steps, changing the thickness and length of the strands (image 18b).

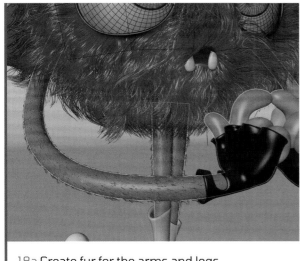

18a Create fur for the arms and legs

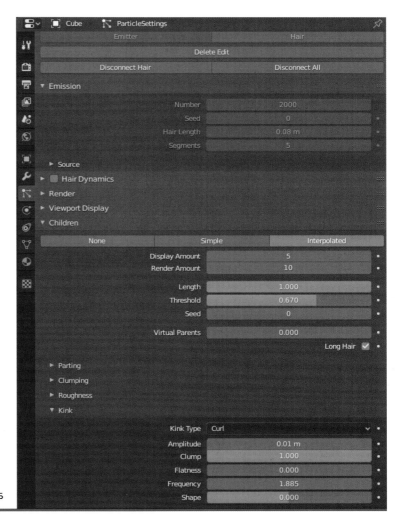

18b The particle settings

For the hands, create a vertex group that is just the fingers at the top (**image 18c**) and create a new particle system with the same specifications as the arms and legs, but put fewer children in the **Render Amount** (**image 18d**). In the end, correct the hairstyle so that the strands do not pierce the other elements.

18c Create fur for the hands

18d The fur settings for the hand

Find out how to edit lighting in your scene in the full tutorial in the downloadable resources.

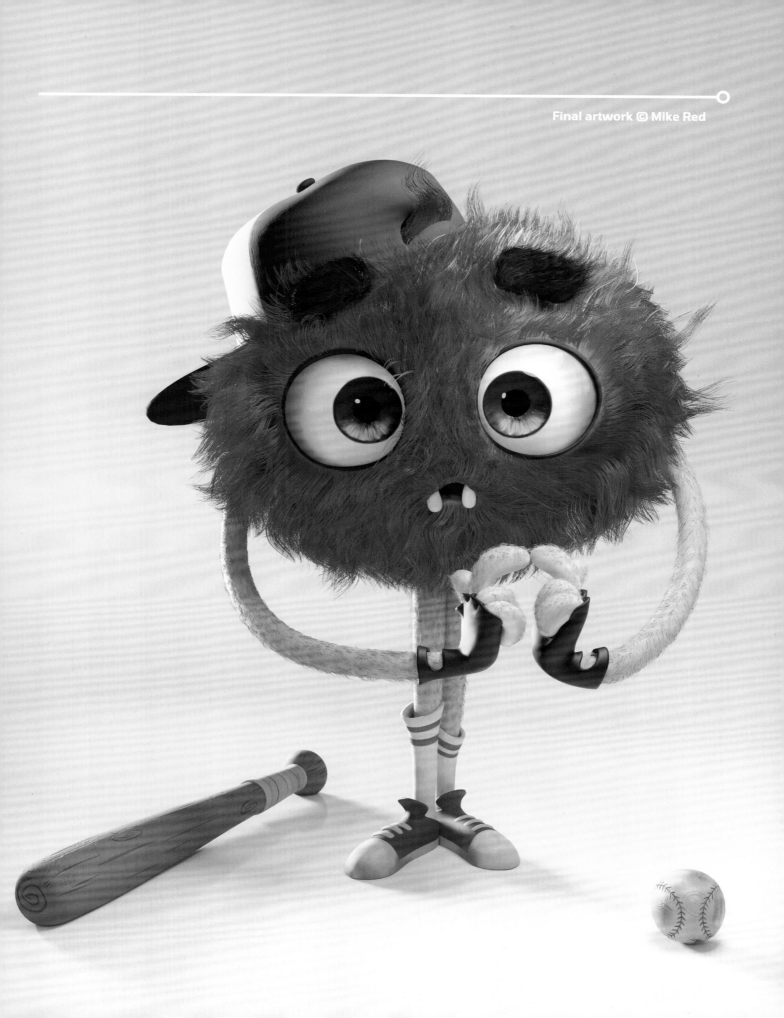

Fish

By Juan Hernández

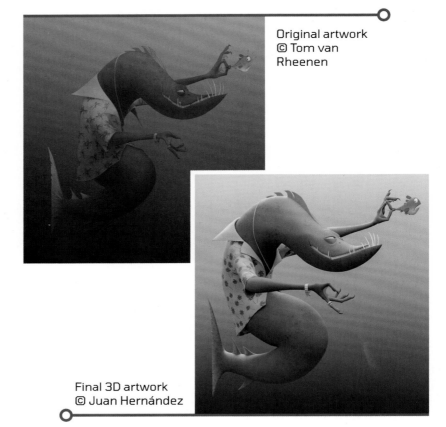

Original artwork
© Tom van Rheenen

Final 3D artwork
© Juan Hernández

CHAPTER OVERVIEW

The basic shape

01 Starting with a vertex

We will start by blocking out the basic shape of the character's body. The general idea is to block out the main volume using simple shapes that are not difficult to model. This is one of the most efficient ways to block out characters, especially because it will provide a base to sculpt on.

Open up a new Blender file. First, add a single vertex into the scene. To do this, you will need to enable the **Add Mesh: Extra Objects** add-on in the **Blender Preferences** window. You can then go to **Add > Mesh > Single Vert > Add Single Vert** (image 01a).

Press **Ctrl + Numpad 3** to work from Left orthographic view and easily manipulate vertices. In **Edit Mode**, make sure you are in Vertex Select mode and press **G** to move the vertex up to mark where the mouth starts (refer to the grid and axes positions in image 01b). Then press **E** to extrude vertices and create, in a very simple way, the shape of the body (image 01b). Imagine you are creating the skeleton of the fish.

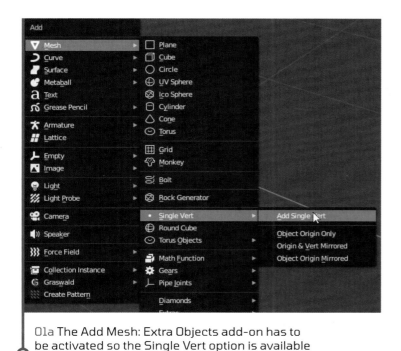

01a The Add Mesh: Extra Objects add-on has to be activated so the Single Vert option is available

01b Extrude the vertex to create the spine of the character

02 Adding modifiers

Next, select all vertices and add a **Subdivision Surface** modifier to smooth out the silhouette, a **Skin** modifier to generate geometry around the vertices, and a second **Subdivision Surface** modifier to smooth the generated geometry (leave the settings as they are). Modifiers are one of the strongest features in Blender, and at this moment you can see how easy it is to create and manipulate geometry using just a few connected vertices.

Afterward, select each vertex individually, press **Ctrl + A**, and move the mouse to pinch or expand the thickness and match the character's shape (image 02a). You may need to use **Alt + Z** to toggle X-Ray view on and off to be able to see the vertices. Continue tweaking the shape in **Edit Mode** if needed, moving vertices with the **G** key. If you need more vertices in between, select two vertices, right-click, and select **Subdivide**.

Go to **Object Mode** and use **S** to slightly scale down the whole character along the X axis so that the body is not completely rounded (you will need to change your view to do this; image 02b).

02a Add modifiers and use Ctrl + A to change the thickness around each vertex

> **LEFT VIEW**
>
> Remember to work using Left orthographic view to keep all vertices on the same working axis so that the generated geometry stays symmetrical.

02b Scale down the character on the X axis

03 Caudal fin

You can continue with the fish skeleton by creating the caudal (tail) fin, again extruding the vertices in **Edit Mode**: select the final vertex on the tail, press **E** and extrude upwards (image 03a); then select the same vertex and extrude down to create the tail fin shape.

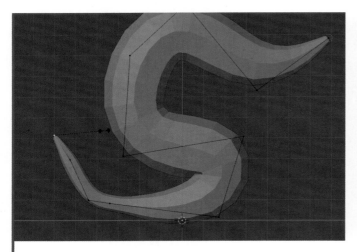

03a Use E to extrude

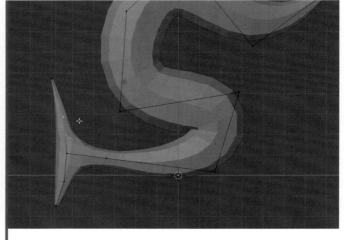

03b Use Subdivide to add two vertices to the fin

Add two more vertices as shown in image 03b by selecting the center vertex and one outer vertex, right-clicking, and selecting **Subdivide**. Do this on each end of the tail fin.

Since this area should be flatter, change the thickness of the vertices by pressing **Ctrl + A** and then **X** to constrain the scale to one axis only (image 03c). You may also want to do this for all vertices so that the character is not so cylindrical.

Now turn on **Smooth Shading** in the **Skin** modifier so that the surface doesn't look completely flat (images 03d and 03e).

03c Use Ctrl + A and X to change the thickness

03d Select the Smooth Shading option

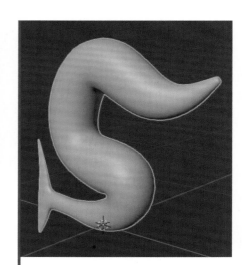

03e The mesh with Smooth Shading checked

04 Other fins

To block the dorsal fin, go to **Object Mode** and add a plane to the scene. Rotate the whole plane along the Y axis by 90°, scale it down, and use Left view to roughly position it where it should be (image 04a).

In **Edit Mode**, select the edges and extrude out new faces by pressing **E** to create the shape of the whole fin (image 04b). Move vertices around and scale edges and faces to achieve the shape you need (image 04b), switching between Front view (**Numpad 1**) and Left view to check the alignment of the sections.

Select the fin in **Object Mode** and add a **Solidify** modifier to generate thickness by increasing the **Thickness** amount until you are satisfied with the look. Then add a **Subdivision Surface** modifier to smooth out the shape (image 04c). Finally, in **Object Mode** with the fin selected, right-click in the 3D Viewport and select **Shade Smooth**.

Repeat this process for each individual fin (image 04d).

04a Don't forget to use X-Ray view to properly see your work

 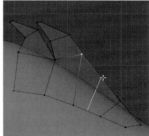

04b Extrude and move vertices and edges to create the fin shape

04c Thicken and smooth the fin

PROPORTIONAL EDITING

You may find it useful to press **O** while working to turn proportional editing on and off (see page 62). This will let you move geometry in a more organic way.

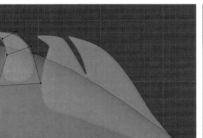 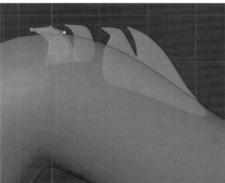

04d Follow the same actions to create the rest of the fins

05 Shoulders

To block out the shoulders, first add a cube to the scene in **Object Mode**. Add a **Subdivision Surface** modifier to it, setting **Levels Viewport** to 2, scale it down, and roughly position it on the shoulder area of the body by toggling between views (refer back to shortcuts on page 20 if needed) and pressing **G**. With this new object selected, right-click and select **Shade Smooth** so you get rid of the flat look (image 05a).

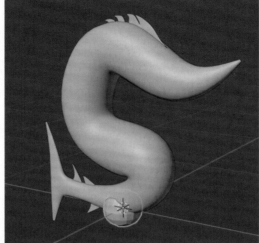

05a Use a cube with a Subdivision Surface modifier to create an arm

To keep your work efficient, add a **Mirror** modifier to the cube and use the eyedropper to set the body as the **Mirror Object** (image 05b) so that the shoulders are symmetrical to the body. You should now have a second cube on the other side of the body that mirrors the first (image 05c).

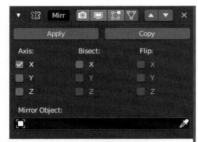

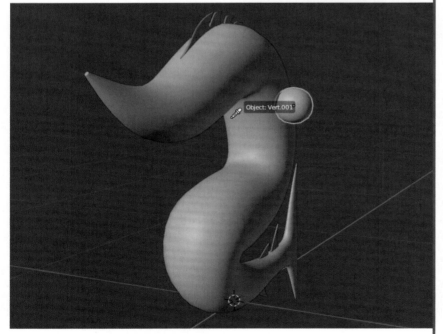

05b Use the eyedropper in the Mirror modifier to set the center point of the mirror

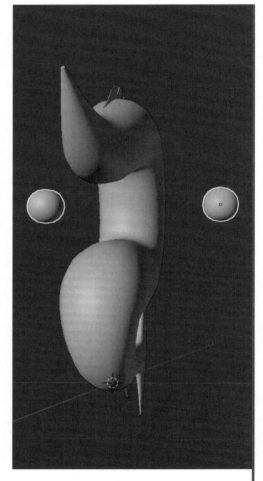

05c The two modified cubes, spread apart for demonstration purposes

06 Arms

At this point you can reuse the cube to block the arms by pressing **Shift + D** in **Object Mode**. This will create an identical object with the same modifiers, so all you have to do is slightly modify the shape in **Edit Mode** and position it in the correct place. In this case, start by making the upper arm, using **G** and **S** to move and scale the cube into an arm-like shape (image 06a).

Add an edge loop by hovering over an edge and pressing **Ctrl + R** to mark where a loop cut will be created. Left-click to confirm the action and click one more time to apply it. You may then select the edge loop by using **Alt + left-click** and **S** to scale it up or down (image 06a). Once you have finished the upper arm, select it in **Object Mode** and use **R** to rotate the arms down into position (image 06b).

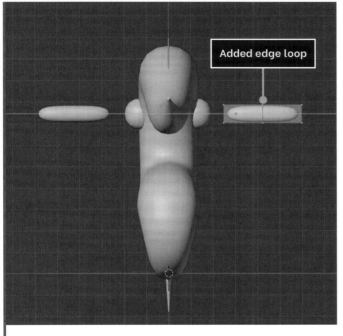

06a Use Move and Scale to shape the upper arm

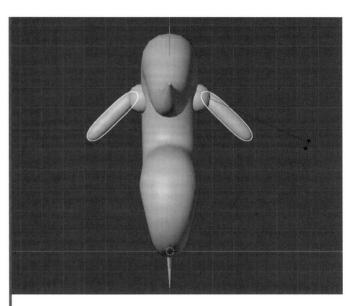

06b Moving geometry in Edit Mode will keep the pivot in the same position. Move it in a way where the pivot (orange dot) stays at one of the ends of the cylinder. This will make rotating arm sections easier

You can then duplicate the shoulder again in **Object Mode** to create the forearms, again using Move and Scale and adding edge loops in **Edit Mode** as shown in image 06c.

06c Follow the same process for the forearm

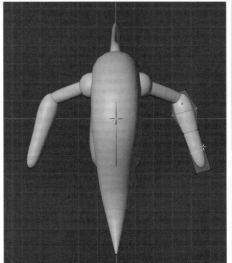

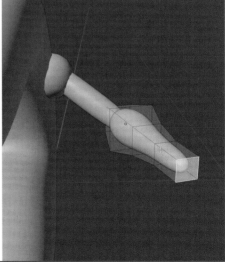

07 Hands

Finally, duplicate the shoulder in **Object Mode** again and position it to where the hands will be (image 07a). Select the bottom face in **Edit Mode** and scale the whole hand down to shape the palm. Then scale it down along the Y axis to make it less spherical (image 07b).

Use **Ctrl + R** to add an edge loop as shown in image 07c. This will help prevent the hand from looking too rounded; since you are basically using a cube, the subdivided result will be very rounded. Adding a loop supports the geometry and makes the subdivided model look more like the original shape.

07a Duplicate the cube used for the shoulder again

07b Scale the bottom face of the hand to make it less spherical

07c Add a loop as shown to make the hand slightly more square-shaped

08 Eyelids

You can duplicate the shoulder once again in **Object Mode**, slightly change the shape in **Edit Mode**, and use it to block out what will be the eyelids.

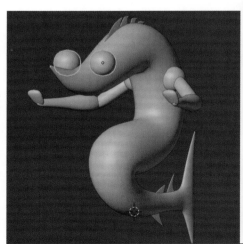

08a Duplicate the shoulder a final time to use for the eyelids

09 Mouth opening

Using the same technique as used to create the fins, you can add a plane and shape it into what will be the mouth opening. Certain parts of the mouth are less curved and will have a crease. To make those areas less curved you need at least three vertices close together; you can either select an edge and bevel it by pressing **Ctrl + B** and increasing the number of **Segments** to 3 in the **Bevel** contextual menu, or add loop cuts manually (image 09a).

With all of the mouth opening selected, this time add the **Subdivision Surface** modifier first and the **Solidify** modifier after, as the plane shape needs to be smooth but the thickness needs to be a solid block. Make sure that the **Solidify** modifier has enough thickness so that it goes all the way through the body (image 09b).

You will now use this object to cut the body object using a Boolean operation. If you activate the **Bool Tool** add-on, you can quickly carry out a Boolean operation by first selecting the mouth mesh in **Object Mode** and then holding **Shift** while selecting the body second. Then press **Ctrl + Numpad -** to create the Boolean subtraction (image 09c). Turn off X-Ray mode to see the effect more clearly.

To get rid of visual artifacts created by the Boolean operation, select the mouth mesh and go to the **Object Data Properties** section of the Properties Editor. Then turn on the **Auto Smooth** option found in the **Normals** section (image 09d).

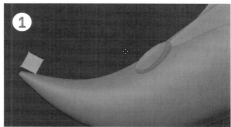

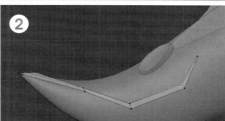

Additional loop cuts

09a Extrude and scale a plane to create the mouth opening, adding bevels or loop cuts for the less curved parts of the mouth

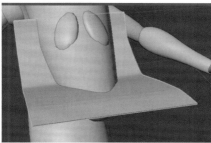

09b Set the Thickness of the Solidify modifier so that it goes all the way through the body

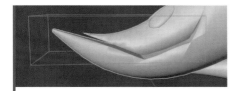

09c Use the Bool Tool add-on to create the mouth opening

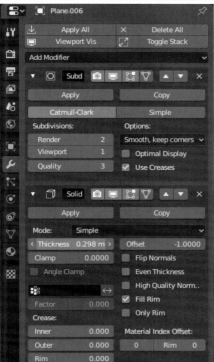

09d Turn on the Auto Smooth option

10 Fingers

Now it is time to create the fingers. For this you will use a similar method as you used to create the arms. Add a cube in **Object Mode**, scale it on the X and Y axes, and add a **Subdivision Surface** modifier (one level is enough). You can also apply **Shade Smooth** by right-clicking in **Object Mode** and selecting **Shade Smooth**. Go into **Edit Mode** and add a couple

of loop cuts as shown in image 10a. Scale down on the Z axis if needed. This will be the first part of one finger.

Duplicate the finger (**Shift + D** in **Object Mode**) and position it to create the second part of the finger (image 10b). Continue adding and editing and positioning cubes to create the claw and joints (image 10b).

10a Scale a cube and add loop cuts

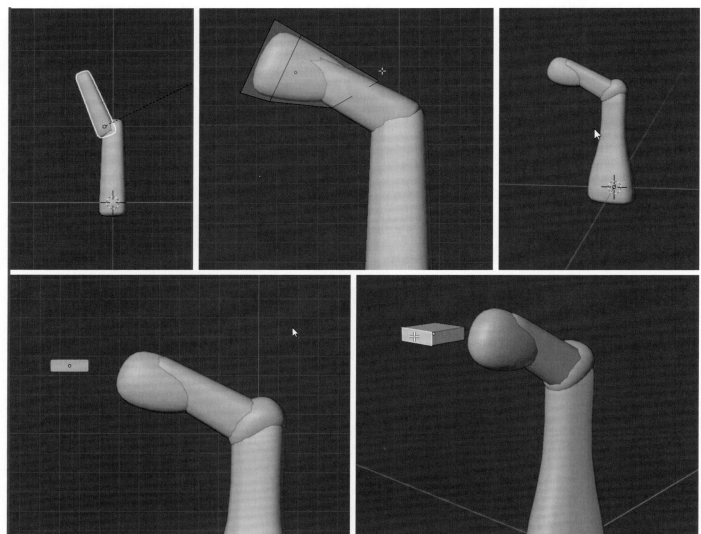

10b Make sure you keep proportions as correct as possible. Doing this now means less tweaking in the future

ISOLATING OBJECTS

To better focus on a specific part of the model, you can select the new object and press **Numpad** / to isolate the object and temporarily hide the rest.

10b continued

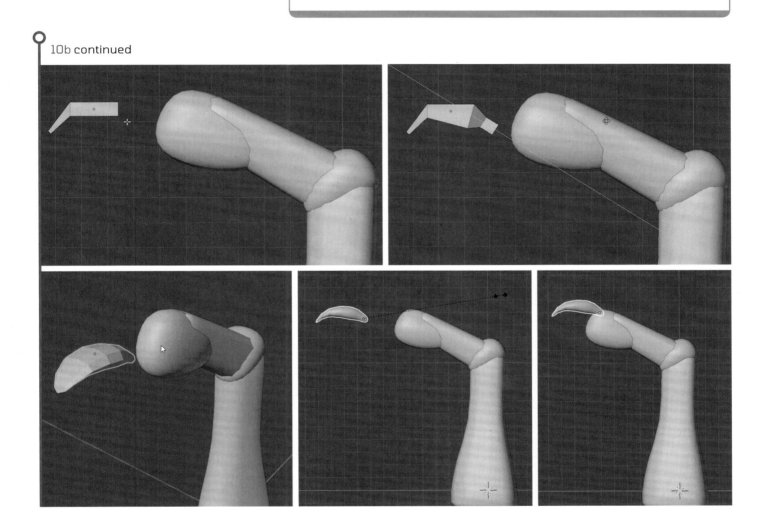

11 Parenting

After you have blocked out one finger, go to **Object Mode** and select all of the finger components and hold **Shift** while selecting the segment that connects the finger to the hand to make that object active (remember that the active object will be highlighted in yellow rather than orange). You may now parent all objects to this section by pressing **Ctrl + P** and selecting **Object (Keep Transform)**. This will make other sections children of the active object, which will allow you to manipulate the position and scale of the whole finger by just manipulating the parent.

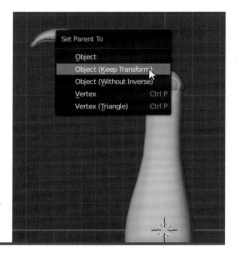

11 Select all sections of the finger and the biggest section last. Press Ctrl + P and select Object (Keep Transform). This will make all parts follow the movement of the biggest section

12 Mirroring & duplicating the finger

Press **Numpad /** to go out of Local view if you were in it. Still in **Object Mode**, select the parent object of the finger and place the finger on the hand using Move, Scale, and Rotate as needed.

You need to mirror this finger on the other hand. Since it is made out of many objects, the quickest method is to transfer the **Mirror** modifier from another object. You will first need to enable the **Interface: Copy Attributes Menu** add-on in the **Blender Preferences** window for this to work.

Select all parts of the finger using **Shift + left-click** and lastly select the hand. Press **Ctrl + C** and then select **Copy Selected Modifiers** (image 12a). A new menu will appear where you can choose which modifiers to copy: select **Mirror** and click **OK**. You will see that a finger now appears on the other hand (image 12b).

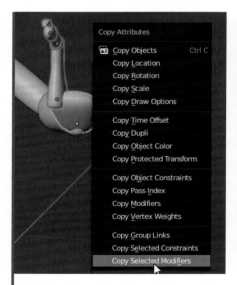

12a The Copy Attributes Menu add-on must be enabled for this menu to appear when pressing Ctrl + C

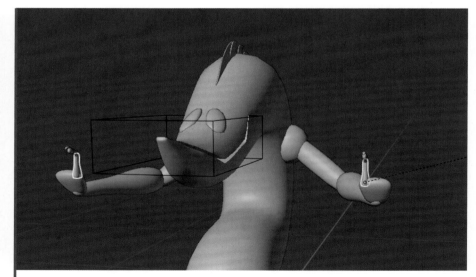

12b The finger should now appear on each hand

CHANGING VIEWS

Remember to keep checking your model from different views to make sure each component is positioned correctly.

You can now select the whole finger and duplicate it by pressing **Shift + D** to create all the fingers. Once you have five fingers, you can simply select the parents and use **S** to scale fingers individually and **R** to rotate them (image 12c).

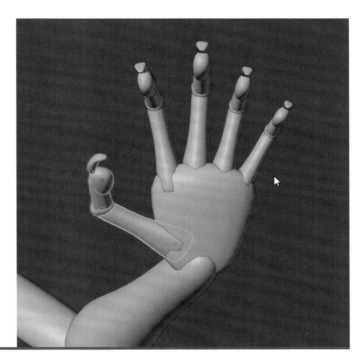

12c Duplicate the finger and move, scale, and rotate each new finger as needed

TESTING MOVEMENT

It is not required, but you can parent all sections of the arm so that you can test its movement. Testing movement will let you see if proportions look correct, which is always good, but it is not essential for the creation process.

In this case, the finger sections are parented to the finger base; each finger base is parented to the palm of the hand; the hand is parented to the forearm; the forearm is parented to the arm; and the arm is parented to the shoulder.

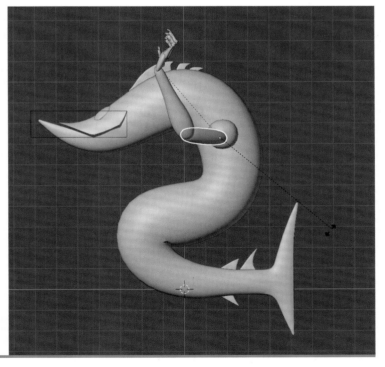

Move and rotate different parts of the arm to test the movement once they are parented

Sculpting

13 Applying modifiers

At this point the character base is ready and you can move to sculpting. To do this you need to apply all modifiers.

First, increase the subdivision levels of the body to maintain smoother surfaces when sculpting by going to the second **Subdivision Surface** modifier and increasing the **Levels Viewport** value to 4 (image 13a). Increase the same level to 2 for the **Subdivision Surface** modifier on other objects.

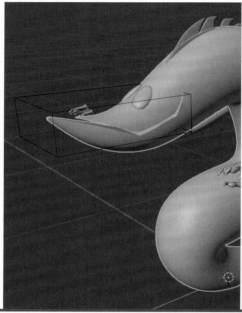

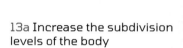
13a Increase the subdivision levels of the body

Then you will need to apply all modifiers to the objects; to do this, select each object and then click **Apply All** in the Modifier Properties panel (image 13b). Start with the body, and then do the same for the arms, hands, and eyes. Note that you will need to select each object individually and apply all modifiers – you can't just select the parent. A quick way to do this is to select the parent in the Outliner, right-click, and select **Select Hierarchy**. This will select all the children objects.

You may have noticed a bounding box around the model's mouth (image 13c), which is the object you used to cut the mouth. Once you have applied all modifiers on this object and the body, you can delete it, as the effect of the Boolean operation will remain.

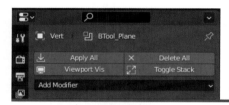
13b The Apply All option

13c Once all modifiers have been applied to the mouth opening object, you can delete the object

CHANGING SUBDIVISION LEVELS

One easy way to change subdivision levels on many objects is to select them and press **Ctrl +** the subdivision level. So for instance, if you wanted two levels of subdivision you can press **Ctrl + 2** (number 2 on the keyboard, not the Numpad).

14 Joining objects & Remeshing

Start joining objects with similar amounts of detail by **Shift + left-clicking** in the 3D Viewport to select them and then using **Ctrl + J** to join them. For example, join all objects that form the hand as one object (image 14). Do this for the rest of the objects until the shoulder to make the arm, and similarly the body with the eyes. Please note that merging objects by pressing **Ctrl + J** will not physically merge geometry.* You will therefore need to resolve this using the Remesh tool.

14a Join the hand objects together

Lastly, you will use the **Voxel Remesh** option in Blender on each object to get rid of intersections. You can do this by selecting the body in **Object Mode** and going to the **Remesh** section of the **Object Data Properties** tab in the Properties Editor (image 14b).

The Voxel Remesher basically projects a square polygon pattern onto the mesh to preserve its shape and create new topology. You can set the size of this polygon pattern and this determines the amount of polygons in the Remesh result. **Voxel Remesh** can be used to lower the polygon density

of an object or to merge various meshes that are in one object but have intersections (which is the case here).

The polygon pattern size is important in terms of keeping the detail you already have. For example: if the pattern is too big, you will get just a few polygons and the object will be very light, but you may not have enough detail to support the shape of the mouth; if it is too small then you will have all the detail but the model could be unnecessarily heavy and take longer to calculate.

Set the **Voxel Size** (try 0.02m) and press the **Voxel Remesh** button. Ensure **Fix Poles** and **Preserve > Volume** are both checked (image 14b). Check the model. If you are losing too much shape, undo the operation, change the **Voxel Size** parameter, and try Remesh again. The smaller the number, the more polygons will be projected. Do this until you are happy with the result. The numbers are sensitive so it is a good idea to change in small increments. Use the **Voxel Remesh** in a similar way on the other objects.

14b Use Remesh to prepare the object for sculpting

*This means it will not get rid of intersections between objects; if you merge two spheres which intersect each other, the intersecting faces will still be there. To be able to properly sculpt an object, these two objects need to be properly merged (with no inner faces). You can do this using Boolean operations or using the Remesh tool.

15 Initial sculpting

At this point shapes should be looking good, so the sculpting phase should be very simple. The first thing you need to do is smooth out creases and tweak any proportions if needed. Select the arm and go into **Sculpt Mode**. Turn on the Dyntopo function by checking the box next to **Dyntopo** on the Header. Go to the dropdown to the right of this and ensure the **Detailing** attribute is set to **Constant Detail** (image 15a). Use the eyedropper that appears at the top of the **Dyntopo** dropdown menu on the arm to sample the current detail amount. Increasing this number will let you add geometry in places where you are sculpting, which is great for adding detail.

Note that **Symmetry** should be turned on for the X axis in the Header so that you only have to work on one side of the model (image 15b). Use the Clay brush to add volume where it is needed (for example, you may feel that the fish belly needs to be bigger), using the **Shift** key to turn on the Smooth brush temporarily.

15a Use Constant Detail in the Dyntopo settings

15b Use the Clay brush to add volume and ensure Symmetry is turned on for the X axis

SYMMETRY NOT WORKING?

If what you sculpt on one side of your model isn't being mirrored on the other, check the origin of your object in **Object Mode**. As you learned on pages 44–45, you can set the origin of the 3D cursor and the object. If in **Object Mode** you notice that the orange dot isn't in the center of the object, this could be why the Symmetry setting isn't working for you. Try making sure that the 3D cursor is set to World Origin (**Shift + S > Cursor to World Origin**) and then go to **Object > Set Origin > Origin to 3D Cursor**. You can also select the object, press **Ctrl + A**, and select **All Transforms**. This will set the pivot to the center of the world, set scale to 1, and rotations back to 0.

Use the Smooth brush to make the surface smoother and remove harsh connections to make the transition of the merged objects more organic. Do this around the eyes too.

You can also press **G** in **Sculpt Mode** to use the Grab brush to tweak shapes (image 15c). For example you could slightly change the profile of the mouth to match the reference more. Try the Inflate brush around the mouth too (image 15d).

15c Use the Grab brush on the mouth

15d Use the Inflate brush to add more volume to the lips

Also work on the arms (image 15e). Set the Dyntopo detail a little higher so that you have more polygons when sculpting. Use the Clay brush to add more volume, as at the moment the whole arm is very cylindrical. Use the Smooth brush to make the surface smoother and also to smooth out transitions left by the Remesh.

Using the same brushes and more detail in Dyntopo, add more shape to the hand. Use the Clay brush to add volume, the Crease brush to make lines on the palm, and the Smooth brush to make the surface more pleasing. Add more volume to the base of the thumb, to improve the way it connects to the hand. Finally, refine all fingers, making some parts puffier using the Inflate brush if needed. Keep using the Smooth brush to smooth out the surface palm (image 15f).

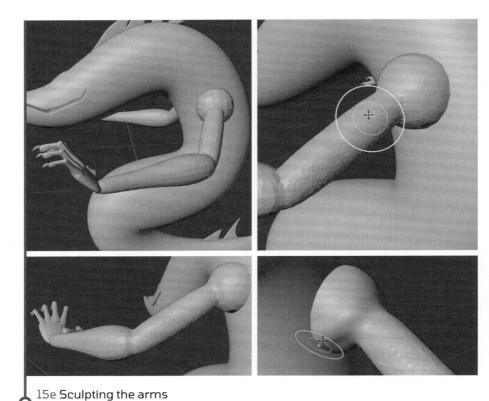

15e Sculpting the arms

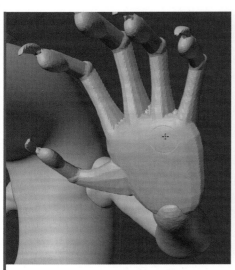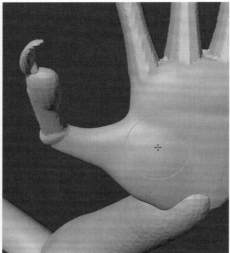

15f Use a higher Dyntopo value for the hand, since it has smaller details

16 Joining the arms & hands

Once you have finished making the connections look more organic, you can join the hands to the rest of the arm as described next. The main reason we did not do this before is that the hand required more detail when using the Voxel Remesher and it would be unnecessary to calculate the whole arm.

This time we will join the geometry using Boolean operations. In **Object Mode**, select the hands and **Shift + left-click** the arm to keep it as active (image 16a). With the **Bool Tool** add-on enabled you can then simply press **Ctrl + Numpad +** to create a union operation (images 16b and 16c; go into X-Ray view to see the effect). You

can then apply the **Boolean** modifier in the **Modifier Properties** panel and delete the old hand object.

The geometry is now merged so you can jump straight into **Sculpt Mode** and again smooth out the connections using Dyntopo.

16a The selected object is outlined in orange (the hand); the active object is outlined in yellow (the arm)

16b Make sure there are no intersections; if there are, you can slightly move the hand up or down until they disappear

16c Now the intersections have disappeared, apply the modifier and delete the bounding box

16d As in step 15, smooth the intersection and add volume where needed

17 Nose cavities

To create the nose and the eye cavities you can use the Mask tool in **Sculpt Mode**. Using masks is a great way to introduce details into a sculpt. Select the body in **Object Mode** and then go into **Sculpt Mode**.

Press **M** and draw on your model to mark the nostrils (reduce the **Radius** and increase the **Strength** so you get a sharp brush). If needed, go to the **Masks** tab in the Header and select **Sharpen Mask**. You can repeat this operation more times if necessary. Make sure you are still working with symmetry during the whole process.

Once you are happy with the shape, press **Ctrl + I** to invert the mask. Use the Draw brush while holding **Ctrl** to temporarily invert the direction of the brush and push the geometry inward to create the nostrils. You will notice that you can only sculpt into the area you marked before.

Once you have finished sculpting the nostrils, press **Alt + M** to remove the mask. Smooth the connection to the body.

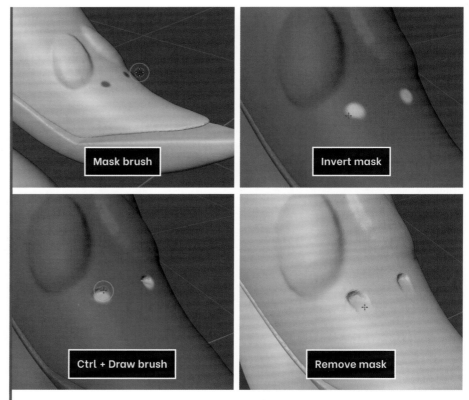

17 Check from all angles to make sure the nostrils are in the correct place

18 Eye cavities & eyebrows

You can use the same technique to create the eye cavity. Mark the shape using the mask brush, turning around your view to make sure you are happy with the overall shape. Invert the mask once again and sculpt into the marked area to make room for the eyes. Once complete, use **Alt + M** to remove the mask and then smooth the connection to the body (image 18a).

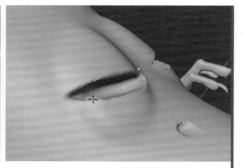

18a Follow the same process as in step 17 for the eye holes

You can then do the same for the eyebrows (image 18b).

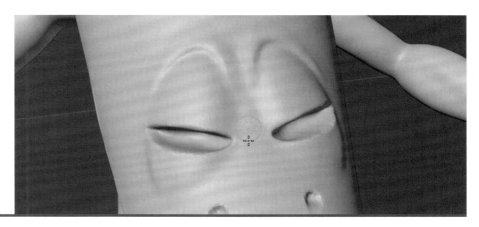

18b Add the eyebrows and smooth out the face

19 Eyes

Before moving on with the creation process, it is time to create the eyes, but they can be still part of the blocking phase. The most important thing is to lock down the size and make sure they fit nicely in the head.

Add a sphere in **Object Mode**, then scale it down along the X axis and along the Y axis to make an oval shape (image 19a). Add a **Mirror** modifier and set the body as the **Mirror Object**. Then rotate, scale,

and position the eye to fit the cavity (image 19b). Once you are happy with the placement, tweak the eye area of the body in **Sculpt Mode** if necessary. Use the Crease brush and hold down **Ctrl** to shape the eyelids (image 19c).

19a Use the side views to manipulate the position easily

19b Position the eye beneath the eyelids

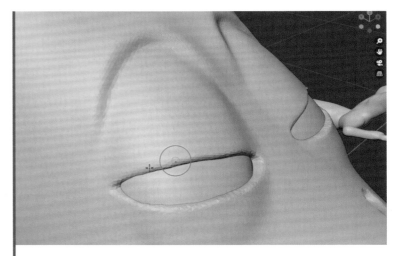

19c Sculpt the eyelids as needed

Retopology

20 Preparation

We will now look at retopologizing the sculpt. Note that you did not join the arms with the body. This is because the body will not be visible thanks to the shirt. This will also make the retopology process a little easier.

To retopologize the body, first use **Shift + A** in **Object Mode** to add a single vertex to the scene and then ensure you are in **Edit Mode**. Before modeling anything, you need to set up some things first. Turn on the Snapping function by clicking the magnet icon in the Header and, in the dropdown the right, set it to **Face** (image 20a). Also turn on **Project Individual Elements** – this will snap each part of the selection onto surfaces.

With the vertex selected, press **G** to move it and you will notice that it will now stick to the surface of the body. To make sure everything you now model sticks to the surface of the body, add a **Shrinkwrap** modifier and set the body as the target using the eyedropper (image 20b). Since the character is symmetrical, you can also add a **Mirror** modifier, setting the body as the **Mirror Object**, which will save you a lot of extra work.

Press **E** to extrude vertices around the body to make a ring of vertices as shown in image 20c. You can always subdivide later, so the less geometry the better. You can connect the vertices at each end of the ring by pressing **F**. To connect them at the center, make sure the **Clipping** option in the **Mirror** modifier is enabled, which will mean that the vertex will snap in the center when you move it towards the center.

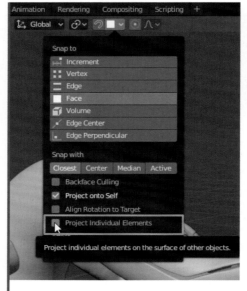

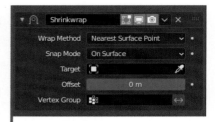

20b Click the eyedropper icon next to the Target field and click the body in the 3D Viewport to select it as the target

20a The Snap menu

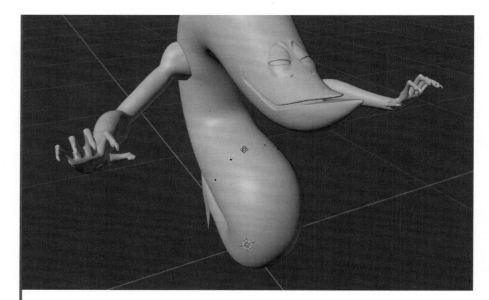

20c Extrude the vertices around the body

228

Try to keep the distance between the vertices as even as possible. You can do this by selecting all the vertices on one side of the body (the other side will be influenced by the **Mirror** modifier), right-clicking, and going to **LoopTools > Space** and **LoopTools > Relax** (image 20d). Note that you will need the **LoopTools** add-on enabled to do this.

20d Use the LoopTools add-on to either space evenly or relax your selection

21 Extruding further

The body has a very cylindrical shape and there are no details along the surface. This means that an even quad geometry will be more than enough. This can be achieved very quickly by simply extruding the vertex ring you just created.

Go into a side view and extrude the ring along the body to cover the basic shape (image 21a). Temporarily turn off Snapping so that vertices do not snap along your view. Thanks to the **Shrinkwrap** modifier, geometry will stick to the body and you can cover most of it just by extruding. You can

make longer extrusions and add loop cuts later to make the geometry more even (image 21b). You may want to hide the arms and scales to be able to see the body more clearly. Enabling **X-Ray** mode may also help you see the faces more clearly.

21a Snapping has to be off so vertices at the center are not snapped to the front of your view

21b Continue extruding the vertices around the body

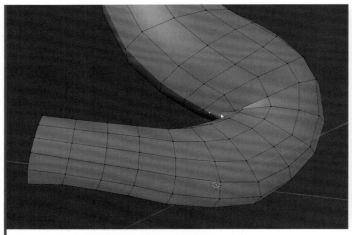

21c This crease section might cause a little trouble;
snap individual vertices to be more precise

VIEWING NEW GEOMETRY

To easily see your new geometry, add a material by clicking **New** in
the **Material Properties** panel of the Properties Editor. Go down to the
Viewport Display section and set the color by clicking on the **Color** field
and choosing a color that will be distinct from the rest of your model. Note
that to see the effect, you will need to have the **Material** option turned on
in the **Color** section of the **Viewport Shading** menu in the Header.

The Material Properties panel

22 Mouth loop

We will leave the body for now and focus on the face. Turn Snapping (set to **Face**) back on, select any nearby vertex, and press **Ctrl + D** to duplicate it. You can use this new vertex to start working on the face in the same way as you did the body.

The key to retopology is to first lock all the important loops and then connect the areas in between. These main loops are usually in areas that mark details or where you find creases.

Position the vertex and start extruding along the mouth to mark the mouth shape (images 22a and 22b). Since you are using snapping, everything you model will stick to the surface. Once you are happy with the shape you can select groups of vertices and extrude out faces to make the loop (images 22c and 22d).

22a You need a minimum of three vertices to properly crease geometry when subdividing

22b Extrude single vertices by pressing E and placing them along the mouth

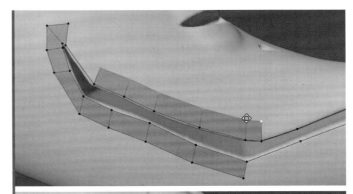

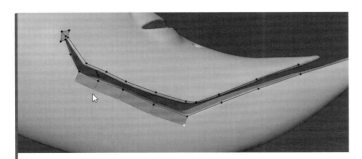

22c Select a line of vertices and press E to extrude a set of faces

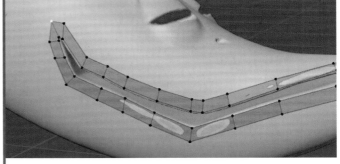

22d Create the missing faces by selecting four vertices and pressing F to fill the selection (refer back to page 77)

23 Nostril, eyelid & eye loops

Create loops along other important areas. In this case there are three other loops you need to create: one for the nostril (image 23a), one for the eyelid (image 23b), and one for the whole eye area (image 23c).

Try to keep everything as simple as possible and keep loops symmetrical, so that it is easier to connect. In the case of the eye, it is easier to join the eyelid loop and the eye loop first and then add a loop cut rather than extruding everything manually. This loop will keep geometry even and help keep the rounded shape.

23a In this case you can see how the loop is symmetrical: there are four faces on the right side and four on the left

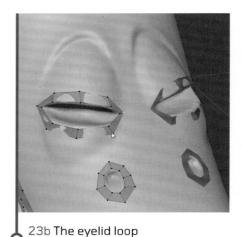

23b The eyelid loop

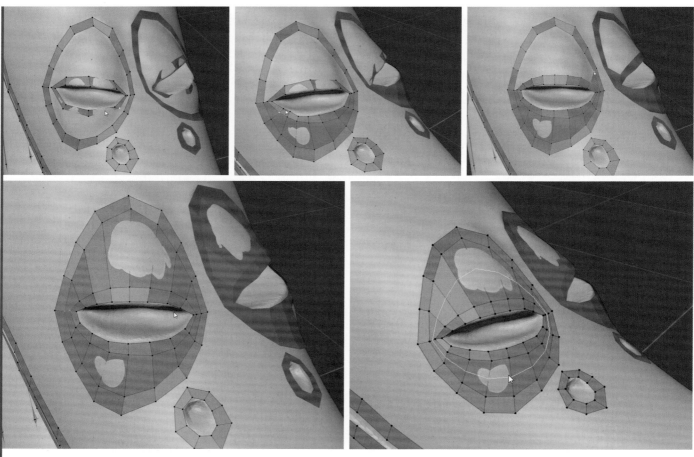

23c Add loop cuts in the inner lid to match the number of faces in the outer loop. If you do some careful planning you can set it up so there is one face on the eye area that could potentially match another from the nose

24 Connecting the mouth & eye loops

Now that all the important loops are ready on the body, you can start planning how to fill the empty spaces with geometry while keeping everything as even as possible and avoiding the use of triangles or N-gons.

It can be good to start connecting geometry that is visually logical. For instance, you know that the geometry coming out from the right side of the lips will flow to the bottom of the mouth and go up again to the left side of the lips. You can therefore select some edges of the mouth loop and extrude them down until they meet the center (image 24a).

There are also four polygons in the eye loop which face part of the lip, and there is no special detail between them. You can join those too (image 24b). The same goes for the area between the eyes (image 24c).

24a Try to match the face distribution of the body as you know you will connect the faces later on. For example, note in this image how the edges on the bottom part of the jaw are aligned with the edges that go down the body. Also the faces are roughly the same size

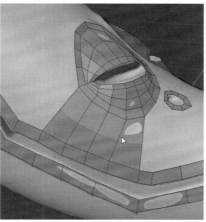

24b Connect the polygons of the eye loop with those of the mouth loop

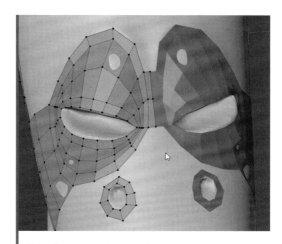

24c Connect the eye loops

CHECKING NORMALS

It can be useful to go into **Object Mode** and isolate the object to properly see how the retopology is going. If you get artifacts, it means that some normals are flipped. Go into **Edit Mode**, select all, and press **Ctrl + N** to recalculate them.

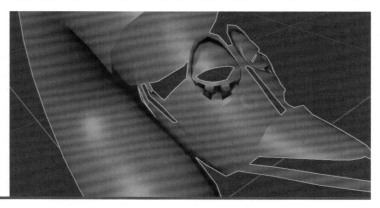

In this image, the artifacts are the dark squares around the eye area

25 Connecting the nostril, eye & mouth loops

Now you can connect part of the nostril to the eye loop and the mouth loop. Usually you can identify a geometry loop in the center of characters that marks the symmetry point, which means you should be able to connect the polygons between the eyes with the center of the mouth loop (image 25a). You can then add edge loops, ensuring you maintain quads (image 25b), and move on to connecting the area between the nostrils (image 25c).

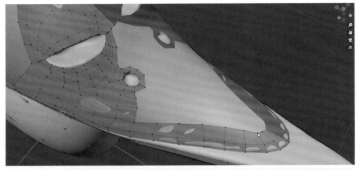

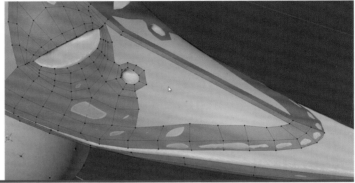

25a Extrude another loop from the lips to close the area if needed. It is easier to create a huge polygon and eventually add loops as needed

25b Add an edge loop as shown to convert this triangular area into a quad

25c The side edges of the nostril can be connected to the center, as they flow to the other nostril

You are now left with an empty area, which just needs to be filled with quad faces. Feel free to extrude, cut, and move edges around to close the area (image 25d).

25d You can fill the rest of the area following similar principles

26 Connecting the head to the body area

The next step is to keep covering the face with geometry, and plan how to connect the face topology to the body. Extrude another set of faces past the eye area to fill the empty space. An edge of the mouth loop border is facing up, and since the face is symmetrical, you can extrude this up to make a loop where the mouth corner meets at both sides of the face (image 26a). Take into account that you will subdivide the body later in this step, therefore each face from the body will be divided.

Edge of mouth corner to be extruded around the head

26a Select the edge near the mouth corner and extrude around the head – this will mean you avoid unnecessary numbers of edges going into the body

This is a great way to keep geometry details flowing into the body but instead looping around the head. This also helps you close the head. Roughly position edges aligned to edges from the body, then fill in the empty areas (image 26b).

Once you are done, finalize the bottom part of the mouth and add any necessary loops so that you can connect it to the body (image 26c). Image 26d shows the retopologized model at this point for reference.

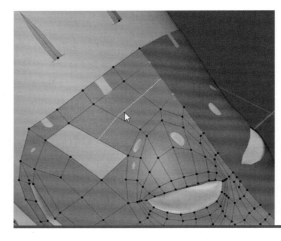

26b Keep thinking about how geometry could be connected later, so for example keep the same number of polygons coming from the eyes, which can also be double the number of ones coming from the body

26c Carry on working on the bottom part of the mouth and head

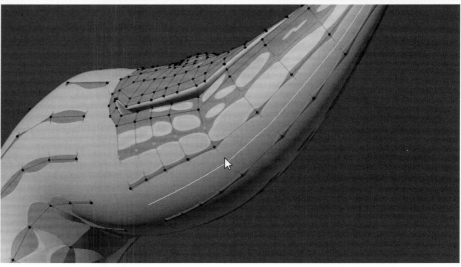

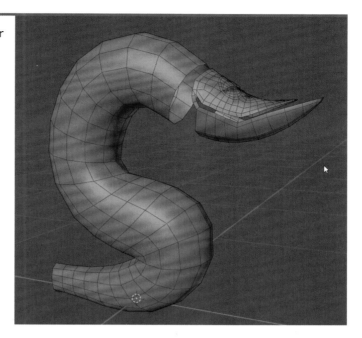

26d The retopologized model so far

Lastly select all of the faces that cover the body (excluding those that cover the face) using **L**, right-click, and select **Subdivide**. Then join the face area with the body part (image 26e).

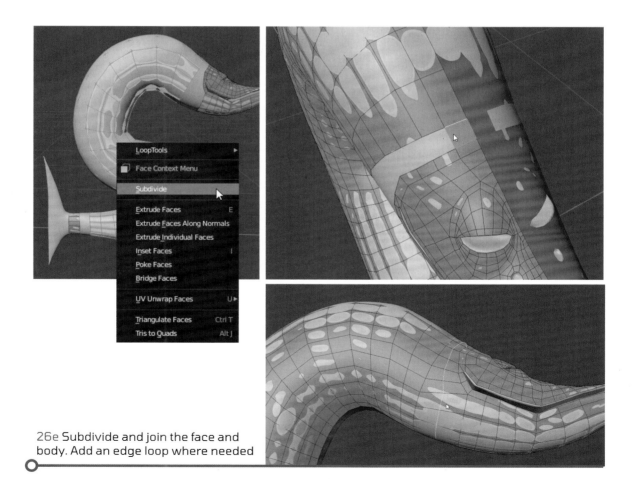

26e Subdivide and join the face and body. Add an edge loop where needed

27 Tail

The only part of the body left to retopologize is the tail. In this case there are no big details or important loops that have to be created. Extrude the side faces so that they meet at the back part of the tail (image 27a).

You are left with two vertex loops at the top and the bottom, which you can extrude to cover the rest of the tail, similar to how you did with the center of the body in step 21, selecting the last edge of the loop and pressing **E** to extrude a new face (images 27b, 27c, and 27d). If you have **Snapping** turned on, you will just need to move the mouse across the tail. Add any necessary loops to make the geometry even and more square-shaped.

You can leave out the tips of the tail for now. This is because small areas can be tricky to work with when using snapping and the **Mirror** modifier. For this reason, we will make the tips manually later without the use of the sculpted model.

27a Extrude to create a loop that is half the resolution of the body. This will make retopology of the fin faster

27b Keep a loop going around the center, marking the symmetry

27c Extrude polygons from the side to close the tail. This will leave the top and bottom of the fin opened in a way that is easy to close

27d Continue extruding and adding loops to cover the tail apart from the tips

28 Face details

Back in the face area, add two loops below the mouth area to make part of the lip less curved and more creased (image 28a).

Add loop cuts with **Ctrl + R** to detail the eyes (image 28b). You can close the nostril by selecting its edge loop using **Alt + left-click** to select, pressing **E** to extrude, and **S** to scale down.

Then fill the center area with four faces (image 28c). You can do this either by selecting the loop, pressing **Ctrl + F**, and selecting **Grid Fill**, or you can select the loop, press **F** to make a fill, and use the knife tool (**K**) to cut the edges in a way that means you only have quad polygons.

You can also create the eye cavity more precisely. To do this you will first need to apply the **Shrinkwrap** modifier back in **Object Mode** (image 28d). Since you already have all the details needed from the sculpt, you can do this without any problem. Once the Shrinkwrap modifier is applied, you can delete the body sculpt since you are left with your new and clean geometry.

28a Vertices should be close like this only where there is creasing; to keep the area around the crease smooth, make sure they are evenly spaced

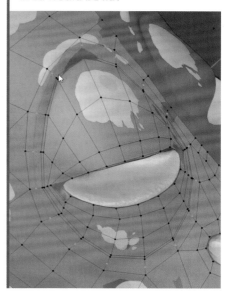

28b Add a loop cut around the eye cavity so the new vertices are snapped onto the eyebrow from the sculpt. Otherwise this area would be flat

28c Fill the center area

28d Apply the Shrinkwrap modifier in the Modifier Properties panel

Go back to **Edit Mode**, select the eyelid border, press **F** to fill the area, and then press **E** to extrude along the normal. Once the extrusion is inside the head, press **X** and select **Faces** to delete the fill (image 28e).

28e This inner part is covered by the eye so it is easier to delete it

29 Arm

Retopologize the arm using the same techniques used for the body. The arm is a cylindrical shape without creases, so you can make a ring of vertices and extrude them along the arm to cover it with even geometry (image 29a). Do not forget to temporarily turn off snapping when extruding edge loops, otherwise vertices from the back part of the arm will stick to the front face of the arm. Add loops to create even geometry.

One simple way to quickly mark the elbow area is to select a group of faces and make an inset by pressing **I** (image 29b). This will create a little more tension and the elbow will be slightly more visible.

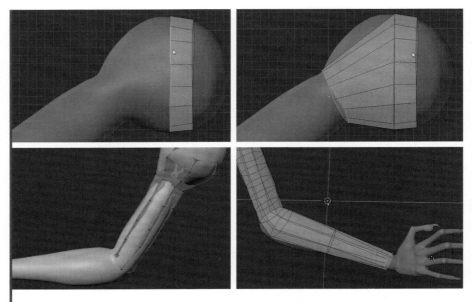

29a Use the same material properties as you did for the body. Extrude to places where the shape changes the most; you can fill the shape back in by adding loop cuts

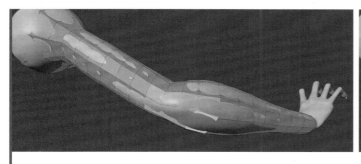

29b Insetting a set of faces is a simple way to mark elbows and knees without adding much geometry

30 Fingers

The same technique can be applied for the fingers. Turn **Snapping** back on, select a vertex from the arm, and press **Ctrl + D** to duplicate it. Position it along the start of one finger and create a loop of vertices as you did in step 20. The loop should have eight edges.

Next, turn **Snapping** off and extrude edges along the finger (image 30a). The **Shrinkwrap** modifier will keep vertices stuck to the finger. As with the elbow, you can inset the knuckle area to make it more visible (image 30b). Continue working to cover the finger (image 30c).

30a Make sure your vertex loop has eight edges to keep the shape round

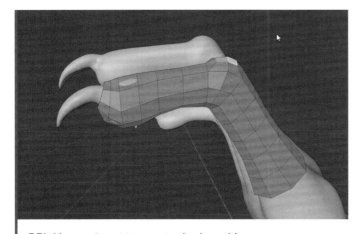

30b Use an inset to create the knuckle

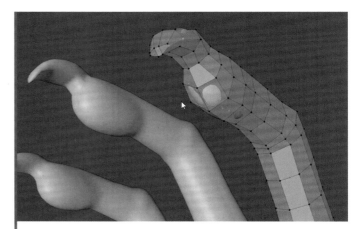

30c Continue extruding to cover the top of rest of the finger and nail

To save time and effort, once a finger is complete, turn off the **Shrinkwrap** modifier, duplicate the whole finger inside **Edit Mode**, and place it on top of another finger. Turn the **Shrinkwrap** modifier back on. Tweak if needed and repeat for all fingers (image 30d).

Finally, connect the space between the fingers and add a loop cut to make a crease (image 30e).

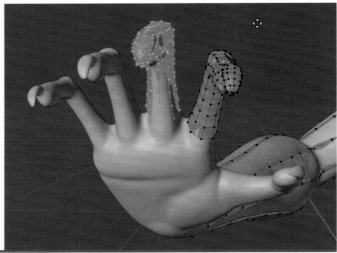

30d Duplicate the finger geometry in Edit Mode

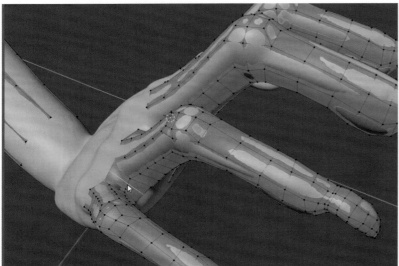

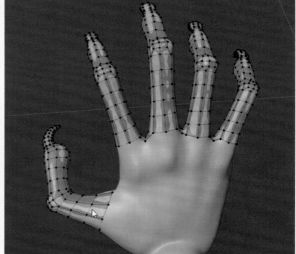

30e Repeat the process for the rest of the fingers, connect the space between them and creating a crease with a loop cut

31 Hands

Making accurate topology for hands can be complicated, but as we are focusing only on rendering and not animation, we can keep it quite simple. Close loops around the base of the fingers and extrude a new face for the knuckles (image 31a). Making a loop around the knuckle will make it more visible when adding subdivision.

Make the same shape for all the knuckles, and once this is done, make a loop that goes around the hand. You can then extrude long faces and add loop cuts as needed (image 31b).

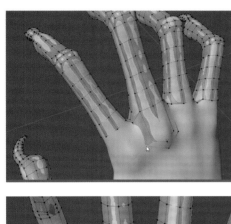
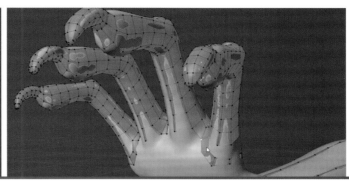

31a Make a loop around the lower knuckle as shown

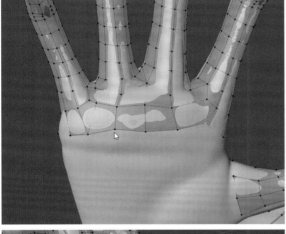
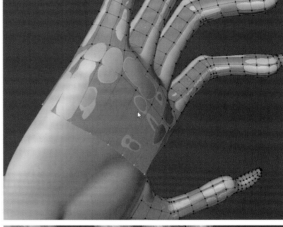

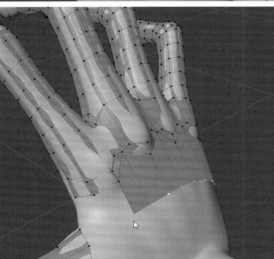
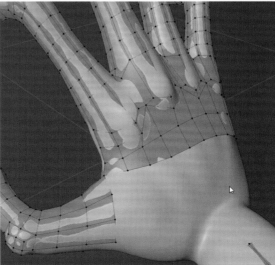

31b Ensure the faces from the knuckles are a closed loop that goes around the hand. Extrude the whole loop of vertices around the hand to fill a big part of the area

32 Connecting the hand & arm

The last step to finish the hand retopology is to connect the hand area with the arm. Similar to some of the facial areas, there are no more details to create and the only task is to fill space with polygons (image 32a).

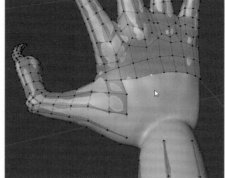 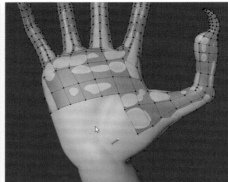

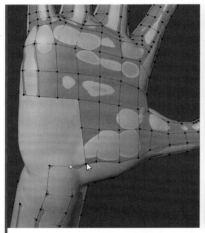 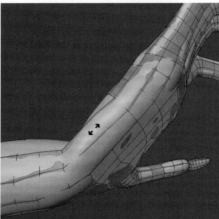 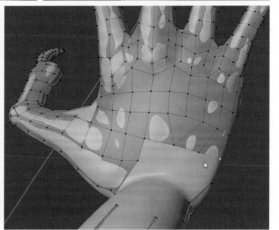

32a Continue extruding polygons into the arm and start connecting areas that match

Usually hands are more dense than the rest of the arm. One way to reduce the amount of detail flowing to the arm is to use a diamond shape, which will change the topology flow and reduce the number of polygons in a certain direction (image 32b).

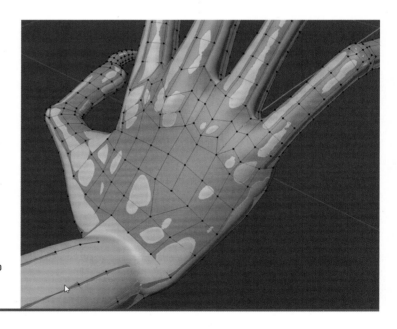

32b Use a diamond shape to reduce the number of faces flowing in one direction

Once you have finished the hand, apply the **Shrinkwrap** modifier in the **Modifier Properties** panel and delete the arm sculpt. Add a **Mirror modifier** (to the retopologized arm and hand object) to see both hands, and a **Subdivision Surface** modifier to see the smoother version (image 32c).

Finally, go to the Material Properties for the body, arms, and hands and change the Viewport Display color to green to better match the character (image 32d).

32c Add a Mirror modifier to see both hands

32d Note that this is for display in the 3D Viewport only and does not change the render color

33 Inner mouth

In **Object Mode**, select the body object and then go into **Edit Mode**. Select part of the mouth edge, leaving out three edges on each side of the center line (image 33a). To do this quickly, select one edge and then click while holding **Ctrl** to select the last one.

Extrude the selection along the X axis (image 33b). Add a loop cut with **Ctrl + R** and fill the remaining area with quads (image 33c).

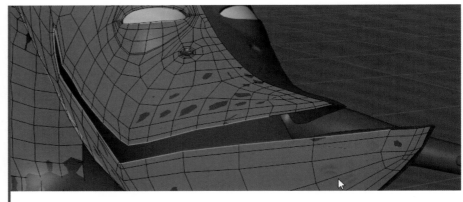

33a Select the mouth edge as shown

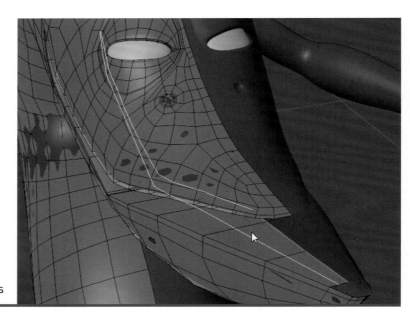

33b Use E and X to extrude along the X axis

33c Fill the remaining area

Select the inner part of the mouth, press **P**, and click **Selection** to separate this part of the mesh. This will mean you can work inside the mouth and not worry about the body. Switch back to **Object Mode**, select the separated mesh, and go back into **Edit Mode** (image 33d).

Split the 3D Viewport and set one side to Right view by pressing **Numpad 3** and turn on X-Ray view with **Alt + Z**. In the other window, move the inner vertices to create the shape of the inside mouth (images 33e and 33f). Since you can still see the body in the first window, you can make sure that the mouth shape stays inside of the head. Do not move any of the vertices that are directly connected to the mouth edge.

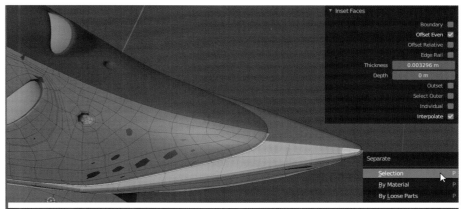

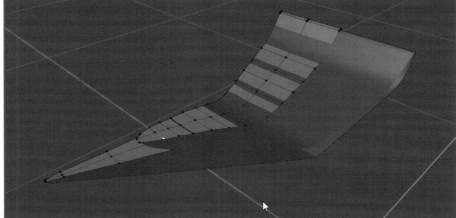

33d You are now ready to modify the inside mouth shape. It is important not to touch the boundary vertices at all. These are in exactly the same place they were connected to the body; leaving them in the same place will let you connect the mouth back to the rest of the body easily

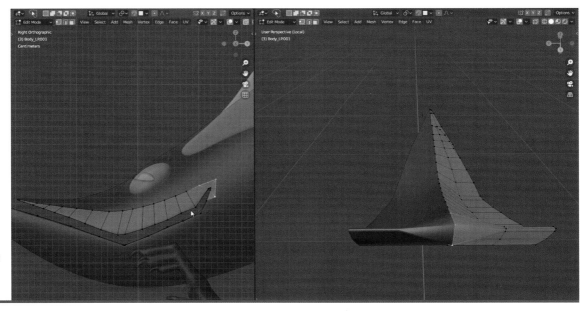

33e Split your view so you can keep an eye on the mouth shape in the context of the head

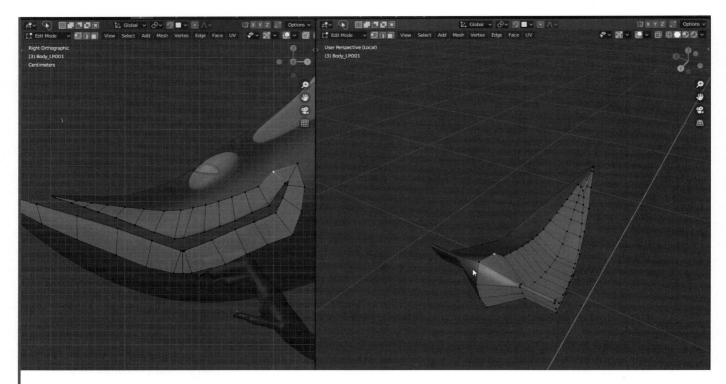

33f Move all the vertices in the center of the model, marking what would be the deepest areas of the mouth

To speed up the process for the second edge loop shown in image 33g, dissolve this loop by pressing **X**. Since you left out that first and last edge when dissolving, the loop you just added will not be complete (as it encountered non-quad geometry). You can connect it back by selecting two vertices and pressing **J** (image 33h).

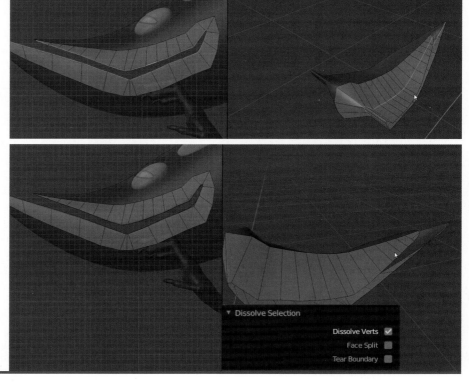

33g Leave out the first and last edge of the loop so as not to affect the mesh boundary

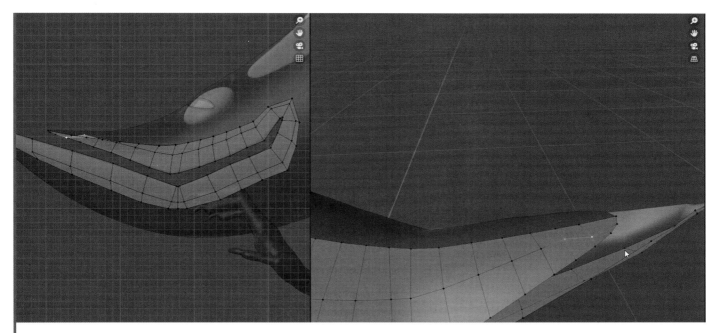

33h Reconnect the loop

Lastly, back in **Object Mode**, select the inside mouth, then the body object, and press **J** to join the objects. It is important to know that the inside mouth is still separated from the body, but since you did not touch the boundary, all the vertices of the mouth overlap and you can easily merge them in **Edit Mode** using the **Merge by Distance** function (press **M** to access the **Merge** menu; image 33i).

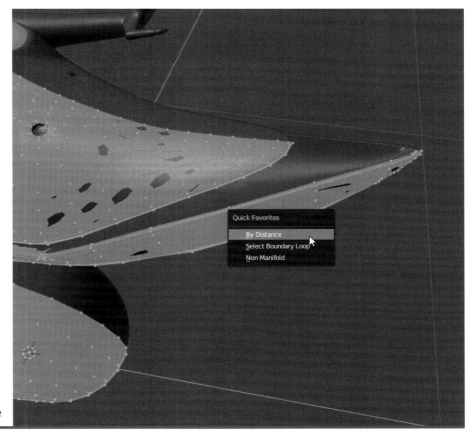

33i Merge vertices by distance

Clothing

34 Shirt body

We can use the retopologized body to create the shirt. Select the body, and in **Edit Mode** make a face selection of the area where the shirt could be (image 34a). Press **Shift + D** to duplicate it, right-click to keep the placement, press **P**, and separate it by selection. In **Object Mode**, select the shirt object and make a new material for it in the **Material Properties** panel, setting it as a yellow color in the **Viewport Display** section for now (image 34b).

Back in **Edit Mode**, you can make the shirt inflate away from the body a little by pressing **Alt + S** and moving your mouse. Left-click to accept the selection (image 34c). Tweak the shape a little using Transform tools and proportional editing in **Edit Mode** or the Grab brush in **Sculpt Mode** (image 34d).

34a Select the faces of the shirt area on the body

34b Create a new material and select the Viewport Display color

34c Inflate the shirt slightly

34d Adjust the shape of the shirt slightly to match the reference image

35 Shirt details

Now go to **Edit Mode** and select a square group of polygons where the arm is (image 35a). Delete these faces and make a loop selection of the hole. One way to make a perfect circle out of your selection is to use the **Circle** option from the **LoopTools** add-on, which you can find by right-clicking. Extrude the loop along the arms to create the sleeves of the shirt.

35a Create a loop and extrude the sleeve down the arm

Right-click and select **LoopTools > Relax** to make edge loops along the sleeve circular. Add some loops with **Ctrl + R** to achieve even geometry (image 35b).

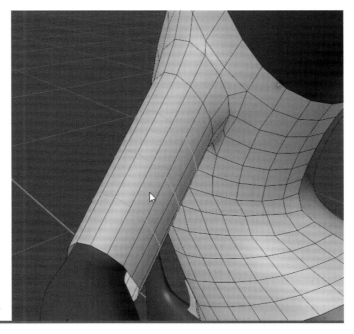

35b Use Ctrl + R to add edge loops

Finally, turn off the mirror temporarily by going to the Modifier stack and clicking the monitor icon. Move some vertices away from the center on the front to create the shirt opening. Tweak in **Sculpt Mode** to create a more natural shape (image 35c).

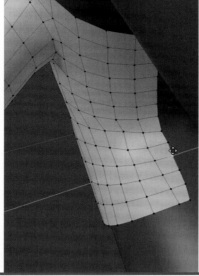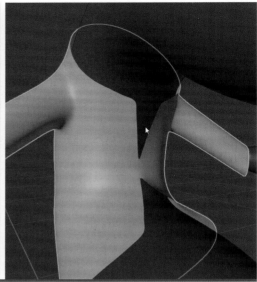

35c You can make an opening in the top part and the lower part

Turn the **Mirror** modifier back on and, in **Edit Mode**, select the neck border of the shirt and extrude it out to create the collar (image 35d). Add a loop cut if necessary to keep the geometry even.

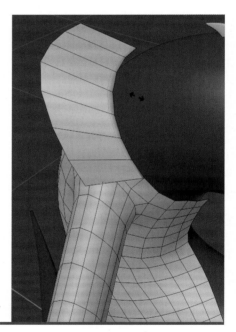

35d Extrude edges of the neck line to create the collar

36 Cloth simulation

You can create a simple cloth simulation to make the shirt look organic. Select the body, go to the **Physics Properties** tab of the Properties Editor, and set it as a collision object by clicking the **Collision** button. Lower the **Thickness Outer** value, which works as an imaginary margin (image 36a). This value depends on the size of your scene. In this case 0.010 should work. Set this for the arms as well.

Now select the shirt and set it as a cloth in the **Physics Properties** tab by clicking the **Cloth** button. Scroll down and set the **Collision > Distance** value as 0.005 m. Click play on the Timeline at the bottom of the interface (or press **Spacebar** to enable play) and wait a few frames until the shirt rests on the body (image 36c). Although we will work on the shirt again later, this gives a nice overview of how the character is looking.

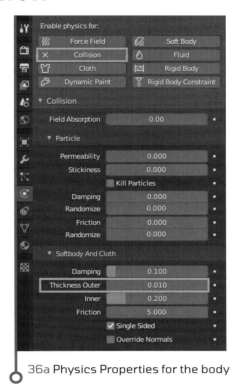

36a Physics Properties for the body

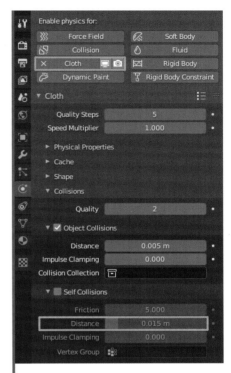

36b Physics Properties for the shirt

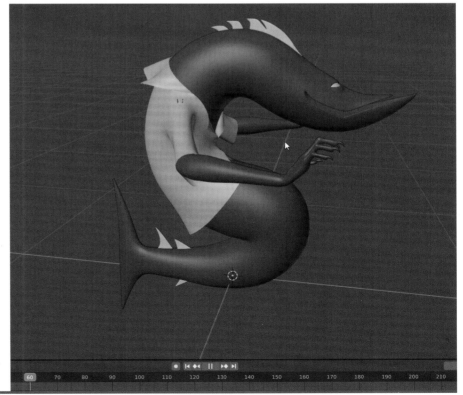

36c Press play on the Timeline to see the shirt come to life

Final retopology

37 Tail & fins

Before moving on, finish the last details of the body. The tail area is very rounded and should probably be thinner. To do this easily, select part of the tail in **Edit Mode**, and use **S** and **X** to make it flatter (image 37a). Move it along the X axis if needed using **G** and **X**.

To close the tips of the tail, select an edge loop, press **F** to close it, and **Ctrl + B** to bevel it (image 37b).

You will need to retopologize the fins as well, as shown in image 37c:

A Use one lower fin as reference and select faces around it.

B Press **I** to create an inset and **B** to keep the boundary (see green box).

C Click to confirm and, in a side view, extrude (**E**) the selection and move it to the tip of the fin.

D E Add loops and points to match the shape.

Do this for all the fins in the tail. Once done, you can delete the previous fin objects (image 37d).

BOUNDARY OPTION

This boundary option is super useful. If you take a look at the fin as an example, you make an inset and that new loop should go around the whole fin – but you are working on only half of it due to the **Mirror** modifier. If you only carry out an inset, you would get a complete loop around the selection (which is half of the model). By pressing **B**, Blender sees the selection is on a boundary (the center of the model) and does not close the whole loop around the selection but continues it in the direction of the boundary.

37a Flatten the tail

37b Do not forget to do this for the lower tip as well

37c The fin retopology process

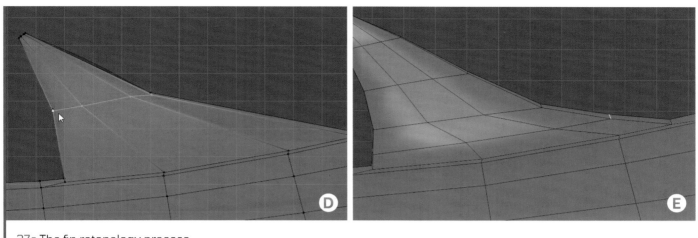

37c The fin retopology process

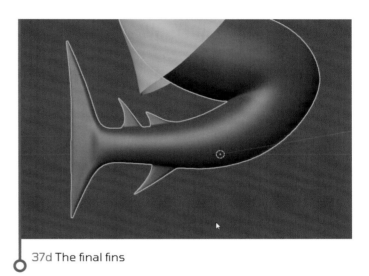

37d The final fins

38 Tail fin details

In the concept, the tail fin is not perfectly straight and it has small triangular gaps. To recreate this, follow the instructions as shown in image 38:

A Select edges along the tail where these gaps would be.

B With all your chosen edges selected, press **Ctrl + B** to bevel and left-click to confirm it.

C Then delete your selection to create the triangular gaps. Join each middle vertex with the one next to it to remove N-gons and keep quads only. To do this, select the two vertices, press **M**, and select **At Center**.

D Tweak the shape to match the reference. Use a side view to properly see the shape of the tail.

E When you are happy with the result, extrude the inner edges and close the missing faces to create the inner part of the gap.

F After all gaps are closed, select the crease border of each and press **Ctrl + B** to bevel it. This way it will make the gaps more defined and creased when using subdivisions.

Repeat this step for each gap on the tail.

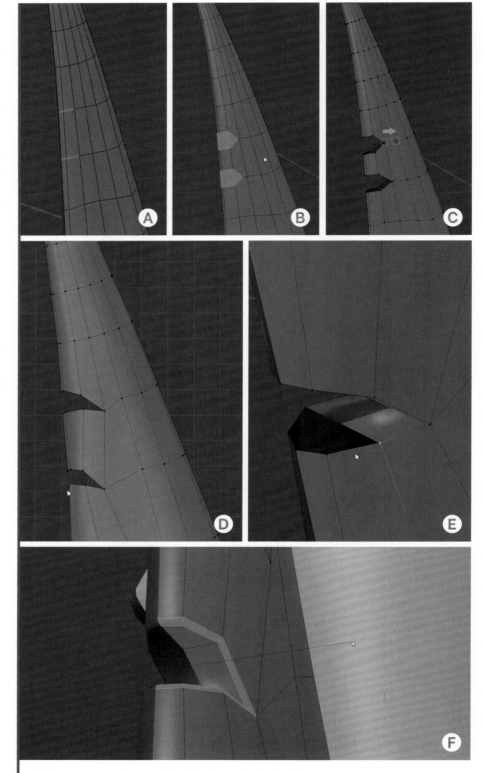

38 The process for creating the tears in the tail fin

Modeling accessories

39 Ring

The next step will be to create the accessories. To make a ring, press **Shift + A > Curve > Circle** in **Object Mode**. Position, rotate, and scale this circle to fit one of the fingers (image 39a).

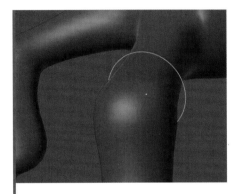

39a Rotate the view through many angles to ensure it is placed correctly

You can then add thickness in the **Object Data Properties** tab of the Properties Editor: increase the **Geometry > Extrude** value to make a cylinder out of the circle and then the **Bevel > Depth** value to add thickness (images 39b and 39c).

Add a new material in the **Material Properties** tab, name it Gold, and change the **Viewport Display** color to something between yellow and orange (image 39d). Follow the same process to add another ring, adjusting the thickness for the second ring as needed (image 39e). Create one more ring that will go on the other hand as in the reference image.

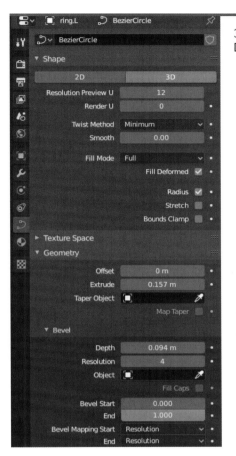

39b Add thickness in the Object Data Properties tab

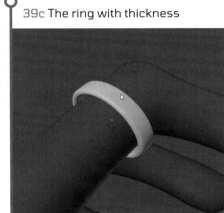

39c The ring with thickness

39d Add a material

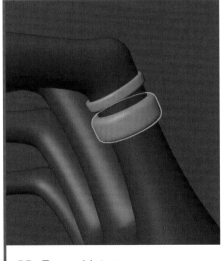

39e Two gold rings

40 Ring detail

One of the rings has a decorative element on top. You can easily recreate this by first adding a cylinder to your scene: use **Shift + A > Mesh > Cylinder** and then open the **Add Cylinder** menu that appears in the bottom left of the 3D Viewport and set the number of vertices as 8 (image 40a). Then follow the instructions as shown in image 40b:

A Scale the cylinder down using **S + Z**.

B Go to **Edit Mode**, select the top face, and create an inset by pressing the letter **I** key and dragging. Create another inset on the new face, and then move this new face down along the Z axis using **G** and **Z**.

C Create one more inset on the newest face. Add a loop cut around the middle of the cylinder using the Loop Cut tool.

D Add a **Subdivision Surface** modifier.

E Add the gold-colored material and place it on the ring.

F Finally, convert the curve into mesh* by going to the Header in **Object Mode** with the curve selected and selecting **Object > Convert to > Convert Mesh from Curve/Meta/Surf/Text**. Then delete part of the ring so there is no intersection with the ring detail – go to **Edit Mode** and loop select the areas that intersect the ring detail; press **X** and select **Faces** to delete this part of the mesh.

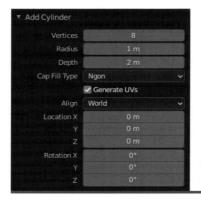

40a Add a cylinder with 8 vertices

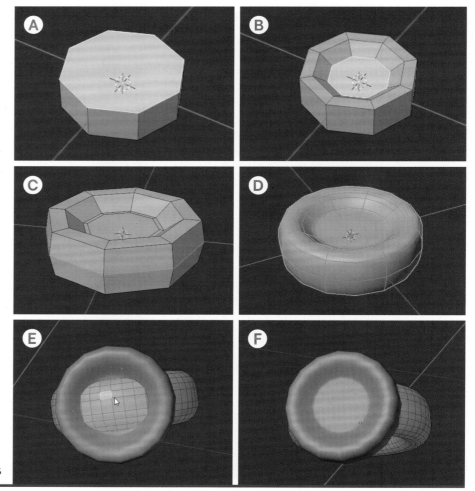

40b The ring detail process

*This is necessary because you need to delete part of the ring, so that it does not go through the cylindrical detail you modeled earlier. It is not possible to delete part of a curve easily, so it is better to make a mesh out of the curve so you can access the polygons in Edit Mode. Other rings have no extra details to delete, so it is only required for this one.

41 Necklace

To make the necklace, you can use the same principle. Add a curve circle and place it on the character. Add thickness to it, this time only by increasing the **Bevel > Depth** value so as to achieve a perfect circular profile. Change the shape using the curve handles in **Edit Mode** (image 41a).

You can create the rest of the necklace using simple shapes. For example, use a cylinder to make the fastener and a curve circle to make a ring from which the cross will be hanging. To create the cross you can use a cube and extrude four of its sides (image 41b). You can also add a **Bevel** modifier to add some detail to the cross (image 41c). Make sure you add the same gold material to all the accessories.

41a Play around with the curve handles to modify the shape of the necklace

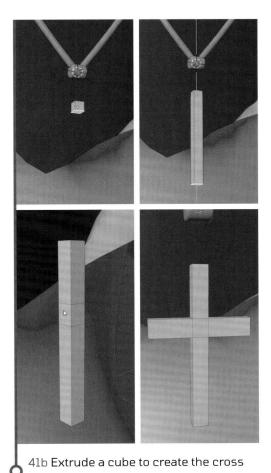

41b Extrude a cube to create the cross

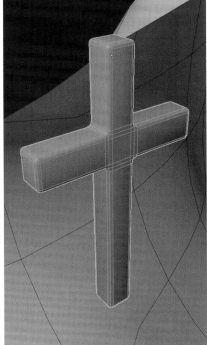

41c Add a Bevel modifier to the cross

Projects

42 Watch

The last piece of jewelry missing is the watch. First you need to create one of the watch segments as shown in image 42a:

A Add a cube and scale it down to create the desired shape.

B Create an inset by pressing **I** and moving the cursor.

C Extrude by pressing **E** and moving the cursor. This will be the link to the next shape. As this area will be connected to other segments, delete the face to avoid inner faces.

D Create an insert (**I**) on the front face and extrude (**E**) slightly.

E Go to the **Modifier Properties** tab of the Properties Editor and add a **Bevel** modifier. Set the **Limit Method** to **Angle**. Set **Segments** to 2.

 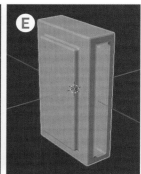

42a Creating a single segment

With that new object selected, add an **Array** modifier (image 42b) and a **Curve** modifier (image 42c). The **Array** modifier will copy the object (image 42d) to create the strap and the **Curve** will help you deform into the circular shape required to make the watch strap. For the **Curve** modifier to work correctly, add a curve object to the scene and set this curve as the **Curve Object** in the watch segment's **Curve** modifier using the eyedropper. The segments will now be positioned around the curve (image 42e).

CHECK OBJECT ORIGIN

Make sure that your object origin is aligned with the world origin (**Alt + G** in **Object Mode**) and has no rotation or scaling (**Alt + R, Alt + S**). You will move the object using the curve it is attached to.

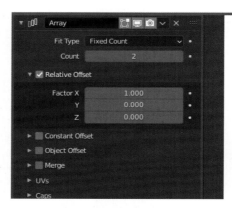

42b The Array modifier

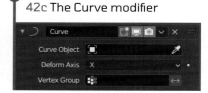

42c The Curve modifier

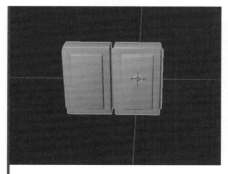

42d The effect of the Array modifier with Count set to 2

42e The segments around the curve

260

Scale and position the curve around the wrist. Now increase the **Count** number in the **Array** modifier until the segments complete the circle (image 42f). Then select the curve, and in **Edit Mode**, tweak the shape using the handles and point positions to match the correct shape in the reference image (image 42g).

Add a gold-colored material again and create the watch face in the same way you created the ring detail in step 40 (image 42h).

STAY ORGANIZED

Do not forget to keep renaming objects in the Outliner with logical names to keep your scene as easy to navigate as possible.

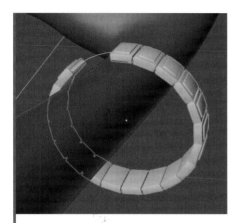

42f The effect of the increased Count number

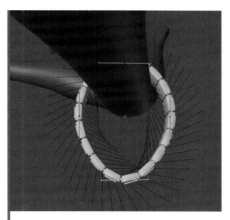

42g Shape the curve to match the reference

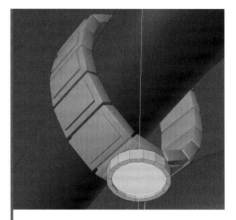

42h Add a material and create the watch face

43 Webbing

Now the jewelry is done, you can move on to other details. To make the web between fingers, start by using the same technique used for retopology. Snap a few vertices on the hand surface to cover the desired area (image 43a), extrude them out using **E** (image 43b), and add loop cuts on the edges (image 43c). Finally add a **Solidify** modifier and a **Subdivision Surface** modifier to create thickness and a smooth shape (image 43d).

Also add a **Mirror** modifier and set the body as a mirror object so that the webbing appears on the other hand.

43a Try to keep the number of vertices as low as possible, so that your mesh is easier to work with

43b Extrude the vertices out

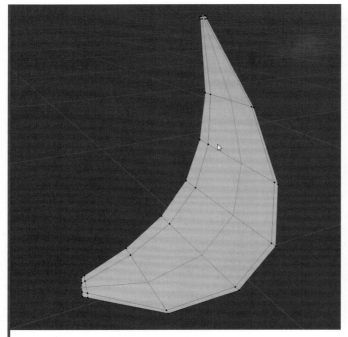

43c Loop cuts are on all sides so when subdividing all edges are sharp

43d The webbing with thickness and a smooth shape

44 Teeth

To create teeth, follow the instructions as shown in image 44a:

A Add a single cube, select the top face, and move it upward.

B Scale the top face down.

C Add a **Subdivision Surface** modifier and apply straight away.

D Now add a **Simple Deform** modifier and select the **Bend** option. Add a **Subdivision Surface** modifier to make the tooth smoother (see also image 44b).

Add a material and set the **Viewport Display** color as a whiteish color. Move the tooth into the mouth, duplicate it a few times, and match its position as in the concept. Rotate and scale as needed (image 44c).

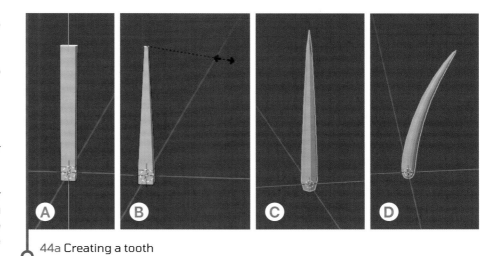

44a Creating a tooth

44b The Simple Deform and Subdivision Surface modifiers

44c Arrange the teeth in the mouth

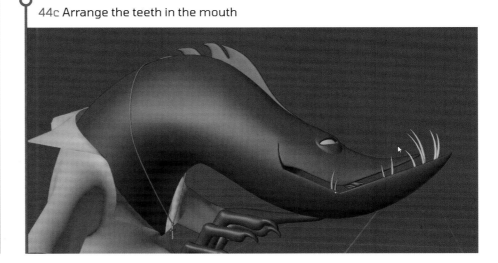

45 Shorter tooth

Make a new shorter tooth, but this time do not add the **Simple Deform** modifier (image 45a). Similar to how you created the watch, you can use an **Array** modifier and a **Curve** modifier to copy and manipulate the shape (image 45b).

Add a Bezier curve and use it to drive the **Curve** modifier (image 45c). In **Edit Mode**, change the curve shape to match the mouth region (image 45d). With all points selected, press **Ctrl + T** to change the teeth rotation. If needed, select two points, right-click and select **Subdivide** to obtain more points to manipulate the curve.

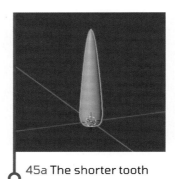

45a The shorter tooth

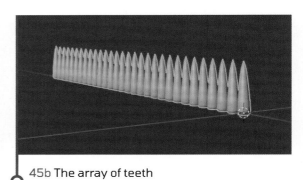

45b The array of teeth

45c The teeth on the Bezier curve

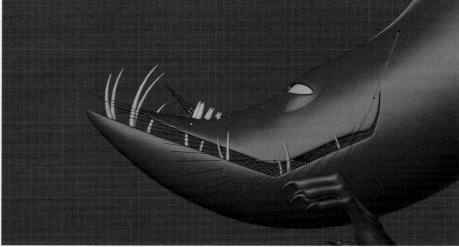

45d Tweak the curve shape from Top view first and then change to a side view to match the mouth shape

Once done, select the first tooth, go into **Edit Mode**, and select everything with **A**. Press **Numpad 1** to go to Front view. Duplicate the geometry using **Shift + D**, place it next to the first tooth, and rotate it by 180 degrees. This way you get teeth in both directions (image 45e).

Check and adjust the position of the curve and increase the **Count** value in the **Array** modifier if needed (image 45f). Add a new material to all teeth and the same gold material we used for accessories to one of the teeth as in the reference.

45e Duplicate and rotate the tooth

45f Increase the Count value in the Array modifier if needed

46 Shirt refinement 1

The last model left to finish is the shirt. Select the shirt, and apply the **Mirror** and the **Cloth** modifiers. Go into **Edit Mode** and, using Front view and X-Ray mode select half of the shirt, delete it, and add back a **Mirror** modifier. This way you can keep working with symmetry (image 46a).

Tweak the collar shape using the **Relax** function of the **LoopTools** add-on (right-click to access it) to make geometry more even (image 46b).

You also need the edge of the shirt to be more creased when smoothing and the tip of the collar to maintain shape. To do this, add another loop closer to the edge and modify the topology using the Knife tool (shortcut **K**; image 46c).

46a Select the center loop, press S, X, and zero to scale it down along the X axis. This will ensure that connection with the Mirror modifier is correct

46b Do not forget to turn on the Clipping option to keep the center attached

Additional loop

46c To make this corner sharp, you need at least three vertices to hold it. To join faces you can select them and press F

Continue tidying up the edge loop as shown in image 46d .

To keep the topology tidy, extrude part of the front collar and connect it to the last loop (images 46e to 46g). This will mean that the shirt will deform better when subdividing.

46d Extrude a vertex, select the three other vertices, and press F to fill

46e Continue creating an outer strip on the collar by selecting edges and extruding them

46f Select the edges on both parts of the collar as shown and press F to create a face between them

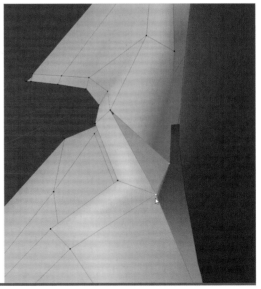

46g Join these two vertices to get rid of the opened triangle. Press M to open the Merge menu

47 Shirt refinement 2

Add another loop around the shoulder to create a more defined transition in the shirt (image 47a). Also add another loop as shown in image 47b. Add a **Solidify** and **Subdivision Surface** modifier to add thickness and smooth the object. You can now apply the **Mirror** modifier. Normally it is good to keep symmetry for as long as possible, but part of the shirt should cross around where the buttons would be so you cannot use symmetry here.

In **Edit Mode**, select the connected edges of the shirt, press **V** to disconnect the geometry, and move it aside slightly (image 47c). Turn on **Proportional Editing**, making sure the **Connected Only** feature is on, and move the two connected faces above the other half. Use the mouse wheel to set the proportional radius.

The shirt should now look more like that shown in image 47d.

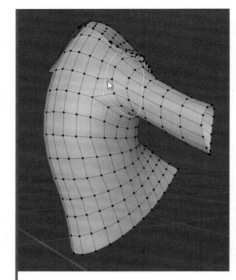

47a Add another edge loop around the shoulder

47b This additional loop creates another three vertices in the collar corner and will keep it sharp when subdividing

47c Pull one side of the shirt over the other slightly

47d The refined shirt

UVs

48 Shirt

At this point you have finished modeling and can prepare the character for texturing. Even though it is possible to create materials and textures without UVs, it is always helpful to have them at hand. To UV unwrap all the key parts of the character, you need to mark seams and virtually slice up the model to have a 2D representation of the geometry. An easy one to start with is the shirt, as you can mark seams in the same places real shirts have seams.

To mark seams, go into **Edit Mode**, select the edges where you want the seams, right-click or press **U**, and select **Mark Seams** (image 48a). Go to the UV Editing workspace so you can see both the 3D Viewport and the UV Editor. Select everything in the 3D Viewport, press **U**, and select **Unwrap**. Now you will see the result in the UV Editor window (image 48b).

48a Seams are marked in red so you can see them. Make sure you mark seams on both sides of the shirt, since you applied the Mirror modifier and need to process both sides now

48b The unwrapped UVs

TEXTOOLS ADD-ON

Remember that you can use grid textures to check your UVs as you learned on pages 169 and 188. The **TexTools** add-on can be useful for this as it will let you quickly add a checkered map to the object for you to check it is made of quads and has unwrapped well. Note that this will delete the original material, so you will have to apply it back when done.

Try the TexTools add-on

49 Arms

Do the same for the arms. It may seem a dark analogy, but the best way to approach character UV unwrapping is as if you wanted to peel off the character's skin and frame it on the wall. Mark seams in places where they will be less visible (image 49a).

49a The arm seams

When working on seams, it can be useful to create some to divide your model and use those as isolation boundaries to work in specific parts without affecting the rest. For example, you could isolate the arms from the hands. In **Edit Mode**, make sure you are in Face Select mode, use **L** to select linked geometry, and you will notice the selection will be limited by UVs (image 49b). This way you can hide geometry, make loop selections, and add seams without affecting areas you do not want to affect.

49b In Edit Mode, you can press H to temporarily hide part of the mesh, Alt + H to unhide everything, and Shift + H to isolate the selection

Image 49c shows the unwrapped UVs. Use a grid texture to check the quality of the unwrapping (image 49d).

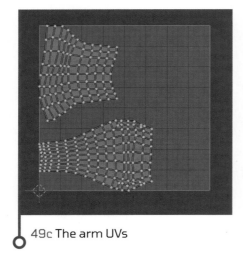

49c The arm UVs

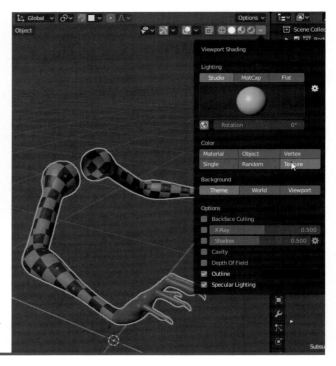

49d Instead of using Material Preview mode to preview the texture, go back into Solid mode and turn on Texture in the Viewport Shading settings. This will be lighter work for the computer when it comes to previewing

50 Hands

Next, focus on the hands. Isolate the geometry by selecting the hand area with **L** and pressing **Shift + H** to isolate it instead of hiding it.

Mark seams where nails start and then hide them (image 50a). To unwrap the hand simply mark a continuous seam around the silhouette to basically split it into two parts. Also mark seams at the first loop of each finger to avoid stretching (image 50b).

Unhide everything by pressing **Alt + H**, select all the nails, isolate them, and make a seam on one side so you will be able to unfold them, in the same way as you would unfold a carton or box (image 50c). Lastly, unhide everything, select everything, and unwrap it (image 50d).

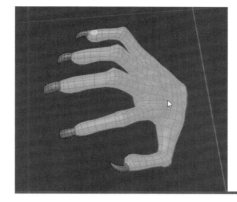

50a Mark the nails so you can hide them

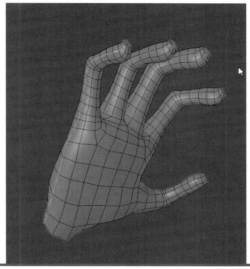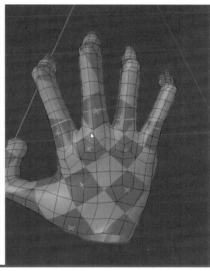

50b Due to the bending of the fingers, the unwrap result will be quite distorted, so it is better to make seams where each finger starts

50c Mark the nail seams

50d Once you are done with all seams on the arm, unhide everything and unwrap

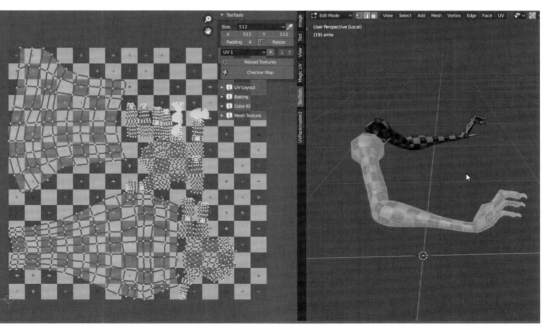

51 Upper fins & body

The upper fins are currently flat geometry, which we can unwrap without making any seams (image 51a). The body of the character is using the **Mirror** modifier, so in some way the actual existing geometry is also flat. That means we can make seams in just a few places.

To avoid stretching, it is usually good to create seams where there are creases, or where geometry drastically changes direction. That said, you definitely need to add seams around the lips, to separate the inner part of the mouth. Add a loop seam around the eye and around the fins on the tail (image 51b). The body is quite long, so also add a loop seam in the middle part as shown in image 51c – this part is good as it is almost halfway but is still covered by the shirt. Other objects have simpler textures so it is not necessary to unwrap those.

Once again apply the checkered material to preview the unwrap result. Once you are done, reapply the body material you created previously.

51a These upper fins are plane geometry and have no real thickness. This means you do not need to add seams and can unwrap as they are

51b The seams on the lower fins, eyes, and mouth

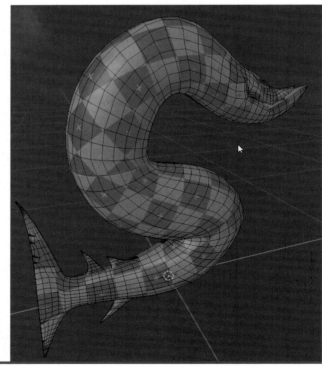

51c The center seam added

Environment

52 Environment shaders

In this step we will set up the world around our character. Split your interface and set the Shader Editor as one of the areas, keeping the other as the 3D Viewport. Access the environment shader by changing the context in the dropdown menu on the left side of the Shader Editor Header to **World** (images 52a and 52b).

52a Select World from the dropdown

52b The environment shader

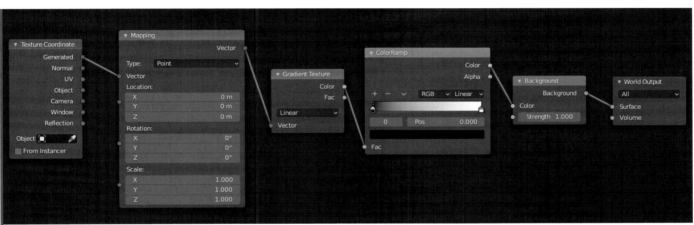

52c The connected nodes

Press **Shift+ A** in the Shader Editor and add a **Gradient Texture** node from the **Texture** section and a **Color Ramp** node from the **Converter** section. Connect the **Gradient Texture** node to the **Color Ramp** and the **Color Ramp** to the **Background** node as shown in image 52c. Select the **Gradient Texture** node and press **Ctrl + T** to automatically add mapping nodes (image 52c).

CAMERA ANGLE

This is also a good moment to set your camera angle. Press **Numpad 0** to go into Camera Perspective. Make sure **Lock › Camera to View** is turned on in the **View** tab of the Sidebar and match the view to the concept image while navigating.

Go to Rendered view in the 3D Viewport to see how the shader is behaving. In the **Mapping** node, rotate the source by 90° on the Y axis so that the gradient is vertical and not horizontal. Change **Linear** to **B-Spline** in the **Color Ramp** node.

You can now tweak the colors in the **Color Ramp** node to create the green background (images 52d and 52e). To change the color, click on the colored bar (it will be black if you haven't used it already); you can then adjust the value slider and select colors from the color wheel.

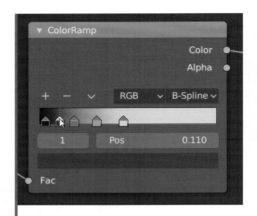

52d Use the plus icon to add more colors to the ramp, and the bottom color bar to change the color

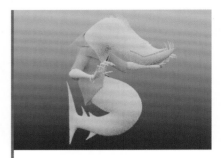

52e Keep the Rendered view while making changes to properly see the result. Use the Cycles render engine for better light results

53 Lighting & basic materials

Now set up some simple elements to properly work on materials. Roughly match the light from the concept by adding an area light in **Object Mode** in the 3D Viewport and placing it above the character facing down (use Rotate to achieve this; image 53a).

Increase the light power in the **Object Data Properties** panel until you see the effect happening. Similarly increase the size as shown in image 53a. Also color the light to light green so that it is not 100% white.

Then add a rim light by adding another area light behind the character (image 53b). Again, increase the power and size. Set the rim light as more of a yellow color.

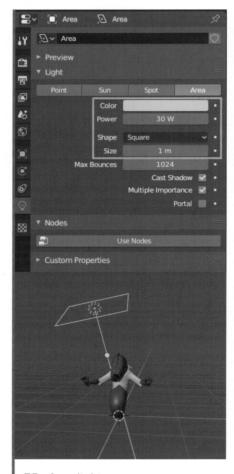

53a Area light

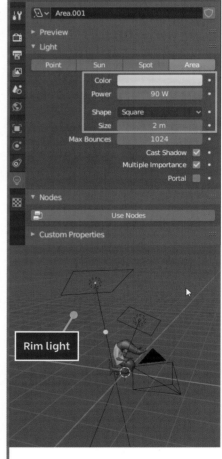

53b Rim light

Now we will go into each material and set at least the basic color to get a better feeling of the overall look. The base of the skin definitely needs some color variation. To do this, select the body in the 3D Viewport and, in the Shader Editor, change the mode in the Header from **World** to **Object**.

In the Shader Editor use **Shift + A** to add a **Texture > Noise Texture** node and a **Converter > Color Ramp** node. Select the **Noise Texture** and press **Ctrl + T** to get the mapping nodes. Connect the **Noise Texture** to the **Color Ramp**, and the other nodes as shown in image 53c. Play around with the **Color Ramp**

colors to match the shades of the skin in the reference image and tweak the **Noise Texture** parameters to change the effects (image 53d).

Going into the material for each of the other objects, change the **Base Color** in the **Principled BSDF** node to

53c The nodes in the Shader Editor

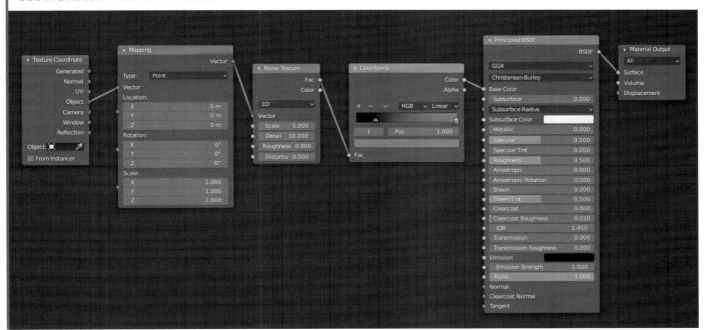

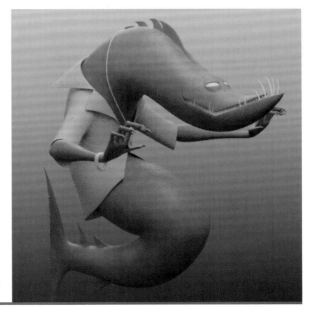

53d The rendered view of the character

get a better feel for the character. For the teeth, increase the **Roughness** value to 0.600 in the **Principled BSDF**.

In the case of gold, change the **Metallic** value to 1 in the **Principled BSDF** node (image 53e).

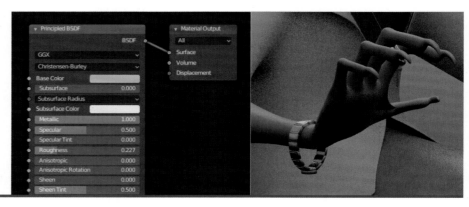

53e Increase the Metallic value for the gold material

Materials & textures

54 Body textures

In this step you will use a Voronoi texture to create dark and light dots and the noise texture to mask regions where you want the dots to be visible. By doing this you divide texture details into layers, and can build complexity in stages. You will also use Voronoi and Bump nodes to create scales.

Dark dots

For the body, create another **Noise Texture** node, a **Voronoi Texture** node and two **Color Ramp** nodes. Connect one **Color Ramp's Fac** socket to the **Noise Texture's Fac** socket. Connect the other **Color Ramp's Fac** socket to the **Voronoi** node's **Distance** socket (refer to the arrangement of nodes for this step in image 54g on pages 277–278).

Connect both texture nodes' **Vector** sockets to the **Vector** socket of the **Mapping** node created for the skin texture in the previous step.

Add a **Color > MixRGB** node and plug the **Color 1** socket into the **Color** output of the skin **Color Ramp** created in the previous step; plug the **Color 2** socket into the **Color** output of the dots **Color Ramp** node (the one

you just connected to the **Voronoi Texture**). Change the blending from **Mix** to **Multiply** in the dropdown on the **MixRGB** node. Note that this will change the name of the node to **Multiply**.

Add a second **MixRGB** node, set it to **Multiply** again, and plug the **Color 1** socket into the **Color** output of the noise **Color Ramp**.

Add another **MixRGB** node and leave it set to **Mix**. Connect the **Color** output of the noise **Multiply** node to the **Fac** input of the **Mix** node; connect the **Color** output of the skin **Color Ramp** to the **Color 1** input of the **Mix** node, and connect the **Voronoi Multiply** node's **Color** output to the **Color 2** input of the **Mix** node.

If you now connect the **Color** output of the **Mix** node into the **Base Color** socket of the **Principled BSDF** shader from the previous step, you will see the effects of the mask (image 54e). Experiment with some of the values shown in image 54g such as the **Scale** and **Roughness** settings in the texture nodes and the black and white values on the slider in the **Color Ramp** nodes to change the dots.

Light dots

Follow a similar process for the light dots, varying values again to create new dots: add new **Noise Texture**, **Voronoi Texture**, and **Color Ramp** nodes and plug them in as shown in image 54g. This time, rather than connecting them to the existing mapping nodes, add new **Mapping** and **Texture Coordinate** nodes and connect them as shown in image 54g.

Add a **Color > Invert** node and a **MixRGB** node set to **Screen**. Connect the **Color** output of the Voronoi's **Color Ramp** to the **Color** input of the Invert node. Connect the **Invert** node's **Color** output to the **Color 2** socket of the **Screen** node.

Now create a new **Mix** node, which will allow you to combine the effects of the dark and light spots. Unplug the **Base Color** socket of the **Principled BSDF** that you connected on the previous page. The new **Mix** node should be connected as follows:

▷ Light spot noise **Color Ramp** node **Color** output > **Fac**

▷ Dark spot **Mix** node **Color** output > **Color 1**

54a Play around with the Color Ramp to add or take away dots

54b The mask used to create lighter dots

54c The effect of the two sets of dots

▷ Light spot **Screen** node **Color** output > **Color 2**

Finally, connect the new **Mix** node's **Color** output into the **Principled BSDF's Base Color** socket. This way you will have both dark and light spots on the body (images 54b and 54c).

Scales

Add another **Voronoi Texture**, plug the **Distance** socket into the **Height** socket of a **Vector > Bump** node, and then plug the **Bump** node's **Normal** output socket to the **Normal** input of the **Principled BSDF**. Press Ctrl + T with the Voronoi Texture node selected to add mapping nodes. This will make little scales on the skin (image 54d). Play around with the Voronoi size and the Bump strength to control the effect.

Do the same again but this time add an **Invert** node between the **Bump** and **Voronoi** nodes so you can have dark and light scales again (image 54e). See the node arrangement in image 54f. Rather than creating new mapping nodes, connect the **Vector** socket of the new **Voronoi** to the **Vector** socket of the **Mapping** node you created for the first Voronoi. Add a **Mix** node, connecting the **Bump** nodes as shown in image 54f and connect the **Color** output to the **Normal** socket of the **Principled BSDF**.

54d Create the scales with another Voronoi texture and a Bump node

54e The effect of the scales

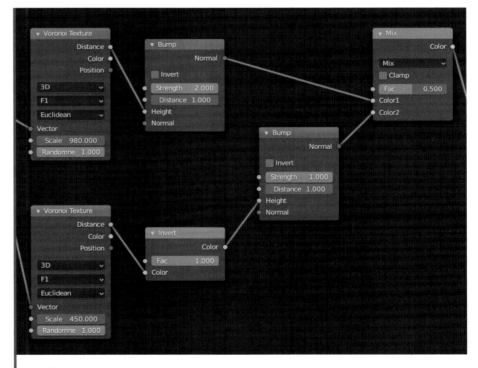

54f The arrangement of nodes for the scales

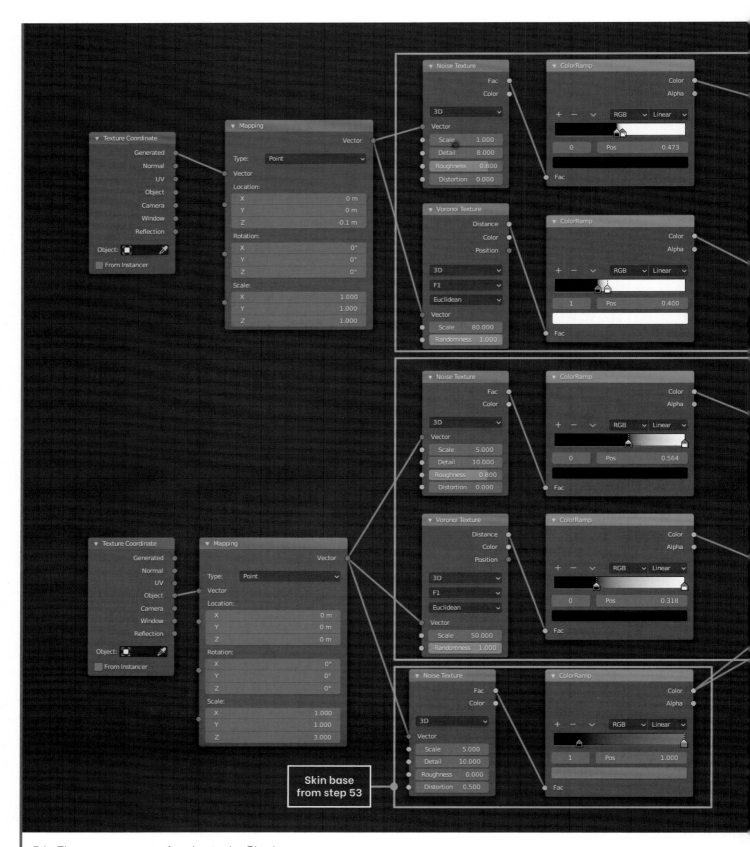

54g The arrangement of nodes in the Shader

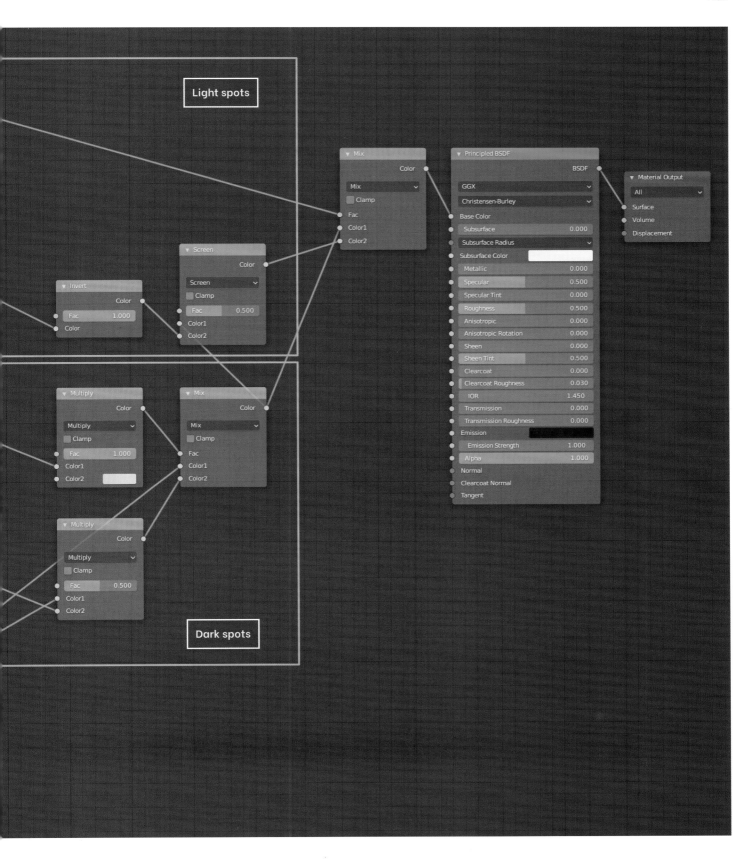

55 Eye texture – preparation

To create the eye and eye texture, you will make two components: an eyeball with a transparent area that will act as the cornea, and a pupil and iris area. To work on both eyes, you can either use a **Mirror** modifier, setting the body as the **Mirror Object**, or copy the finished eye and rotate it into position.

To texture the eye in more detail, it will be actually easier to add a new sphere that is not deformed, which you can easily edit. Go to **Object Mode** in the 3D Viewport and add a UV Sphere. This will be the eyeball.

In **Edit Mode**, select the area where the iris and pupil could be, duplicate it with **Shift + D** and separate it with **P > Selection** to make a new object. You

may find it useful to hide the eyeball object, but keep the iris object where it is as this will save you having to position it later.

Back in **Object Mode**, select the iris and go into **Edit Mode**. Select the center and move it backward to make room in the eye (image 55a). Add two new materials in the **Material Properties** panel – one with a **Base Color** suitable for the iris and the other suitable for the pupil. You can then assign the second material to your selection to mark the pupil by hitting the **Assign** button for that material (image 55b).

Go back to the UV Sphere you added, select the front part in **Edit Mode**, and move it forward to make the cornea. Add a loop where the cornea

ends, to make the transition sharper (image 55c). The next step will explain how to make the cornea transparent.

55a Duplicate faces on a new sphere to create the iris

55b Material assignment per face is only possible in Edit Mode

55c Edit the cornea of the UV Sphere

56 Eyeball texture – vertex color maps

For the eyeball shader, you could make two materials again and assign them accordingly, but it would be useful to explore another method here: using vertex color maps to mask out areas of the geometry.

In **Edit Mode**, select the faces that should be transparent (the cornea, which will overlap the iris and pupil). Go into **Vertex Paint Mode** and turn on face masking (the button to the right of the **Mode** drop down – see image 56a). This enables you to only paint the selection. Set the paint color to black and press **Shift + K** to fill (image 56a). Note that you need to be in **Material Preview** mode to see the effect.

Now in the Shader Editor you can mix the **Principled BSDF** shader with

a **Shader > Glass BSDF** shader using a **Shader > Mix** shader and use the mask as a factor – by default, any new vertex color map is called Col, and you can access it by adding an **Attribute** node and writing down Col (image 56b). Give the eyeball a pale **Base Color** in the **Principled BSDF**.

Ensure you have **Cycles** set as the Render Engine in **Render Properties**, and are in **Render** mode in the 3D Viewport; you should be able to see the iris and pupil through the transparent cornea. Lastly, position the eye again and scale it accordingly to fit the head as before (image 56c).

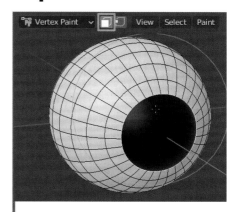

56a This will make the black area from the mask use the Glass node and the white area the Principled BSDF Shader

56b The node arrangement in the shader and the effect on the eye

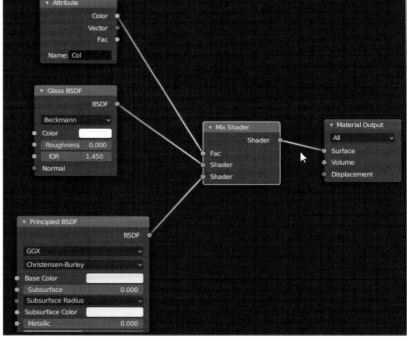

56c Adjust the eye shape and position in the eye socket on the character

57 Shirt material

Looking at the shirt material, in the Shader Editor add a **Texture > Magic Texture** node and a **Bump** node and plug the **Magic Texture** node's **Color** output into the **Bump** node's **Height** input (refer to image 57a for the node arrangement for the shirt material). The **Magic Texture** node is great for simple fabrics, as its pattern is similar to a generic cloth. Press **Ctrl + T** with the **Magic Texture** node selected to add its mapping nodes.

Plug the **Bump Normal** socket into the **Normal** input in the **Normal** socket

of the **Principled BSDF** node to see the result. Set the **Scale** value of the **Magic Texture** quite high, for example 280.00. Tweak the **Bump** strength as you think looks best.

Create an image texture to make the palm pattern and save it as a separate file. Add an **Image Texture** node, click the **Open** button, and look for the palm pattern file you created. Press **Ctrl + T** to add its mapping nodes, and tweak the scale and rotation of the texture in the **Mapping** node to make it smaller and add variation.

Finally, we will use this texture as a mask. Add a **MixRGB** node and plug the **Color** socket of the **Image Texture** to the **Fac** socket of the **MixRGB** node. Set the first color as yellow and the second color as green to match the concept. Plug the **Color** output of the **MixRGB** node into the **Base Color** socket of the **Principled BSDF** shader to see the effect (image 57b; note that in image 57a there is an additional **MixRGB** node and **Attribute** node which will be used to erase the pattern on the collar in the next step).

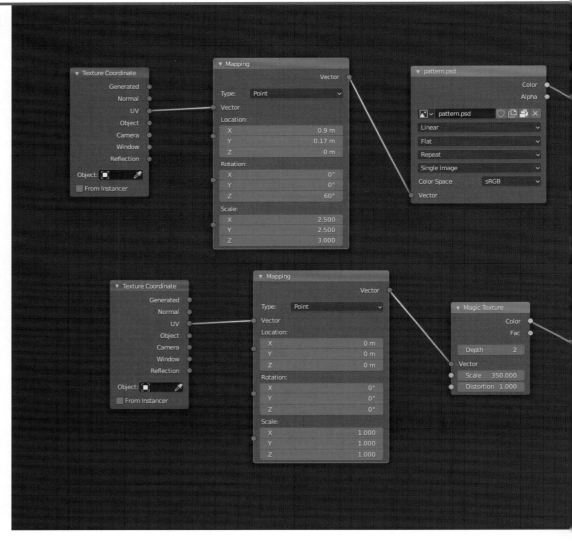

57a The arrangement of nodes for the shirt.

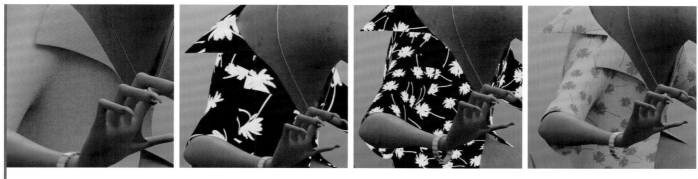

57b The shirt texturing process

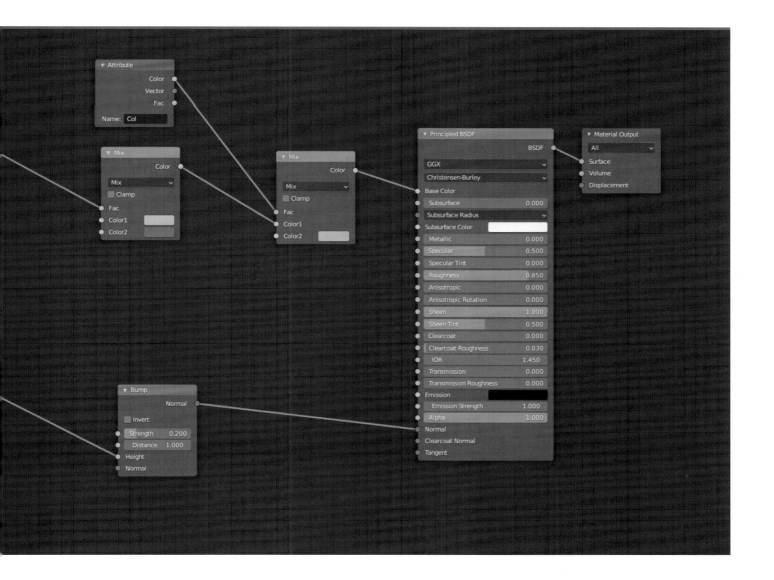

58 Shirt collar

At this point we need to eliminate the palm pattern on the collar of the shirt. Even though you can paint a mask by hand, it would be beneficial to add a loop along where the cloth folds down. This will mean you can use vertex color to mask out the collar and also make the fold sharper.

In **Edit Mode**, cut a line roughly where the fold is by using the Knife tool (**K**). Then select all edges that create the fold and press **Ctrl + B** (bevel) to make a loop of polygons in between

(image 58a). Do the same for the other side.

Next, you can follow a similar process as you did for masking the eye in step 56: select the neck collar where you don't want the palm pattern to appear (image 58b), press Ctrl + I to invert (image 58c), go to **Vertex Paint Mode**, turn on face masking, and fill the collar with white. That mask is by default called 'Col' so you can add an **Attribute** node in the shirt material with the name **Col** and access that

mask; duplicate the last **MixRGB** node and connect everything as shown in image 57a on the previous page. Note the remaining color will be the color of the neck collar. You can hover with the mouse over a color and press **Ctrl + C** to copy the color (in this case the yellow for the shirt) and paste it into the new **MixRGB** node. The neck collar should now be yellow.

58a Make a loop cut at the loop you created, and mark a seam to divide the UVs. Due to the bevel, you might have to fix seams in some small areas

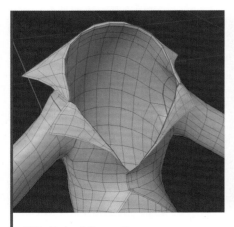

58b Select the collar

58c Invert

58d Follow the same principle you used for masking the eyes in step 56

59 Fins: masking

Since the yellow parts of the fins are fused more organically into the body, it will be more efficient to paint these areas by hand, especially around the tail. Split one of your windows and open the **Image Editor**. Click on **New**, name the image, set its resolution to 2048, and press **OK**. Save this image the first time you create it, and later on if you make changes on it (images 59a and 59b).

With the body selected in the 3D Viewport, go to the Shader Editor and add an **Image Texture** node and find your new image in the dropdown menu. Press **Ctrl + T** to add the **Mapping** and **Texture Coordinate** nodes, then connect the **Color** output of the **Image Texture** node to the **Base Color** node of the **Principled BSDF**. With the **Image Texture** node selected, go into **Texture Paint Mode** in the 3D Viewport. In a side view, paint the areas where the yellow will appear (image 59c). Once done, go back to **Edit Mode**, select other fins, and paint those as well (image 59d).

59a **2048 resolution should be more than enough, but you can choose any resolution you want**

59b Save the image

59c When painting, you will notice your strokes appearing on the Image Editor. Do not forget to hover over the Image Editor and press Alt + S to save the changes made to the painted texture

59d Continue painting the other fins

60 Fins: painting

In the **Shader Editor**, add a **Color > Hue/Saturation** node to the body material and connect the mask you just created to the **Fac** socket (image 60a). This means that only the white areas will be affected by this node. Play with the parameters until you are happy with the result. Do not forget you can use **Ctrl + Shift + left-click** a node to preview its output.

You can now move on with painting this mask. Paint the whole caudal fin area to cover the yellow parts. To make the transition more organic, you can feather the mask by increasing the brush size and decreasing the strength. As everything is plugged in the **Shader Editor**, you can change to Lookdev view and see the actual result while painting.

To add some detail, decrease the brush size and paint the back with little black lines to make the structure of the fin. Repeat this for all fin areas (image 60b).

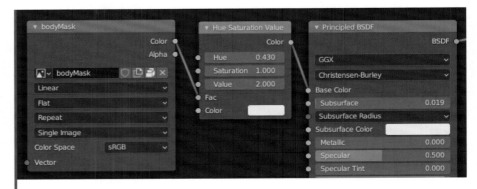

60a Using masks and nodes is helpful in case you want to make changes in the future. If you paint everything in one texture, making changes means redoing everything

60b Use the brush to add structure to the fin

Final adjustments

61 Checking for improvements

Now that you are happy with how the model is looking, it is always good to make some renders and look for elements that could be improved, for example, shaders, shapes, or lighting. Render by going to **Render > Render Image** or pressing **F12**.

In this case, you may want to add some little details to the texturing, such as on the nails and eyelids. You could also add a value of 0.019 of subsurface scattering (this is the **Subsurface** field in the **Principled**

BSDF shader) for the body material and the teeth to make the skin look more organic. This effect is very heavy for rendering but it will let light go through the skin, therefore making it look more realistic.

Using the same techniques we have learned through the creation of our character, we can make the little fish being held. This means doing basic blocking, sculpting, retopology, and texturing.

If you want to learn how to change the pose of your model using an armature, use the advanced section of this tutorial in the downloadable resources.

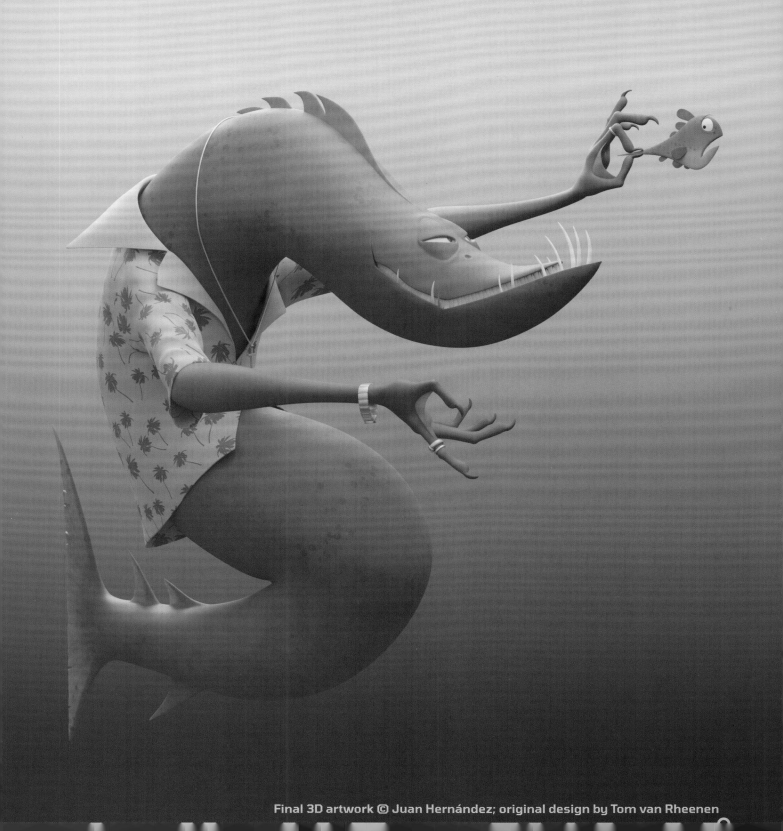

Warrior

By Alejandro Treviño

CHAPTER OVERVIEW

- Setting up
- Blocking in
- Modeling the foundations
- Modeling the details
- Combining modeling & sculpting

- Retopology
- Sculpting details
- Lighting setup
- Adding materials
- Materials

- Fur & hair
- Rendering
- Post-production

Setting up

01 Reference image

This model is based on a 2D concept by Luis Gadea.

Before starting the project, it can be useful to place the image of the concept inside Blender. This is particularly practical if you have only one monitor, as it means that you don't need to continually change program every time you want to see the image.

To do this, create a new area by splitting the Viewport – go to the top-right corner of the Viewport until the cursor changes to a cross; left-click and drag left to create the new area. Change the **Editor Type** to Image Editor in this new area (shortcut **Shift + F10**). You can then simply drag and drop the concept image into the Viewport (**image 01**). You can now manipulate and zoom in/out of the image without leaving the program.

01 Create a new area by splitting the Viewport and add the concept image

Original final artwork © Luis Gadea

SET UP THE CAMERA

You can also set up the camera at this stage. It can just be roughly placed for now, and does not have to be in the final position. Refer back to page 47 for how to set up a camera.

Blocking in

This section will outline the basic process for building up and smoothing out the shapes of the character. It will then look at some of the components in more detail in the next section.

02 Basic shapes

You can use four basic meshes to start blocking in this project – plane, cube, sphere, and cylinder – each of them with different properties (**image 02a**). Practice creating these shapes as follows so you can easily add them when it comes to building up the character.

In **Object Mode**, add the plane by selecting **Add > Mesh > Plane** or using the shortcut **Shift + A** to access the **Add** menu. The cube will already be in place as this is the base cube already in the Viewport, but you can add another one using **Shift + A** again and selecting **Mesh > Cube**.

For the sphere, duplicate the cube by selecting it, pressing **W**, and hitting **Duplicate Object** (shortcut **Shift + D**). With the second cube selected, use **Ctrl + 2** to apply two subdivisions to make it round.

Finally, to create an eight-faced cylinder, go to **Add > Mesh > Cylinder**. To change the number of vertices, open the **Add Cylinder** menu in the bottom left of the Viewport and change the **Vertices** number to 8 (**image 02b**). You will now need to connect some vertices in **Edit Mode**. First select two opposite vertices (hold **Shift** to select more than one vertex) as shown in **image 02c** and press **J** to add an edge between them. Repeat this so you have the vertices shown in **image 02d**. You'll need to do this on both ends of the cylinder.

02a The four basic meshes that will be used in this project

02b Adjust the number of vertices if needed

MOVING OBJECTS AROUND

Remember you can move the objects around in **Object Mode** by pressing **G**. Press **X**, **Y**, or **Z** while dragging to move only along the relevant axis.

02c The cylinder with an added edge

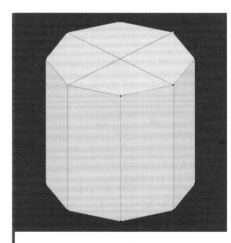

02d The cylinder with all added edges

03 Wire cube

Now you are familiar with the basic shapes, you can start to build up basic forms. First, decide the character's dimensions. You can then use these to create a wireframe cube to help guide your placement of the different parts of the model. Move aside the meshes you made in step 02, and in **Object Mode**, use **Shift + A** to add a basic cube and change the size from 1.60 to 1.80 meters in the **Add Cube** menu in the bottom left of the viewport. In **Edit Mode**, go to the **Object Properties** section in the Properties Editor on the right-hand side, select the **Viewport Display** dropdown, and change the **Display As** setting to **Wire** (image 03). Refer back to pages 50-51 for Viewport Display options.

> **EDITING THE CUBE**
>
> To edit the size of the cube after you create it, click **N** and select **Item > Dimensions**.

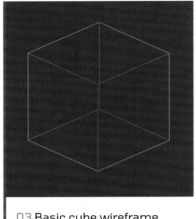

03 Basic cube wireframe

04 Torso

Back in **Object Mode**, start blocking the main body by adding a cylinder as created in step 02. This will form the shape of the upper torso and shoulders. Rotate the cylinder by pressing **R** and **X**, **Y**, or **Z** depending on which axis you want to turn. After pressing **R** and the axis letter, you can also type **90**, for example, to specify the angle. Left-click to accept the transformation. Scale it by pressing **S** and the relevant axis letter (image 04a).

Finally, add a cube and scale it. This will be the mid-section of the body. To create the trapezium shape shown in image 04a, go into **Edit Mode**, select the bottom four vertices, and scale them closer together.

Back in **Object Mode**, move both meshes together. To ensure that the objects are in their correct position, check the top, side, and front views: select the meshes and click on **Numpad "."** to focus the Viewport on them; then use **Numpad 7** for top view, **Numpad 1** for Front view, and **Numpad 3/Ctrl + Numpad 3** for Right/Left view.

04a Build up the torso

If you want to be extra precise when positioning the objects, use the Snap to Vertex tool. To do this, go to **Edit Mode**, toggle the magnet icon in the Header, click the arrow to access the dropdown, and check the **Vertex** option (image 04b). You can now either move one object as a whole toward another object and hover the cursor over a vertex, which will snap the object to that vertex (left-click to confirm transformation), or you can select each vertex of one object manually and move it toward the vertex you want to join it with. When the vertices are together, a circle will appear over the cursor (image 04c). It doesn't matter if the shape is distorted, as this is just a base and will not affect the final topology.

04b The Snap menu

04c The circle that appears when the vertices are together

05 Legs & feet

To make the legs and feet, follow the instructions as shown in image 05a:

A Add a plane with **Shift + A**

B Scale it in one direction to turn it into a narrow strip.

C In Edit Mode, select two end vertices and extrude the leg by pressing **E** and dragging. Use **G** to move the two end vertices out slightly to create a trapezium.

D Use the Loop Cut tool with **Ctrl + R** to add an edge loop. You then need to apply the **Solidify** modifier to give thickness to the plane to match the depth of the leg in the reference: go to the **Modifier Properties** tab of the Properties Editor, click the **Add Modifier** dropdown menu, and select **Solidify**, which is under the **Generate** list. There are many settings in this modifier, but focus on the **Simple** setting in the **Mode** dropdown and edit the **Thickness** (image 05b).

05a Use a plane to create the legs and feet

05b The Solidify modifier

06 Continue building

With the same methods outlined in steps 04 and 05, keep adding forms to create the general shape of the character as shown in **images 06a** and **06b**. For example, to make the cloak clasp, use the basic 8-vertex cylinder blocked out previously and scale it on the Z axis to make it flatter; for the hands and fingers, use a series of cubes. For the skirt of the tunic, extrude a plane around the character, and then join the edges by selecting two edges and pressing **F**. You can use the **Extrude tool** to create the cape, too. Use the list on the right as a guide to what objects to use. More details will be added later, so just focus on the shapes shown in **images 06a** and **06b** for now. The cloak clasp and sword will be covered in steps 13 and 14, so wait to create those until then.

Switch between **Object Mode** and **Edit Mode** as needed using the **Tab** key. Do not try to overpopulate with details at this moment. Note that the sword requires a few additional tools, so refer to step 14 for how this should be created.

PLANE	Legs/feet
	Cloak
	Skirt
CUBE	Head
	Hands
	Fingers
	Mid-section
	Sword
	Buckle
CYLINDER	Upper torso
	Arms
	Cloak clasp

SELECTION

Ensure you don't have an existing object selected when you add a new object to your scene, otherwise the objects will be linked.

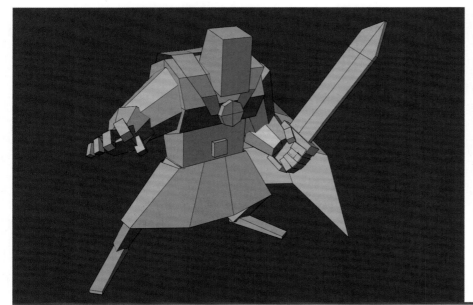

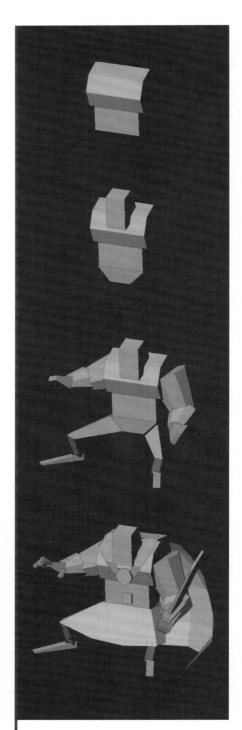

06a The basic forms blocked out

06b The basic model with key components blocked out

07 Smoothing edges and faces

Now, focus only on the cylinder added as the upper torso. You can isolate any object by using the forward slash (**/**) on the Numpad; this will hide everything except the selected object. The isolated object text will be colored orange in your **Scene collection** list – this is useful for knowing which object to select in the list in order to add a modifier.

The first thing to do is achieve a more refined mesh, smoothing the faces and deciding how sharp the forms should be. Begin by adding two extra edge loops around each end of the cylinder to help decide the angle. To add the edge loops, go to **Edit Mode** and hold **Ctrl + R** while moving the mouse to select the number of edges (**image 07a**). You can also select the four end faces, press **I** (Inset) and move the mouse to create a loop.

In the Properties Editor in **Object Mode**, go to **Modifier Properties** and add the **Subdivision Surface** modifier with 3 subdivisions (or click **Ctrl + 3**) (**image 07b**). In **Edit Mode**, select all faces by pressing **A**, then select **Face > Shade Smooth** (**image 07c**).

Now you have a clean, smooth mesh for that body part (**image 07d**). Use the same process (**image 07e**) to smooth out other areas of the mesh.

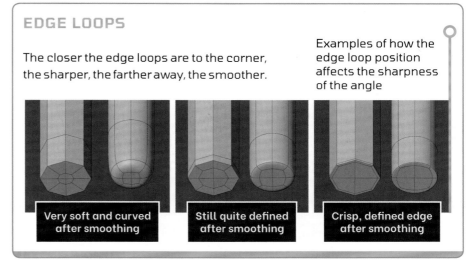

EDGE LOOPS

The closer the edge loops are to the corner, the sharper, the farther away, the smoother.

Examples of how the edge loop position affects the sharpness of the angle

Very soft and curved after smoothing

Still quite defined after smoothing

Crisp, defined edge after smoothing

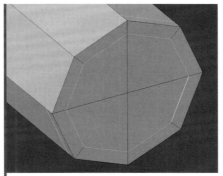

07a Add an edge loop on each side of the angle

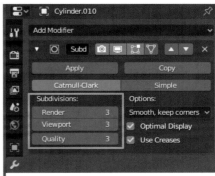

07b Smooth the mesh

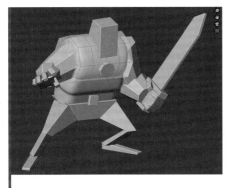

07d Rounded upper torso

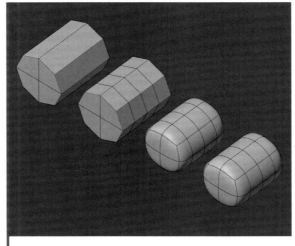

07e The basic cylinder; edge loops added; Subdivision Surface modifier applied; Shade Smooth applied

07c Apply Shade Smooth

Modeling the details

08 Face

With the basic mesh smoothed out, you can now define the basic shape of the face as shown in image 08a by adding more meshes. Use multiple cylinders, adding 2–3 subdivisions and applying **Shade Smooth** as you did in the previous step, except for the ears, for which you can use cubes.

For the ears, use the **Mirror** modifier: once you have created an ear and positioned it (image 08b), use the main mesh of the head as an object that works like a mirror to set the ears with symmetry. You can do this by adding the **Mirror** modifier to the ear in the **Object Modifiers** section of the

Properties Editor. Then, in the **Mirror Object** field, select the head cube (image 08c). If the mirror doesn't work correctly, you can use an **Empty** by pressing **Shift + A > Empty > Plain Axes**. Move the empty object to the desired location, and use it as a **Mirror Object** in the **Mirror** modifier.

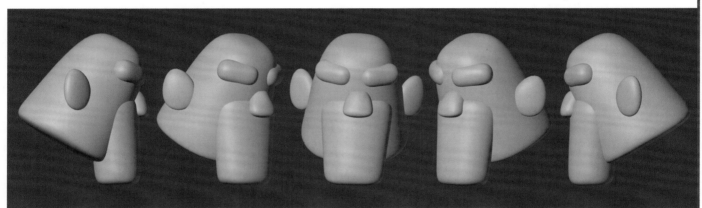

08a Develop the basic head form

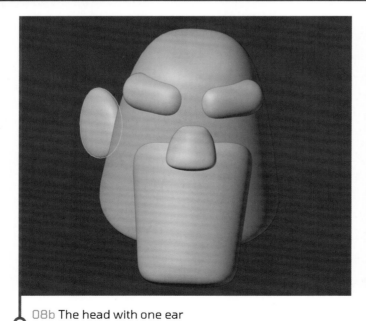

08b The head with one ear

08c Select the head as a Mirror Object

09 Eyes

For the eyes, add a UV Sphere with **Shift + A.** Change the information in the **Add UV Sphere** menu so there are 8 segments and 10 rings. Rotate it by 90˚. In **Edit Mode**, make part of the sphere concave by selecting the faces that touch the center vertex and then moving them inward along the relevant axis. Finally, select the vertex in the center only and move it inwards. You now have a concave shape that will be the iris of the eye (**image 09a**).

Now select the outer loop of the concave portion using **Shift + Alt + left-click** and make a bevel using **Ctrl + B** and dragging. Then add the **Subdivision Surface** modifier with 3 subdivisions. Next select all the faces and **Shade Smooth** (**image 09b**). Finally, you can adjust the eye and set the **Mirror** modifier to create both eyes, using the main part of the head as the Mirror Object as you did in step 08.

09a Move the vertices to change part of the eye from convex to concave

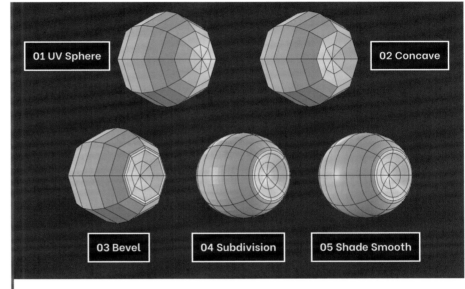

09b The eye process including smoothing

10 Tunic vest

For the top part of the tunic, just extrude some faces from the bottom part. Then add a **Multiresolution** modifier and finally add a **Solidify** modifier (**image 10**).

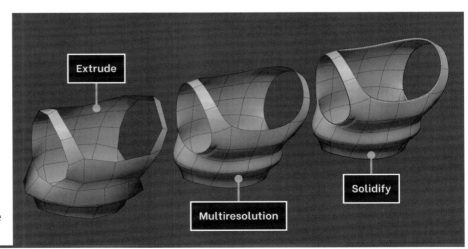

10a The process for the top part of the tunic

11 Hair

Although there are many ways to create hair, curves are an easy way to approach this in this instance. Add a curve with **Shift + A > Curve > Path**. In the **Object Data Properties** section of the Properties Editor, add thickness to the curve in the **Geometry > Bevel > Depth** field (image 11a). Then go into **Edit Mode**, select a vertex, and scale it with **Alt + S** to give a more organic shape to the mesh (image 11b). Finally, add a **Subdivision Surface** modifier with 2–3 subdivisions.

To place the hair on the character, select the object and move it with **G** in **Object Mode**. Once it is in place, you can transform the shape further as needed in **Edit Mode** using vertex selection. To add more strands, duplicate any strand with **Shift + D**. Place them as shown in image 11c.

11a The Geometry section under Object Data Properties

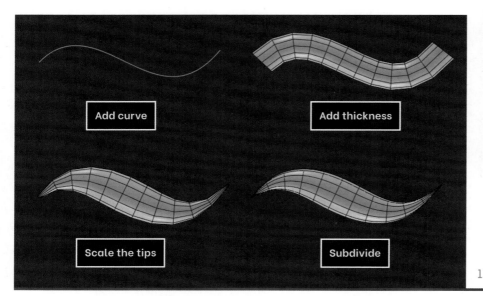

11b Use curves to create the hair

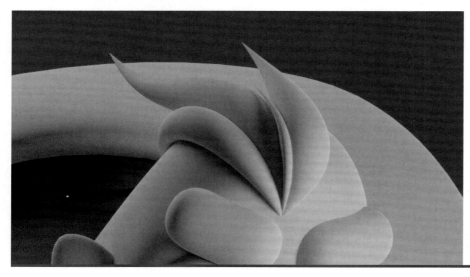

11c Place the strands – note that this image is a render view of the model later in the process, just for reference

12 Belt

To create the belt, follow the instructions as shown in image 12a:

A Start with a cube.

B Scale it down on the Z axis.

C Then delete the upper and lower faces in **Edit Mode** by selecting them and pressing **Delete > Faces**.

D After that, add the **Subdivision Surface** modifier with 3 or 4 subdivisions and select all faces to apply **Shade Smooth** (**Face > Shade Smooth**).

E Finally add the **Solidify** modifier, adjusting the **Thickness** setting to a suitable belt thickness.

Note that the order of the modifiers will affect the result, so decide which order works best for you; if you put the **Solidify** modifier above the **Subdivision Surface** modifier, the mesh will be smoother (shown on the left in image 12b); if you put the **Subdivision Surface** modifier over the **Solidify** one, the mesh will have sharp edges (shown on the right in image 12b).

12a Start with a cube to model the belt

12b A different modifier order will affect the result

ORGANIZATION

Sometimes the process of a project is not linear, in which case it is good to maintain an overall order in your workflow. As you add new objects, ensure you label them logically in the **Scene Collection** list (for example "Head," "Torso," "Right hand." This will help make it easier to quickly check the element you are editing later on.

To make the buckle, follow the steps shown in **image 12c**:

A Start with a cube.

B Move a face with the **G** key.

C Delete the back and frontal faces.

D Add a **Solidify** modifier.

E Add edges to the corners.

F Add **Subdivision Surface** modifier.

G Then add a new plane.

H Move the edges with the **G** key.

I Add more edges with **Ctrl + R**.

J Add a **Solidify** modifier.

K Add **Subdivision Surface** modifier.

L Then join both meshes.

12c The process for the belt buckle

Place the belt on the body as shown in **image 12d**. To adjust the belt to fit, use the **G** key to move between Front and side views (**Numpad 1** and **Numpad 3/Ctrl + Numpad 3**). It doesn't need to fit perfectly to the body, but should give the impression that it is tight.

12d A render view of the belt – note that this image is a render view of the model later in the process, just for reference

13 Cloak clasp

To create the cloak clasp (image 13):

A Begin with the flattened cylinder.

B In **Edit Mode**, select the front faces and add an inset by pressing **I** and dragging.

C After that, extrude the middle part faces inside the mesh with **E**. Left-click to accept the extrusion.

D Now extrude again, but outward. Left-click to accept the extrusion and then scale it down slightly with the **S** key.

E Lastly, to smooth the mesh, add the **Subdivision Surface** modifier by pressing **Ctrl + 3**, and smooth all faces with **Face > Shade Smooth**.

13 Cloak clasp process

14 Sword

To make the sword, divide the blocking into four parts: the blade, rain guard, grip, and pommel. All of them start from a cube.

For the blade, flatten and elongate the cube using **S**. Then switch to **Edit Mode** and add an edge loop using the Loop Cut tool so that the blade is bisected vertically. Select the middle vertices on top of the blade and press **G + Z** to bring the vertices to a point. Apply an inset to sharpen the weapon, then add edge loops of support to sharpen some of the corners (image 14a).

14a Blade process

The crossguard starts as a stretched cube. Add some edge loops and extrude the end faces. Then add another edge loop either side of the top face and give a circular shape to the tips (**image 14b**).

For the grip, scale the cube as shown in **image 14c** and delete the top and bottom faces. Add one vertical edge loop and three horizontal ones. Apply a bevel (**Ctrl + B**) to each of the horizontal ones; in the **Bevel** menu, set the **Segments** option as 2, leaving three lines for each loop. Select only the middle line of each one and scale

it inward, and perform another bevel on the center line. Add a **Subdivision Surface** modifier of 3–4, press **A**, and go to **Face > Shade Smooth**.

For the pommel, scale the cube and add some edge loops as shown in **image 14d**. Press **Ctrl + 3** followed by **A** and go to **Face > Shade Smooth**.

Finally, select all components of the sword and join them in one mesh with **Ctrl + J**. Add the **Subdivision Surface** modifier with **Ctrl + 3**. **Image 14e** shows the sword development as a whole.

14b Rain guard process

14c Grip process

14d Pommel process

14e Sword process as a whole

15 Mouth

The mouth will consist of three parts: the shape, teeth, and tongue. The shape will be created using a Boolean in step 21.

For the teeth (image 15a):

A Start with a cube.

B Scale it.

C Delete all but three faces.

D Add **Solidify** and **Subdivision Surface** modifiers, and edge loops if needed to refine the shape.

For the tongue (image 15b):

A Use a cube.

B Scale it down.

C Add three edge loops in the center.

D Scale the middle line inwards.

E Finally, add the **Subdivision Surface** modifier and use **Shade Smooth**.

15a Teeth process

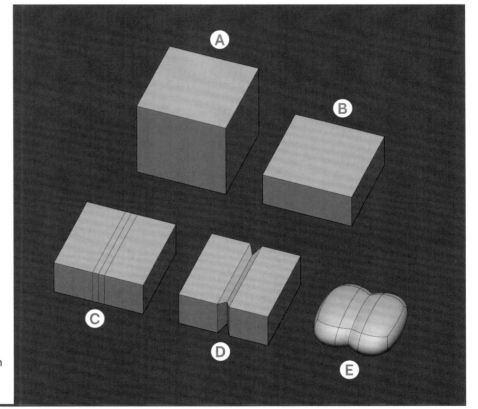

15b Tongue process – you can position the teeth and tongue in step 21 once you have created the mouth shape

Combining modeling & sculpting

In the following steps we will introduce some basic sculpting brushes into the workflow to allow you to shape some elements more organically.

16 Leg

Using the basic mesh you created in step 06, add another edge loop as shown in image 16a. Transform vertices to taper the foot and shape the upper part of the leg. Then add the **Subdivision Surface** modifier once.

You can now use sculpting brushes to shape the leg more naturally. To do this, go to **Sculpt Mode** in the dropdown menu in the top left of the Header. Use the **Elastic Deform** brush (image 16b) to shape the mesh to look more like the reference image. Finally, add the **Subdivision Surface** modifier again and apply **Shade Smooth** to all faces (image 16c).

16a Editing the basic leg mesh

16b The Elastic Deform brush

16c Shaping the leg using Elastic Deform (left) and Shade Smooth (right)

17 Cloak

For the cape, ensure you have added a **Subdivision Surface** modifier with 2–3 subdivisions. Then add the **Solidify** modifier to give thickness to the plane. Use this modifier on the cloak and other clothing, giving different thicknesses to each one.

Then, to move the mesh more naturally, go into **Sculpt Mode** and drag the **Grab** and **Elastic Deform** brushes over the mesh to achieve a more organic shape (**image 17**).

17 The solidify and sculpting process for the cloak

18 Hands

Once you have added the **Subdivision Surface** modifier to each mesh of the hands, go into **Sculpt Mode** and deform the meshes with the **Elastic Deform** brush to give it a more precise shape. Then, join all meshes of the hand by selecting them all and pressing **Ctrl + J** (**images 18a** and **18b**).

You can find out how to retopologize the hands in steps 19 and 20.

18a Right hand process

01 Blocking
Use simple meshes

02 Subdivision modifier
Move with Elastic Deform

03 Retopologize
Use poly build

04 Add subdivision
Move with elastic deform

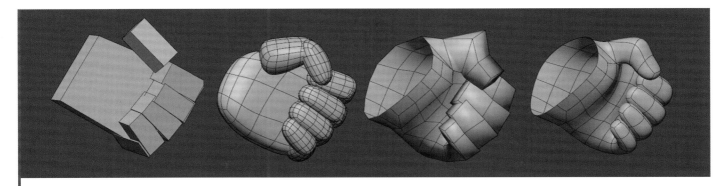

18b Left hand process

Retopology

19 Preparing for hand retopology

In the next two steps you will retopologize the hand, using Poly Build as your primary tool. First, you need a mesh to use as a base for the retopology. Add a plane with **Shift + A** (image 19a), then scale it down and move it next to the surface of the mesh you want to retopologize. Also, change the behavior of the **Snap** setting so that it sticks to the mesh base: in **Edit Mode**, go to the **Snap** menu and select **Face** and **Project Individual Elements** (image 19b). Finally, you need the new mesh to be visible over the base mesh: in the **Object Properties > Viewport Display** menu, check the **In Front** option (image 19c).

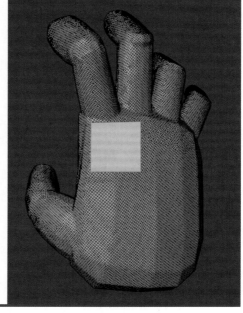

19a Add a plane

If you would rather use another method to retopologize the hand (and the head in step 21), feel free to work with what you are comfortable with. For example, you could start from a vertex as was used in the Fish tutorial.

19b The Snap menu

19c Check the In Front option

20 Using Poly Build

You are now ready to start using the **Poly Build** tool, which is found in the Toolbar in **Edit Mode**. With **Poly Build**, you can move vertices quickly: select the vertex, which will turn blue, and you can move it as you like using the LMB (image 20a). You can also extrude faces, by selecting an edge, which will change to blue, dragging it, and creating a new face (image 20b). You can create a face from two edges, using **Ctrl** (image 20c). Finally, use **Shift** to delete a face or vertex (image 20d). Only when you use **Shift** will the highlighted element change to red, notifying you that you will delete geometry. Add and edit polygons in this way to cover the whole hand, giving it a cleaner topology.

When the retopologized hand is compete, add the **Multiresolution** modifier, adding three subdivisions. You can then add details in **Sculpt Mode** using the Crease brush. You can delete the old hand mesh after finishing the retopologized hand.

Next, we will retopologize the head – note that only the head and hands need retopologizing in this project, as the rest of the body consists of very simple meshes already.

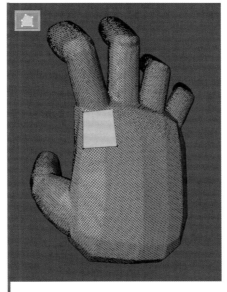

20a Move a vertex in Poly Build

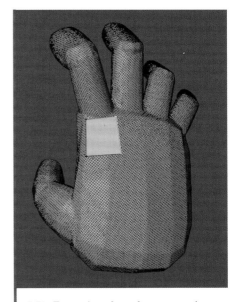

20b Extrude a face from an edge

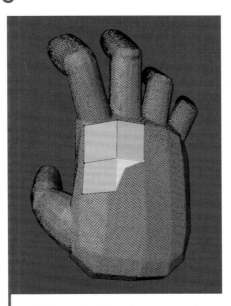

20c Extrude a face from two edges

20d Use Poly Build to delete a face

POLY BUILD SHORTCUTS

Add Geometry	Ctrl + LMB
Delete Mesh Elements	Shift + LMB
Move Vertices	LMB
Extrude Edges	LMB

21 Retopologizing the head

Before retopologizing the head, you ned to create the shape of the mouth using a **Boolean** modifier. For this modifier, you need two meshes: the main mesh (the jaw) and the mesh that will be subtracted from it (mouth shape). For the mouth shape, use a new cube stretched into a rectangular shape.

Add the **Boolean** modifier to the main mesh (the jaw) by selecting the object and choosing the modifier from the Properties Editor. Ensure **Difference** is selected (**image 21a**). Then select the cuboid mouth shape (the mesh that will be subtracted

from the main mesh) using the eyedropper tool in the **Object** setting of the modifier. To see the Boolean working, select the mesh that you subtracted and switch from **Textured** to **Wire** in **Object Properties > Viewport Display > Display As**. Now move the mesh you are subtracting until you create the mouth shape you want (**image 21b**). Click the arrow next to the modifier name and click **Apply** to apply the modifier. You can then position the mouth and teeth.

Apply all modifiers and join all of the meshes of the head with **Ctrl + J**.

Next, you can carry out an automatic Remesh. Go to **Sculpt Mode**, open the **Remesh** menu, select the **Voxel Size**, and click **Remesh** (**image 21c**). With that you will have the base form to make the final topology of the head mesh (**image 21d**).

Now go to **Edit Mode** and use **Poly Build** as you did for the hands, focusing on having the eyes, mouth, and nose loops (**image 21d**). After that, add the **Multiresolution** modifier, add some subdivisions, and sculpt details using the Crease and Smooth brushes in **Sculpt Mode**.

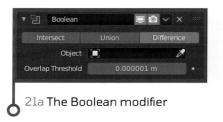

21a The Boolean modifier

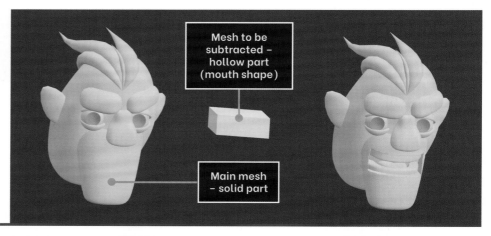

21b Boolean operation

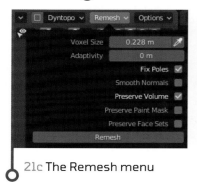

21c The Remesh menu

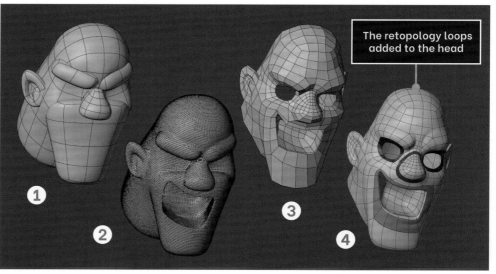

21d The head retopology process

22 Sculpting

Now you have retopologized all the basic shapes of your model, you can begin sculpting further details. As you will have noticed, to sculpt details on an object with subdivisions it is necessary to use the **Multiresolution** modifier instead of the **Subdivision Surface** modifier (image 22a). Add the modifier, then subdivide it several times until the mesh reaches a good smooth quality.

Go to **Sculpt Mode** and use essential brushes like Draw, Smooth, Crease, Clay Strips, and Elastic Deform.

Start with these brushes to familiarize yourself with sculpting, but don't forget to test all of them as you work through each element. Image 22b shows the sculpting process for the skirt. Continue sculpting further details for the rest of the character (image 22c).

22a The Multiresolution modifier

22b The sculpting details process for the skirt

APPLY ALL TRANSFORMS

There are cases when tools such as Dyntopo, Remesh, or UVs do not work properly; for these cases, it is generally necessary to **Apply All Transforms** with **Ctrl + A**. Now the tools should work correctly.

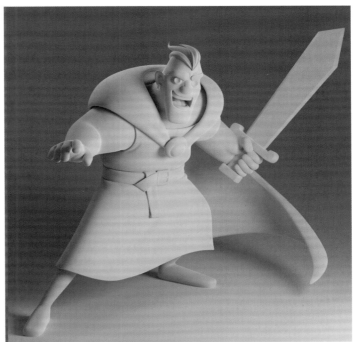

22c A rendered view of the sculpted character for reference

Lighting setup

23 Scenario modeling

For this project you can use an infinity wall as a background, imitating a photography studio by hiding the corners and blurring the floor with the wall, following the process you learned on page 154.

23 Infinity wall process

24 Adding and editing lights

This scene will use four types of light:

► key light;
► fill light;
► rim light;
► bounce light.

As the name suggests, the bounce light will "bounce" the light more around the scene, adding extra illumination and creating soft shadows.

Illuminate the scene starting with the World Environment. In the Properties Editor, select the **World Properties** icon. Once in this menu, select **Blackbody** in the **Color** dropdown. You can then set the temperature to

23,000 K with a strength of 0.05 W (**image 24a**). This is the fill light.

Next you need to add additional lights to the scene. In **Object Mode**, use **Shift + A** to select **Light > Point** to add an additional light to the scene. We will use **Point** light for all lights. You can then move the light object around the scene as you would a mesh, using the **G** key. To edit the light's properties, go to the **Object Data Properties** section of the Properties Editor, ensuring the correct light is selected. Add and set the key (**image 24b**), rim (**image 24c**), and bounce (**image 24d**) lights as shown in the table below. If you cannot find the temperature and strength options shown, go to the

Render Properties section and ensure that your chosen Render Engine is set to Cycles rather than Eevee.

Image 24e shows the effects of the different light temperatures for reference.

LIGHT	POSITION	TEMPERATURE	STRENGTH	SIZE
KEY LIGHT	In front of character	6,000 K	100 W	1.00 m
RIM LIGHT	Close behind character	4,000 K	30 W	0.80 m
BOUNCE LIGHT	Far behind character	5,000 K	50 W	1.00 m

24a **Fill light setup**

24b **Key light setup**

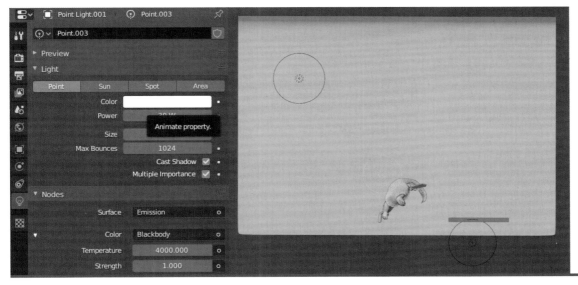

24c **Rim light setup**

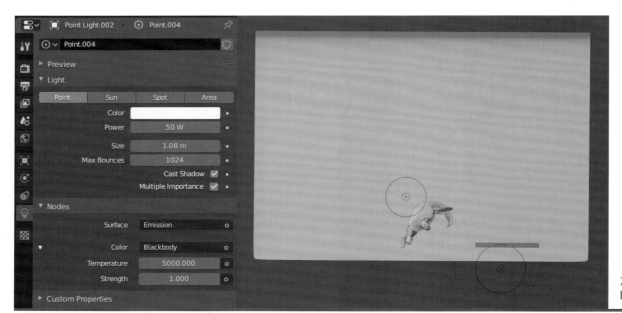

24d Bounce light setup

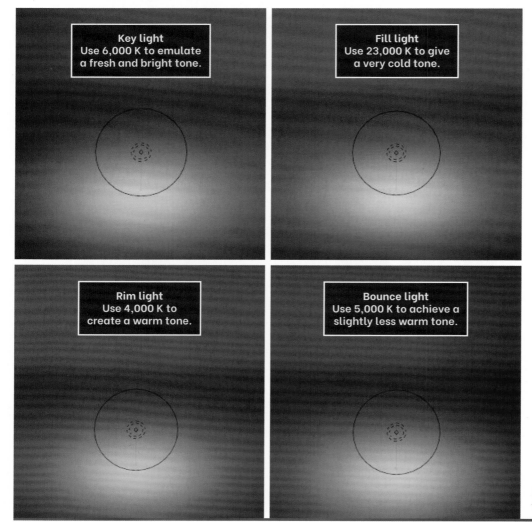

Key light
Use 6,000 K to emulate a fresh and bright tone.

Fill light
Use 23,000 K to give a very cold tone.

Rim light
Use 4,000 K to create a warm tone.

Bounce light
Use 5,000 K to achieve a slightly less warm tone.

24e Different light temperatures

Adding materials

25 Marking the seams

You are now ready to apply materials to the model. Although procedural textures are very helpful, sometimes it is necessary to use UV maps for more complex objects and thus wholly control the surfaces. With the UV map, you can decide which part of the texture will be attached to each polygon in the mesh. To achieve this, the process is distributed into three parts:

▶ marking the seams;
▶ unwrapping;
▶ checking the texel density (find out more in step 28).

For these steps, you will need Ivan Vostrikov's **Texel Density Checker** add-on, which can be downloaded online from sites such as Github and Gumroad, to select the density, and **TexTools**. This add-on offers great tools to fix UVs.

First, it is necessary to mark where you are going to put the seams. Place them preferably in places that will be hidden. It is essential to keep in mind where you put them and to carry out several tests to achieve a good result and avoid distorted textures. To mark the seams, go to **Edit Mode**, turn on **Edge Select**, and use the **Shift + Alt + LMB** shortcut to select the complete loop (**image 25**). Lastly, press **U** and then **M** (the **Mark Seam** shortcut) to mark the selected edges. Now the seams are colored in red.

25 Marked seam on the skirt

THE BLENDER COMMUNITY

Remember that if you have questions about the program, you can consult the Blender Manual, which is quite comprehensive. If that is not enough, you can ask questions in various online forums and social networks, where people with more experience can help.

311

26 Unwrapping

Go through the whole character and mark each mesh with a seam. When this is complete, you are ready to unwrap. To do this, ensure you are in **Edit Mode**, select all the faces with **A**, then press **U** to access the **UV Mapping** menu (**image 26a**). Here you can choose different algorithms to make the UVs. In this case, use **Unwrap**. (For occasions when you haven't marked the seams, you can use **Smart UV Project**, where Blender decides where to put them automatically, but not always with good results.)

Select the **UV Editing** workspace on the Topbar. Once **Unwrap** is selected, you will see the UV map created in the UV Editor (**image 26b**).

26a UV Mapping menu

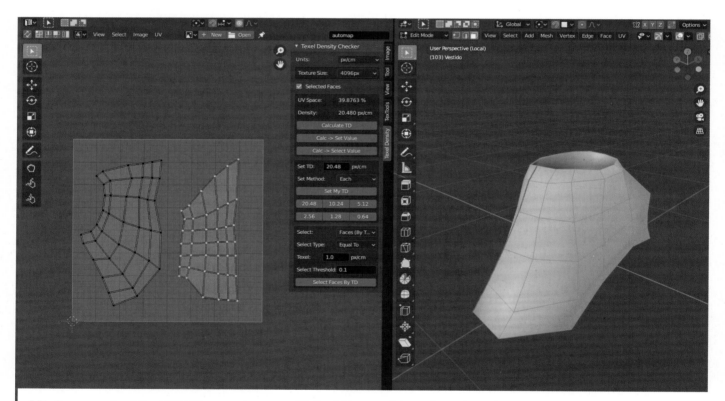

26b An example of the UV Editing workspace with the UV map of the selected mesh

27 UV grid image

To be able to see the object's texel density, it is necessary to have an image with a grid. First, go to the UV Editor, click on **New**, and set the name, size, and type of image (**image 27a**). In this case, create a 4096 × 4096 pixel image and set the **Generated Type** option to **UV Grid**. Click **OK** and you will see the grid UV image (**image 27b**).

To see the texture on the model, go to the **Shading** workspace on the Topbar and press New at the top of the node panel to create a **Principled BSDF** node. With this node selected, press **Ctrl + T** and set the image as a **Base Color** by selecting the grid from the image browser in the **Image Texture** node (**image 27c**; you need the **Node Wrangler** add-on enabled for this shortcut to work). **Image 27d** shows the UV grid material on the mesh.

27a New Image options

27b The grid UV image created by Blender

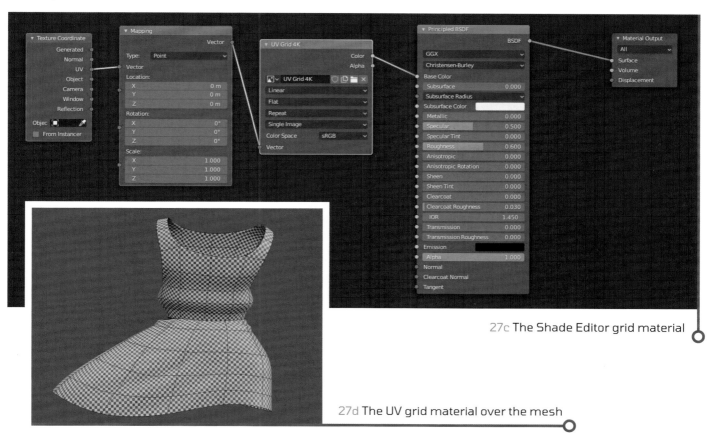

27c The Shade Editor grid material

27d The UV grid material over the mesh

28 Texel density

The texel density measures the texture resolution used by the mesh. As mentioned, you ideally need to have the same texel density between different objects with the same texture. If not, you will have different resolutions on different meshes, and if you take a close-up, some meshes will look blurry.

With the **Texel Density Checker** add-on enabled, go to the **UV Editor**. Select all faces with **A**, open the Sidebar with **N**, and go to the **Texel Density** tab. In this case, set **Texture Size** to 4096 pixels and test different densities (the **Set TD** option) to see which is the highest density that fits inside the map. In this case, set the

Set TD option to 20.48 px/cm. This density can then be used for other objects as well.

If the **Texel Density Checker** add-on does not work correctly, try using an older, more stable version.

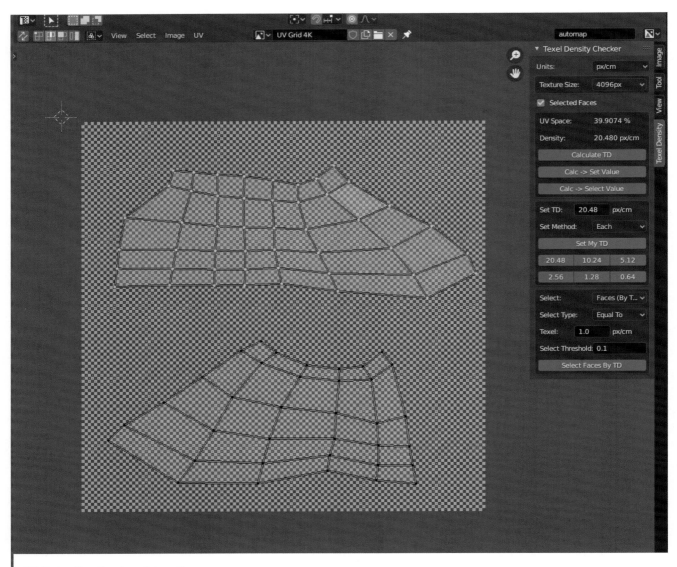

28 Selecting the texel density

Materials

29 General setup

To create the materials for each component, you need to select the component in the 3D Viewport and then go to the **Shading** workspace. Add a new material with **Material Properties > New**, and, by default, there will be a **Principled BSDF** node in the Shader Editor.

With the **Node Wrangler** add-on enabled, you can use **Ctrl + T** with the **Principled BSDF** node selected to generate a texture setup. Refer back to page 158 for useful shortcuts to use in the Shader Editor. In the following steps you will learn about the different settings that can be used for each material on this model.

29 Texture setup

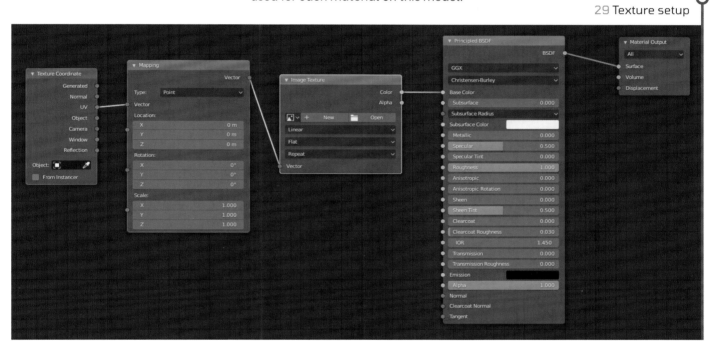

30 Damaged part of the cloth

Using an alpha map for the damaged part of the clothing will allow you to create the illusion of torn fabric without cutting the mesh. For this, you need to create a texture in the Image Editor. Click New at the top of the Image Editor, and add a name and size (image 30a). Select white for the color. Click **OK**.

In the Shader Editor, connect this new image into the **Alpha** section of the **Principled BSDF** node (image 30b). Finally, in the 3D Viewport area of the Texture Paint workspace, paint in black what you want to hide and leave in white what you want to show.

30a Create an alpha map

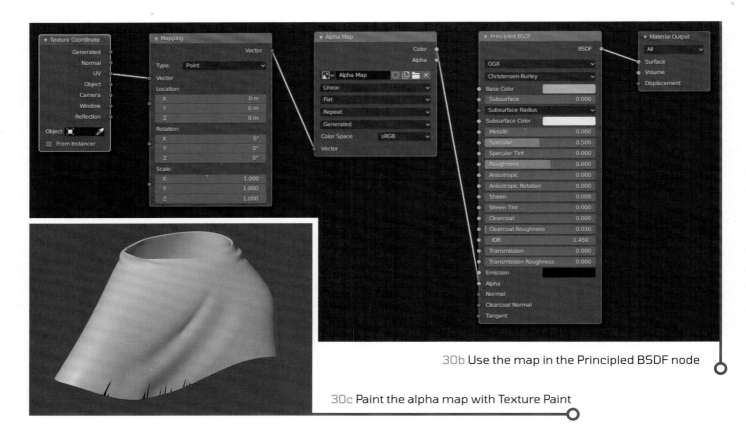

30b Use the map in the Principled BSDF node

30c Paint the alpha map with Texture Paint

31 Crystal

To make the brooch crystal, use the **Principled BSDF** node again. First, make the **Base Color** red (**image 31**). Set **Roughness** to a low value of 0.3 so that it reflects but has a slight irregularity. Set **Clearcoat** to 0.5 to create a light-reflective layer. Set **IOR** to 1.554 to emulate the refraction of an amethyst. Finally, set **Transmission** to 1.0 so that the object is completely transparent. You can see the result in the **3D Viewport**.

You can assign several materials to one mesh by going to **Material Properties** > **Add Material Slot** (the **+** icon). We'll make some metal materials later, which you can add to the desired areas of the cloak clasp.

31 Setting the parameters of the crystal material

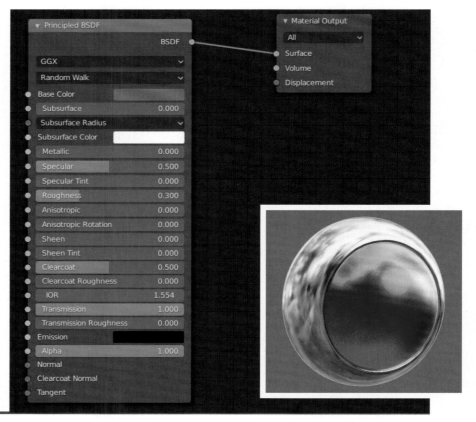

32 Skin

For the skin material, use the **Principled BSDF** node again. Instead of selecting a single color in **Base Color**, add a **Geometry** node and connect the **Pointiness** socket to a **Color Ramp** node (**image 32a**) and therefore set at least two color variations, using a darker color in the concave parts. Set the position of

the dark color around 0.49 and use a position of 0.51 for the light color. It is worth mentioning that this node only works with the Cycles render engine.

In the **Principled BSDF** node, set **Subsurface** as 0.1. Finally, set **Roughness** at 0.4. With this, we have skin that looks like a toy, adding

stylized appeal to this cartoony character (**image 32b**).

32a **Skin material**

32b **Viewport render**

33 Tongue

For the tongue material, focus on three sockets of the **Principled BSDF** node: **Base Color**, **Roughness**, and **Normal**. The main base should consist of the **Texture Coordinate**, **Mapping**, and **Voronoi Texture** nodes. Add these nodes manually using the **Add** button in the Shader Editor Header and connect them as shown in image 33.

For the **Base Color** socket on the **Principled BSDF** node, you will use

a **ColorRamp** node divided into two colors: #DBABAA and #BF7F75. To do this, add a **ColorRamp** node, click one of the slider markers, click the black color bar below it, and insert the Hex code of the desired pink color. The first slider will now be a pink color.

Click the second slider and apply the second, darker pink hue to create a gradient between the two, and then connect this node to the **BSDF** node's **Base Color** socket.

Add another **ColorRamp** node to manage the amount of reflection in **Roughness**, this time with a gradient between light gray and medium gray. And lastly, add another **ColorRamp** node and a **Bump** node for the **Normal** socket, with the settings and connections shown below. With that, the tongue material is ready.

33 Tongue material

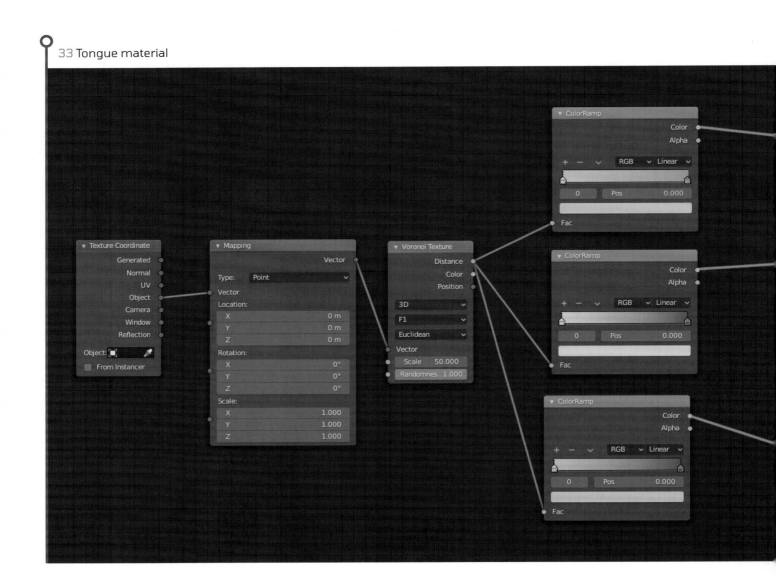

34 Teeth

For the material of the teeth, use the **Principled BSDF** node with a slightly red color, such as hex code #E7D5C8, as the **Base Color** in order to avoid plain white. It is essential to use subsurface scattering to give a more believable effect to the material, so set **Subsurface** as 0.02 and select the **Christensen-Burley** method at the top. Leave **Roughness** at 0 as this will be entirely reflective. This is a simple material, but gives the effect needed.

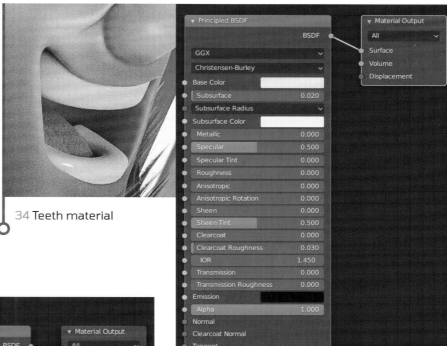

34 Teeth material

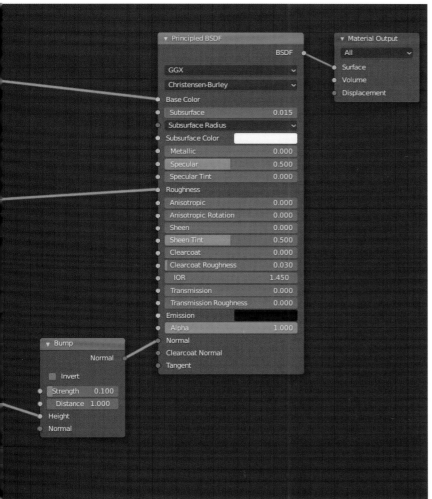

35 Eyes

Divide the eye material into three parts: the iris, pupil, and sclera (the "white" of the eyeball) by creating a new Slot (**Slot** > clicking the **+** icon) at the top of the Node panel for each part of the eye.

Use the **Principled BSDF** node for all the eye materials. First, for the pupil, use a **Base Color** of #220E08 and set **Roughness** to 0.15 so it is slightly reflective (image 35a). For the iris, use a **Base Color** of #716950 and set **Roughness** to 0.3 and **Clearcoat** to 1.0 (image 35b). Finally, for the sclera, use a **Base Color** of #E7E7E7 and set **Subsurface** to 0.015 and **Roughness** to 0.5 (image 35c). Then,

assign these materials by selecting the faces in **Edit Mode** and clicking **Assign** in the **Material Properties** section of the Properties Editor.

You can use this same process to add extra materials to meshes such as the brooch, applying a metal ring around the gemstone.

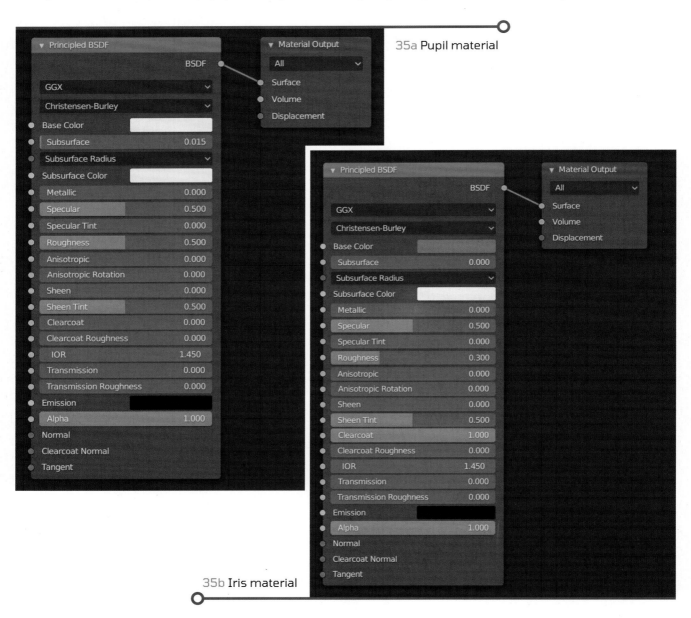

35a Pupil material

35b Iris material

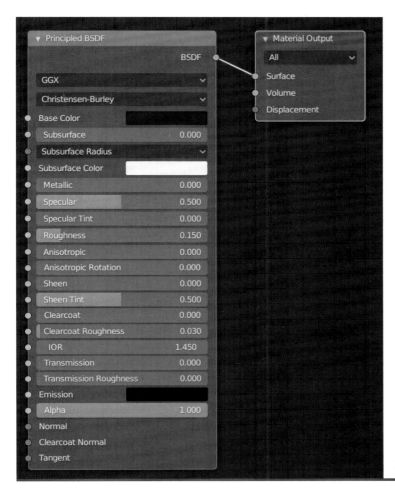

35c Sclera material

35d Assign the material to the relevant parts

36 Fabric

For the fabric material, you can use a free **PBR** texture, which includes the **Base Color**, **Roughness**, **Normal**, and **Displacement** maps. The texture shown here was downloaded from Texture Haven (texturehaven.com), a website that provides free textures, but any PBR texture should work. These maps are automatically connected using the **Node Wrangler** add-on with the **Ctrl + Shift + T** shortcut. After that, arrange the UV islands on the UV map created in step 26 to orient the fabric correctly. Finally, add an **Ambient Occlusion** node and connect to a **Color Ramp** node, adding at least two colors – one light and another dark – to accentuate the fabric folds.

36a Nodes for the fabric material

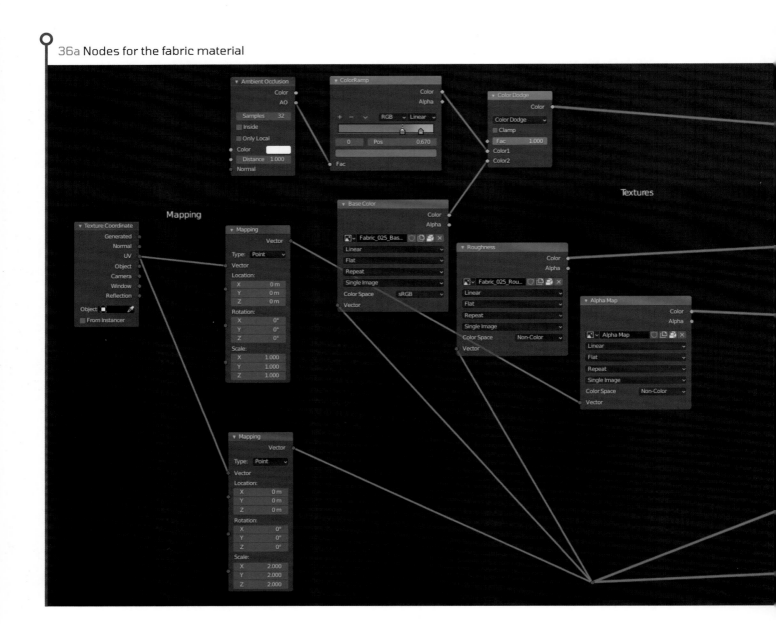

36b The rendered fabric material

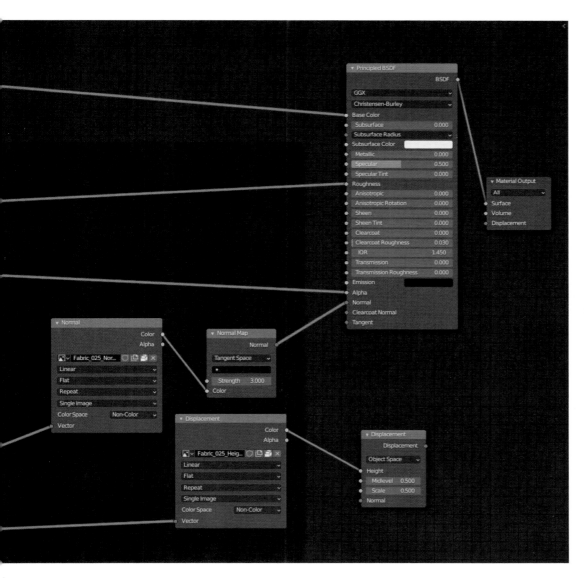

37 Metal

Creating a metallic material using the **Principled BSDF** node is very simple. You can look up metal colors online for inspiration on the types of metal you want to use, and judge the base colors from there. For example #C0BDBA for iron, #FAF9F5 for silver, #FEDC9D for gold, and #F4E4AD for brass. Add the relevant hex code to the **Base Color** section and set **Metallic** as 1.0 to define that this material is a metal. Finally, assign a low value to **Roughness**, such as 0.27, to achieve a reflective surface with a slight roughness.

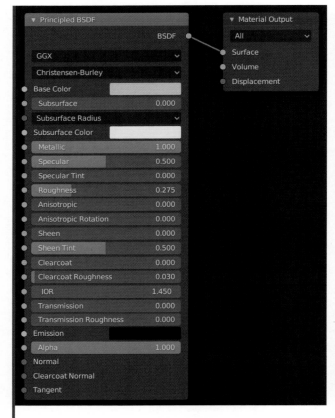

37 An example of a metal material used

38 Brass on sword

To make the brass material for the sword handle, use the **Principled BSDF** node with a **Base Color** simulating brass (for example hex code #F4E4AD) and set **Metallic** to 1.00, designating that this material is metallic. For **Roughness**, add a **Texture Coordinate** node, **Voronoi Texture** node, and **ColorRamp** node, then connect all the nodes. In the **Voronoi Texture** node, select **Smooth F1** and change **Scale** to around 121. In the **Color Ramp** node, play with the controls until you achieve the desired result (images 38a/38b).

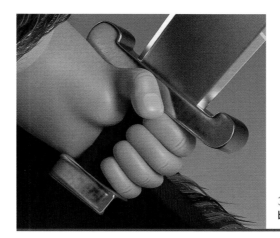

38b The rendered brass sword handle

38a Brass sword handle material

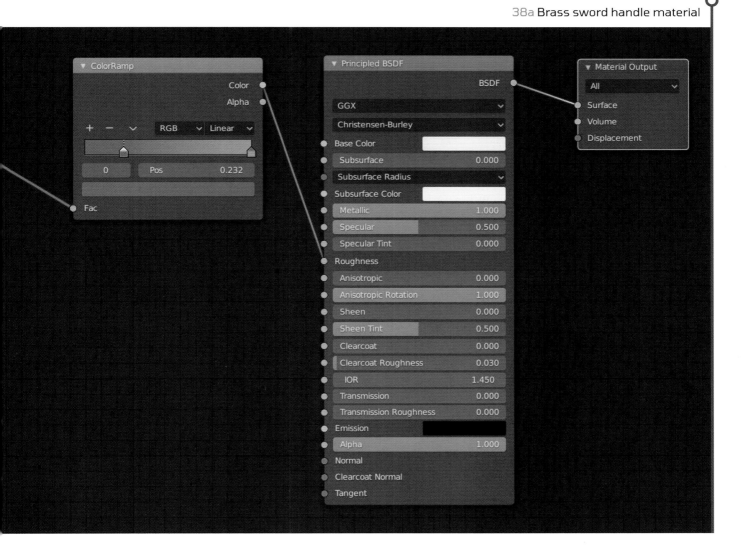

39 Scratched sword

For the damage to the sword, it is necessary to use six nodes to make three masks. These nodes only apply to the sword's blade, in the same way we assigned materials to different parts of the eye mesh. The first mask is a **Texture Coordinate** node connected to a **Voronoi Texture** node connected to a **Color Ramp** node. The second mask is an **Ambient Occlusion** node with another **Color Ramp**. These are then mixed with a **MixRGB** node set to **Multiply** to create the final mask that only has scratches on the blade edge. Finally, add a **Bump** node to decide the intensity of the scratches and connect it to the **Normal** socket in the **Principled BSDF** node (images 39a and 39b).

39a Scratched sword material

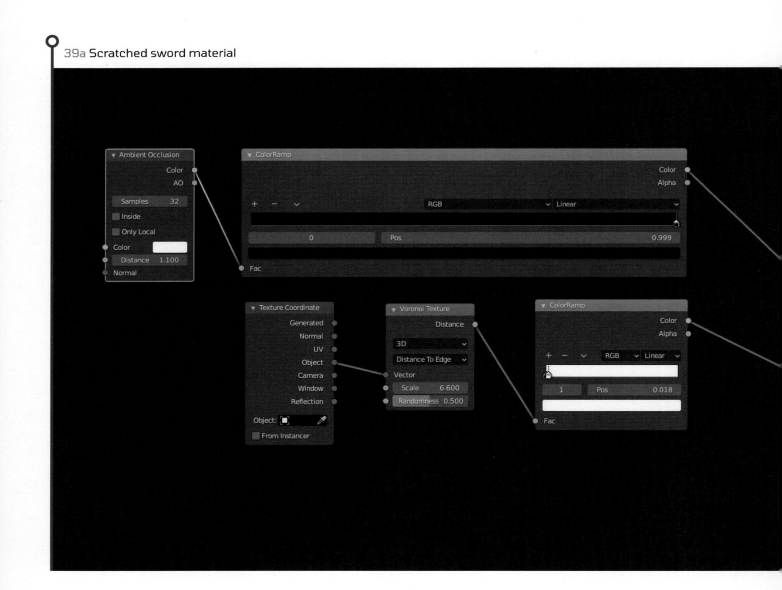

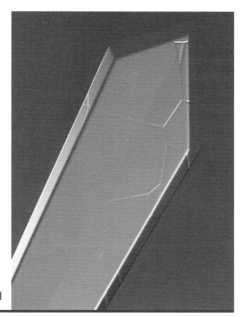

39b **The rendered scratched sword material**

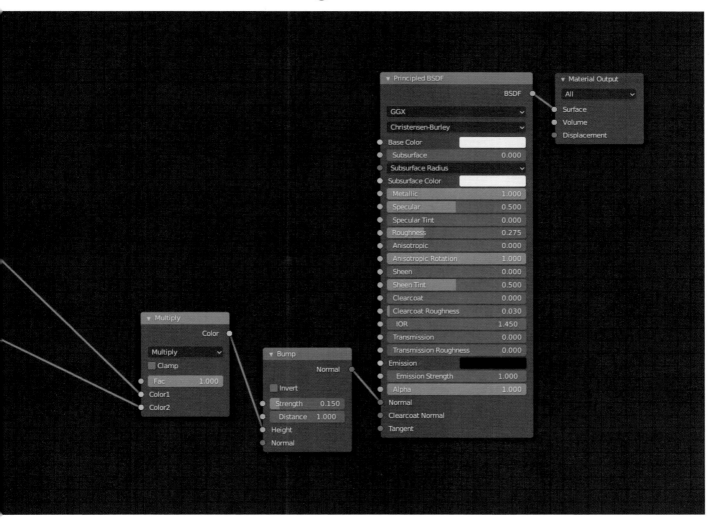

40 Leather

For the leather, use a premade seamless material, downloaded from a website such as Texture Haven (texturehaven.com). To add this material you only need to use the **Node Wrangler** shortcut **Ctrl + Shift + T** in the **Principled BSDF** node. The **Base Color**, **Roughness**, **Normal**, and **Displacement Maps** will be added automatically. With that, you have made the default material. Next, change the color by adding an **RGB** node and selecting the color you want. Lastly, mix this node and the **Base Color** texture with **Ctrl + 0** (**images 40a** and **40b**).

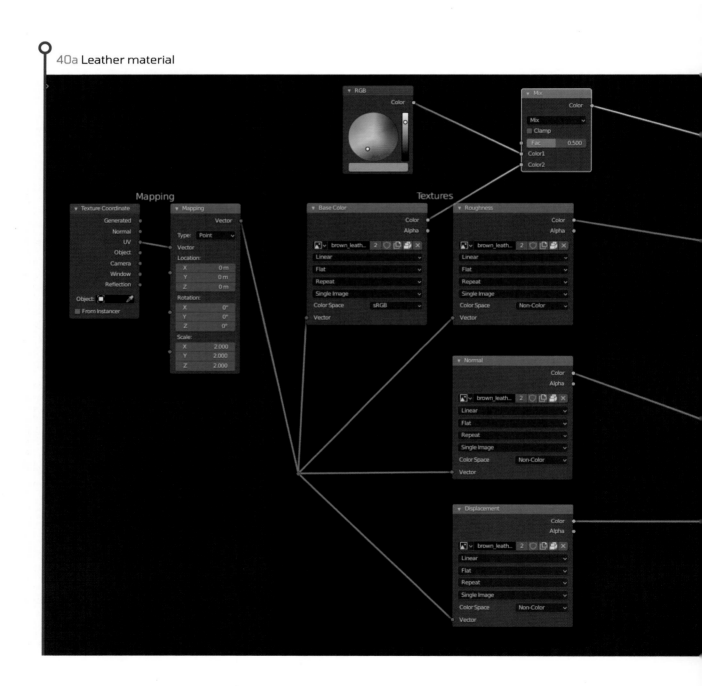

40a Leather material

40b The rendered
leather material

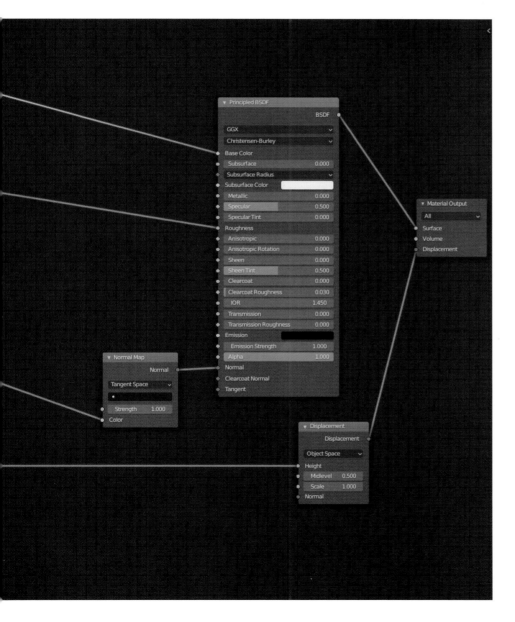

41 Beard

The body has no UVs, which is why the beard needs to be painted in **Vertex Paint**. The beard color will then be stored in a **Vertex Color** group. Go to **Vertex Paint Mode** in the 3D Viewport and paint the beard using a brush (**image 41a**).

Next go to the skin material previously created (step 32) in the Shader Editor and add more nodes: with a **Vertex Color** node, you can use what you just painted, and add a **Color Ramp** node to modify the strength; adding a **Gradient Texture** node generates a gradient and you can adjust the intensity with a **Color Ramp** node.

Add a **MixRGB** node set to **Screen** mode, and plug both new **ColorRamp** nodes into it. Connect this to another **MixRGB** node, which will be the alpha map to join the **RGB** node with the blue color of the beard and the nodes of the skin already created (**images 41b** and **41c**).

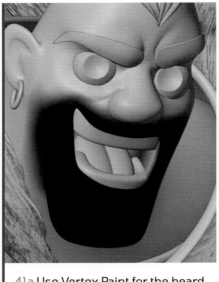
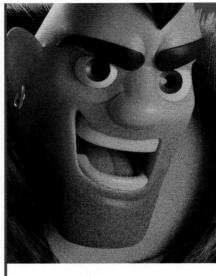

41a Use Vertex Paint for the beard

41b Viewport render

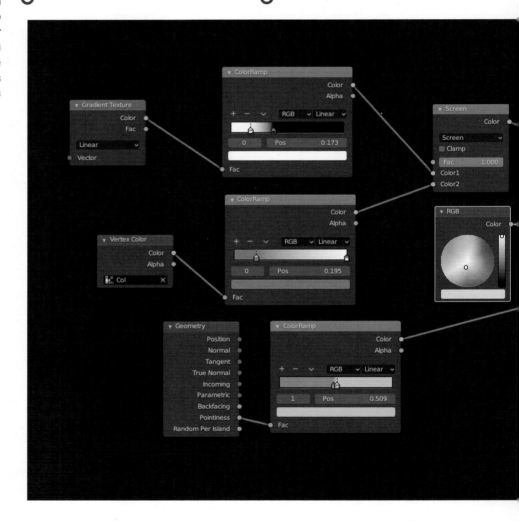

NODE GROUPS

As you learned on page 164, when using many nodes, it is a good idea to make a node group. Select the nodes you want to join in a group with **Ctrl + G**. You can use groups in the Shader Editor when working on materials and in the Compositor, where it helps to speed up the post-production process by gathering all nodes like **Sharpen**, **Brightness**, **Contrast**, and **Blur** in one place.

41c Shader Editor for the beard

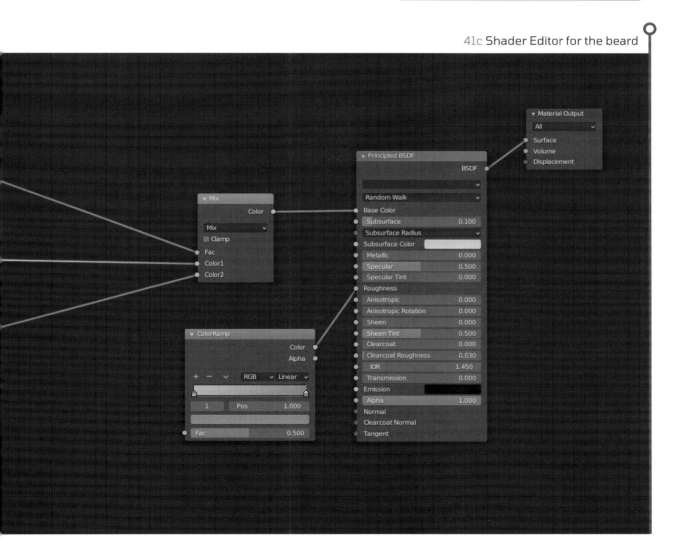

42 Fur cloak

Ensure the fur cloak is composed of multiple colors, not just one, which will give a more natural look to the fur. Use the **Principled Hair BSDF** node and add a **Voronoi Texture** node, increasing the **Scale** to generate patterns in black and white – in this case, use 22. To this, add a **ColorRamp** node and select the range of fur colors you want to use - you can add extra color sliders by clicking the plus sign. Connect all this to the Color socket in the **Principled Hair BSDF** node (**image 42**). The resulting spotted pattern is an ideal base for adding organic fur.

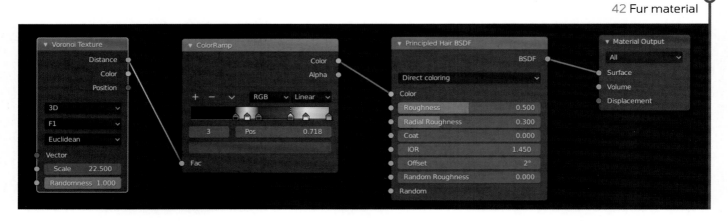

42 Fur material

Fur & hair

43 Weight Paint

As you learned on page 34, Weight Paint is used as a way of setting an influence level for a certain element. In this case you will be using it to influence the amount of fur on the warrior's cloak. Remember that weight is displayed as a hot and cold gradient color system. Low-value areas are shown in blue and are close to 0.0; high-value areas are red and close to 1.0.

Go to **Weight Paint Mode** and select the radius and weight, for example as shown in image 43a. Paint the object to indicate where areas of more hair are needed, as shown in image 43b. Then go to **Particle Properties** in the Properties Editor, click the **+** icon, and in **Vertex Groups > Density** select the new Weight Paint group.

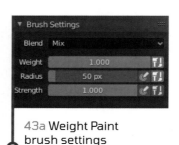

43a Weight Paint brush settings

43b Using Weight Paint on the cloak

WEIGHT PAINT TOOLS

In addition to the Draw tool, other useful Weight Paint tools are:

► **Blur** for smoothing;
► **Smear** for dragging colors to other areas; and
► **Gradient** for gradual painting.

You can smooth the weight distribution of the whole object in a single step by selecting **Weights > Smooth** in the Header.

44 Hair particle theory

To create hair, you need three things:

▶ an object which will emit the hair (**image 44a**);

▶ a particle system where you can decide the size, quantity, and style of the hair (**image 44b**);

▶ the **Principled Hair BSDF** shader, with which you can use melanin to determine the color of the hair realistically (**image 44c**).

For this, choose the object that will be the emitter (in this example, the cloak) and add the **Principled Hair BSDF** node in the Shader Editor. In the next step you will add a hair particle system and finally handle the hair in **Particle Edit Mode** in step 46.

44a Emitter

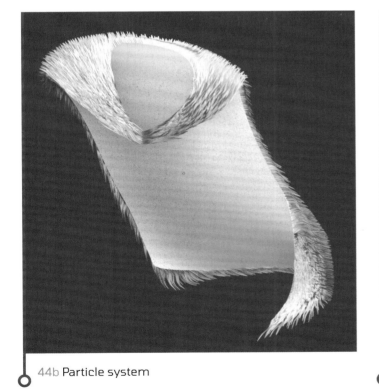

44b Particle system

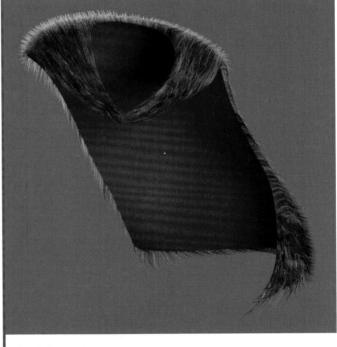

44c Material

45 Hair particle system

In **Particle Properties**, add a new particle system by clicking the plus sign in the top right and select **Hair** (**image 45a**). Under **Emission**, you can decide how many hair particles you want and what size (see settings in **image 45b**). In the **Render** dropdown, select **Path > B-Spline** with **Steps** set to 8, and match that number in **Viewport Display > Strand Steps**.

Under **Children**, select **Interpolated** and the number of particles you want in the Viewport and the render (for example, 15; see **image 45c**). Activate **Clumping** by going to **Clumping** dropdown and checking the **Use Clump Curve** box. Slide the clump curve down into a diagonal line by clicking and dragging the points on the line (**image 45d**).

Finally, under **Kink**, select **Wave** from the multiple **Kink Type** options. You now have the base for the hair and are ready to edit.

45a Particle Properties

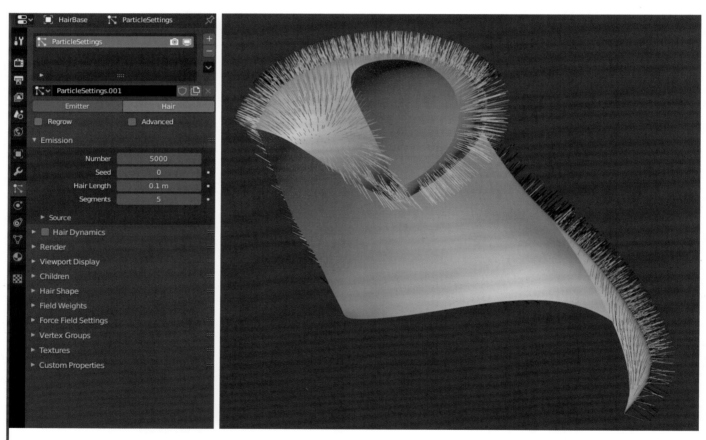

45b Starting to set the particle system

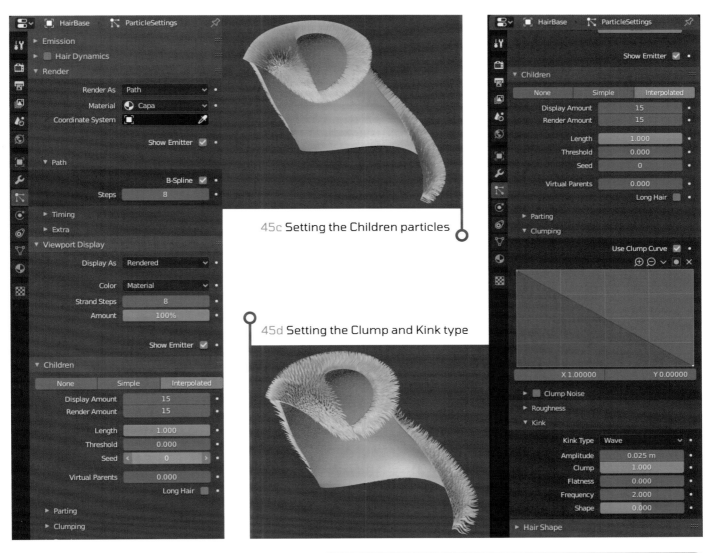

45c Setting the Children particles

45d Setting the Clump and Kink type

CAN'T SEE THE PARTICLES?

If you can't see the hair particles in the Viewport, check that you are in **Object Mode**. If that doesn't fix it, go to the **Render** menu and activate **Hair**.

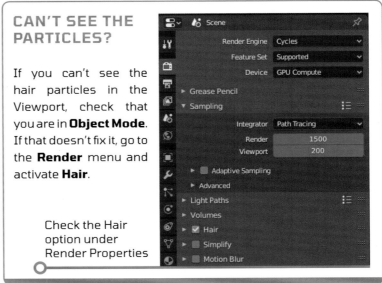

Check the Hair option under Render Properties

46 Editing the hair particles

To edit the hair particles, you need to go to **Particle Edit** under the **Mode** dropdown menu in the top left of the Header. To enable you to move the particles, activate the **Point** selection mode (**image 46a**). There are several tools for handling hair particles:

▶ **Comb** allows you to arrange the particles.

▶ **Add** lets you add more particles.

▶ **Length** extends or shrinks the particles depending on whether you are pressing **Ctrl**.

▶ **Puff** pushes the particles up/down.

Experiment with each of these tools to shape the fur on the cloak (**image 46b**).

46a Particle Edit tools

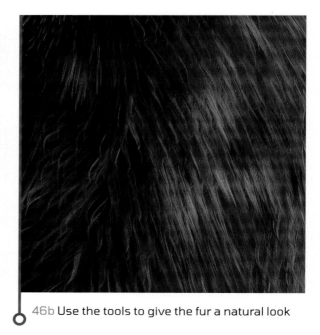

46b Use the tools to give the fur a natural look

47 Arm hair

For the arm hair, create a **Weight Paint** group and paint on the object to indicate where you want the hair to appear and where you don't want it to appear. Add and edit the hair particle system as you did for the fur on the cloak, adjusting the settings to fit the look you want the arm hair to have.

In this case, due to the **Multiresolution** modifier, it may be tough to comb the hair in **Particle Edit Mode** because of the slow response. To fix this, send the **Multiresolution** modifier to the bottom of the modifier stack.

Next, select the **Principled Hair BSDF** node in the Shader Editor and use **Melanin concentration**. Set **Melanin** to 0.0 to make the **hair** white (**images 47a** and **47b**).

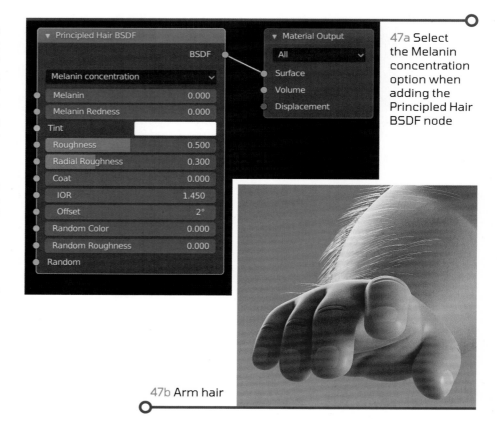

47a Select the Melanin concentration option when adding the Principled Hair BSDF node

47b Arm hair

Rendering

48 General settings

You will use the Cycles render engine. As this scene is small, it will be possible to render using only the video card. Go to **Edit > Preferences > System** and check the GPU option (in image 48a, it is CUDA because the graphics card used is an Nvidia GeForce GTX 1080).

In **Render Properties** in the Properties

Editor, select **Cycles** in the **Render Engine** dropdown and choose **GPU Compute** in the **Device** dropdown (image 48b). Go to **Sampling** and set **Render** at 1500 to avoid noise and check the **Adaptive Sampling** option, setting **Noise Threshold** to 0.0020 to accelerate the render. Finally, under **Performance**, use large tiles, for example 256 pixels × 256 pixels.

48a Blender Preferences window

48b Render Properties settings

Post-production

49 Color Management

To avoid a gray-looking image, you can play with the color curves. Still under **Render Properties**, open **Color Management** and set the **View Transform** as **Filmic**. For the **Look** option, choose the amount of contrast. This image uses **Very High Contrast**, with **Exposure** set to 0.750. Finally, go to **Use Curves** and, under **Black Level**, change the red (R) channel to -0.010, giving a reddish black. Under **White Level**, increase the red channel to 1.100, the green (G) to 1.100, and the blue (B) to 1.500, giving a general warm tone to the image (**image 49**).

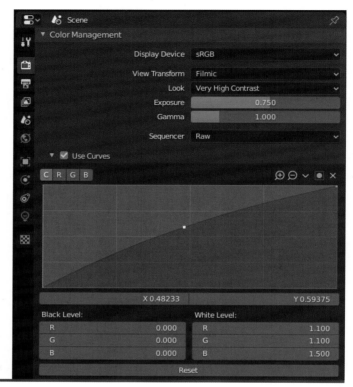

49 Using the Color Management settings

50 Compositor

Go to **Render > Render Image (F12)** to render the image, and then you can use the Compositor for the post-production of the picture. Go to **Compositing** in the Topbar and activate **Use Nodes** in the top left of the Header. Two nodes will appear: **Render Layers**, which are the active passes you have enabled in the **View Layer Properties**, and **Composite**, which is the final output. You can add more nodes using **Shift + A**. There are a lot of nodes to choose from, so start with the basic ones, like **Brightness and Contrast**, **Blur**, **Sharpen**, **Mix**, **RGB Curves**, and **Color Balance**. Tweak the settings in each one and review the render to see how they affect the image (**image 50**).

50 Examples of nodes in the Compositor

51 Denoise

You can remove noise in renders using the Denoise node inside the Compositor. This will save you some render time without losing quality. To use this node, activate **Normal Pass** in **View Layer Properties > Passes > Data**. Then, go to the Compositor and add the Denoise node with **Shift + A > Filter > Denoise**. Lastly, connect **Image** and **Normal** in the **Render Layers** node to those in the **Denoise** node. Now, every time you carry out a render, the denoise function will activate (image 51).

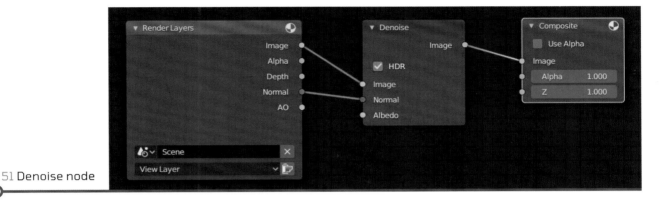

51 Denoise node

52 Vignetting

To emphasize the character, you can simulate a vignette effect inside the Compositor. First, add the **Ellipse Mask** node with **Shift + A > Matte > Ellipse Mask**, and play with the width, height, and rotation. Then, add the **Filter > Blur** node, using **Gaussian** and **X** and **Y** to decide the amount of blur. Finally, add the **Color > Mix** node and connect the final image and the blurred mask, using the **Multiply** blending mode. With this, the vignette is ready (image 52).

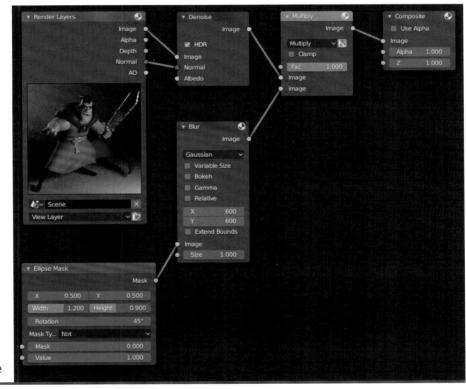

52 Applying a vignette

53 Final version

The model and rendered image are now complete. Here is the character rendered from different angles.

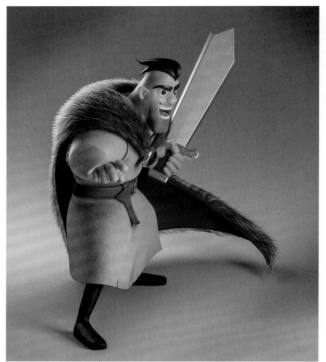

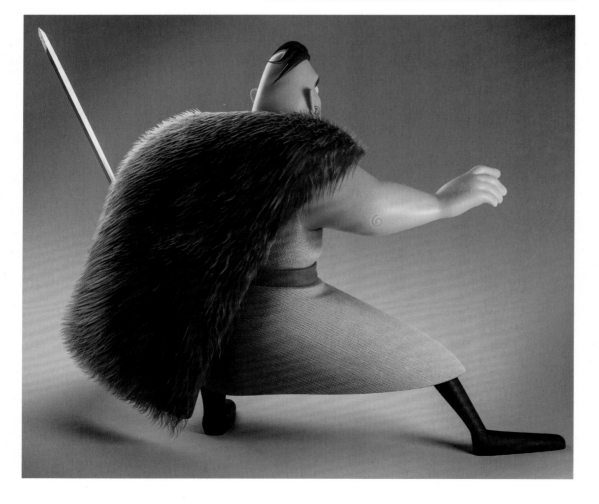

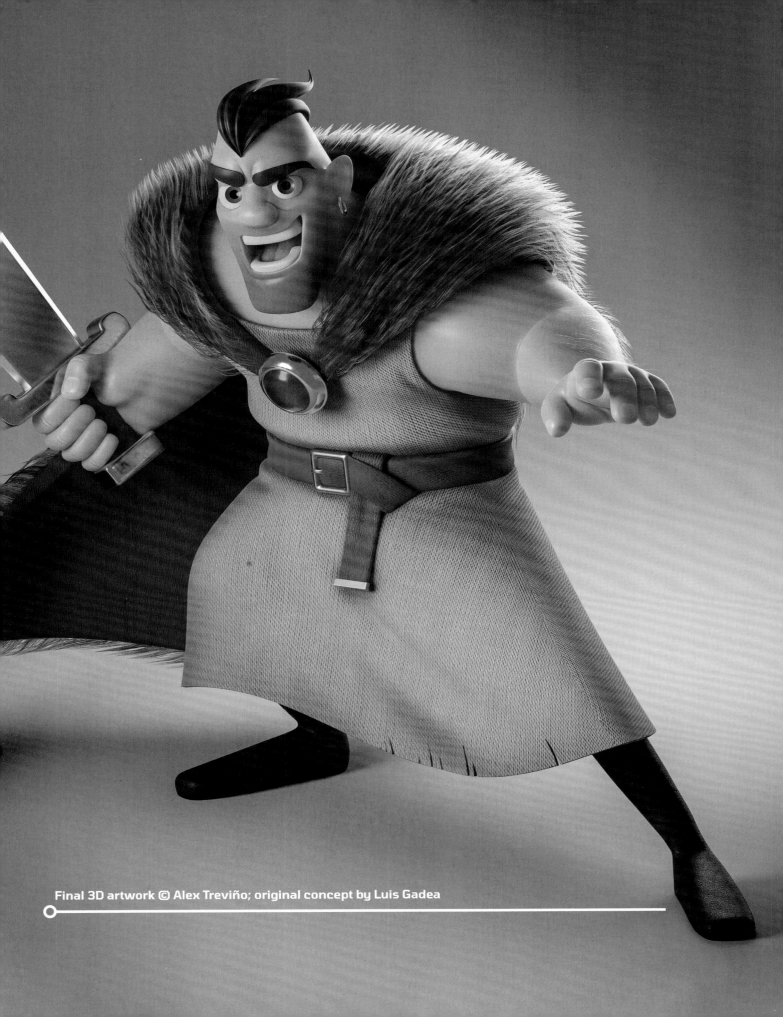

Final 3D artwork © Alex Treviño; original concept by Luis Gadea

Glossary
By Pierrick Picaut

Adobe After Effects:
After Effects was originally a video-editing software, but has since evolved into a compositing software. It is commonly used for video effects, compositing, motion design, and video-editing.

Albedo:
The albedo map (or diffuse map) is the texture used to set the base color of a material without any other physical behaviors such as specularity, roughness, or reflectiveness.

Ambient occlusion:
Ambient occlusion is a method to approximate shading on any surface in a 3D environment. It simulates the loss of illumination when two surfaces are close to each other, as the light bounces multiple times until it fades.

Bevel:
A beveled edge is an edge that is not perpendicular to the surrounding two faces. A bevel adds a slope that smooths the angle between the two surfaces.

Boolean:
A Boolean operation is one that allows you to merge, subtract, or create geometry based on the intersection of two or more mesh objects.

Chromatic aberration:
In optics, chromatic aberration is a failure of a camera's lens to focus the red, green, and blue color wavelengths on the same point. This creates a colored fringe or haze around the edges of the subject in a photograph. In computer graphics, an artist can deliberately offset each color channel of an image to simulate this physical issue and make a result that feels more realistic and cinematic.

CPU:
The central processing unit is the main asset that allows your computer to process any calculation. The more powerful your computer's CPU, the more complex and demanding operations it is able to run.

Deformation:
The act of bending, twisting, or scaling an object using a modifier or manipulation tool.

Edge:
The line between two vertices or where two faces meet. A minimum of three edges are needed to create a face.

Extrude:
Generating new geometry by pushing or pulling out a single point, multiple points, edges, or faces. Extrusion generates the new geometry along the chosen axis.

Face:
A plane whose shape is defined by edges and vertices. Multiple faces define the surface of a 3D object. Three edges create a triangular face; four edges create a **quad**; and more than four edges creates an **n-gon**.

Gaussian blur:
This is the result of blurring an image using a Gaussian function (named after the mathematician and scientist Carl Friedrich Gauss). It creates a smooth, even blur effect.

GPU:
A computer's graphics processing unit, usually part of a graphics card. Like the CPU, it is made to run calculations, but its calculations are specific to displaying graphics. A GPU's structure allows it to calculate simple algorithms at a fast pace.

Hex code:
A hexadecimal number used commonly in web design language and graphics software to identify colors. Each color has its own ID code of six letters or numbers.

Interpolate:
Interpolation is mathematical operation that defines the behavior of a curve. It influences the behavior of an output such as the color contrast of a gradient or the speed of a movement.

Texture mapping:
In 3D graphics, texture mapping refers to how an image (a texture) is project onto the surface of a 3D model.

Material:
A material is a combination of algorithms and shaders that determine the way a surface will react to lighting – the specularity, transparency, translucency, and roughness of a color.

Mesh:
The structure of a 3D object, consisting of vertices, edges, and faces. This network of points in space constitutes the mesh of a 3D object.

Node:
A visual representation of a mathematical function, color function, or shader algorithm. Nodes can be linked and combined by the user in an intuitive and visual manner.

Normal:
Normals are directional vectors perpendicular to a surface point. They are used to calculate the behavior of light bouncing off a surface.

NUKE:

NUKE is a compositing software developed by the Foundry. It is comparable to Adobe After Effects in its functionality, but is node-based, thus offering more possibilities. It is often favored for bigger, more complex productions.

Object:

In Blender, an object is a container that has a location, orientation, and scale, and can contain any type of object data.

Object data:

Object data is contained within a Blender object and defines its purpose, whether it is a mesh object containing mesh data, a camera object containing camera data such as focal length or depth of field, and so on.

Plane:

In Blender, a plane is a 3D primitive mesh object made of four vertices and two triangles. The word is also used more generally to describe a flat, 2D surface or shape.

RAM:

Random-access memory is the memory used to store information being processed by the CPU at the moment it is calculating. Once the calculation is completed, the RAM is free for another calculation. A computer with a large amount of RAM can run more demanding calculations and multi-task them more effectively.

Rasterize:

This is the process of converting an image into pixels that can be displayed by a computer screen. Raster images have a finite size and quality, and are usually contrasted with vector images, which can be resized infinitely as they are defined by mathematical formulas rather than pixels.

Render:

Rendering is the process of calculating the behavior of light on the surfaces of an object, through a virtual camera, and outputting the result as an image. This resulting image is also often referred to as a "render."

Shader:

Shaders are a sub-component of a material, defining its surface properties, such as a transparent shader defining the surface's opacity or an emission shader making a surface emit light. These algorithms are built to simulate these specific behaviors.

Specularity:

Specularity refers to the reflectivity of a surface – its level of shininess.

Sub-surface scattering:

Also known as SSS, sub-surface scattering is when light enters a translucent surface, such as skin or frosted glass, bounces inside it and is "scattered" while exiting the material, creating a soft glow Most materials around us do this to some degree SSS. A common example is the reddish light shining through a person or animal's ears when the head is lit from behind.

Texture:

A 2D picture that can be projected onto a 3D object to enhance its appearance and influences its material behavior.

Threads:

Threads define the virtual core of a CPU. Modern CPUs have multiple cores, divided in 2 threads each. Each thread can be assigned to specific calculation, allowing you to work on multiple softwares at once or render your images faster.

Tiles:

When rendered, an image is divided in a grid of homogeneous smaller chunks, each of them calculated one after the other by the CPU or GPU. Each tile will use one thread to be calculated. The more powerful your CPU, the more tiles can be calculated at the same time.

Topology:

The coordinates and ordering of vertices, edges, and faces on a mesh object. It refers more specifically to continuous surfaces and defines the way a mesh will deform or interact with light.

UV:

The UV refers to the 2D coordinates of an unwrapped or projected 3D object. UVs are used to generate UV maps, which allow you to apply textures to an object corresponding with those coordinates.

Vertex:

A point that can form the corner of a polygon or the end of an edge when connected to other vertices.

Vignette:

The process of darkening the corners of a picture to help emphasize the centre of the image. Vignetting was originally an undesirable effect caused by some cameras, but can beused to give more realism to a rendered image and focus the viewer's eye on its center.

VRAM:

Video random-access memory (VRAM) isRAM that belongs to the graphics card and is only used by the GPU. The more VRAM is available, the more complex the calculated picture can be.

Contributors

PIERRICK PICAUT

CG director & Blender tutor

p2design.eu

Pierrick Picaut is a Blender foundation certified trainer and is the CG director at Atypique Studio, working on the game NOARA. He produces educational content, courses, and tutorials about Blender and CG in general, with a passion for game animation.

ALEX TREVIÑO

3D generalist

aendom.com

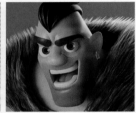

Alex Treviño is a self-taught 3D independent artist always searching for new ways to improve his skills. His quest for knowledge involves experimenting with new techniques to improve his abilities and find better workflows with each new project.

MICHAEL A. ROJAS (MIKERED)

Digital artist

artstation.com/mikered

Michael A. Rojas (aka MikeRed) is a self-taught digital artist born in Venezuela, in a small town called Ocumare del Tuy. When he was twenty-three years old, he moved to the city of Lima in Peru. He loves art, character design, and nature. Since he started using Blender he has not been able to stop.

JUAN HERNÁNDEZ

CG designer

artstation.com/donchuan3d

Juan Hernández is a 3D designer and character artist born in Venezuela. Working at PFX Studio in Prague, Czech Republic, Juan enjoys creating stylized and realistic illustrations in 3D. He is a self-taught artist.

Artwork acknowledgments as in individual chapters

Index

3dtotalPublishing

3dtotalPublishingisatrailblazing,creative publisher specializing in inspirational and educational resources for artists.

Our titles feature top industry professionals from around the globe who share their experience in skillfully written step-by-step tutorials and fascinating, detailed guides. Illustrated throughout with stunning artwork, these best-selling publications offer creative insight, expert advice, and essential motivation. Fans of digital art will enjoy our comprehensive volumes covering Adobe Photoshop, Procreate, and Blender, as well as our superb titles based around character design, including *Fundamentals of Character Design* and *Creating Characters for the Entertainment Industry*. The dedicated, high-quality blend of instruction and inspiration also extends to traditional art. Titles covering a range of techniques, genres, and abilities allow your creativity to flourish while building essential skills.

Well-established within the industry, we now offer over 100 titles and counting, many of which have been translated into multiple languages around the world. With something for every artist, we are proud to say that our books offer the 3dtotal package:

LEARN · CREATE · SHARE

Visit us at 3dtotalpublishing.com

3dtotal Publishing is part of 3dtotal.com, a leading website for CG artists founded by Tom Greenway in 1999.